MW01077876

Iconology, Neoplatonism, and the Arts in the Renaissance

The mid-twentieth century saw a change in paradigms of art history: iconology. The main claim of this novel trend in art history was that renowned Renaissance artists (such as Botticelli, Leonardo, or Michelangelo) created imaginative syntheses between their art and contemporary cosmology, philosophy, theology, and magic.

The Neoplatonism in the books by Marsilio Ficino and Giovanni Pico della Mirandola became widely acknowledged for its lasting influence on art. It thus became common knowledge that Renaissance artists were not exclusively concerned with problems intrinsic to their work but that their artifacts encompassed a much larger intellectual and cultural horizon. This volume brings together historians concerned with the history of their own discipline – and also those whose research is on the art and culture of the Italian Renaissance itself – with historians from a wide variety of specialist fields, in order to engage with the contested field of iconology.

The book will be of interest to scholars working in art history, Renaissance history, Renaissance studies, historiography, philosophy, theology, gender studies, and literature.

Berthold Hub is Lecturer at the University of Vienna and visiting professor at the Beuth Hochschule für Technik Berlin.

Sergius Kodera is Senior Researcher at the New Design University St. Pölten and external reader in Philosophy at the University of Vienna.

Cover Image: Michelangelo, *Giuliano de Medici*. Florence, San Lorenzo, Medici Chapel. Photo by Aurelio Amendola.

Routledge Research in Art History

Routledge Research in Art History is our home for the latest scholarship in the field of art history. The series publishes research monographs and edited collections, covering areas including art history, theory, and visual culture. These high-level books focus on art and artists from around the world and from a multitude of time periods. By making these studies available to the worldwide academic community, the series aims to promote quality art history research.

Academies and Schools of Art in Latin America
Edited by Oscar E. Vázquez

The Australian Art Field
Practices, Policies, Institutions
Edited by Tony Bennett, Deborah Stevenson, Fred Myers, and Tamara Winikoff

Lower Niger Bronzes
Philip M. Peek

Art, Mobility, and Exchange in Early Modern Tuscany and Eurasia
Edited by Francesco Freddolini and Marco Musillo

The Cobra Movement in Postwar Europe
Reanimating Art
Karen Kurczynski

Emilio Sanchez in New York and Latin America
Victor Deupi

Henri Bertin and the Representation of China in Eighteenth-Century France
John Finlay

Picturing Courtiers and Nobles from Castiglione to Van Dyck
Self Representation by Early Modern Elites
John Peacock

The Reception of the Printed Image in the Fifteenth and Sixteenth Centuries
Multiplied and Modified
Edited by Grażyna Jurkowlaniec and Magdalena Herman

Iconology, Neoplatonism, and the Arts in the Renaissance
Edited by Berthold Hub and Sergius Kodera

For a full list of titles in this series, please visit https://www.routledge.com/Routledge-Research-in-Art-History/book-series/RRAH

Iconology, Neoplatonism, and the Arts in the Renaissance

Edited by
Berthold Hub and Sergius Kodera

Routledge
Taylor & Francis Group

NEW YORK AND LONDON

First published 2021
by Routledge
52 Vanderbilt Avenue, New York, NY 10017

and by Routledge
2 Park Square, Milton Park, Abingdon, Oxon OX14 4RN

Routledge is an imprint of the Taylor & Francis Group, an informa business

© 2021 Taylor & Francis

The right of Berthold Hub and Sergius Kodera to be identified as the authors of the editorial material, and of the authors for their individual chapters, has been asserted in accordance with sections 77 and 78 of the Copyright, Designs and Patents Act 1988.

All rights reserved. No part of this book may be reprinted or reproduced or utilised in any form or by any electronic, mechanical, or other means, now known or hereafter invented, including photocopying and recording, or in any information storage or retrieval system, without permission in writing from the publishers.

Trademark notice: Product or corporate names may be trademarks or registered trademarks, and are used only for identification and explanation without intent to infringe.

Library of Congress Cataloging-in-Publication Data
Names: Hub, Berthold, editor. | Kodera, Sergius, 1963- editor. | Iconology:
Neoplatonism and Art in the Renaissance (Conference) (2011 : Universität Wien)
Title: Iconology, neoplatonism, and the arts in the Renaissance / edited by Berthold Hub and Sergius Kodera.
Description: New York : Routledge, 2021. | Includes bibliographical references and index.
Identifiers: LCCN 2020025119 (print) | LCCN 2020025120 (ebook) | ISBN 9780367895297 (hardback) | ISBN 9781003019671 (ebook)
Subjects: LCSH: Art, Renaissance--Historiography. | Art and philosophy. | Neoplatonism.
Classification: LCC N6370 .I29 2021 (print) | LCC N6370 (ebook) | DDC 709.02/4--dc23
LC record available at https://lccn.loc.gov/2020025119
LC ebook record available at https://lccn.loc.gov/2020025120

ISBN: 978-0-367-89529-7 (hbk)
ISBN: 978-1-003-01967-1 (ebk)

Typeset in Sabon
by Taylor & Francis Books

Contents

Figures

Contributors

Marlen Bidwell-Steiner is Senior Lecturer for Spanish at the Department of Romance Studies at the University of Vienna, where she obtained her habilitation in 2015. She currently holds a grant by the FWF, Austrian Science Funds, for her project "Casuistry and Early Modern Spanish Literature" (2019–2022). She has published widely on the intersection of philosophical and imaginary literature and on gender regimes in the Early Modern Mediterranean.

Paul Richard Blum is T. J. Higgins, S.J., Chair in Philosophy (emeritus) at Loyola University Maryland, Baltimore. He specializes in Renaissance and Early Modern Philosophy, including the Jesuit tradition. Among his publications are "Early Jesuit Philosophers on the Nature of Space," in *Jesuit Philosophy on the Eve of Modernity*, edited by Cristiano Casalini, 1371–65 (Leiden: Brill, 2019); *Nicholas of Cusa on Peace, Religion, and Wisdom in Renaissance Context* (Regensburg: Roderer, 2018); *Giordano Bruno Teaches Aristotle* (Nordhausen: Bautz, 2016); *Studies on Early Modern Aristotelianism* (Leiden: Brill, 2012); and *Philosophers of the Renaissance* (Washington, D. C.: Catholic University of America Press, 2010).

Angela Dressen is Andrew W. Mellon Librarian at I Tatti, the Harvard University Center for Italian Renaissance Studies, Privatdozentin for Art History at the TU Dresden, Visiting Professor for Renaissance Art History at the University of Vienna, and Discipline Representative for Digital Humanities at the Renaissance Society of America. Beyond Renaissance Art History, her research embraces the fields of Intellectual History, Digital Art History, and Contemporary Architecture. Her habilitation thesis *The Intellectual Education of the Italian Renaissance Artist* is under contract with Cambridge University Press.

Berthold Hub received his PhD from the University of Vienna in 2006 with a dissertation on ancient aesthetics entitled "The Perspective of Antiquity: Archeology of a Symbolic Form," which was published in 2008. He was fellow of the Warburg Institute, London, and of the Kunsthistorisches Institut in Florenz (Max-Planck-Institute), assistant professor at the ETH Zürich, and visiting professor at the Albert-Ludwigs-Universität Freiburg im Breisgau, at the University of Zurich, and at the University of Vienna. Currently, he is lecturer at the University of Vienna and visiting professor at the Beuth Hochschule für Technik Berlin. His habilitation thesis *Filarete: Der Architekt der Renaissance als Demiurg und Pädagoge* was published in 2020 (Vienna: Böhlau).

Sergius Kodera has been teaching Early Modern and Renaissance philosophy at the Department of Philosophy at the University of Vienna since he received his doctorate

there in 1994. He received his habilitation in 2004 and has had fellowships in London (Warburg Institute), Vienna (IFK), New York (Columbia), and Berlin (Freie Universität). From 2004 to 2020, Kodera taught at New Design University, St. Pölten, Austria, a private University of which he is a founding member; here he was dean of the Faculty of Design (2012–2019). Kodera has published on and/or is a translator of Renaissance authors such as Marsilio Ficino, Fernando de Rojas, Machiavelli, Leone Ebreo, Girolamo Cardano, Giovan Battista della Porta, Giordano Bruno, and Francis Bacon. Currently, he is working on a book-length study on Della Porta in English. His main fields of interest are the history of the body and sexuality and of objects, magic, and media.

Jeanette Kohl is Associate Professor of Art History at the University of California, Riverside. Her research focuses on portraiture, sculpture, and concepts of mimesis, memory, and representation in the Italian Renaissance. She earned her PhD from the University of Trier, Germany with a dissertation on Bartolomeo Colleoni's burial chapel (*Fama und Virtus*, Berlin: Akademie Verlag, 2004). She was a postdoctoral fellow at the Kunsthistorisches Institut in Florence (2001–2004), Wissenschaftliche Mitarbeiterin at the University of Leipzig (2004–2008), and Visiting Professor at the Friedrich-Schiller-Universität in Jena (2007). Kohl has received fellowships from the NEH (2012), the Getty Research Institute (2014), and the Morphomata Center for Advanced Studies at the University of Köln (2015), among others. In 2018/19, she was the Agnes Gund and Daniel Shapiro Member at the Institute for Advanced Study in Princeton. She is currently working on her book *The Life of Busts: Fifteenth-Century Portrait Sculpture in Italy*.

François Quiviger is a fellow of the Warburg Institute (University of London), where he studied and worked as curator of digital resources, researcher, teacher and librarian from 1983 to 2016. His research centers on early modern European cultural history and ideas and beliefs about images, perception, imagination, and nature. His publications include research papers on Renaissance academies, art theory, and festive culture, as well as biographies of Caravaggio and Leonardo da Vinci (2019). His book, *The Sensory World of Italian Renaissance Art* (London: Reaktion, 2010), analyzes representations of non-visual sensations in early modern art and their relation to ancient and modern theories of cognition.

Valery Rees has worked for many years on *The Letters of Marsilio Ficino* (London: Shepheard-Walwyn, 10 vols. to date). She has published numerous articles, including studies of Ficino's influence on two poets, Edmund Spenser and Michele Marullus. She has co-edited several collections of academic essays and contributed to several episodes of BBC Radio 4's *In Our Time* and other programs. Her monograph *From Gabriel to Lucifer: A Cultural History of Angels* (2013) was reprinted in 2015 and published in a German translation in 2015. She leads Renaissance Studies at the School of Philosophy and Economic Science in London, home of the *Letters* project, and she is an Associate of Newnham College, Cambridge.

Andreas Thielemann (b. 1955, Dresden, d. 2015, Rome) studied physics in Dresden. In 1983, he escaped from the GDR to Greece and subsequently settled in Western Germany. Here, Thielemann studied and later taught history of art at the University of Cologne. In 2000, Thielemann moved to Rome, where he worked for the Max-Planck-Institut für Kunstgeschichte. He became the director of its library, the Bibliotheca Hertziana. His highly original texts are *inter alia* on Raphael, Dürer, Michelangelo, Rubens, and Adam Elsheimer, as well as on the history of scholarship and of objects such as mirrors.

Stéphane Toussaint is an Italianist, a historian of philosophy and art, and a specialist in the history of Renaissance philosophy and humanism. He is Directeur de recherches in philosophy at CNRS, Paris, where he is a member of the research group Philosophies et théologies antiques, médiévales et modernes. Toussaint is founder and editor-in-chief of *Accademia*, and *Cahiers d'Accademia*, journals dedicated to the investigation of Renaissance Neoplatonism. His prolific work comprises numerous books and scholarly articles on Ficino, Giovanni Pico della Mirandola, Reuchlin, Leonardo, and Cattani da Diacceto, focusing on topics such as Renaissance magic and cabala, orphism, mechanics, on the history and problems of humanism and anti-humanism from the Renaissance to Heidegger, as well as on eminent Renaissance scholars such as Eugenio Garin, André Chastel, and Paul Oskar Kristeller.

Introduction

Sergius Kodera

Sometimes it seems that, like garbage on a building site, polemics accompany and are even intrinsic to scholarly discourse: indeed, controversy (like the accumulation of garbage) might be indicative of work in progress. Polemics also often create room for new arrangements of old subject matters, thus causing the attacked party to carefully re-examine and critically revise their stance in response to the assailant. In the process, the tables are often turned on the authors of the polemics. In our case, the contested tradition is iconology.[1] This volume grew out of a 2011 conference, since which Andreas Thielemann, sadly, has passed away; the editors and contributors regret the untimely death of this enormously energetic and lucid scholar. We treasure the fondest memories of his lively and inspiring talk during the event, and we dedicate this volume to his memory.

The mid-twentieth century saw a change in paradigms of art history: iconology. The main claim of this novel trend in art history was that renowned Renaissance artists (such as Botticelli, Leonardo, or Michelangelo) created imaginative syntheses between their art and contemporary cosmology, philosophy, theology, and magic. In particular, the Neoplatonism in the books by Marsilio Ficino and Giovanni Pico della Mirandola became widely acknowledged for its lasting influence on art. It thus became common knowledge that Renaissance artists were not exclusively concerned with problems intrinsic to their work but that their artifacts rather encompassed a much larger intellectual and cultural horizon. Yet the tradition was not uncontested, even on its own terms.

Even though iconology undeniably had its greatest impact on the study of European Renaissance art, in principle this approach can be applied to any work of art: or at least this was believed by the proponents of this tradition.

But what is, then, the difference between iconography and iconology? In his *Studies in Iconology* (1939) Erwin Panofsky explains that there are three different ways to approach a work of art: pre-iconographic description of a work of art, iconographical analysis, and iconological interpretation; these approaches are related to three different forms of histories: the history of style, of types, and what Panofsky calls "cultural symptoms."[2] These three strata of interpretation cannot neatly be separated; they have to be applied together in order to discover the "meaning of an artwork." This meaning "may be defined as a unifying principle which underlies and explains both the visible event and its intelligible significance, and [...] determines even the form in which the visible event takes shape."[3] Thus the domain of iconography is "the identification of [...] images, stories and allegories."[4] We make full use of iconographical interpretation once

> [...] we try to understand [a work of art as the *Last Supper* fresco] as a document of Leonardo's personality, or of the civilization of the Italian High Renaissance, or of a

peculiar religious attitude, we deal with the work of art as a *symptom of something else* which expresses itself in a countless variety of other symptoms, and we interpret its compositional and iconographical features as more particularized evidence of this 'something else.' The discovery and interpretation of these *'symbolical' values* (which are generally unknown to the artist himself and many even emphatically differ from what he consciously intended to express) is the object of what we may call *iconography in a deeper sense*: or a method of interpretation which arises as a synthesis rather than an analysis.[5]

Thus iconology is an

> interpretation of the *intrinsic meaning* or *content*, of dealing with what we have termed the *'symbolical' values* [and it] requires something more than a familiarity with specific *themes* or *concepts* as transmitted through literary sources. When we wish to get hold of those basic principles which underlie the choice and presentation of *motifs* [...] we need a mental faculty comparable to that of a diagnostician, – a faculty which I cannot describe better than by the rather discredited term *'synthetic intuition'* [...] [which] has to be controlled by an insight into the manner, in which under varying conditions, the *general and essential tendencies of the human mind* were expressed by specific *themes* and *concepts*. This means what may be called a history of *cultural symptoms* or *'symbols'* in Ernst Cassirer's sense – in general.[6]

Central to that process is the intrinsic meaning of a work of art. Thus the art historian has to consider "documents bearing witness of the political, poetical, philosophical, and social tendencies of the personality, period or country under investigation [and] in the search for *intrinsic meanings* or *content*."[7] In the context of these highly innovative claims, Panofsky maintains that with this iconological approach "the various humanistic disciplines meet on a common plane instead of serving as handmaidens to each other."[8] In such ways, iconology would then transcend or surpass iconography, yet the 1955 edition of Panofsky's *Meaning in the Visual Arts* evidences a shifting of attitudes. Here Panofsky says that iconology is "an iconography turned interpretive and thus becoming an integral part of the study of art," and he has more qualms about his own approach, for he admits the "danger" that iconology when compared to iconography will behave like "astrology as opposed to astrography."[9] We thus realize that Panofsky was quite hesitant about iconology. Gorges Didi-Huberman has astutely commented on the fact that, later on, Panofsky (in the preface to the French edition of iconology) went so far as to suggest abandoning iconology altogether and to "revert to the term 'iconography.'"[10] Thus even with its inventor, the concept of iconology was neither monolithic nor uncontested.[11]

Even so, during the mid-twentieth century, many art historians were convinced that Neoplatonism had a lasting conceptual influence on the production of Renaissance art. The resulting synthesis between art and theory was discussed by the most outstanding scholars of what one could call "the Warburg Circle," amongst them Ernst Cassirer, Erwin Panofsky, Rudolf Wittkower, Ernst Gombrich, Edgar Wind, Eugenio Garin, and André Chastel.[12] They all pointed to the keen awareness Renaissance artists had of contemporary cosmology, philosophy, and theology. The Christian version(s) of Plato's philosophy for which Petrarch had yearned were enriched during the second half of the fifteenth century with important textual materials through Marsilio Ficino's pioneering translations and

interpretative work. Indeed, Ficino's monumental work in accommodating Platonic traditions to the Latin West cannot be underestimated. Yet Ficino's Plato was a figure very different from the Plato of twentieth- and twenty-first-century classical philologists. To fathom the vast differences in the cultural backdrops against which Platonism was received, it is instructive to remind the reader of a no less famous contemporary of Ficino's: Giovanni Pico della Mirandola and his intellectual apotheoses of Platonism that formed an integral part of his philosophic-theologic-kabbalistic frenzies.[13]

In tandem with the intellectual frame of Renaissance Neoplatonism, the Warburgians also subscribed to a more general premise: namely, that artists are not exclusively concerned with problems intrinsic to their work but rather that their artifacts encompass a much larger intellectual and cultural horizon. In this specific approach, the Warburgians demonstrated how many individual works of Renaissance art can be conceptualized as references to the tradition of Renaissance Neoplatonism. This methodological vantage point sketched above with regard to Panofsky led to the development of a new tradition in art history: iconology.

Iconology was also motivated by the wish to supplant a merely 'aestheticizing' practice of art history with a new form of highly erudite research into the intellectual backgrounds of individual works of art. For a considerable period in the history of scholarship, the influence of Neoplatonism on visual arts during the Renaissance seemed to be more or less commonplace. Since the 1970s, however, the influence of Neoplatonism on the fine arts during the Renaissance (and consequently the significance of iconology for art history in general) has been repeatedly called into question. Since then, numerous authors have opposed Neoplatonist interpretations of works of art from the Italian Renaissance – among them Charles Dempsey. For this reason, since at least Bredekamp's "Götterdämmerung," silence has reigned in German scholarship regarding the influence of Neoplatonism on the fine arts.[14] By contrast, Italian and, in particular, American researchers have continued to assume that there existed a close link between Neoplatonism and art.[15]

Our conference had solicited responses to Horst Bredekamp's "Götterdämmerung des Neuplatonismus" ("Twilight of Neoplatonism" or "Twilight of the Gods for Neoplatonism"). Published in 1986, this is a highly polemical and at the same time seminal text.

Bredekamp argues against the dominant (and superficial) focus on Neoplatonism in this field ("A critique of this conceptual approach thus does not imply condemning iconology as such, but can be regarded rather as a means of defending and reviving it").[16] Bredekamp's most important point of critique of this particular tradition of iconology is that it tends to treat images as mere "materializations of philosophy" and ignores art's "distinct conceptual power that goes beyond word-related model systems and intervenes in cultural incrustations and schematic forms of thought in a liberating way" (Appendix, p. 222).[17]

This volume presents several distinctive responses to Bredekamp, bringing together historians concerned with the history of their own discipline – and also those whose research is on the art and culture of the Italian Renaissance itself – with historians from a wide variety of specialist fields, in order to engage with the contested field of iconology. Moreover, since the "Götterdämmerung," there has been an extension of the traditional concept of the image, opening up a whole range of new research areas with remarkable results concerning theories of the imagination, magic and performance, gender issues, and body discourse – giving the significance of Renaissance Neoplatonism a new prominence and a new profile. As Bredekamp's 1986 essay still seems to be the most polemic and influential repudiation of the connection between Neoplatonism and Renaissance Art, and as many of the contributions in this volume directly take issue with this text, we have chosen to

reproduce it in an English translation, as well as to summarize his theses for the reader. Since in the present volume the essays by Andreas Thielemann, Stéphane Toussaint, Angela Dressen and Berthold Hub take direct issue with Bredekamp, this introduction therefore merely intends to supply a brief overview, omitting the scholarly documentation of Bredekamp's main theses. Bredekamp sets out with the following remarks:

> What had long been regarded as symptomatic of the period now seems oddly unfamiliar: although its presence can still be felt, Neoplatonism appears to have lost its leading role in the interpretation of Renaissance art. This raises the question of whether Neoplatonism was ever actually located anywhere except in the mind of posterity. [...] the Neoplatonism that was evident in philosophy and poetry, and sometimes also in the theory of art, exercised only a rather minor effect on the visual arts.[18]

According to Bredekamp, numerous central works of the Italian Renaissance such as Botticelli's *Primavera* and Titian's *Sacred and Profane Love*, and the works of Michelangelo in particular, were presented in the texts of the "Neoplatonic interpretative speculators"[19] in a one-dimensional perspective. He claims that Neoplatonism provided erudite art historians with a kind of "magic formula" and maintains that

> The highest goal, the paradise of interpretation, appeared to have been attained when one had succeeded in making the work of art gleam with the aura of Neoplatonism, under whose Christianized dome it was possible to gather together even Rubens's mythological paintings.[20]

Bredekamp is quick to identify the lasting influence of scholarly iconology with the prestige of the Warburg Institute. Moreover, he claims that art historians such as Erwin Panofsky, Edgar Wind or Ernst Gombrich had designed iconology – with its focus on the classical tradition – as an intellectual shield against the ideology of Nazism.[21] Bredekamp considers this methodical orientation to be incorrect, "the wrong fortress" against Nazism, because Neoplatonism was "an esoteric dead end."[22] According to Bredekamp, the "mania for Neoplatonism," with iconology becoming "attached in terms of its content to Neoplatonism," "in the process of establishing its methodology," led to numerous objectionable developments in the historiography of art.[23] In particular, iconology constituted an accessory to the "new version of the anti-Enlightenment pictorial hermeneutics," which merely *experienced* visual phenomena instead of *researching* them.[24] Thus Bredekamp blames the adherents of iconology for aestheticizing the history of art. (Ironically, the Warburg Circle had set out to oppose exactly this propensity in art history.)

Bredekamp's polemic does not stop here, for he goes on to consider interpretative alternatives to Neoplatonism:

> The Neoplatonic burdens weighing on the works of art could have been shrugged off more quickly, with greater conceptual clarity and more comprehensively if the full implications of the alternatives developed by historians of culture and philosophy had been more openly accepted.[25]

According to Bredekamp, these "alternatives" are (a) Christian traits, (b) atheistic traits, and (c) occult traits that are represented in Renaissance art. Corresponding to these traditions, Bredekamp associates three emblematic names: Aristotle, Epicurus, and Hermes

Trismegistus. And this catalogue of alternatives leads him to a most remarkable change of course in his polemic: he contends that there can be no doubt "regarding the objective importance of this method [iconology] of illuminating the work of art on the basis of its literary, philosophical and cultural setting and in this way interpreting the special qualities of its form historically."[26] Therefore, Bredekamp's criticism of this conceptual approach should not be regarded as a condemnation of iconology as such but rather as a means of defending and reviving it. Paradoxically, he wishes to see a "renovation of the pre-Platonic vigor of iconology."[27]

Important aspects of Bredekamp's polemic against the practice of iconology are certainly appropriate. Admittedly, some authors seem to have lost their way in their search for hidden meanings, with their "reading" of art works often supported by the thinnest evidence. Moreover, Neoplatonic interpretations indeed have an intrinsic tendency to dematerialize images – for instance, by desexualizing them. In scholarly literature, the term 'Neoplatonism' is all too often used only as a slogan aiming to avoid a differentiated analysis – and also to elide the need to provide evidence for readings in contemporary formative primary texts such as Ficino's *De amore*. Another conceptual vagueness: many iconologists do not seem to distinguish clearly (if at all) between the traditions (a) of Platonism, (b) the highly eclectic tradition of Neoplatonism in late antiquity, and (c) the Neoplatonism of the Christian Renaissance. Florentine Neoplatonism was shaped by Marsilio Ficino and his successors and represents a conceptual framework on its own with practical implications (for instance, in medicine and magic).

In addition to the objections raised by Bredekamp, the editors of this volume also point to other flaws in contemporary scholarship: there is a deplorable lack of interdisciplinary research on the different forms of Platonisms, since research on them is carried out separately in different departments of universities. Just as art historians (with the notable exception of the Warburgians) tend to be rather unaware of research done on primary texts of Renaissance Neoplatonism, intellectual historians of the period often seem barely interested in the findings of art history. The disconnectedness between research traditions is also demonstrated by the fact that Bredekamp's "Götterdämmerung" has elicited hardly any reaction in the USA or in Italy.[28]

However, and in spite of these quite justified criticisms, the editors (as well as many of the contributors of the present volume) also feel that Bredekamp's polemic has gone too far. If an artist's intellectual horizon was conditioned by Neoplatonism, then it is not only legitimate but even necessary to at least raise the question of its influence on his or her art. Compared perhaps to their patrons, Italian Renaissance artists were certainly not concerned solely with internal artistic problems: their works also took issue with cosmological debates and the ensuing theological implications discussed in contemporary philosophy. Moreover, it is highly disputable whether Bredekamp's suggestions for "alternative" currents to help conceptualize Renaissance art should truly be conceived of as "oppositions" or "alternatives" to Renaissance Neoplatonism, which was actually a highly heterogeneous and all-encompassing tradition. Bredekamp is mistaken, for example, in contrasting occult aspects of thought with Neoplatonism (and is also mistaken to regard these occult aspects as reducing Neoplatonism's importance): Renaissance Neoplatonists regarded the texts ascribed to Orpheus and to Hermes (this being what Bredekamp means by 'occult writings') as formative for Plato's philosophy, since they were the oldest, most venerable testimony to the Platonic tradition. The Orphic Hymns and the *Corpus Hermeticum* were for this reason included among the 'Platonic' texts and formed an essential basis for and an essential component of what we now call Renaissance Neoplatonism; and the lasting influence via Lucretius of Epicurus' atomism on Renaissance

magic is present, for instance, in Ficino's seminal theory of vision, infatuation and infection, *De amore*. Lastly, one must add that Aristotelianism in Renaissance culture was not necessarily perceived in opposition to Platonism: at least from Plotinus onward, the Neoplatonic tradition had integrated the Stagrite's *libri naturales* into the great tradition of wisdom that Ficino subsequently was to rediscover and which he accommodated to the intellectual and spiritual sensitivities of his day.

Indeed, since 1986 knowledge of these complex intellectual formations (and their institutional bases in the various cultures of the Renaissance) has immensely expanded in the field of intellectual historians. We are most grateful that three highly profiled exponents of our expanded knowledge on Ficino have agreed to contribute to this volume: Valery Rees from the UK and Stéphane Toussaint in France and Italy, with Paul Richard Blum from Germany. With their indefatigable work on editions, their commentaries, and translations, they have furthered our knowledge of Renaissance Platonism in general and Marsilio Ficino in particular from their very different perspectives over the past decades as few others have in their field after P. O. Kristeller.

How to Read this Collection of Essays

Naturally, a reader already conversant in the tradition of iconology and the polemics surrounding it will make his or her own choices. For all who are less familiar with the topic, there are various options: a good idea would be to start with Thielemann's essay, since his contribution is not only a very interesting reply to the critics of iconology but also a distinctive appreciation of and introduction to one of the seminal books of this tradition, Panofsky's *Idea* (1924). Then, various choices are open to you: those interested in the dimension of art history will welcome Hub's contribution on Michelangelo as an introduction to the field; the same is true of Dressen on the *Primavera*, which could be followed by a reading of Kohl on the "Bargello Youth." If you are more interested in Marsilio Ficino's image theory and its relevance to magical practices and Classical mythology and historiography of iconology, you should go to Toussaint (magic) and then read Rees (images). For readers conversant in the intertwining of material cultures, art and magic, there are the contributions of Kodera (demonology and magical lamps) and Quiviger (Bacchus and wine consumption); for scholars interested in the subversion of Renaissance Neoplatonic ideals and gender relationships in Renaissance literature, Bidwell-Steiner is indispensable reading. If you are looking for a formidable introduction to the religious dimensions of Renaissance image theories, read Paul Richard Blum's essay on the role of images in what was the most vital movement of the Counter-Reformation, Loyola's *Spiritual Exercises*. But of course, the editors would wish that you read all the essays, not least because they take up, directly or indirectly, the challenges brought to a new and revisionary appreciation of iconology and of course also of Renaissance Neoplatonism.

A Brief Introduction to the Individual Contributions

In his case study of Erwin Panofsky's seminal book *Idea: ein Beitrag zur Begriffsgeschichte der älteren Kunsttheorie* (1924), the late Andreas Thielemann challenges Bredekamp's sweeping "Götterdämmerung" claims. Thielemann points to the fact that since its publication *Idea* has remained the standard general exposition of the topic; moreover, Panofsky's book paved the way for the systematic study of art theory. Thielemann emphasizes that the distinctive quality of Panofsky's style reveals a sophisticated dramaturgy for explaining

general epistemological tensions. This leads Thielemann to the conclusion that contrary to what the title "Idea" would suggest, Panofsky's book is in no way committed to Neoplatonic models of interpretation, instead tracing the history of the concept of "idea" as a versatile theoretical tool, forged and reforged – often radically – to suit ever-changing functional requirements. Importantly, Thielemann thus claims (*pace* Bredekamp) that far from any essentialist interpretation of "Idea" Panofsky was writing a conceptual history of a problem, approaching it with his consummate understanding of Neo-Kantian constructivism as advanced by Ernst Cassirer and magisterially developed by Panofsky to suit the latter's own scholarly goals.

Stéphane Toussaint's contribution critically examines Charles Dempsey's 1992 polemic against "Neoplatonic readings artificially superimposed" upon Botticelli, as well as Bredekamp's "Götterdämmerung." Toussaint's text is also a highly readable counterpolemic citing a wealth of literature and the history of scholarship on the topic. But Toussaint does not stop here. By magisterially examining textual evidence, he points to Ficino's visual and tactile – even olfactory – sensitivity to the materiality of objects, particularly magical objects, and in general his fascination with the 'materiality' of art. According to Toussaint, this is a result of Ficino's unorthodox Plotinism, which is grounded in the diffusion of ideal beauty through human art. Toussaint discusses astrological talismans, Renaissance automats or robots, and *materia medica* – even pointing to textual evidence that Ficino had a certain susceptibility to the physical beauties of women. Toussaint thus firmly debunks the thesis of a disembodied Renaissance Neoplatonism, tracing this misconception to Panofsky's *Idea* in his intriguing conclusion. Moreover, this misconception was reinforced by the marked tendency in the Anglo-American scholarly community to ignore André Chastel's no less groundbreaking text *Marsile Ficin et l'art*, as well as the polemics between Chastel and Kristeller on that topic.

The contribution by Valery Rees points in a similar direction, for she draws attention to the importance of figurative imagery, description, and allegory in Marsilio Ficino's texts, also showing how Ficino used images to support his philosophical reasoning. Images also assist and accompany Ficino's development of anagogical interpretations related to the life of the soul, and in particular to the concept of ascent. Therefore, Rees also turns the tables in the debate: instead of asking what artists got out of Ficino, she asks what Ficino drew from artists.

The contribution of Sergius Kodera addresses the more practical aspects of Renaissance Neoplatonism. In relating some important aspects of Ficino's theory on the embodiment of demons as optical illusions to Giovan Battista della Porta's recipes for magical lamps, Kodera points to the continuity as well as important changes of perspective at both ends of the Renaissance natural magic tradition. In particular, he identifies some aspects of both transition and continuity in that particular tradition of demonology, from Ficino's characteristic orientation towards inspiration and perfection of *the self* to a particular form exerting control over the mind *of other* people through Della Porta's recipes for inducing or inculcating hallucinations.

In her contribution on Ariosto's *Orlando furioso*, Marlen Bidwell-Steiner explores the characteristic duplication (or even duplicity) and consequent mutual intertwining of Orlando and Ruggiero regarding their objects of Neoplatonic desire (Angelica and Olimpia) and their complex relationship to the myth of Perseus and Andromeda. Importantly, Bidwell-Steiner claims that these mutual associations effectively undercut and subvert the Christian motifs of virtue, purity and transcendence that are ostensibly and repeatedly celebrated in the *Orlando*. Bidwell-Steiner describes these correspondences as chiastic liaisons, which she conceptualizes

as Warburgian formulas of pathos. She further substantiates her observations by a perceptive deconstruction of Orlando's madness and his metamorphosis into a beast (notably, after the hero has lost the object of his desire, Angelica, to his rival Ruggiero). Bidwell-Steiner shows that it was Orlando's hermeneutic acumen and his chivalric ideals that ultimately jeopardized his spirit, and not his body. She concludes that rather than a panoptic vision of Christianized Neoplatonic doctrines and ideals, the *Orlando* opens a poetic and subjective Warburgian *Denkraum*.

Berthold Hub's essay on Michelangelo again takes direct issue with Bredekamp's "Götterdämmerung" in various and important respects. After unfavorably reviewing the neglect of Michelangelo's sexual orientation by many of his most important biographers, Hub turns to examining the history and contexts of two closely related drawings (*Ganymede* and *Tityus*), which the elderly Michelangelo had presented to the love of his life, Tommaso Cavalieri, in 1538 (a youth who was then just seventeen years of age). In the context of these two images, Hub effectively demonstrates the importance of Michelangelo's Neoplatonism, just as Panofsky had claimed in his *Studies in Iconology*. Yet Hub claims that Panofsky's interpretation, for its part, was too tidy: according to Hub, this *Ganymede* was not simply intended as the visualization of a disembodied human soul enjoying heavenly ecstasy. Hub emphasizes that Panofsky's reading, although geared towards the intellectual form of homoerotic desire already prominent in Ficino's *De amore* eclipses not only same-sex physical intercourse but the concomitant social realities of Renaissance same-sex relationships that are so obvious in the drawing's graphic representation. Accordingly, Hub reminds the reader of the fact that many Renaissance humanists and artists were not only theoreticians of mutual (disembodied) love between men but also practitioners of sodomy. He finds ample evidence for this as reflected in Michelangelo's poems but also in a fascinating comparison with a much earlier pair of sketches (*Leda and the Swan*), which serves as a virtual cryptograph for *Ganymede* and *Tityus*, since it depicts heterosexual inversions of the *Ganymede* drawing. Hub concludes his discussion of these graphic sexual inversions with an intriguing analogy from Michelangelo's biography: just as the artist, early in his adolescence, had in all probability assumed a passive role during intercourse with older men, he was in 1538 taking an active role with Tommaso Cavalieri.

In her contribution on Botticelli's *Primavera*, Angela Dressen again takes issue with Bredekamp and Dempsey. She strongly argues for the importance of contemporary vernacular commentaries on Plato, Horace, Ovid and Dante towards a correct understanding of the iconology of Botticelli's famous painting. Rather than turning to the classical sources, Dressen argues that these vernacular commentators facilitated much-needed access to classical myth, also introducing and intermingling topics from other ancient sources that had been totally absent in the original versions. She claims that Botticelli selected some of these Renaissance vernacular commentaries that dealt with topics of love and marriage well known to the circle of humanists. To bolster her claim, Dressen discusses *inter alia* some passages from Marsilio Ficino's Italian version of the *De amore* (*El libro dell'amore*, 1469) as well as Cristoforo Landino's commentaries on Dante's *Divine Comedy* (1481) and on Horace (1482), and Paolo Marsi's Latin commentary on Ovid (1482).

Jeanette Kohl's text is on the famous *Platonic Youth* in the Florentine Bargello, which has often been attributed to Donatello. Her essay addresses the topic of Renaissance Neoplatonism in art from the opposite perspective to that taken by Hub. Instead of pointing to the often grim somatic backdrop of images, Kohl's description of the famous

bronze leads her to conclude that the sculpture was not intended as a 'portrait' bust at all. She argues that the particular configuration of its image – on the borderline between religious and profane – embodies an intricate, original way of speculating on and negotiating the limits of representation in Renaissance art and in Renaissance Neoplatonic thought. According to Kohl, the "Bargello Youth" essentially constitutes a sort of 'reliquary bust' of humanist Platonic thought. In this context, she discusses the historical interpretations of this artifact by Wittkower, Panofsky, Chastel, and Janson.

Paul Richard Blum's contribution provides the reader with a subtle reading of the functions of images in St. Ignatius of Loyola's *Spiritual Exercises*. In doing so, Blum shows that the founder of the Jesuit order develops a peculiar epistemology that aims at gathering and coordinating a host of psychic faculties and processes: memory, imagination or vision, rational discourse, projection, empathy, abstraction, and conceptualization. The ultimate aim of these images is not the external object of a painting or a narrative but the formation and self-regulation of internal psychic faculties. Blum further connects these observations with Gerome Nadal's engravings of the life of Christ, which were used as accompaniments to the *Spiritual Exercises*; and Blum shows how Nadal's illustrations rehearse certain aspects of the emblematic tradition as well as of Neoplatonic tropes and patterns. Blum concludes by pointing out that this highly intellectualized use of images could have been conducive to the success of Jesuit art and architecture; this in turn leads him to air the possibility that Loyola's spiritual aesthetics might have been at the origin of the modern understanding of art as arousing rationalized emotions.

François Quiviger's contribution is on images and habits of drinking wine in the Renaissance. He explains the role of wine consumption for Ficino, who recommended avoiding inebriation in favor of a moderate but constant consumption of wine in order to restore the spirit. Another important aspect for Ficino was the link between inebriation and the various states of philosophical frenzies – or divine inspiration – discussed in Plato's *Phaedrus*. Quiviger shows that Ficino understood the influences personified by Bacchus and Apollo as complementary energies. From Michelangelo onward, Renaissance artists took up the topic of wine consumption whenever they were commissioned to do so. Quiviger argues that while tending to eclipse social or moral comment as well as Neoplatonic iconologies, these images of Bacchanals highlight a high sensual intensity and thus introduced the subject of intoxication into high art. Quiviger discerningly sets the proliferation of these Dionysian themes in Renaissance art within the context of the rising production and consumption of wine characteristic of the early modern era. However, drawing on evidence gathered from numerous biographies, letters, and contracts, Quiviger shows that Renaissance artists did not seem to have regarded wine-drinking per se as a source of inspiration.

Notes

1 For a very good introduction, see Holly (1984, 158–93).
2 Panofsky (1939, 15, 17).
3 Panofsky (1939, 5).
4 Panofsky (1939, 6).
5 Panofsky (1939, 7).
6 Panofsky (1939, 14–6). For a thoughtful discussion of the ways in which Panofsky's ideas about iconology anticipate the concept of archaeology developed by M. Foucault in the *Order of Things* (1970) and the similarities of both approaches to the French Annales School, see Holly (1984, 185–8).

7 Panofsky (1939, 16). Holly (1984, 180–1) suggests that "perhaps we should consider the stage where we have discovered the level of cultural meaning only as the initial process, as Panofsky once clearly did."
8 Panofsky (1939, 16).
9 Panofsky (1955, 32).
10 Didi-Huberman (2009, 125, 118–27).
11 Holly (1984, 180–1).
12 See, for instance, Zorach (2007, 190–1).
13 Hankins (2000).
14 For contemporary developments in Anglo-American scholarship, see O'Donnell (2018, 114).
15 See, for example, De Gerolami Cheney and Hendrix (2002) and De Gerolami Cheney and Hendrix (2004).
16 Bredekamp (1986/1992, 77); Appendix, p. 217–218
17 Bredekamp (1986/1992, 83); Appendix, p. 217–218
18 Bredekamp (1986/1992, 75); Appendix, p. 216.
19 Bredekamp (1986/1992, 79); Appendix, p. 219. Bredekamp borrows the term from Alexander Perrig.
20 Bredekamp (1986/1992, 78); Appendix, p. 219.
21 For a thoughtful and critical reappraisal of Edgar Wind's and Erwin Panofsky's different approaches to iconology and their commitments to twentieth-century American Pragmatism (Wind) and Ernst Cassirer's neo-Kantianism (Panofsky), see now O'Donnell (2018, 113–36). He argues that "[…] neo-Platonic ideas for Panofsky offered themselves […] as a plausibly integrated, overarching unity or historical whole within which specific individual objects or historical parts could be explained. For Wind, in contrast, neo-Platonic ideas did not add up to a historically given whole that needed to be assumed for the sake of explanation but rather provided a hypothetical framework that could and should be tested by the individual objects or parts that purported to compose it." For an even more nuanced discussion of the complex role of Nazi politics, philosophy and art history in the development of Erwin Panofsky's different approaches to iconology in Germany and in the American exile respectively, see Elsner (2012, especially 494–8). For a fine reading of Wind's reading of Botticelli's *Primavera* in the context of contemporary US American Politics, see Zorach (2007, esp. 2 and 33).
22 Bredekamp (1986/1992, 77); Appendix, p. 221. See also Traeger (1997, 23–4).
23 Bredekamp (1986/1992, 77); Appendix, p. 217.
24 Bredekamp (1986/1992, 77); Appendix, p. 217.
25 Bredekamp (1986/1992, 81); Appendix, p. 220.
26 Bredekamp (1986/1992, 76); Appendix, p. 217.
27 Bredekamp (1986/1992, 82); Appendix, p. 222.
28 One notable exception is Zorach (2007).

Bibliography

Bredekamp, Horst. 1986/1992. "Götterdämmerung des Neuplatonismus." *kritische berichte minusculae* 14, 4:39–48. Reprinted 1992 in *Lesbarkeit der Kunst: Zur Geistes-Gegenwart der Ikonologie*, edited by Andreas Beyer, 75–83. Berlin: Wagenbach.

De Gerolami Cheney, Liana, and John Hendrix, eds. 2002. *Neoplatonism and the Arts*. Lewiston, NY: Edwin Mellen Press.

De Gerolami Cheney, Liana, and John Hendrix, eds. 2004. *Neoplatonic Aesthetics: Music, Literature & the Visual Arts*. New York: Peter Lang.

Didi-Huberman, Georges. 2009. *Confronting Images: Questioning the Ends of a Certain History of Art*. University Park: Penn State University Press.

Elsner, Jaś, and Katharina Lorenz. 2012. "The Genesis of Iconology." *Critical Inquiry* 38:483–512.

Foucault, Michel. 1970. *The Order of Things: An Archaeology of the Human Sciences*. New York: Pantheon Books.

Hankins, James. 2000. *Plato in the Italian Renaissance*, 2 vols. Leiden: Brill.

Holly, Michael Ann. 1984. *Panofsky and the Foundations of Art History*. Ithaca and London: Cornell University Press.

O'Donnell, C. Oliver. 2018. "Two Modes of Midcentury Iconology." *History of Humanities* 3, 1:113–136.

Panofsky, Erwin. 1939. *Studies in Iconology: Humanistic Themes in the Art of the Renaissance.* New York: Oxford University Press.

Panofsky, Erwin. 1955. *Meaning in the Visual Arts: Papers in and on Art History.* Garden City, NY: Doubleday.

Traeger, Jörg. 1997. *Renaissance und Religion: Die Kunst des Glaubens im Zeitalter Raphaels.* Munich: C. H. Beck.

Zorach, Rebecca. 2007. "Love, Truth, Orthodoxy, Reticence, or, What Edgar Wind Didn't See in Botticelli's *Primavera*." *Critical Inquiry* 34:190–224.

1 Erwin Panofsky's *Idea* (1924)[*]

Andreas Thielemann

Panofsky's book *Idea* was published in 1924 as volume 5 of the "Studien der Bibliothek Warburg."[1] It has been the go-to textbook on the concept of "Idea" in art theory for the past ninety years and enjoys the respect of even the most passionate of Panofsky critics. Although there has been no shortage of revisions and corrections – some addressing individual passages, others whole sections or fundamental ideas – nobody has published a fully-fledged follow-up.[2] That this should be so is perhaps not altogether surprising; after all, who would want to risk comparison with an author capable of tracing the concept of "Idea" in art theory from antiquity to the eighteenth century and of producing a book that stands not so much as a survey but as a scrupulous reconstruction of a complex problem. Just as daunting a feat is the way in which Panofsky interweaves concisely presented sources and their thorough analysis to form a coherent thread of argument that runs through the entire book. To be strictly accurate, the metaphor of the thread is somewhat misleading, as Panofsky actually deals with tensions. He describes with great eloquence the drama of the build-up and resolution of conflicts. As though possessed of muscles and tendons, his text invites the reader to follow wave after wave of contraction and tension release.

And it does so right from the first sentence of the introduction. Panofsky begins, in the gentlest of tones, with Plato's impact on aesthetic theory, only to build up the tension by stating – still in the same sentence – that Plato was not able to do full justice to the fine arts. Any lingering Parnassian mood is roundly dispelled by the second sentence, which cites a theory hostile to art. This is followed by a few paragraphs describing Plato's position before culminating in an inspired closing sentence that refers us to Cicero and implies a collision: "classical antiquity itself had transformed the Platonic concept of the 'idea' into a weapon against the Platonic view of art, thereby preparing the ground, as it were, for that of the Renaissance."[3] This contrast sets up the conflict that forms the plot of the ensuing disquisition: the constant forging and reforging of an intellectual tool that does occasionally serve as a weapon.[4]

We will come back to the style of the book and to the principle of tension that governs much of its reasoning. For the moment, however, allow me to stress its consummate stylistic artistry, which conveys a palpable sense of the unremitting intellectual energy of its author and probably constitutes another reason why nobody has hazarded a follow-up. Panofsky's *Idea* remained the point of reference for quotations and annotations and became the subject of controversies on the history of scholarship.

One could, of course, read *Idea* as an outline of a philosophy of art in its own right. However, this approach not only tends to diminish the complexity of Panofsky's thinking and to overlook his attention to factual issues, it also encourages an overly facile labeling of the scholar as a follower of a particular school of thought – for instance Platonism. But that too forms part of the multifaceted history of *Idea*'s reception and influence.

The Hertziana's copy of Panofsky's *Idea* bears the marks of this remarkable history. When the book was beginning to fall apart and needed rebinding, the original thick, linen-covered board was preserved and mounted in a shadow gap frame onto the new cover. This reverent treatment underscores the book's value and significance. It presents the publication from the early days of the Hamburg institute as a relic, a precious antique – its stains and discoloration bearing testament to its historicity – or as a miraculous icon enshrined into a later work of art. In a way, this provides a poignant parallel to the contents of the book, which does, after all, deal with the role of models and archetypes and the reverence in which they are held.

Interest in Panofsky and his book last peaked in the 1980s and was not confined to the lofty realm of art history. I remember an exhibition at Tanja Grunert's gallery in Stuttgart in 1984. Opened on the day of the inauguration of the Neue Staatsgalerie – which was the subject of fierce debate on account of James Stirling's liberal use of postmodernist architectural quotations – it was curated by the gallerist and theorist Rüdiger Schöttle, a connoisseur of Plotinus and other Neoplatonists as he revealed on a different occasion. Together with Tanja Grunert, he showed eleven artists, all of whom worked with quotations and adaptations from art or architectural history, from literature, the theatre, or the media world. Their partly conceptual, partly neoclassicist appropriation of established forms and meanings was presented under the ambitiously programmatic title "Idea." The accompanying catalogue reprinted the introductory chapter of Panofsky's text. Its cover featured a detail from the title vignette "Idea" from Bellori's *Lives of the Artists* (1672), which also adorns the introduction to Panofsky's book. All this was very much in keeping with the intellectual climate of the 1980s. Architectural critics such as Michael Greenhalgh spoke of a new classicism. There was a distinct shift away from individual 'Phantasia' and towards 'Idea,' towards established forms of more or less time-hallowed status.

The subject also informed many of the discussions I had at the time with the sculptor Hartmut Bonk as we explored the traces of antiquity in Greece, Italy, and Turkey. He later dedicated one of the watercolors he had painted in Paestum in 1986 to me, inscribing it with the words "materialisierte Idee" (materialized idea). It reminds me of our long walks and discussions – an art historian and an artist pitting their stamina and wit against each other. On one occasion, the artist put it to the theorist that perhaps it might be a good idea to actually practice what he was preaching. Unlike theorists, he charged, painters, sculptors and architects did not see their be-all and end-all in developing grand ideas but in actually realizing them. This was a well-aimed barb, brought home with all the weight of the temple of Paestum behind it. It was a different take on the relationship between idea and work, this time with the focus firmly on the latter. Panofsky might have been intrigued; after all he was specifically looking at the many transformations of the concept of "Idea", in this case a correlation of the "Idea" question with the Aristotelian categories of potentiality and actuality.

These reminiscences from the 1980s may suffice to show that the appropriation and variation of the "Idea" theorems continued well into the twentieth century – spurred primarily by Erwin Panofsky, who collated them in his book and communicated them with compelling cogency.

But what was the situation in universities? I can only speak for the department of art history at Cologne University, where I was studying at the time. On the one hand, there was Joachim Gaus, who provided his students with a great educational experience, introducing them to brilliant thinkers such as Plato, Plotinus, Augustine of Hippo, Gadamer,

Blumenberg, and Foucault, who challenged and fascinated them in equal measure. Gaus had not published much in this area; it was his compelling performance of total absorption that captivated students with its existential, near-metaphysical earnestness and allowed them to look at art through the prism of philosophy. Needless to say, Panofsky's Neoplatonic interpretations and his book *Idea* were held in great esteem by the Gaus circle, as was Edgar Wind's *Pagan Mysteries of the Renaissance*. And after Gaus had demonstrated how to use the interpretative key provided by Wind to find further Plotinian Triads in Renaissance paintings – stepping stones on the path from the material and sensual to the transcendental and supra-sensual – one would come across groups of students in the photographic library or in the corridors discussing Plotinus and poring over illustrated books to discover hitherto undetected Triads, either to please their teacher or to satisfy their own enthusiasm. Yet the outsider, however much he had profited from Gaus's suggestions, could not help feeling that much of this fervor was driven by the sort of group dynamics that led to the uncritical adoption and mechanical application of a pat interpretative model.

On the other hand, there was Hans Ost, who had little time for either Panofsky or iconology and even less for Neoplatonism. In his view, these intellectual exercises generally failed to do justice to the actual artistic, technological and functional reality of the painting in question. He rarely went into iconological niceties and made no bones about his low opinion of the sublimatory impulse that drove some colleagues to see the Neoplatonic triumph of Sacred Love over Profane Love even in paintings of courtesans.

Talking about the concept of "Idea", it is important to remember these discussions of the 1980s and to open the history of art historiography to the input of oral history. Especially when it comes to the subject of iconology and Neoplatonic interpretation, it is imperative to go beyond the analysis of the relevant publications and to recapitulate the trends and discussions that animated the classrooms, photographic libraries and corridors of academic art history departments in the 1980s.

Only then can we understand the swingeing condemnation published by Horst Bredekamp in 1986. His essay "Götterdämmerung des Neuplatonismus" was a challenge and an ostracism. Rarely has our field seen so impetuous a refutation of an entire area of research as Bredekamp's text, first published on 20 November 1986 in the *Frankfurter Allgemeine Zeitung*. It was republished the same year in the magazine *kritische berichte: Zeitschrift für Kunst- und Kulturwissenschaft* and once again in 1992, when a revised and expanded version appeared in the anthology *Die Lesbarkeit der Kunst: Zur Geistes-Gegenwart der Ikonologie*.[5]

In my essay I would like to demonstrate that Panofsky's book was unjustly dragged into this all-out settling of academic scores. Bredekamp went even so far as to denounce it as the origin of the Neoplatonic evil in art history:

> It may be suggested as a hypothesis that the validity of Neoplatonism is less of a problem for the reality of art history than it is for the type of scholarly history that was associated mainly with the Warburg Library, in Hamburg and later in London. With slight exaggeration, it might be said that Neoplatonism in Renaissance art had its origins in the impression that was made on Erwin Panofsky by a lecture given by Ernst Cassirer at the Warburg Institute in Hamburg in 1924, on 'The Problem of the Beautiful and of Art in Plato's Dialogues'. Panofsky's book *Idea*, which provided the program establishing a Platonic pattern of interpretation, is certainly indebted to the lecture.[6]

Of course, the first objection to this has to be that there is nothing programmatic in the style of Panofsky's carefully argued book. Nor does it deal with the philosophy-based interpretation of iconographic or stylistic findings. In fact, the book is not at all about the interpretation of images; it is, as the title indicates, a "Beitrag zur Begriffsgeschichte" (Contribution to the History of Concepts). It is groundbreaking not as an iconology of individual images but as the first example of a conceptual history in the history of art. All later studies of this type – among them Wolfgang Kemp's work on "disegno," Martin Kemp's on "phantasia" and David Summers's on "contrapposto" – follow in the footsteps of Panofsky's pioneering history.[7]

What, then, about the alleged impact of Ernst Cassirer's lecture about Plato (*Eidos und Eidolon: Das Problem des Schönen und der Kunst in Platons Dialogen*), which, according to Holly and Bredekamp, was the event that inspired Panofsky's *Idea*.[8]

It is true that in the foreword to his book, written in March 1924, Panofsky mentions Ernst Cassirer's talk and expresses his "sincerest gratitude" to Professor Cassirer for his "various suggestions and an oft-tried readiness with gracious help."[9] He explains that although his book and Cassirer's talk were closely connected, his study – primarily because of the addition of excerpts from sources and notes that had swollen into small excursuses – had become too extensive to be included in the Warburg Library's Lecture series. Cassirer's lecture, however, was going to appear in the second volume of *Vorträge der Bibliothek Warburg*.

Although Cassirer's lecture had been delivered on 27 January 1923,[10] it had yet to be published when Panofsky wrote his foreword in March of the following year. The closing lines of Cassirer's text, when it did finally come out in print, referred readers interested in pursuing the subject further to the "excellent work by Erwin Panofsky" published in volume 5 of the series *Studien der Bibliothek Warburg*.[11] The very fact that Cassirer's lecture was published after Panofsky's rather more complex and substantial study makes it seem highly unlikely that the latter was written as a result of Cassirer's talk.

I consider it much more plausible that it was the other way round. Panofsky, thirty-two years old when *Idea* was published and a *Privatdozent* at Hamburg University since 1920, had been pondering the subject of his study for quite some time before he decided to approach Cassirer, eighteen years his senior and a professor of philosophy, because *Idea* was taking him beyond the traditional bounds of art history. It makes eminently good sense for a young art historian to consult the philosophers onto whose domain he is straying – especially if his appointment to a full professorship depends on their good will. Cassirer's part in the genesis of Panofsky's *Idea* was thus one of both giving and taking.[12] Cassirer's lecture on the idea of beauty in Plato's Dialogues, delivered before *Idea* was published, addressed the book's starting point in antiquity and gained him recognition for his contribution to Panofsky's seminal work. At the same time, there can be no doubt that the lecture was intended to help pave the way for the younger colleague.

Cassirer's talk, soundly argued and linguistically well rounded though it was, did not break much new ground – apart from the assertion that the later reception of Plato's Theory of Forms in art theory had taken a paradoxical course, which provided him with an opportunity to elaborate on the tensions and contradictions already inherent in Plato's thought. The multifaceted and paradoxical nature of the reception of Plato, however, was something that Panofsky had reconstructed through his own close reading and analysis of art literature sources that lay outside Cassirer's purview. The tension between Plato as an epistemologist and Plato as an artist was no new discovery either. The philosopher and later art historian Carl Justi had already discussed the subject in his doctoral dissertation on the aesthetic elements in Plato's philosophy.[13] Written in 1859, Justi's study is the only book Cassirer cited as secondary literature in the footnotes to his published lecture.[14]

Held at the Warburg Library in Hamburg, Cassirer's *Eidos und Eidolon* was an erudite evening lecture intended to appeal to an educated but non-specialist audience. The subject of the talk was demonstrably not one that preoccupied him at the time and has to be seen as a *parergon*, prompted to no small degree by his dialogue with Panofsky. This also explains why he made practically no attempt to tie the lecture into his magnum opus, *Philosophie der symbolischen Formen*, the first volume of which had only just been published in 1923.[15] And it is for the same reason that *Eidos und Eidolon* offers no more than a faint glimmer of Hermann Cohen and Paul Natorp's highly original interpretation of Plato.[16] Steering clear of the onto-logical dimension of his work, the Neo-Kantians of the Marburg School sought to formulate a logical and methodological interpretation of Plato, which they hoped would prove fruitful in the Neo-Kantian theories of concept and judgment. In view of Kant's profound disdain for Plato, this was a decidedly bold step to take, but the stated aim of the Marburg School was the systematic expansion of Kantian philosophy, and they were not going to let history or philol-ogy dictate their approach to either Plato or Kant. Unlike Carl Justi and Ernst Panofsky, the Marburg philosophers did not concern themselves with Plato's paradoxical stance on art and aesthetics, so that even a thinker of Cassirer's caliber could not easily step into the breach. And it is for that reason that he did not go into the epistemological interpretation of Plato in his *Eidos und Eidolon* lecture. What is more, he did not even cite the controversial book on Plato's Theory of Ideas by his teacher Paul Natorp, which had recently gone into a second edition (1921).[17] One might almost be tempted to suspect that Cassirer had turned his back on the Marburg tradition, but in 1925 he defended the book in his obituary for Natorp, who had died in 1924,[18] and in a chapter on Greek philosophy he contributed to Max Dessoir's *Lehrbuch der Philosophie*, in which he continued to elaborate the Marburg interpretation of Plato.[19] Cassirer had not abandoned the Neo-Kantian line of enquiry, but in terms of both subject and moti-vation, *Eidos und Eidolon* was extraneous to his major projects of the time.

For Panofsky, on the other hand, the "Idea" subject was central, and his fascination with it can be traced to his doctoral dissertation on Dürer's art theory, completed in Freiburg in 1913 under the supervision of Wilhelm Vöge.[20] The dissertation, begun in 1911 in response to a Grimm Foundation call for papers, won the prestigious Hermann Grimm Prize in 1913. Here, in his very first publication, Panofsky already clearly outlined the dilemma that was to become the central focus of his later study: how can art achieve a beauty that is superior to nature even though it practices mimesis and does not actually encounter this higher beauty in any of the natural objects it is based on? According to Panofsky, several Italian artists and theorists had touched upon this dilemma, either at the same time as Dürer or even earlier, but had ultimately glossed it over or instinctively resolved it in favor of the naturalism that was essential to their art.[21] Dürer, on the other hand, preoccupied not only with extremely painstaking studies after nature but also with trying to uncover the laws and principles governing proportion and beauty, was the first artist to experience and describe the full extent of the chasm. Unable to bridge it, he ultimately capitulated to the "non-rationalisability of the real" (Nicht-Rationalisierbarkeit des Wirklichen). After his second Italian journey, according to Panofsky, Dürer gave up on the idea of an underlying mathematical law and replaced it with the only workable compromise: artistic discretion, borne of experience and the close study of nature.[22] Accepting that beauty is the product of both nature and abstract principles, he sought to overcome their apparent contra-diction. Reality, if it is to be seen as beautiful, is subject to certain laws, which are, however, inherent to nature. "This thought, which despite its apparent affinity with the theory of election on the one hand and Platonic philosophemes on the other is quite original, is based to a certain extent on self-deception." But Panofsky concedes that it is "one of the most sensible [...] articulated at the time about the nature of natural beauty."[23]

The systematic problems that Dürer's makeshift solution failed to solve did, of course, not escape Panofsky's razor-sharp dialectical mind, and so he pursued other solutions to them. As the Grimm Prize specifications had called for a comparison with Italian art theory, Panofsky devoted the final chapter of his dissertation to a comparative study of the dichotomy between the realist and the idealist conception of art in Dürer, Leonardo and Raphael, including the necessary recourse to Plato and a view ahead to Bellori's understanding of the "Idea" concept. Panofsky's *Idea* pursues in greater depth the very questions that had first preoccupied him in his dissertation. The final chapter in particular has to be seen as the starting point of the later study. Thus the roots of the book do not lie in Hamburg or the Warburg Institute; its genesis has nothing to do with Ernst Cassirer or Marsilio Ficino. The starting point was Panofsky's engagement with the topic of the Grimm Prize. Dürer demanded not only that artists pay strict attention to the "irrationabilia of nature" (Irrationabilien der Natur) – that is, the minutest wrinkle on the face of an old woman – but also that they attain "consummate mastery of abstract general principles."[24] It was between these extremes that the other solutions could be found.

The dissertation provided more than just the subject for *Idea*; it was in this early text that Panofsky first developed that brilliant dialectical analysis of polar opposites that allowed him to undertake his later *tour de force* through 2000 years of art theory without losing the thread of his argument in historical or philological details. He begins his study by delineating the full extent of the problem and posits Cicero as a pioneer of the non-Platonic notion of the idea. Particularly inspired is the way he gets to Cicero by way of the German Renaissance and the reformer Philipp Melanchthon, who had explained the Platonic idea in his commentary on Aristotelian ethics thus: "It is certain that Plato everywhere calls Ideas a perfect and lucid notion, as Apelles carries in his mind the most beautiful image of the human body."[25]

What made this passage so useful for Panofsky's introduction was the fact that Melanchthon had, in an entirely un-Platonic manner, translated the Platonic idea into the human mind and that he had named Apelles as the carrier of such an idea. And all that in the inevitably un-Platonic context of a commentary on Aristotle. Thus the knot was tied, linking the Platonic idea and art theory in the modern period and, with it, the reversal of the Platonic idea that could remain "Platonic" in name only in order to make such a bond possible. And since Melanchthon had cited Cicero in justification, Panofsky, having skipped to Melanchthon, was able to press on and to name Cicero as the great turning point. Then he finishes his introduction with that rousing sentence that heralds a battle against the Platonic concept of art.

There is no hint of having been unduly impressed by a lecture on Plato or of an infatuation with Platonism or Neoplatonism in any of this. Nor do we find the sort of monolithic praise of Plato that punctuated Cassirer's lecture.[26] In fact, Panofsky was as interested in sources that rejected Plato as he was in those that endorsed him, and he developed an almost obsessive interest in difference, divergence, and transformation. This had deeper methodological reasons: in his own special way, Panofsky had adopted the dialectics of Neo-Kantian constructivism and functionalism and used it to reconstruct a dynamic history of the concept of "Idea." Comparing his book with Cassirer's signally more conventional lecture, we might well conclude that the young Panofsky had out-Cassirered Cassirer.

There can be no doubt that the two scholars were perfectly aware of their nascent rivalry and that, far from merely engaging in a game of friendly intellectual repartee, they also wrote against each other in a pointedly performative manner. This competitive situation only sharpened Panofsky's dialectical edge. But then, for the purposes of his history, he only had

to highlight the dynamic driving forces. The system builder Cassirer, on the other hand, always had to try and contain each pair of opposites in a higher unity.

In a constellation such as this, the older and more established scholar generally has but two options: he either ups the ante or he deliberately chooses to adopt the role of the experienced, imperturbable *éminence grise*. It is probably partly for this reason that Cassirer adopted that knowing tone (occasionally verging on patriarchal *gravitas*) that tends to stress unity over disagreement and harmony over tension.

The different ways in which the two scholars dealt with opposites are also evident in the schemata they used to visualize contrast. Whereas Cassirer – intent on unity and smoothing over rough edges – referred to the polar opposites of *Eidos* and *Eidolon* in Plato's thought as two focus points, thereby evoking the image of a well-rounded ellipse,[27] the more empirically inclined Panofsky wrote of individual entanglements, of armed attacks, played out, as it were, in an open field. And whereas Cassirer described the poles of *Eidos* and *Eidolon* as an immanent content of Plato's theory, Panofsky differentiates much more between historical description and systematic analysis. For him, the systematic poles lie not within the description field but, so to speak, along the outer edges of the field, in which the historical and empirical findings present themselves almost as discharges of the potential applied from outside.

With this figure of thought, Panofsky contributed to the spread of Kantianism in the Humanities. In matters of language, myth or art, Neo-Kantianism inquires into the schemata or conditions imposed by time and system, analogous to what Kant had called the "conditions of possibility" in the field of conceptual cognition. As early as 1915, when he wrote his essay "Das Problem des Stils in der bildenden Kunst," Panofsky distanced himself from Wölfflin's descriptive methods by insisting that art history first had to establish the "general possibilities of representation" (allgemeine darstellerische Möglichkeiten) pertaining to each stylistic period.[28]

In his critique of Alois Riegl's concept of "artistic volition" (Kunstwollen), published in 1920, Panofsky pursued this line of argument further. Referring explicitly to Kant's *Prolegomena*, he argued for a "transcendental/aesthetic mode of looking at things."[29] On no account should the transcendental aesthetic categories be equated with Wölfflin's categories of description; as fundamental *a priori* concepts they should be situated below the phenomenal sphere.

In 1925, he returned to this subject in his essay "Über das Verhältnis der Kunstgeschichte zur Kunsttheorie."[30] Here he presented his own system of a transcendental aesthetic antithetics whose ontological categories of "fullness" ("Fülle") and "form" ("Form") built directly on Kant's "forms of intuition" of space and time. For the description of phenomena, he envisaged Wölfflin's binary polarities, albeit in a modified and systematized form.

It was not without pride that Panofsky referred to this system as "Tafel." The term sounds eminently Kantian and brings to mind the way Kant had enshrined his *a priori* categories in just such a table. It gave Panofsky the freedom to operate within Kantian categories and to distinguish clearly between the individual phenomena of art in the world of appearance and the necessarily antithetical qualities of the fundamental problems that are grounded in "a polarity between two principles that exists beyond the world of appearance and that can be located by means of theory."[31] This fundamental conceptual system of art history, Panofsky reminds the reader, is not to be confused with "art-historical characterisations" that

only refer to works of art themselves and thus operate not in contrasts but on a flexible scale. The fundamental system of concepts for a science of art defines the poles of a polarity that is constituted a priori and that cannot be grasped in a manifest form; normal art-historical characterisations describe a conciliation of these polarities, which is executed a posteriori and for which there are not two but an indefinite number of solutions.[32]

Historians of art history record this line of Panofsky's development under the heading "Wölfflin reception," "Cassirer," and "Neo-Kantianism."[33] *Idea*, on the other hand, is tagged with keywords such as "Neoplatonism," "Cassirer," and "Warburg Library."[34]

Yet on closer inspection it becomes apparent that Panofsky faced the same problem of absolute polar opposites in both his art-theoretical dissertation and in his critique of Wölfflin. As mentioned earlier, it was Dürer's grappling with art theory that helped Panofsky discover the irreconcilable chasm between "Idea" as a rational law of proportions on the one hand and mimesis of empirical, "non-rationalisable" reality on the other. Panofsky's awareness of the one, fundamental dualism and its many person-, country- and time-specific solutions was thus something that dated all the way back to his doctoral dissertation – and something that had preoccupied him for some ten years, in both formal analysis and art theory, before he found the solution to both around 1923–25. The above-mentioned essay on the relationship between art history and art theory clearly shows that he fully understood the problems at hand and was able to solve them authoritatively with the help of his "Tafel." And while Panofsky's Neo-Kantianism is fairly obvious in the 1925 essay, it is no less present in *Idea*, which needed a similar antithetical structure to underpin its plot. Instead of a history of the reception of the concept of "Idea," Panofsky wrote something much more modern; namely, a history of the concept's construction and function. He was not wedded to a substantialist or essentialist interpretation of the concept of "Idea;" instead, he examined its function in each period and how it was modified to fulfill that changing purpose. That Kant's oft-cited "conditions of possibility" shimmer through in some passages – for example, in the chapter on Mannerism[35] – or that the final chapter makes direct reference to Kant's revolutionary epistemology[36] needs no more than a passing mention, for it has no bearing on the systematic findings. It is much more important to recognize the non-essentialist, un-Platonic operating principle that was completely overshadowed when – partly because of its seemingly Platonic title and partly because of later Platonic fashions to which the later Panofsky contributed – *Idea* was dragged into an ideological dispute. Peeling away the fateful Plato label, we discover a masterpiece of Neo-Kantian constructivism and functionalism.

There can be no doubt that the exchange with Cassirer had a decisive impact on Panofsky's Neo-Kantian breakthrough in 1923–25. But instead of looking to the methodologically weak Plato lecture, we should look to those of Cassirer's texts that articulate the transcendental approach of the humanities, chief among them "Die Begriffsform im mythischen Denken," the manuscript of which Panofsky read,[37] then the introductory lecture "Der Begriff der symbolischen Form im Aufbau der Geisteswissenschaften,"[38] and, finally, the first volume of Cassirer's "Philosophie der symbolischen Formen" published in 1923.[39]

As mentioned at the beginning of this essay, Panofsky's *Idea* is one of those rare books that successfully combines systematization and dramatization. The reader is confronted with successive waves of contraction and tension release, but these are not an end in themselves; they underpin Panofsky's rhythmic line of argument, which called for just that exposition of problems and tensions and their resolution.

Karen Michels is surely right when she says that by adopting a formal and mannered style Panofsky sought to conform to an antiquated and professorial academic ideal.[40] But she overlooks the fact that he also used these mannerisms as a vehicle for his own stylistic artistry, injecting them with a nimble dynamism that allows his style to follow his train of thought with seismographic sensitivity.

It is little wonder that Ernst H. Gombrich, who had always objected to dazzling displays of virtuoso style in the sciences, chafed at this quality of *Idea* and described it with great vividness. At the International *Idea* Conference in Rome in 1989, he gave a paper with the title "Idea in the Theory of Art: Philosophy or Rhetoric?" in which he compared Panofsky's description of the different philosophical positions in antiquity with a dance or a ballet:

> Having thus established these contrasting positions Panofsky proceeds to describe their subsequent evolution and interaction, demonstrating how they cross, intertwine, separate and join again almost like the dancers in an intricate ballet.[41]

And because Gombrich misread the philosophical and methodological basis of the book, he professed himself disappointed by the way in which Panofsky lifts the veil in the final paragraph and makes direct reference to Kant and his epistemology.

> I must still refer you to its concluding paragraph in which the producer of that ballet of ideas steps before the public and explains that it was all an idle play, because that antithesis between idealism and naturalism which continued to engage the minds of philosophers is really nothing but a dialectical antinomy, since we now know – if I may cruelly over-simplify Panofsky's involved argument – that what we call reality is in itself nothing but the product of our minds.[42]

At least Gombrich eventually realized that Panofsky was as unconcerned with essentialist concepts as he was with naturalist ones. Gombrich rightly remarked that several passages of the book are written in a highly visual style and can be likened to a stage production. However, what seemed mere "idle play" to him was in fact the stylistically radicalized consequence of that constructivism and that field theory, which explained the internal movements as a consequence of a tension or as applied on the outside.

Incidentally, with his perceptive vision of a ballet, Gombrich made an unintended contribution to the iconology of the book. Panofsky's constructivist ballet is a near-exact contemporary of Oskar Schlemmer's *Triadic Ballet*, first performed in Stuttgart in 1922. And it is not wholly inconceivable that Panofsky was touched by this ballet, in which the dancers embodied abstract ideas or principles rather than individuals. But at the highest level of what Panofsky referred to as "Interpretation of *Weltanschauung*," it no longer even matters whether the erstwhile protagonists actually knew of each other. What is at work here is the *ex post* synopsis of the historian who detects affinity in the perhaps merely contemporary.

Let us hear and watch a passage of Panofsky's ballet.

> Thus we see the old questions 'How does the artist represent things correctly?' and 'How does the artist represent the beautiful?' rivalled by the new one, 'How is artistic representation, and in particular the representation of the beautiful, *at all possible*?' In order to answer the latter questions art theorists recalled everything in the way of metaphysical speculation that was at their disposal, that is, the essentially

Aristotelian system of medieval Scholasticism as well as the Neoplatonism of the fifteenth century. In both cases, however – and this is what is so illuminating for us – it was the theory of Ideas that, recognized in its entire consequences for the first time and therefore placed in the center of art-theoretical thinking, fulfilled the double task, first, of making the theory of art aware of a problem that had not been acute before, and second, of indicating the way to its solution. During the Renaissance the Idea concept, not yet consistently reasoned out and too important in art theory, had helped conceal the gap between mind and nature. During the Mannerist period it served to reveal it: the forceful stress on the artistic personality pointed directly to the problem of 'subject' and 'object.' But at the same time the Idea concept made it possible to close up the gap by reinterpreting 'Idea' in its original, metaphysical meaning; for this metaphysical meaning resolves the opposition of 'subject' and 'object' in a higher, transcendental unity.[43]

Panofsky speaks of "sehen" and "erleben" (seeing and experiencing), and he invites his audience to feel the mounting tension of the string of opening questions and has them watch a wide range of philosophemes enter from the wings before, finally, a protagonist capable of infinitely elastic changes – the Theory of Ideas – takes center stage and performs a richly varied choreography of showing and concealing, opening and closing.

And all of this with a positively breathtaking dynamic urgency. Only twice in the entire passage does Panofsky permit himself to take a breather in the form of a full stop. Yet even the quickest and most brilliant moves never overstep the bounds of the stage. The historical development that is at the heart of the performance stays firmly within the space opened by the questions raised at the outset. The individual sequences are linked by a wide range of temporal conjunctions: "nun" – "jetzt und erst jetzt" – "früher noch nicht" – "sogleich"– "noch nicht" – "jetzt" – "zugleich." Panofsky did not conceive of his history as a chronological progression; instead he interlocked its individual moments of movement and shift so that they seem to emanate from one another. He evidently found the model for this approach in the first volume of Cassirer's *The Philosophy of Symbolic Forms*, particularly in the historical outline Cassirer presented on the first few pages. Here we find the same interlocking narrative mode, albeit rather less tight and less dramatic than Panofsky's. It is probably true to say that one has to be attuned to Panofsky's syncopated rhythm to notice the similarity in Cassirer's style. But Panofsky does not only impart greater tempo to his narrative; he also gives it a torsional moment. He conveys the impression that the historical thrust is driven, as though via a conrod, by the spiraling motion of a "dialectical antinomy."

Hermann Cohen, the founder of the Marburg School of Neo-Kantianism, had already argued that historical developments were based on "a priori combinations."[44] And it is in this spirit that Panofsky understood the motor of the process. In that last paragraph, he speaks of his study that so scandalized Gombrich:

The contrast between 'theory of ideas' and 'theory of imitation' in art theory may be compared to the contrast between 'representationism' and (in the broadest sense) 'conceptualism' in epistemology. [...] In both fields the constant vacillation between these various possibilities and also the insoluble difficulty of proving the necessary correspondence between that which is 'given' and the cognition of it without appealing to a transcendent authority is based on the presupposition of a 'thing in itself' [...]. In epistemology the presupposition of this 'thing in itself' was profoundly

shaken by Kant; in art theory a similar view was proposed by Alois Riegl. We believe to have realized that artistic perception is no more faced with a 'thing in itself' than is the process of cognition; that on the contrary the one as well as the other can be sure of the validity of its judgments precisely because it alone determines the rules of its world (i.e. it has no objects other than those that are constituted within itself). Thus the opposition between 'idealism' and 'naturalism' [...] must in the final analysis appear as a 'dialectical antinomy.' But just from this point of view we can understand how this opposition could affect art theoretical thought for such a long time and force it again and again to search for new, more or less contradictory solutions. To recognize the diversity of these solutions and to understand their historical presuppositions is worthwhile for history's sake, even though philosophy has come to realize that the problem underlying them is by its very nature insoluble.[45]

What is remarkable about this finale is the clean Kantian construction and reduction to an antinomy. There was no model for this application to art theory in either Kant or Cassirer. Faced with that pointedly open ending, in which the antinomy is decreed insoluble, the reader begins to see where Panofsky found the confidence to boldly soar past Cassirer from whose methodology and style he had learned so much. Not without a dig at philosophy, he professes that he could easily do without synthesis in history. Cassirer, on the other hand, struggling to unite diverging modes of thought ("symbolic forms") within a single philosophical vision, was necessarily more committed to reconciling their common truths and formulating a unified proposition. Yet there can be no doubt that Cassirer learnt from the virtuoso performance of the young Panofsky. An echo of Panofsky's *Idea* resonates in Cassirer's later works and merits more serious attention than it has received to date.[46]

Let me conclude by returning to the question why an art theoretical study of the concept of Idea could no longer be written in this form. It has not only to do with the advance of knowledge and increasing specialization. We have lost that constructive optimism of the 1920s that inspired both Oskar Schlemmer's *Triadic Ballet* and Erwin Panofsky's art theoretical reconstruction. We no longer believe that it has possible to identify the mechanism that underpins the movements and history of humanity with the help of *a priori* screws, springs, and levers. Panofsky's *Idea* conjures the bold sound of a bygone century. In our new and more skeptical century, each reader has to decide for himself whether to react with nostalgia, approach the text from a strictly academic-archaeological perspective or, perhaps, find some inspiration in that confident rhythm of constructivism.

Notes

* Translated from the German by Carola Kleinstück-Schulman.
1 Panofsky (1924); slightly modified reprint with new preface: Panofsky (1960); English translation: Panofsky (1968).
2 First corrections and bibliographical additions were made by Panofsky himself in his foreword to the reprint: Panofsky (1960). An actualized report would go beyond the aims and limits of this essay.
3 Panofsky (1968, 7). Panofsky (1924, 4): "Melanchthon [...] weist uns somit darauf hin, daß schon die Antike selbst, der Renaissance-Anschauung gleichsam den Boden bereitend, den platonischen Ideenbegriff zu einer Waffe gegen die platonische Kunstauffassung umgebildet hatte."
4 On the concept of the weapon, see also Panofsky's essay on perspective (published 1927; Panofsky 1998, 741) in which he described perspective as a "zweischneidige Waffe" (a double-edged sword).
5 Bredekamp (1986/1992).

6 Bredekamp (1986/1992, 75); Appendix, p. 216. This passage of Bredekamp's essay ends in a footnote (n. 3), in which he states "In contrast to his later work, Panofsky still draws a clear distinction here between the general concept of the 'Idea', Neoplatonism, and art theory." This qualifying footnote was a later addition and notably absent in the 1986 version of the essay: see Bredekamp (1986/1992, 41 and 45, n. 21).

7 Kemp (1974), Kemp (1977), Summers (1977).

8 Bredekamp seems to follow Holly (1984, 150), who described *Idea* as "written […] in response to Cassirer's lecture." Krois (2008, 304) makes a point of the fact that Panofsky was in the audience when Cassirer held his lecture.

9 Panofsky (1968, ix). Panofsky (1924, foreword, unpaginated): "mannigfache Anregungen und eine oft bewährte gütige Hilfsbereitschaft."

10 Not in 1924, as Bredekamp wrote (see above n. 6).

11 Cassirer (1924, 27, n. 1).

12 It took an authority of the calibre of the eminent philosopher Jürgen Habermas to establish that within the Hamburg circle of art and cultural historians Cassirer was not only an inspirational instigator but that he, in turn, adopted many of Warburg's ideas: Habermas (1997, 9–11). The same is true of his relationship to the young Panofsky while the latter was working on *Idea*.

13 Justi (1860).

14 Cassirer (1924, 17, n. 1).

15 Cassirer (1923b). See also Cassirer's lecture on the concept of "symbolische Form": Cassirer (1923a).

16 Cohen (1878/1928), Natorp (1903/1921).

17 Natorp (1903/1921).

18 Cassirer (1925a, 277).

19 Cassirer (1925b, 83–135).

20 Panofsky (1915).

21 Panofsky (1915, 152, on Leonardo).

22 Panofsky (1915, 152).

23 Panofsky (1915, 151–2): "Dieser Gedanke, der übrigens trotz seiner scheinbaren Verwandtschaft mit der Elektionstheorie einerseits, mit Platonischen Philosophemen andererseits recht originell ist, beruht nun zwar gewissermaßen auf einer Selbsttäuschung," but it is for Panofsky "einer der sinnvollsten […], der in jener Zeit über das Wesen des Naturschönen geäußert worden ist."

24 Panofsky (1915, 183): "vollkommene Beherrschung abstrakt-allgemeiner Gesetze."

25 Panofsky (1968, 6). Panofsky (1924, 4 and 73) quotes "Melanchthon, *Ennaratio libri I, Ethicor. Arist.* chapter VI (Corp. Ref. XVI, col. b290)": "Certum est, Platonem ubique vocare Ideas perfectam et illustrem notitiam, ut Apelles habet in animo inclusam pulcherrimam imaginem humani corporis."

26 For example Cassirer (1924, 3): "It is not claiming too much to say that *all* systematic aesthetics in the history of philosophy has, fundamentally and inescapably, been Platonism." ("Es ist nicht zuviel behauptet, wenn man sagt, daß im Grunde *alle* systematische Ästhetik, die bisher in der Geschichte der Philosophie aufgetreten ist, Platonismus gewesen und Platonismus geblieben ist.") The italicized emphasis is Cassirer's! And while there are other passages in which he concedes that the later development of art theory was subject to "a strange oscillation, an antagonism, intellectual attraction and repulsion" (4: "eine eigentümliche Oszillation, ein Widerspiel, geistige Anziehung und Abstoßung"), he never explains what these "antinomies", which must, after all, embrace the Platonic as well as the non-Platonic, consisted of. These passages on "oscillation" are but a feeble echo of Panofsky's results.

27 Cassirer (1924, 5). There is a certain charm in envisioning the passage about the "focus points" in the setting of the elliptical library and lecture theatre of the Warburg Library in which it was first heard. According to Saxl – see Saxl's letter to Warburg from 28 November 1920 in (Cassirer 2009, 241–2) – Cassirer had grasped the underlying concept of the library on his very first visit, and so it is not entirely inconceivable that his turn of phrase was intended also as an oblique reference to the library's elliptical layout.

28 Panofsky (1998, vol. II, 1016).

29 Panofsky (1998, vol. II, 1031–2): "'transzendental-kunstwissenschaftliche' Betrachtungsweise" – see p. 1029: "transzendental kunstwissenschaftliche Kategorien" ("transcendental/aesthetic categories").

30 Panofsky (1998, vol. II, 1035–63).

31 Panofsky (1998, vol. II, 1040), Panofsky (2008, 49).

32 Panofsky (1998. Vol. II, 1041), Panofsky (2008, 50).

33 Holly (1984).

34 This label severed *Idea* from the unbroken line of research logic reaching back to Panofsky's doctoral dissertation. It is deplorable that this strategy, which Bredekamp had adopted to serve a polemical purpose, was still followed in 2008, when Cassirer's lecture and Panofsky's book were published alongside each other in the *Fundus* series. John Michel Krois, a friend and frequent co-author of Bredekamp, wrote the epilogue entitled "Neuplatonismus und Symboltheorie bei Cassirer und Panofsky" (Krois 2008). In among a number of commonplaces on the subject of the Warburg Library and the study of symbols, he makes a point of mentioning that Panofsky was in the audience when Cassirer gave his talk but makes no effort to analyse or compare the two texts. One can only assume because to do so would not have substantiated Bredekamp's claims of causality.

35 See the quotation on p. 21. E. H. Gombrich also noticed the echo of the Kantian approach: Gombrich (1990, 414).

36 See the quotation on p. 21–22.

37 Cassirer (1922, v, foreword).

38 Cassirer (1923a).

39 Cassirer (1923b).

40 Michels (1994, 61).

41 Gombrich (1990, 414).

42 Gombrich (1990, 415).

43 Panofsky (1968, 84). Panofsky (1924, 46–7) Italics in the German text are Panofsky's: "So sehen wir also die alten Fragen: 'Wie stellt der Künstler richtig dar?' und 'Wie stellt der Künstler Schönes dar?' rivalisieren mit der ganz neuen: 'Wie ist die künstlerische Darstellung, und insbesondere die Darstellung des Schönen, *überhaupt möglich*?' und wir erleben, wie nun, um diese beiden Fragen zu beantworten, auf alles zurückgegriffen wird, was der Epoche überhaupt an metaphysischer Spekulation zu Gebote stand, d.h. sowohl auf das wesentlich *aristotelisch* eingestellte System der mittelalterlichen *Scholastik*, als auf den seit dem 15. Jahrhundert wiederbelebten *Neuplatonismus*. In beiden Fällen aber ist es nun – und dies ist das für uns so Aufschlußreiche – die *Ideenlehre* gewesen, die, jetzt und erst jetzt in ihren ganzen Konsequenzen erkannt und daher in das Zentrum des kunsttheoretischen Denkens gestellt, die doppelte Aufgabe erfüllt, auf der einen Seite das früher noch nicht akute Problem dem theoretischen Bewußtsein *deutlich zu machen*, auf der andern aber sogleich den Weg zu seiner Lösung zu weisen. In der Renaissance hatte der von der Kunsttheorie noch nicht konsequent durchdachte und für ihr Denken nicht allzu belangreiche Begriff der Idea dazu beigetragen, die Kluft zwischen Geist und Natur den Blicken zu *entziehen*, – jetzt macht er sie *sichtbar*, indem er durch die kraftvolle Betonung der künstlerischen Persönlichkeit auf das Problem 'Subjekt' und 'Objekt' hinweist, und vermag ihn zugleich wieder zu *schließen*, indem er eine Umdeutung im Sinne seiner eigentlichen metaphysischen Bedeutung erfährt, und in dieser seiner metaphysischen Bedeutung den Gegensatz zwischen Subjekt und Objekt in einer höheren, transzendenten Einheit aufhebt."

44 Cohen (1866, 403): "Each discovery, however much it is historically prepared by an a posteriori body of knowledge, ultimately springs from an a priori combination – in this way alone the discovery is a mental process. If one wanted to describe a discovery, it is not enough to outline it in an artful conjunction of the historical conditions and to conceive the new thoughts as a mere concentration of the old knowledge [...]." ("Jede Entdeckung aber, so sehr sie durch den aposteriorischen Wissensstoff geschichtlich vorbereitet ist, entspringt doch ihrem letzten Grunde nach aus einer apriorischen Combination, nur so ist sie – ein psychischer Prozeß. Will man daher eine Entdeckung beschreiben, so genügt es nicht, sie in geschickter Verbindung der geschichtlichen Bedingungen zusammenzureihen, und die neu entstandenen Gedanken als bloße Verdichtung des alten Wissens zu fassen [...].")

45 Panofsky (1968, 125–6). Panofsky (1924, 71–2): "Der kunsttheoretische Gegensatz zwischen 'Ideenlehre' und 'Nachahmungstheorie' gleicht in gewisser Weise dem erkenntnistheoretischen Gegensatz zwischen 'Abbildtheorie' und 'Konzeptualismus' [...] hier wie dort erklärt sich das dauernde Schwanken zwischen diesen verschiedenen Möglichkeiten und die unauflösliche Schwierigkeit, ohne Berufung auf eine transzendentale Instanz die notwendige Übereinstimmung zwischen dem Gegebenen und der Erkenntnis zu erweisen, aus der Voraussetzung eines 'Dinges

an sich' […]. In der Erkenntnistheorie ist die Voraussetzung eines '*Dinges an sich*' durch Kant erschüttert worden – in der Kunsttheorie hat sich die gleiche Einsicht erst durch die Wirksamkeit *Alois Riegls* Bahn gebrochen. Seitdem wir erkannt zu haben glauben, daß die künstlerische Anschauung ebensowenig einem 'Ding an sich' gegenübersteht, als der erkennende Verstand, vielmehr – genau wie jener – der Gültigkeit ihrer Ergebnisse gerade deswegen sicher sein darf, weil sie selbst ihrer Welt die Gesetze bestimmt, d.h. überhaupt keine anderen Gegenstände besitzt als solche, die sich allererst in ihr konstituieren, wird uns der Gegensatz zwischen 'Idealismus' und 'Naturalismus' […] im letzten Grunde als eine '*dialektische Antinomie*' erscheinen müssen; allein wir werden es gerade von hier aus verstehen, wenn er das kunsttheoretische Denken so lange bewegen konnte und immer wieder zu neuen und einander mehr oder minder widersprechenden Lösungen drängte. Diese Lösungen in ihrer Verschiedenartigkeit zu erkennen und von ihren historische Voraussetzungen aus zu begreifen, wird der geschichtlichen Betrachtung auch dann nicht wertlos erscheinen, wenn die Philosophie das ihnen zugrundeliegende Problem als ein seiner Natur nach der Lösung sich versagendes erkannt hat." Italics in the German text are Panofsky's.

46 For example the chapters on aesthetics in: Cassirer (1932).

Bibliography

Bredekamp, Horst. 1986/1992. "Götterdämmerung des Neuplatonismus." *kritische berichte* 14, 4:39–48. Repr. 1992 with minor revisions in *Die Lesbarkeit der Kunst: Zur Geistes-Gegenwart der Ikonologie*, edited by Andreas Beyer, 75–83 and 102–106. Berlin: Wagenbach.

Cassirer, Ernst. 1922. *Die Begriffsform im mythischen Denken*. Leipzig and Berlin: Meiner [Studien der Bibliothek Warburg 1].

Cassirer, Ernst. 1923a. "Der Begriff der symbolischen Form im Aufbau der Geisteswissenschaften." *Vorträge der Bibliothek Warburg 1 (1921–1922)*:11–39. Leipzig and Berlin: Teubner.

Cassirer, Ernst. 1923b. *Philosophie der symbolischen Formen. Erster Teil: Die Sprache*. Berlin: Cassirer.

Cassirer, Ernst. 1924. "Eidos und Eidolon: Das Problem des Schönen und der Kunst in Platons Dialogen." *Vorträge der Bibliothek Warburg 2 (1922–1923)*:1–27. Leipzig and Berlin: Teubner.

Cassirer, Ernst. 1925a. "Paul Natorp. 24. January 1854–17. August 1924." *Kant-Studien* 30:273–298.

Cassirer, Ernst. 1925b. "Die Philosophie der Griechen von den Anfängen bis Platon." In *Lehrbuch der Philosophie*, edited by Max Dessoir, vol. I:1–139. Berlin: Ullstein.

Cassirer, Ernst. 1932. *Die Philosophie der Aufklärung*. Tübingen: Mohr.

Cassirer, Ernst. 2009. *Ernst Cassirer, Nachgelassene Manuskripte und Texte*, vol. 18, edited by John Michael Krois. Hamburg: Meiner.

Cohen, Hermann. 1866. "Die platonische Ideenlehre psychologisch entwickelt." *Zeitschrift für Völkerpsychologie und Sprachwissenschaft* 4:403–464.

Cohen, Hermann. 1878/1928. "Platons Ideenlehre und die Mathematik" [1878]. In Hermann Cohen, *Schriften zur Philosophie und Zeitgeschichte*, edited by Ernst Cassirer and Albert Görland, vol. I:336–366. Berlin: Akademie-Verlag.

Gombrich, Ernst H. J. 1990. "Idea in the Theory of Art: Philosophy or Rhetoric?" In *Idea. VI Colloquio Internazionale Roma, 5–7 gennaio 1989*, edited by Marta Fattori and Massimo Luigi Bianchi, 411–420. Rome: Edizione dell'Ateneo.

Habermas, Jürgen. 1997. "Ernst Cassirer und die Bibliothek Warburg." *Vorträge aus dem Warburg-Haus* 1:1–29.

Holly, Michael Ann. 1984. *Panofsky and the Foundations of Art History*. Ithaca and London: Cornell University Press.

Justi, Carl. 1860. *Die ästhetischen Elemente in der platonischen Philosophie: ein historisch-philosophischer Versuch* [PhD Marburg, 1859]. Marburg: Elwert.

Kemp, Wolfgang. 1974. "Beiträge zur Geschichte des Begriffs zwischen 1547 und 1607." *Marburger Jahrbuch für Kunstwissenschaft* 19:219–240.

Kemp, Martin. 1977. "From 'mimesis' to 'fantasia': The Quattrocento Vocabulary of Creation, Inspiration and Genius in the Visual Arts." *Viator* 8:347–398.

Krois, John Michael. 2008. "Neuplatonismus und Symboltheorie bei Cassirer und Panofsky." In Ernst Cassirer, *Eidos und Eidolon: Das Problem des Schönen und der Kunst in Platons Dialogen / Erwin Panofsky, Idea: Ein Beitrag zur Begriffsgeschichte der älteren Kunsttheorie*, edited and with epilogue by John Michael Krois, 302–314. Hamburg: Philo Fine Arts.

Michels, Karen. 1994. "Bemerkungen zu Panofskys Sprache." In *Erwin Panofsky: Beiträge des Symposions Hamburg 1992*, edited by Bruno Reudenbach, 59–69. Berlin: Akademie Verlag.

Natorp, Paul. 1903/1921. *Platos Ideenlehre: Eine Einführung in den Idealismus*. Leipzig: Meiner. [2. durchgesehene und um einen metakritischen Anhang vermehrte Ausgabe. Leipzig: Meiner.]

Panofsky, Erwin. 1915. *Dürers Kunsttheorie, vornehmlich in ihrem Verhältnis zur Kunsttheorie der Italiener*. Berlin: Georg Reimer.

Panofsky, Erwin. 1924. *'Idea': Ein Beitrag zur Begriffsgeschichte der älteren Kunsttheorie*. [Studien der Bibliothek Warburg 5]. Leipzig and Berlin: Teubner.

Panofsky, Erwin. 1927. "Die Perspektive als 'symbolische Form'." In *Vorträge der Bibliothek Warburg 1924/25*, 258–330. Leipzig and Berlin: Teubner.

Panofsky, Erwin. 1960. *'Idea': Ein Beitrag zur Begriffsgeschichte der älteren Kunsttheorie*. 2nd rev. ed. Berlin: Hessling.

Panofsky, Erwin. 1968. *Idea: A Concept in Art Theory*, translated by Joseph J. S. Peake. New York: Harper & Row.

Panofsky, Erwin. 1998. *Deutschsprachige Aufsätze*, 2 vols., edited by Karen Michels and Martin Warnke. Berlin: Akademie Verlag.

Panofsky, Erwin. 2008. "On the Relationship of Art History and Art Theory: Towards the Possibility of a Fundamental System of Concepts for a Science of Art," translated by Katharina Lorenz and Jas' Elsner. *Critical Inquiry* 35:43–71.

Summers, David. 1977. "Contrapposto: Style and Meaning in Renaissance Art." *The Art Bulletin* 59:336–361.

2 "My Friend Ficino"

Art History and Neoplatonism: From Intellectual to Material Beauty[1]

Stéphane Toussaint

FOR PHILIPPE MOREL

"My Friend Ficino": Panofsky, Chastel, and Kristeller

> I quite agree that your friend Petrarch is, as always, the prime mover in this development [of perspective], and one of the most significant cases of perspective in a metaphorical sense is my friend Ficino, so acutely conscious of what separates his own period from Classical Antiquity, yet attempting to coordinate everything he knows, from Zarathustra and Orpheus to the medieval scholastics, into one unified image, the 'vanishing point' of which is determined by what he thought was Plato.[2]

This telling excerpt is taken from Erwin Panofsky's letter to the historian of Italian humanism Theodor Mommsen, dated 2 July 1953. It shows, beyond the parallelism found between Petrarca (Mommsen's "friend") and Ficino (Panofsky's "friend"), how Ficino was understood by possibly the most philosophical mind among the art historians of his time. As it appears, Panofsky transferred the philosophical figure of Ficino into the field of Renaissance perspective. For him, Ficino had been "in a metaphorical sense" a "perspectivist" on his own: he was a humanist able to distantiate himself from the past, Classical Antiquity, and also, in the historical distance he had so created, a thinker capable of reorganizing a new space of reflexion around a "vanishing point" – that is, Plato and Platonism newly interpreted. Ficino brought forth the evidence that what we call Renaissance humanism was a mental rather than chronological event.[3] This is why a comparison was made possible between time perception and space perception, and between Ficinian thought and Renaissance art.

Panofsky's 'friendship' with Ficino was not ultimately motivated by his insatiable quest for sources and for iconological programs; it was legitimated, on a much deeper level, by a striking analogy in mid-Quattrocento Florence between the artistic mind and the philosophical mind. Much of the controversy about Neoplatonism in the fine arts derives, firstly, from the oblivion of this deeper layer of Panofsky's thesis, and, secondly, from antagonistic views about Ficino's thought and impact.[4] While historians of Renaissance philosophy have, usually, little doubt about the cultural influence of Ficino, such is not, or no more, the *doxa* among many historians of Renaissance art. The contemporary reaction against a much-abused iconological model – frequently associated with Panofsky, Ernst Gombrich, and Edgar Wind – would not be an unhealthy one if only the fertile dialogue between philosophy and art history, consequently, had not been well-nigh interrupted. Here we enter a somewhat complex historiographical topic which requires some initial warnings and *mise en garde*.

The relationship between art historians and the philosophy of Marsilio Ficino has been, and continues to be, biased by misunderstandings, and this is so, paradoxically, for quite understandable reasons. Ficino was not an art theorician *stricto sensu*. Hence he left

nothing comparable to Alberti's, Zuccari's or Lomazzo's treatises. His philosophy was not meant primarily for artists, and the ideal of Plotinian beauty it conveyed outshone other more material concerns with its radiance. As a matter of fact, the otherworldliness of Ficino was long an ordinary assumption during the twentieth century. Even so, for the reason that many Ficinian texts (known by a few specialists) do not convey abstractness when properly interpreted, this kind of assumption has become increasingly untenable in the twenty-first century.

Panofsky, who is currently associated with the Neoplatonic hypothesis, saw the diffracted influence of Ficino in the artistic environment of the Renaissance in terms of the metaliteral diffusion of his Platonism and Plotinism as "a vanishing point." As one could expect from a keen scholar of perspective, Panofsky expressed through a geometric metaphor his intimation that Ficino was himself a fleeting figure, more like a central spot in the distance of Renaissance art than an actor in the forefront of the picture. For instance, it was Panofsky's old conviction in *Idea* (1924) that Alberti's naturalism could have well hampered the penetration of Ficinian idealism into the artistic milieu.[5] That said, Panofsky's observation, thirty years later, that the conflation between Alberti and Ficino, impossible in Quattrocento Italy, was made possible in Northern Europe should be remembered.[6]

On the contrary, in his book *Marsile Ficin et l'art*, André Chastel neither nurtured doubts about the compatibility of Alberti's program with Ficino's Neoplatonism[7] nor about the importance of art in Ficino's prose and philosophy. All through his analysis, Chastel inverted the Panofskyan picture: for him, art tended to be the vanishing point in Ficino's Platonism; a thesis frankly rejected by the major Ficinian scholar of the twentieth century, Paul Oskar Kristeller. In Kristeller's opinion, the focus of Ficino's contemplative philosophy was essentially metaphysical and not artistical. Thus, two general trends of interpretation were, and still are, latently in conflict, not only concerning Alberti and Ficino but, ultimately, the possibility of transgressing the limits of what critics deemed expedient to define Ficinian Neoplatonism: metaphysical and idealistic.

Incontrovertibly, when one looks into the artistic features of Ficino's highly visual mind, his Neoplatonic philosophy is fraught with symbols and images, while his thinking is focused on mythological and emblematical metaphors.[8] On the one hand, a prose packed with eminently aesthetical qualities, as is Ficino's *De amore* or *De vita* for instance, is also to be characterized in itself as a work of art, regardless of any immediate contact with the surrounding artistic world of his time; on the other hand, there is no doubt that the *De amore* and the *De vita* exerted an influence on artists. To evidence one single yet significant case during the classical period or golden age of Dutch painting, Samuel van Hoogstraten's *Introduction to the Academy of Painting* (1678) was influenced by Ficinian tenets.[9]

Yet historians have searched recurrently for an elusive transitivity between Ficino and the fine arts of his days, without finding more than a transcendental theory of beauty remote from the plasticity of art. In retrospect, an excellent introduction to this inherently aporetic question could be the unheeded controversy occasioned by *Marsile Ficin et l'art* between Chastel and Kristeller in 1958, when the latter argued that:

> There is one basic point of doctrine on which I must disagree with Professor Chastel's interpretation. It concerns Ficino's theory of contemplation. This notion, which is central in Ficino, has for him strong metaphysical and 'mystical' connotations, and

it is rooted in the Neoplatonic and mediaeval Augustinian tradition. Contemplation is for Ficino the source of spiritual experience and of our knowledge of the invisible, which includes God and Ideas. It has no artistic connotations for him whatsoever [...]. Hence I cannot follow Professor Chastel where he tends to ascribe to Ficino a theory of artistic contemplation.[10]

To be exact and true to Chastel's thesis, *Marsile Ficin et l'art* did not essentially promote a Ficinian "theory of artistic contemplation." It defined, quite on the contrary, Ficino's positive appraisal of the active "homo artifex" as a true "coup d'état" within Neoplatonism,[11] a claim adopted by Gustav René Hocke in his influential book *Die Welt als Labyrinth* (1957)[12] yet neglected by Kristeller and subtly at variance with Panofsky's own idealistic reading of Plotinus and Ficino. According to Chastel:

> We should consider the problem of art on the level of the creative power [*puissance créatrice*], which by vocation dominates the order of natural things [...]. The artifact is here represented as mirroring an individual thought and not a supernal idea [...]. The analogy with the divine artifex [...] glorifying the function of art and showing it at the apex of human order, puts it above analysis, beyond any possible justification by a putsch [coup d'état] inside Platonism, which was to meet a broad recognition during the Renaissance due to the Academy [of Careggi].[13]

The very idea of an individualistic justification of artistic creation was certainly a new way of approaching Ficino and his concept of art.

Quite differently from Chastel's theory of the "coup d'état," Erwin Panofsky and Paul Oskar Kristeller had their own reasons to believe that during the Quattrocento Ficinian beauty and art were barely in synchrony, since art, in the medieval sense of *ars* (a category common to craft and learning), did not correspond to any *aesthetica*, a modern term coined much later.[14] Furthermore, Ficino, they said, could well have theorized about beauty without having any actual concern for art, since his thought was not aimed at producing buildings, paintings, or sculpture.[15] As for a "système des Beaux Arts," it is all the more evident that Ficino could never have theorized it during the Quattrocento, when aesthetics, as an academic discipline, was still to be invented. So Marsilio was doomed to remain outside the history of art in the restricted sense. As early as 1924, Panofsky had formulated a law of reciprocity that seemed inescapable: insofar as Ficino did not care about art and artifacts, art theory did not care about him.

As of 1949, with his sincere admiration for Panofsky's method of "decompartmentalization," Chastel followed the alternative intuition that it was possible to study Florentine Neoplatonism "sub specie aestheticae." In the footsteps of Chastel, David Hemsoll has also developed sensible postulates in favor of Ficino's "new aesthetic outlook."[16] And with a different historiographical scope, revealing new aspects in the genesis of *Marsile Ficin et l'art*, Ginevra de Majo has stressed the intersecting influences of Renaissance art and Neoplatonism in Chastel's thought.[17]

One of Chastel's great merits was his understanding of Ficino as a sort of 'Neoplatonic artist' *sui generis*. After all, does not Ficino place Eros – a Platonic demon – as the starting point of all artistic activities? As Chastel observed, reading *De amore* – a text also available to non-Latin readers during the Quattrocento because it circulated in Ficino's own Italian translation – and particularly chapter III, 3, "Amor est magister artium et gubernator" or "Che l'Amore è maestro di tutte le arti"[18] – it becomes apparent that

Ficino's Neoplatonic idea of the artist as an *artifex* never reproduces Plato's alleged disparagement of technical activities.[19] Here Ficino exalts the conjunction of *ars* and *eros* in a way that, for instance, according to Stefan Albl, may have well influenced the Lucchese painter Pietro Testa.[20] Indeed, Ficino's notion of *ars* as a human activity inspired by a demonic Eros is not only applied to medicine, music, astrology and prophecy but possibly to all *artes*: "Questo medesimo nel'altre arti si può coniecturare, e insomma conchiudere l'Amore in tutte le cose essere, inverso tutte factore e conservatore di tutte, a signore e maestro d'ogn'arte."[21]

We should be aware that art for Ficino, as is the case here above, is intended in its concrete meaning of *technē*. It is true that Marsilio, elsewhere in his work, borrowed the notion of intellectual beauty from Plotinus' *Ennead* I, 6;[22] however, it is also central to our argument that, combining *technè* with *eros* and *magia*,[23] Ficino gave birth to a specific form of *Kunstwollen*,[24] or rather to what could be termed as a Platonic *Kunstliebe*,[25] where the human arts and their *artificia* are the very practical consequence of *amor*.[26] As the first effect of art, in the Ficinian meaning, is to create harmony by matching opposites, gaining *concordia* through universal attraction, then cosmical love clearly has artistic implications. Reciprocally, mundane art depends on love with its almost magical attraction for specific materials, shapes, and colors.[27]

In this context, Ficino's visual mind relies on a series of powerful symbols, like the eye and the mirror,[28] in close connection with the *spiritus phantasticus* and the *phantasia*, fertile notions for Renaissance humanists like Fabio Paolini, Francesco Cattani da Diacceto, and Niccolò Leonico Tomeo (to quote just a few), who were well introduced into artistic circles and 'accademie.'[29] As a matter of fact, Ficino's overall theory of imagination was taken up by Renaissance followers of peculiar forms of dionysiac, orphic, hermetic, or demonic arts, grouped under the imprecise appellation of Neoplatonism.[30]

For all this, a specious argument would be that Ficino is of no interest to art historians, only because his thought never generated an art theory or never inspired Botticelli (or the Pollaiuolo brothers, with whom he was well acquainted).[31] Before attempting to qualify this difficulty in the next section, "The 'Besieged Fortress'," a short survey may help us to understand a heterogeneous situation.

First of all, the so-called Neoplatonic model is no exclusive invention of the Warburgian school. As early as 1879, Hermann Hettner had introduced the notion of a Platonic rebirth in the study of Renaissance painting.[32] And since 1904, the French scholar Emile Gebhart had underscored in his book on Botticelli the influence of Plato and of the Academia Platonica on the new artistic mood of the Florentine Quattrocento.[33] Years later, in a memorable and often quoted book, Nesca Adeline Robb[34] emphasized the social and artistic role of Ficino. Finally, because the Warburgian moment received (too) much attention from art historiography,[35] it seems useless to remember how, with Warburg and his school, between the 1920s and the 1960s a Neoplatonically oriented scholarship produced extremely influential books. Nonetheless, a history of the waxing and waning of Neoplatonism inside the Warburg Circle still appears to be a *desideratum*.

Turning now to contemporary scholarship, one should acknowledge that the Neoplatonic paradigm never completely collapsed, as we can judge (quoting here just a few cases of a very different nature) from essays by Liana Cheney and John Hendrix,[36] Alexander Nagel,[37] Damian Dombrowski,[38] Berthold Hub,[39] Maria-Christine Leitgeb,[40] and recently Marieke van den Doel[41] and Marina Seretti.[42] It is obvious that, by reason of their universal legibility beyond metaphysics, the Neoplatonic texts continue to exert an everlasting attraction after various anti-Ficinian disputes that we must now evaluate.

Figure 2.1 Marsilio Ficino, *Argumentum in librum de pulchritudine* (= Plotinus, *Ennead*, I, 6), title page.

Source: Florence, Biblioteca Medicea Laurenziana, Ms. Laur. Plut. 82.10, fol. 79v. © Su concessione del Ministero dei Beni e delle Attività Culturali e del Turismo.

The "Besieged Fortress": "Abstract Neoplatonism" under Attack

In her very instructive conference on "The Metaphor of Painting in Ficino's Works," Patrizia Castelli remarked that the thesis of Ficino's centrality in the Florentine artistic milieu has become a "besieged fortress."[43] A rapid history of the siege appears even more illuminating.

The year 1968 saw a double funeral: Panofsky died and the Neoplatonic thesis was buried with him. That very year, Charles Dempsey published a thought-provoking paper entitled "Mercurius Ver." Its claim was very simple: the time had come to abandon the Neoplatonic reading:

> Mercury has been the basis by which, in Panofsky's words [...], 'we may infer the presence and import of a 'metaliteral' significance in Botticelli's composition.' The source in which recent attempts to explain this 'metaliteral significance' have been founded is the Neoplatonism of Ficino; and at the heart of the Neoplatonic exegesis of the *Primavera* lie two assumptions: that Mercury cannot otherwise be accounted for, and that the *Primavera* bears a programmatic relationship to the *Birth of Venus*. Both assumptions are questioned in this paper.[44]

Dempsey mentioned the name of Ficino once and never repeated it in his article. Apparently, Marsilio had become a superfluous reference in as much as the *Primavera* was motivated by an agrarian calendar and by Poliziano's poetry for a rural retreat, the Villa di Castello near Florence, in contrast with Gombrich's thesis that Neoplatonism inspired Botticelli at the time the *Primavera* was painted. Since Dempsey's article, the Castello hypothesis has been invalidated; nevertheless, the claim that a coherent historical reading of Botticelli's mythologies can be obtained in light of Neoplatonic imagery, as Gombrich once asserted, has been a favorite target for generations of historians.[45]

As Dempsey himself explained in 1992 in his book *The Portrayal of Love: Botticelli's Primavera and Humanist Culture at the Time of Lorenzo the Magnificent*, Warburg had long ago demonstrated the predominant influence of Poliziano on Botticelli's representations of the ancient gods. This demonstration was adopted in an almost sociological sense by Pierre Francastel – Chastel's academic adversary – whose influence on Dempsey's thesis is evident:

> There are at present [1992] two dominant hypotheses claiming to explain the phenomena appearing in Botticelli's picture. The first hypothesis, maintained with varying emphases by Warburg, Francastel and me, holds that the appearances of the ancient gods shown by Botticelli may be explained by recourse to the characterization of them given in ancient poetry known by humanists [...]. Politian in particular, and imitated by them in their poetry [...]. Moreover, all serious scholars of the *Primavera* (by whom I mean those who are fully cognizant of the philological issues), with the single and notable exception of Gombrich, have taken Warburg's remarkable demonstration of this hypothesis as their own point of departure. As Pierre Francastel, for example, observed, 'La comparaison fondamentale est celle des *Sylves* et des *Stances* de Politien avec le fameux *Printemps* de Botticelli.'

Once the philological legitimacy of Poliziano's model had been established as the only hypothesis for "serious" scholars, the Neoplatonic model came under fire:

The second hypothesis, championed with varying emphases by Gombrich, Wind, and Panofsky, is the Neoplatonic model. [...] It might be suggested at once that there is a prima facie case for regarding this second, Neoplatonic hypothesis with caution, in part because of the unexamined assumption that a painting such as the *Primavera* must have been conceived on the basis of some program (Wind) or basic text (Panofsky). [...] On a more fundamental level, however, the Neoplatonic model as it has thus far been conceived has not been sufficiently integrated with the poetic traditions that its proponents acknowledge to be the starting point for Botticelli's invention. Rather than growing naturally out of the poetry, Neoplatonic readings instead have been artificially superimposed on it [...].[46]

Notwithstanding the wish to harmonize Neoplatonism and agrarian poetry,[47] such a reading dwelt insistently on Ficino's Neoplatonism as an intellectual and esoteric doctrine centered on the "aulic" Venus. Understandably, the author blamed Wind and Panofsky for adopting Ficino as "a philosophical model artificially grafted onto a poetic one."[48] Dempsey insisted further that their "Neoplatonic interpretation had also been mistaken [...] because the concept that Botticelli's invention arose from an *intellectually abstract Neoplatonism, remote and aulic*, rested on the same misconception of Florentine culture."[49] It was the strongest critique addressed to the Panofskyan thesis: not wrong in its arguments but in its very understanding of Florentine culture! What undermined Panofsky's Neoplatonism was not its iconological statement but the historical syllogism lying behind it, because a vernacular image could not derive from a metaphysical concept. Thus the Neoplatonism to be banished was vitiated by an erroneous assimilation between a disembodied idea and the poetic *Primavera*.[50] Underlying these subtle arguments, the tendential dualism concerning "abstract Neoplatonism" *versus* "Florentine culture" is to be weighed for the great impact it had on successive scholarship.

Dempsey's posture, which altogether eluded the living tradition of the 'Ficino volgare'[51] and of the 'amore volgare,'[52] is fairly understandable when we come to realize the core of his thesis: Warburg was the scholar whose "compelling demonstration of the closeness of Botticelli's imagery to [...] the general aesthetic of Poliziano's Stanze" was unattended, while "[s]cholarly energies instead concentrated on attempts to establish the Neoplatonic hypothesis."[53]

The betrayal of Warburg's thesis was vindicated by the new Dempseyan interpretation, where many of the Ficinian 'notations' – *pulchritudo, voluptas, humanitas* – currently associated with Venus were adopted only in subsidiary terms, *in absentia* of a real philosophical program expressed by Botticelli's painting. In his conception of love, Ficino had fused *Amor* and *Caritas*, antiquity and Christianity, in the "melting pot of present day experience," so that Botticelli's invention finally bore a loose resemblance to Neoplatonism.[54] The evasive connection with Ficino's Neoplatonism was never causative but always derivative, from *fabula* to *philosophia* and not vice versa.

As we know, the Ficinian hypothesis suffered more radical assaults during the late 1980s. Let us continue with a resolutive deconstruction of it. So spoke Horst Bredekamp in his pamphlet "Götterdämmerung des Neuplatonismus":

What was deemed for a long time as a signum of the Renaissance period, nowadays produces a peculiar estrangement: though Neoplatonism may be still present, it has lost its leading role for the interpretation of Renaissance art. [...] Its importance [for

the history of art] is less a problem related to art-historical reality than to the history of scholarship.

Considering this background [the political condition of Nazi Germany] it is a pity to acknowledge that the aforenamed iconologists [Panofsky, Gombrich, Wind], by their escape [from the contemporary nationalism of the Nazis] to Neoplatonism had chosen the wrong fortress.

With their compulsorily Neoplatonistic manner, the magic moments of iconology, proved unwillingly to be signposts into a dead-end.[55]

In the above three excerpts, Bredekamp's critique of the 'Neoplatonic model' is thus summarized: Neoplatonism is unessential to the understanding of Renaissance art because its art-historical relevance only pertains to the history of scholarship; Neoplatonizing art history was a political reaction of Jewish iconologists in 1933; Neoplatonism was a dead-end in history of art. These claims bear something in common: Neoplatonism had been a wrong "fortress," in a derogatory sense obviously contrary to Patrizia Castelli's later metaphor of the "besieged fortress." The "Zauberwort," the magical word of Neoplatonism, had been disconnected from historical realities and from artistic documents:

> Neoplatonism became the magic word of the erudite art historian. One seemed to have reached the supreme goal, the summit of interpretation when one succeeded in representing a work of art shining with the aura of Neoplatonism […].[56]

There is the rub: the Neoplatonic "system" fossilized works of art into mere "Denkformen." Bredekamp yearned for freedom from Ficino's idealistic spell. His mission was to set free the energy of the forms in an almost vitalistic gesture – power *versus* signification and form *versus* interpretation – somewhere between Nietzsche's criticism of Platonism and Warburg's "Pathosformeln." At the end of his short manifesto, Bredekamp knowingly encouraged a "farewell to the obsession with Neoplatonic Florence" ("Abschied von der Fixierung auf das neuplatonische Florenz") in the hope of liberating the works of art from the fate of intellectual formulas.[57]

In this large 'mouvement de libération' from Ficino's grip, another influential author was Ronald Lightbown, who published a second edition of his *Sandro Botticelli: Life and Work* in 1989, three years before Dempsey's *Portrayal of Love*. For Lightbown – as for Bredekamp – any interpretation resting on Ficinian speculation did not depend on strict philology but on some sort of entrancing intoxication:

> But it must be said that no one has yet been able to produce any firm historical evidence of any kind from fifteenth-century Florence, that the current of Neoplatonic philosophy and the current of painting were ever made to interflow, even by the most philosophically minded patron.[58]

The issues of Lightbown's almost harsh judgment consisted, firstly, in the alleged iconological incommunicability between Neoplatonism and painting and, secondly, in specific opposition between Botticelli's carnality and Ficino's didactic *humanitas* displayed in the famous letter to Lorenzo di Pierfrancesco de' Medici.[59]

Dempsey sometimes used to see in Ficino's myth of Venus a lesson of astrology, not fully compatible with Botticelli's earthly imagery. For Lightbown, the problem with Ficino's Venusian myth was quite another: it rested on the disembodied symbol of human

duty imposed by "propugnators" of Neoplatonic allegories. So that "the great argument against interpreting the *Primavera* in too lofty and didactic a mode" would be "the sensuality, discreet but inequivocal, that pervades it." Consequently "the frank if restrained carnality of the picture" would seem "so strange if we see it as an *exemplum* of *humanitas*" as it was illustrated by Ficino's "grave Neoplatonic allegory."[60]

In developing stylistic objections, Lightbown extended, considerably more than Dempsey, the range of his critics: Neoplatonism was now confined to metaphysics, and since metaphysics is unrepresentable, its aniconic character was transferred onto Ficino's philosophy. After Lightbown, we can trace back the commonplace of the 'aniconic Ficino' among the best opponents to Ficino's influence on arts. The following statement by Francis Ames-Lewis in 2002 appears symptomatic: "'Ficino's own visual sensibility was 'slight' as Wind tactfully put it; [...] Ficino's philosophical ideas are not generally susceptible of visual representation because of their abstract character."[61]

Successively, in 2005, Frank Zöllner observed in his illuminating paper on "The 'Motions of Mind' in Renaissance Portraits":

[...] there is another widespread literary topos which discloses substantial doubts about the mimetic abilities of the fine arts in the realm of mentality and which, in part, bears witness to a long lasting antagonism between the inferior image of the body (eventually created by art) and the better image of the mind [...]. In the fifteenth century, Marsilio Ficino voices similar opinions, judging the material representation of the essentially immaterial soul to be impossible (cf. *De amore*, 5, 3).[62]

The representation of the soul through the body is the intricate Ficinian problem I shall turn to further on in the section "Ficino on Plotinian Beauty." Let me here observe retrospectively that Dempsey proved judicious when, in his *Portrayal of Love*, he evoked Pico della Mirandola and Cortesi on poetry *versus* the inferiority of painting. Revisiting rhetorical categories used by Elizabeth Cropper in two famous papers,[63] Dempsey observed that Botticelli had reached a sort of balance between *effictio*, the description of outer appearance, and *notatio*, the connotation of inner character pertaining to moral philosophy.[64] If understood correctly, Dempsey's discerning comment implied that pictorial balance between form and idea offered the only hermeneutical, yet unexplored, possibility to reintroduce *in fine* Ficino's visible lesson.

An essential remark should be made here: critics were unable to address a long-lasting contradiction, or at least a revealing discrepancy, between two possible Ficinos, the 'aniconic'[65] and the 'iconic,' hence the Ficino 'excludible' from art history and the 'includible' one. This is certainly why, with such ambivalence, the visual implications of Ficino's philosophy could neither be totally erased nor precisely identified, while the towering genius of Poliziano, so representative of the art of his century,[66] was overexposed. Meanwhile, nobody noticed how much the stereotype of 'abstractness' turned out to be an obstacle to scholars with a genuine interest in Ficino's work.

Due to space constraints, it is not possible to observe in detail how far from their initial domain of application (*id est* Botticelli's paintings) the arguments *pro* Poliziano and *contra* Ficino are widespread. To give just one telling example: in her three studies on Niccolò Fiorentino's medals for Giovanna Tornabuoni, Maria DePrano acknowledges the failure of the Neoplatonic model in the numismatic field.[67] Arguing against Edgar Wind, the author opposes Poliziano's non-Platonic humanism after 1480 to Ficino's

Neoplatonism.[68] Already by 1982, Paul Holberton had placed the iconological change under the influence of Poliziano almost in syllogistic form:

> Both Wind and Panofsky point out that Ficino had no interest in art. By contrast Politian's description of the reliefs in the palace in the Realm of Love in the *Stanze* make interesting art criticism. Warburg's proposition that Politian provided the programme for the Primavera is surely correct.[69]

But had Aby Warburg always and exclusively insisted on the centrality of Poliziano's poetry, leaving Ficino completely outside of his concerns? Is this simplified historiographic view totally convincing?

Warburg on Ficino

In fact, Warburg seldom alluded to Ficino in his studies. As we know, in the 1932 edition of Warburg's *Gesammelte Schriften*, in two volumes, Ficino is quoted only with reference to Francesco Sassetti and the concept of *fortuna* (1907) and to astrology in Luther's time (1920), but nowhere does Warburg deal properly with Ficino and the visual arts.[70] However, some penetrating allusions to Florentine Neoplatonism and to Ficino may be found in the *Anhang* or addendum at the end of each of the two volumes. We notice that well after 1893 Warburg had read Della Torre's *Storia dell'Accademia Platonica di Firenze* (1902). Therefore, Warburg could explicitly parallel Botticelli's paintings, Ficino's Platonism and Orphic magic under the sign of Venus, since Ficino and Pico had both been involved in the revival of the *Orphica theologia* between 1462 and 1486:

> Both *Birth* and *Realm of Venus* can be more firmly drawn into the sphere of Platonic and magical practices. Marsilio Ficino's first translations from the Greek were the Homeric and Orphic Hymns, which he sang in 1462 *all'antica*. (See Arnaldo della Torre, *Storia dell'Accademia Platonica di Firenze*, 1902, 537, 789.) And Pico della Mirandola, in his *Conclusiones*, on the Orphic Hymns, refers to Venus and the Graces in the *arcana* of Orphic Theology. [...] Not to speak of his [Pico's] *Commentary* on Benivieni's *Canzone d'Amore*, where Venus and the Graces also appear (bk. 2, ch. 15).[71]

Perhaps for the first time Warburg insisted on Venus and the Graces in connection with magical Neoplatonism: a philological hint not taken into account by a simplified reading of his work. Warburg also quotes Pico's Thesis "secundum magiam" on the secret meaning of Venusian trinity from a clearly deeper intellectual perspective ("als Arcanum") than Poliziano's charming courtly poems. Had Warburg's late intimation that Poliziano's poetry did not represent a unique option in the intricate culture of Quattrocento Florence perhaps predisposed him to seek more esoteric meanings behind Botticelli's imagery? Regardless, it is certain that Warburg had some reading of Ficino's *De vita* after Giehlow's pioneeristic study of Dürer's *Melancholia I* (1903/4). He made use of it in his famous essay "Heidnisch-antike Weissagung in Wort und Bild zu Luthers Zeiten" (1920), so that Ficinian magic quite easily came to his mind:

> Against this, the Florentine philosopher and physician Marsilio Ficino advocated a combination of therapies: psychological, scientific or medical, and magical. On the

one hand, his remedies included mental concentration to enable the melancholic to transmute his sterile gloom into human genius; on the other – aside from purely medical treatment to counter excessive mucus formation ('sniffles') and thus facilitate the transformation of the bile – the benefic planet Jupiter must be enlisted to counter the dangerous influence of Saturn.[72]

In the latter text, the "innere geistige Konzentration" is the key to understanding Warburg's appreciation of Ficino. The next quotation immediately following the precedent passage (in Warburg's essay on Luther) stresses Ficino's "symbolic way of conceiving melancholy" ("Denksymbol der Melancholie") by the geometry of the center, the circle, and the sphere:

> According to Ficino, in the old German version, the compasse and circle (and thus also the sphere) are emblems of melancholy: 'But the natural cause is that to attain and achieve wisdom and learning, especially of the difficult art, the soul must be drawn inward, away from outward things, as it might be from the circumference of the circle to the center, and adapt accordingly.'[73]

Here again, intellectual concentration is at its height. What is difficult to assess is whether Warburg reckoned with a Ficinian intellectual melancholy psychologically neutralized by the sight of cosmic harmony, the smile of Venus, the gifts of Mercury, and the colors of the world. In fact, in Ficino's medicine, contemplative operations and circular inwardness are the cause of, as well as the remedy against, monstrous melancholy[74] according to the very object of contemplation itself, be it Saturnine or Jovian, Mercurian or Venusian.

It is all the more striking to observe, on a historiographical level, how the very treatment of the mental metamorphosis of the barbaric demons, so important for Warburg in his essay on the iconographic program of the frescoes of Palazzo Schifanoia in Ferrara, runs parallel to Ficino's aesthetic sublimation of melancholy. While insisting so interestingly on the intellectual traits of Ficino's theory – which was broadly interpreted as an abstract philosophy by some of his 'orthodox' followers – Warburg ignored many passages of the *De vita* dedicated to the luminous and bodily qualities of the universe.[75] Indeed, Warburg says nothing about the paramount attention Ficino dedicated to the very colors of nature and of grace: blue, green, red, yellow or gold,[76] not to mention the celestial qualities of the *figura mundi* in *De vita*, book III, chapter 19 ("De fabricanda universi figura") and of mechanical devices like the planetary clock by Lorenzo della Volpaia.[77] Noticing, *en passant*, the Neoplatonic qualities of Botticelli's painting, Warburg did not quote Ficino explicitly: "The chthonian element becomes aetherial, for Botticelli's ideal sphere is pervaded by the pneuma of Plato and Plotinus."[78]

Warburg's silence on Ficino is all the more astonishing when, with regard to the Palazzo Schifanoia frescoes, Warburg spoke of celestial contemplation – a specific tenet in Ficino's *De vita* – as a means of defending humanity against the evil and conflicting demons of barbaric astrology:

> Catharsis of the belief in omens through astral 'contemplation' [circumscription]. The metamorphosis from self-defense against a monstrous portent (*placatio*) to the contemplation of divinatory hieroglyphs of fate: from the omen to idea.[79]

Although Ficino is not acknowledged here, his cosmic idea would have fit perfectly as the missing link in the process leading from "Monstrum zur Idee."

Beyond and after Warburg, Ficino's loss of visibility in various fields of art history is easy to ascertain in other authors, as demonstrated by the following two quotes from Panofsky's *Idea* (1924) and from *Saturn and Melancholy*, published together with Raymond Klibansky and Fritz Saxl in 1964:

> In his writings Ficino was dealing with beauty and not with art, and art theory almost never interested him, but we face this notable fact in intellectual history, that the mystical and psychic beauty of Florentine Neoplatonism, a century later, newly emerged with Mannerism as a metaphysic of art.[80]
>
> This Florentine [Ficino] who lived at such close quarters with the arts of the Renaissance, and with its theory of art based on mathematics, seems to have taken no parts either emotionally or intellectually in the rebuilding of this sphere of culture. His Platonist doctrine of beauty completely ignored the works of human hands, and it was not until a good century later that the doctrine was transformed from a philosophy of beauty to a philosophy of art.[81]

The first of the two quotations is telling because, according to Panofsky, Ficino had prepared Mannerism and the artistic trend of the Cinquecento, all the while secluding his thought from the art of his own time. Turning now to the second quote, forty years after the publication of *Idea*, nothing had changed in the way iconologists represented Ficino's mentality. If *Saturn and Melancholy* is a masterpiece of scholarship, as it is, then its huge legacy all the more conveyed a misleading commonplace: Ficino's aloofness from the arts and craftsmanship. Unfortunately, moreover, André Chastel's French alternative masterpiece, *Marsile Ficin et l'art* (1954), with its emphasis on Ficino's artistic fascination with geometry, optics, talismans and magic never became a bestseller in Anglo-American universities.[82] Who remembered that one of Ficino's favorite models had been Archimedes?[83] Who remembered Ficino's eulogy of the mechanical arts, of the "figura mundi," and his familiarity with Della Volpaia's clock?

Certainly, it would be unfair not to recognize that, with his *Studies in Iconology* of 1939 and 1962, Panofsky himself had significantly changed his mind about Ficino's aesthetic. But contrary to Gombrich, who was receptive to the dialogue between art and magic,[84] Panofsky limited the area of Ficino's sensibility.[85] For him "in spite of his positive attitude towards sculpture and painting, Ficino's personal aesthetic interests were largely limited to music and, next to music, poetry."[86]

Ficino on Plotinian Beauty: Towards a "Corporeal Intellectuality"

To be sure, I would not dare to deny that Ficino may be strongly idealistic in the Panofskyan meaning of the term, as evidenced by the following letter, addressed to Gismondo della Stufa on the occasion of his wife's death:

> Marsilio Ficino gives consolation to Gismondo della Stufa. If each of us, above all, is that which is greatest within us, which always remains the same and by which we understand ourselves, then certainly the soul is the man himself and the body but his shadow. Whoever is so mad as to think that the shadow of man is man, is a wretch doomed to mourn and cry like Narcissus. You will only cease to weep, Gismondo,

when you cease looking for your Albiera degli Albizzi in her dark shadow and begin to follow her by her own clear light. For the further she is from that misshapen shadow, the more beautiful will you find her, past all you have ever known. Withdraw into your soul, I beg you, where you will possess her soul which is so beautiful and dear to you; or rather, from your soul withdraw to God. There you will contemplate the most beautiful idea through which the Divine Creator fashioned your Albiera; and as she is far more lovely in her Creator's form than in her own, so you will embrace her there with far more joy. Farewell. 1st August 1473, Florence.[87]

This could be a perfect illustration that Ficino only had in mind an idea of Plotinian beauty located in the afterlife, above all an artistic appearance. But the context reveals it could not be otherwise: the supernatural tone of a consolatory letter, mourning one of the most beautiful ladies of Florence, Albiera degli Albizzi, whose husband was Ficino's friend and potential patron, perfectly fits its purpose. It would have been improper to evoke the carnal presence of Albiera after her death.

Therefore, such evidence does not compromise the powerful iconic nature of Ficino's thought in many other cases, especially in another and most famous piece, letter V, 46, written to Lorenzo di Pierfrancesco. Its essential message is encapsulated thus:

Men can be taken by no other bait whatsoever than their own nature. Beware that you never despise it, perhaps thinking that human nature is born of earth, for human nature itself is a nymph with an incomparable body. She was born of an heavenly origin and was beloved above others by an ethereal god. For indeed, her soul and spirit are love and kinship; her eyes are majesty and magnanimity; her hands are liberality and greatness in action; her feet, gentleness and restraint. Finally, her whole is harmony and dignity, beauty and radiance. O excellent form, O beautiful sight![88]

This letter needs no comment, because it has been discussed by Gombrich and recently received the mindful attention of Ursula Tröger.[89] The sentence applied to the *nympha humanitas* remains unequivocal: her body, not her idea, is of incomparable humane beauty. "Ipsa praestanti corpore nympha." The expression of humanity spectacularly results in excellent form and beautiful sight.

The complete transposition of an idea into a *spectaculum* can be perfectly observed in the much lesser-quoted letter V, 51, to Bembo and Lorenzo de' Medici, probably dating from 1478, where the picture of a beautiful body ("pictura pulchri corporis") is created through the imagination and where, above all, it is Ficino's explicit intention to invert the priority of *verba* over *species* ("nihil [...] tibi opus est verbis"), thus to celebrate the triumph of *formositas* over *laudatio*, the implicit superiority of *evidentia* and *effictio*[90] over *notatio*:

A picture of a beautiful body and of a beautiful mind. Marsilio Ficino of Florence to his friends. Also to Lorenzo il Magnifico and to Bernardo Bembo. Philosophers debate, orators declaim and poets sing at great length to exhort men to true love of virtue. I praise and admire all this. Indeed, if I did not praise good things, I would not be a good man. But I consider that if virtue itself was ever to be displayed openly she would encourage everyone to take hold of her far more easily and effectively than would the words of men. It is pointless for you to praise a maiden to the ears of a young man and describe her in words in order to inflict upon him pangs of love, when you can bring her beautiful form before his eyes. Point, if you can, to her

beautiful form, then you have no further need of words. For it is impossible to say how much more easily and impetuously beauty herself calls forth love than do words. Therefore, if we bring into the view of men the marvelous sight of Virtue herself, there will be no further need for our persuading words: the vision itself will persuade more quickly than can be conceived. Picture a man endowed with the most vigorous and acute faculties, a strong body, good health, a handsome form, well-proportioned limbs and a noble stature. Picture this man moving with alacrity and skill, speaking elegantly, singing sweetly, laughing graciously: you will love no one anywhere, you will admire no one, if you do not love and admire such man as soon as you see him.[91]

All this accounts for the celebration of the beautiful human figure "sese movens" (in action), far beyond an idealistic eulogy of virtue. The extent to which Ficino could distantiate himself, when necessary, from the Plotinian ideal of invisible "bonum" is quite evident in this excerpt, where the philosopher is ready to favor the superiority of images over words and ideas. In the same way, the letter to Lorenzo il Magnifico, as already noted by Baldini[92] – whose perceptive comments were unfortunately not acknowledged by later scholarship – makes Zöllner's and Lightbown's assertions on the absolute Ficinian primacy of the immaterial soul over bodily forms more fragile.[93] Indeed, in this letter, Ficino does not trust disembodied concepts and asks for humane sight and shape. For him, as already remarked by Chastel and Castelli in their studies, the soul can always be expressed visually, and, conversely, the human body can speak eloquently for the invisible.[94] As expected from a physician, the number of biological metaphors in Ficino, extending into all areas of his philosophy, is impressive.[95]

In perfect harmony with the androgynous attributes of his own thought, Ficino depicted a portrayal of *humanitas* through feminine beauty in letter V, 46, and then, in letter V, 51, a portrayal of *virtus* through masculine beauty.[96] To shape a moral idea into a bodily form was for him the equivalent of painting a portrait. It is done in order to bring mankind to admire "the divine aspect of the mind from the corresponding likeness of the beautiful body."[97]

Should we perhaps take for granted that portraying a virtue in the guise of a beautiful body was for Ficino an ordinary act of "philosophical painting,"[98] comparable *mutatis mutandis* to the unidentified "femmine ignude" painted in Botticelli's bottega around 1482[99] and to the standard "uomini esemplari" or "virtuosi" in Desiderio's atelier?[100] The *Platonic Youth*[101] attributed to Donatello or, more convincingly, to Bertoldo, would also fit into this convention. At any rate, it is hard not to apply to Ficino and his portraying of the "animi species" Leonardo's own determination to express, in Cropper's words, "the beauty of the soul through the representation of the graceful movements of the body."[102] And it seems out of discussion that, in a few letters addressed to his patrons, Ficino clearly conceived the *spectaculum* of visual beauty susceptible of embodying a spiritual *virtus* through physical *proportio* and *splendor*. As Gombrich once observed about Ficino's theory of image and its "expressive function":

He [Ficino] thought that the numbers and proportions preserved in the image reflect the idea in divine intellect, and therefore impart to the image something of the power of the spiritual essence which it embodies. Moreover the effect of images on our minds can be considered a valid proof of this type of magic effect.[103]

To be more precise, in a passage of his *Dell'amore*, probably reminiscent of Leon Battista Alberti, Ficino enumerated three basic elements composing the beauty of a figure: distance, quantity, and color.[104]

Nonetheless, an aesthetically subtle, but philosophically profound, difference subsists between well 'identified' portraits, like Leonardo's *Ginevra de' Benci* or Ghirlandaio's *Giovanna Tornabuoni*, and more 'unidentified' portraits, like Ficino's *Humanitas* or Botticelli's series of Venus. Beneath the reciprocity of all these feminine figures, a delicate antinomy operates in the existing stylistic gap between a model (Ginevra) and a prototype (Venus). On this elusive point, art historians could adopt a conceited but striking definition by Roberto Longhi in his article on Mattia Preti: "l'intellettualismo corporeo fiorentino."[105] Longhi's "corporeal intellectuality" is the right oxymoron for our problem: the physical individuation of impersonal beauty.

An adequate definition of Ficinian art, at this stage, would correspond to a 'prototypical' portrait, in the measure of its success in expressing the light and the charm of an un-individual beauty; a beauty otherwise impossible to represent once it is shining in the physiognomy of a precise sitter, when the individual soul and its mysterious moral qualities are constantly defying their own portrayal by the artist. Invincible grace or *pulchritudo* irradiates from this calculated ambiguity.

How far from our modern sensibility this problem appears to be is easy to figure out; but one could venture to observe that the Renaissance portraits under study are always painted on the verge of this iconic debate: are they representing pre- or post-individual beauty?

In some way, Ficino re-directed the rays of divine beauty onto humanity, and his attitude stands in contradiction with outdated dualities like soul *versus* body. Here again, what appeared to be evidence for precedent scholars, namely Ficino's dualism, had been partly historiographically constructed. We should remember that Panofsky, too, insisted on the "immobility" of Ficino's ideal and on the "inferiority" of material beauty with respect to the *Eidos* or Platonic idea. His thesis left the reader with the persuasion that Ficino never transgressed a law of Platonic transcendency: harmonious forms were measured by the degree to which they recalled intelligible realities. In its frame, Panofsky's book *Idea* conveyed the impression that Ficino's philosophy, with its disdain for matter and body, was extensively indebted to the Plotinian treatise *De pulchro* (*Ennead* I, 6). Was not Ficinian beauty retrograde to the extent that it always proceeded backwards from phenomenon to idea and from body to disincarnated soul?

Indeed, expanding on Panofsky's famous remarks in chapter 1 of his *Idea*, one could claim that portraying beauty would probably sound absurd for Plotinus. Plotinian beauty stands before individuation and matter and cannot be portrayed in the pictorial sense of the term: Porphyry informs us that Plotinus abhorred portraits. The only admitted case is the divine Zeus sculpted by Phidias according to his own mental model, in the first paragraph of *Ennead* V, 8, *On intelligible beauty*, not commented on by Ficino.

In his insightful survey of the *Enneads*,[106] Panofsky observed how Plotinus, with his 'poietic' and thus anti-mimetic attitude, had manifested the more 'dangerous' aspects of his metaphysic of beauty: it is against imitation, against proportion, and against symmetry. Do we have to insist that such was not Ficino's appreciation of the "congrua amplitudo membrorum" in his own human model of letter V, 51?

Since Plotinus deals with a superior ascetic beauty of an invisible kind, it is solely through mere reflection, as in a mirror, that a manifested beauty is made visible in an imperfect matter. Only then and only by similitude can Plotinus answer this essential question: "What is it which makes us imagine that bodies are beautiful?"[107] In his reply,

Plotinus sharply distinguishes bodiness from beauty; what makes the body beautiful is always the haunting presence of some imperscrutable intelligible form.[108]

A more explicit statement for the depreciation of incarnated beauty recurs in the mythological allusion made by Plotinus in *Ennead* I, 6, 8, where the handsome man, implicitly Narcissus, is exposed to falling into the lethal abyss of watery matter, Hades, by pursuing the exterior image of himself.[109] As is well known, while Leon Battista Alberti exalted the myth of Narcissus,[110] Ficino followed the Plotinian interpretation of the myth,[111] for it is true that he frequently associated Narcissus with the umbratile nature of the body. However, Marsilio diverges from Plotinus on one important point: his own conception tended to distinguish between narcissism as an aesthetic experience and narcissism as an ethic failure. Alluding to the myth of Narcissus, Plotinus wanted to symbolize the inherent opposition between interiority and exteriority: a man cannot love the inner beauty of his soul while he is also captured by the superficial harmony of the body; therefore, human passion for visible beauty is doomed, and this is what happens in *Ennead* I, 6, 8.[112] Deftly distinguishing himself from Plotinus, Ficino in his *De amore* VI, 17, hiding behind an anonymous source, explains that Narcissus does *not* properly fall in love with his own image. Rather, he does not see it: "he does not see his own face" and "he escapes his own aspect," Ficino repeatedly says.[113] Hades is not even mentioned by Ficino, who prefers the Ovidian version of death by tears and exhaustion. A possible philosophical justification for this subtle variation is that, in retrospect, Ficinian beauty continuously bridges different ontological orders, from the individual body to the universal soul, and suffers no cosmical hiatus. Therefore, the harmonious aspect of a human being is nothing but the expression of the secret radiance of the soul, the hidden beauty concealed in each of us.

If Ficino ascribes positive harmonious beauty to the human figure, in contrast with the Plotinian antithesis between the soul and body,[114] how then could he claim to intermediate between the two?[115] As he reveals in his own commentary, Ficino takes some liberty with his Plotinian model: "satis sit hactenus pulcherrimum Plotini de pulchritudine librum liberioribus (ut ita dixerim) pedibus percurrisse."[116] The core of his reinterpretation, in the first two chapters of his *Argumentum*, is the vivification of the forms. Through a remarkable series of statements, Ficino proceeds by degrees and by concentric circles from intellectual beauty to physical beauty: step by step, beauty is essence, life, movement, seduction, and light. Firstly, essence ("essentia prima") and formal beauty ("pulchritudo formalis") are equivalent. Secondly, the true form of beauty corresponds to the true form of life ("Vera enim pulchritudinis ipsius forma est ipsa vita"). Thirdly, beauty is akin to an innate seduction in constant evidence everywhere in the cosmos ("Pulchritudo vero ubicunque nobis occurrat"), comparable to a flow of light ("sicut et splendor ad lumen").[117] In plain words, we find in Ficino's commentary on *Ennead* I, 6 what we frankly do not expect from a Plotinian ascetic vision connotated by bodily impurity: beauty, dynamically enhanced, is fecundating the world.

It is remarkable how Marsilio imperceptibly extends his thought beyond the separate exemplarity of beauty: beauty, as experienced by mankind, is positively (but negatively for Plotinus) anchored in "admiratio," "vis," "voluptas," and "provocatio". His revisitation of Plotinus concurs to increasingly humanize a detached ideal into an attractive force whose seduction essentially works, here again, by "congruentia"– that is, through the perfect proportion existing between our sensitive and our intellectual sense of beauty.

Moving from the same *Argumentum* on *Ennead* I, 6, Panofsky instead emphasized the hierarchical subordination of beauty to the "divina mens." Thus he involuntarily accredited in art history the leitmotiv of Ficinian subordinationism, in which good remains steadily

above beauty. For some mysterious reason, Panofsky did not want to exploit the parallel insistence of Ficino on "voluptas" and "congruentia." Nevertheless, from Ficino's viewpoint, the unilateral idea of a hierarchically subordinated beauty could only be misleading, as he typically resorts to a circular geometry where beauty voluptuously irradiates from center to periphery beyond inflexible hierarchical structures.[118] Thus, the seminal concepts of life and proportion converging in the first two chapters of Ficino's commentary on Plotinus' *De pulchro* – a treatise translated by Ficino for his *De amore* quite early on in his career[119] – prepare for the flowing of "splendor" into the perfectly harmonious body of humankind. It is in agreement with this intrinsic dynamism that Marsilio channeled his interest into "congruous" human figures of beauty.

On account of what has been said so far, portraying *humanitas* was highly specific of Renaissance culture: Neoplatonism and the ideal painting of humanity were linked. This is precisely the case with the Platonist Giovanni Andrea Gesualdo in his commentary (1533) on Petrarca's famous sonnet 77, *Per mirar Policleto a prova fiso*,[120] where the Tuscan poet alluded to Laura's now lost portrait painted by his friend, the great Simone Martini. Gesualdo remarks how the beauty of Laura mirrored Simone Martini's vision of an ideal humanity, transposed in her portrait: "Nondimeno la mente di Simone havendo il concetto de la più bella figura de l'huomo quando vide M(adonna) L(aura) in terra, si ricordò tal esser la più bella forma humana, la quale quando egli era in cielo inteso avea."[121] Sixteen years later, the Florentine *accademico* Giovan Battista Gelli, also a careful reader of Gesualdo and Ficino, would have enhanced the latent Ficinian trait of such "bella forma humana" in his own commentary (1549):

Dalla quale opinione pare anchora che fusse il poeta nostro, avendo scritto in uno sonetto:
In qual parte del cielo, in qual idea
era l'esempio onde natura tolse
quel bel viso leggiadro, in che ella volse
mostrar quaggiù, quanto lassù poteva.

Quasi dicendo se nella mente di Dio non sono le idee di ciascheduna cosa particulare, donde cavò natura lo esemplo della bellezza di M. Laura? alla quale dubitazione risponde dottissimamente il Giesualdo, il quale è il primo che io abbia trovato fino a qui, che mi paia che habbia inteso prefettamente questo sonetto, dicendo che *se bene maestro Simon non vide una idea e una forma particulare di M. Laura, non si dando come si è detto le idee degli individui particulari*, egli vide *la idea e lo esemplare della natura umana in universale*, la quale conviene che sia la più bella figura umana che si possa ritrovare [...].[122]

That a painter could produce a specimen of ideal humanity imagined before its individuation would be in complete accordance with Ficino's ideal. Thus, according to Gelli, the prototype of "human universal nature" also inspired Simone Martini's portrayal of Madonna Laura; and unsurprisingly, the author also quotes Ficino, together with Alcinous and Bessarion, at the very beginning of this exposition.[123]

It is tempting to check whether Marsilio ever theorized the idea of universal human nature: as a matter of fact, he did so in his *Epitome in Rempublicam* (or *De iusto*) on "humanitas idealis."[124] Hence, following the perception of some influent Renaissance

authors, who were also readers of Ficino and Plato, there was no aesthetically motivated incompatibility between "ideal humankind" and pictorial representation. Ficino believed that the convertibility of ideal humanity, or humankind, into human beauty was not only possible but real. His claim since 1469 was that

> we fall in love with a human being who is a member of the universal order, especially if a sparkle of divine beauty is shining [on his face] [...] because the figure of a handsome man perfectly coincides with the idea of humankind.[125]

Ficino and the "Works of Human Hands"

Lastly, in response to the capital question of Ficino's ignorance of "the works of human hands," postulated by Klibansky, Panofsky and Saxl, we should now consider a fourth letter (X, 14), dated 10 April 1490. It describes a decorated box offered to Ficino by his friend, the German jurist Martin Prenninger, alias Martinus Uranius, after the publication of *De vita*. In his letter, Ficino depicts himself as fascinated by gemstones, especially by polished jaspers and chalcedonies, two kinds of semi-precious gems whose magical-medical properties, associated with Saturn and Venus, were celebrated in the *De vita coelitus comparanda*:[126]

> I received recently on your behalf a box set with gems and gold containing knives with decorated handles (or hafts): a gift which is fit not only for a philosopher but for a king; a gift fully worthy of your kingly soul. Above all, it gratified me to the full, especially when I realized, as is obvious from this gift, that we were, you and I, under the same demon. In fact, while I was considering a chalcedony right in the middle of Aquarius and a jasper in Saturn dominating Aquarius, [I felt] I had been longing for these two gems. So that my wish, being perceived by my demon, then immediately perceived by yourself, proves that we are governed by the same demon. And what about the fact that I started fancying those gems last Autumn? In the meantime and at the same moment, as I suppose, you had in mind to send me your gift [...].[127]

With this letter, we enter further into the realm of Ficino's concreteness, where the philosopher deals precisely with the "works of human hands." Above all, the letter provides a glimpse into an artifact proceeding from demonic astrology. Ficino describes an astrological (and perhaps talismanic)[128] golden box set with jewels. On it, he sees projected the horoscopic portrayal of his good demon (not a threatening demon), which he happens to have in common with his dear friend Uranius. The astrological box is also the expression of the supernatural attraction of his 'demonic' soul for fine arts. Moreover, considering the psychology expressed in this text, it would be difficult to distinguish between Ficino's and Ghirlandaio's sensitivity for precious stones.[129]

At this point, we are confronted with a rare case of preternatural thinking, in which the true patron of an artistic product is not considered a single man but a demon, common to Ficino and Uranius. Unexpectedly and contrarily to current opinion about Ficino and his circle, a tight link between materiality and spirituality, craftsmanship and Neoplatonism emerges here before our eyes. As already stated in 1999 in my study "Ficino, Archimedes and the Celestial Arts" with reference to the planetary clock – the technological marvel praised around 1480–1490 simultaneously by Ficino and Poliziano, two protagonists of Florentine culture frequently seen to be in opposition by art

historians! – the Renaissance Platonists and their associates praised the work of gold-smiths and clockmakers.[130] Until now Ficino's appreciation has not been sufficiently recognized because scholars preferred to focus on the masterworks of Renaissance painters instead of considering that the craftsmen from the medieval tradition were themselves praiseworthy *artifices* working in a milieu of humanists and philosophers.

To summarize and conclude, Ficinian doctrine looks quite different from how huma-nist 'classicism' was seen in past decades, partly because Ficino never considered himself *stricto sensu* an antiquarian fascinated by the revival of Olympian beauty (as the War-burgian tradition sometimes conceived Florentine humanism[131]), partly because his unorthodox Plotinism rested on the diffusion of ideal beauty through human art.

Moreover, as a "disturbingly innovative theologian" (in Michael J. B. Allen's words),[132] Ficino found hints in topics that were close to his concerns. From the 1470s, he aimed to introduce to Italy a new type of Christian spirituality, in which piety, hermetism and magic were of equal importance.[133] This is why the theological facets of Florentine and Venetian Neoplatonism should be taken into greater consideration, as Dombrowski observed in his innovative book *Die religiösen Gemälde Sandro Botticellis*.[134] We could reasonably hold that Ficino's *Kunstliebe* also has theological and metaphysical roots, conveying aesthetical impulses which are fully compatible with the artistic production of his time. This is at least what a final document suggests: Ficino's depiction of an *auto-maton* produced by a German craftsman. The work was visible in Florence before 1482, the very year of the publication of the *Theologia platonica*, in which this passage (II, 13) is to be found:

> We saw recently in Florence a small cabinet made by a German craftsman in which statues of different animals were all connected to, and kept in balance by, a single ball. When the ball moved, they moved too, but in different ways; some ran to the right, others to the left, upwards or downwards, some that were sitting stood up, others that were standing fell down, some crowned others, and they in turn wounded others. There was heard too the blare of trumpets and horns and the songs of birds; and other things happened there simultaneously and a host of similar events occur-red, and merely from one movement of one ball. Thus God through His own being [...] moves everything which depends on Him with one easy nod.[135]

In all the documents we have scrutinized, passive contemplation of immaterial beauty is simply absent. In depth, Ficinian artistic taste is all but a nostalgic recollection of immobile archetypes. It admits human characterizations and bodily representations. Its intrinsic dynamism is related to the cycle of life and to the pregnancy of matter, *materia*, because Ficino's philosophy has to do with the many-faceted question of embodiment.[136] It is conditioned not only by ideas but by the expansive role of *phantasia*, of *simulacra*,[137] of physical and ethereal bodies.[138] Accordingly, for Ficino images as well as artifacts are not mere illusions in the Plotinian meaning but products of their own spiritual kind that offer useful psychological instruments: acting on memory, on will, on dreams and on melancholy,[139] they are the vehicles of the intentions of their makers. It is surprising, in a final conclusion, to observe how our 'vanishing point' has changed and how our initial perspective has been transformed: Ficino's fascination for the 'materiality'[140] of art exer-ted a more tangible, and far more captivating, influence on him than his conjectural influence on Botticelli.

With this background in mind, we have come closer to the core of a Ficinian *ars*, not as a vague otherworldly Neoplatonism but as a consistent concern attested by the texts. This is why, posing a multiform intellectual challenge to scholars in his unexpected complexity, "my friend Ficino" will always require careful learning and erudite knowledge in the future.

Notes

1 I would like to pay grateful tribute to Stefan Albl, Michael J. B. Allen, Berthold Hub, Thomas Gilbhard, Sergius Kodera, Ortensia Martinez, Alessandro Nova, Samuel Vitali, and to the young scholars of the Kunsthistorisches Institut in Florence, who discussed many issues of this paper with me. This very paper – being an expanded and entirely revised version of a lecture given at the international conference "Iconology, Neoplatonism, Art" (Vienna, 15–17 September 2011) – is now rightly republished in the proceedings of the Viennese symposium following a first publication in the *Mitteilungen des Kunsthistoriches Institutes in Florenz*, vol. LIX (2017), no. 2, pp. 147–73.

2 Panofsky (2001–14, vol. 3, 459–60).

3 According to Panofsky's statement: "The intervening period [Renaissance] had changed the mind of men […]"; Panofsky (1972, 30).

4 See for instance Ames-Lewis (2002).

5 See on this Panofsky (1924, 28); Jäger (1990, 44–7); Caye (2001); Toussaint (2006). For further discussion of Panofsky's *Idea*, see Ghelardi (1998, VII–XXIV, XVIII–XIX); Krois (2008, 302–15: "Nachwort: Neuplatonismus und Symboltheorie bei Cassirer und Panofsky").

6 Panofsky (2001–14, vol. 3, 387), letter to Theodor E. Mommsen, 6 April 1953: "[…] the northerners received Ficino's Neoplatonism simultaneously with Albertian rationalism and synthesized the two ideas without delay […]."

7 Chastel (1954/1996, 36, 117–120), esp. (120): "[…] l'enseignement de l'Académie [de Careggi] tient compte des acquisitions du Quattrocento, déjà énoncées par Alberti." For a different view on Alberti's idea of beauty, see now: Di Stefano (2007, esp. 35–40; on the "stravolgimento semantico" of the Platonic idea in Alberti).

8 See Allen (1989, esp. 117–67) for one of the few available thorough analyses of Ficino's theory of perception.

9 Weststeijn (2008, 55f., 64, 151, 269). It is noteworthy that Ficino's *De vita* served as an overall philosophical and moral model to Hoogstraten in the composition of his own treatise.

10 Kristeller (1958, 79).

11 As exemplified by the following considerations: "[…] c'est précisément vers les fulgurations de la vision supérieure et ses symboles qu'inclinent les curiosités de Ficin. C'est là qu'il pourrait développer la doctrine de Plotin: mais tout au contraire, il souligne dans les arts plastiques […] le fait que la personnalité de l'artiste s'y exprime vigoureusement […]"; Chastel (1954/1996, 74–5). On all this see Toussaint (2015).

12 Hocke (1957, 37–44).

13 My translation of Chastel (1954/1996, 74–5): "On doit donc poser le problème de l'art sur le plan de la puissance créatrice, qui domine par vocation les données naturelles […]. L'oeuvre d'art est donc représentée ici comme un miroir d'une pensée individuelle et non d'une idée supérieure […]. L'analogie avec l'artifex divin […] en glorifiant la fonction de l'art, en le montrant au sommet de l'ordre humain, le place au-dessus de l'analyse, au delà de toute justification, par une sorte de coup d'état à l'intérieur du Platonisme, que l'Académie fera largement accepter à la Renaissance." See similar views in Leinkauf (2006).

14 Panofsky (1924, 28 and 55); Kristeller (1951, esp. 518) and Kristeller (1952). On this well-known problematic, see now the criticism of Porter (2009). On Kristeller and fine arts, see Labalme (2006), where the exclamation "Woe to this scholar [Chastel] who had failed to read Kristeller's earlier essay on 'The Modern System of Arts'!" (p. 160) could unintentionally be somewhat misleading because in his letter to Kristeller, dated 17 May 1958, Chastel explains that Kristeller's thesis in *The Modern System of Arts* on "the absence of esthetics before the XVIIIth century" was precisely the initial point of his own study. See Toussaint (2015, 221).

15 In Panofsky's often repeated formula: "Ficino hatte sich in seinen Schriften wohl um Schönheit nicht aber um die Kunst gekümmert, und die Kunsttheorie hatte sich bisher nicht um Ficino gekümmert [...]"; Panofsky (1924, 55).

16 Hemsoll (1998, 67). For another different approach of the problem see now Gress (2015, vol. 1, 13–48).

17 De Majo (2007).

18 Ficino (2002b, 56–61).

19 Ficino (1987, 51): "Resta dopo questo a dichiarare come l'Amore è maestro e signore di tutte l'arti. Noi intenderemo lui essere maestro dell'arti [...]. Chiamasi ancora signore a governatore dell'arti, perché colui conduce a perfectione l'opere dell'arti, el quale ama l'opere dette e le person a chi fa l'opere. Aggiugnesi che gli artefici in qualunque arte non cercano altro che l'amore." This passage clearly derives from Plato's *Symposium*, 197a (Plato 1925, 159): "And who, let me ask, will gainsay that the composing of all forms of life is Love's own craft, whereby all creatures are begotten and produced? Again, in artificial manufacture, do we not know that a man who has this god for teacher turns out a brilliant success [...]." On Eros, see Chastel (1954/1996, 133–41). Needless to recall that Michelangelo and Leonardo had access to *Dell'amore* in the Italian language. For Leonardo see Toussaint (2005).

20 Albl and Canevari (2014, 192, 200).

21 Ficino (1987, 51).

22 See below, notes 106, 107, 111.

23 On this aspect, see Tirinnanzi (2000, 65–86).

24 On the concept of *Kunstwollen* see, for example, Rieber (2009).

25 Seretti (2015b, 295–7) has convincingly demonstrated that Ficino's erotic vocabulary, especially in his *De amore*, VI, is fraught with metaphorical expressions related to painting and sculpting.

26 Marsilio Ficino, *Platonic Theology*, XIII, 4; Ficino (2001–6, 188): "[...] your reason is concerned both with your body and with other bodies, and it fashions artefacts in external matter. This reason, since it is equally adept in handling all material, also sets about handling different materials at different times, in whatever way love takes it. When the love that moved it to carve stone ceases, it instantly sets the statue aside. When love attracts it to earthenware, it takes up the potter's art."

27 As in the case of Ficino's colourful "figura mundi": Toussaint (2002).

28 On this: Kodera (2002); Kodera (2010, esp. ch. 2). For the Platonic and Plotinian mirror: Armstrong (1988); D'Ancona (2008).

29 See: McDonald (2012: on Paolini and the Accademia degli Uranici); Mozzati (2008, 96–100: on Cattani da Diacceto); and Carson (2010, 101–41: on Niccolò Leonico Tomeo).

30 See Castelli (2006, 229–30); Morel (2002); Morel (2009); Morel (2008); Morel (2015, esp. 297–326); Schneider (2012, 164–174: on *spiritus*); Cole (2002).

31 Chastel (1954/1996, 36).

32 Hettner (1879, 165–89). On Hettner, see Schlott (1993).

33 Gebhart (1908, 75–8, and 81, 119, for a balanced appreciation of Poliziano's influence on the *Primavera*).

34 Robb (1935, esp. ch. 3: on Marsilio Ficino and the Platonic Academy).

35 See these few titles: Holly (1984); Ginzburg (1989); Cieri Via (1994); Mazzucco (2011); Efal (2016, 49–90).

36 De Gerolami Cheney (1985); De Gerolami Cheney (1993). See also: De Gerolami Cheney and Hendrix (2002); De Gerolami Cheney and Hendrix (2004); Hendrix (2010, 99–115: on Ficino, the *De amore*, Plotinus, and the vanishing point).

37 Nagel (2011, esp. 121–3: on Ficino's *De Vita*, 178: on Tomeo, 268–280: on Zorzi).

38 Dombrowski (2010, esp. 67–88). See also Meltzoff (1987); Paolozzi Strozzi (2005, 11–16); Zambrano and Katz Nelson (2004, esp. 120, 122, 287, and note 51): on Ficino's *De christiana religione* and Botticelli, quoted in Olszaniec (2012, 238).

39 Hub (2005) and Hub (2008). See also Leporatti (2002).

40 Leitgeb (2006).

41 Van den Doel (2008); Van den Doel (2010).

42 Seretti (2015a). See now also Seretti (2015b).

43 Castelli (2006, 223): "[...] un certo tipo di indagine storico-critica, a partire dagli scritti di Panofsky del '39 [...] si era orientata a trattare della centralità del pensiero ficiniano nell'universo artistico fiorentino della seconda metà del '400; tesi questa, per citare solo i capofila, avallata, con diverse sfumature, da Chastel, Wind, Klein, e recentemente ridotta a una fortezza assediata dalle opinioni di altrettanti illustri studiosi."

44 Dempsey (1968, 255, note 20).

45 Gombrich (1945, 13). The bibliography on Botticelli's *Primavera* is endless. For a first orientation, see Zöllner (1997); Leuker (2007, esp. ch. 15 – I wish to thank Jacques Heinrich Toussaint for pointing me to this book); Hatfield (2009); Dempsey (2001, 352–4). The Castello hypothesis, first formulated by Herbert Horne, was refuted in 1975 by the publication of the 1499 inventory by Smith (1975) and Shearman (1975). See Angela Dressen's contribution to this volume.

46 Dempsey (1992, 5–6).

47 Dempsey (1992, 65): "[...] in order to reintroduce a Neoplatonic interpretation of the *Primavera*, in a way that is neither in conflict with the appearances so far observed, nor in conflict with the hypothesis that explains those phenomena on the model of ancient and humanist poetry".

48 Dempsey (1992, 65).

49 Dempsey (1992, 77), my italics. In Dempsey (2012, 87–8), the author stressed again the anomaly of "a purely abstract conception of Florentine classicism [...]" in association with Panofsky and Ficino.

50 See in this regard the subtle argument in the conclusion by Dempsey (1992, 162): "Ficino, however, as a lover simultaneously of poetry and philosophy, understood the differences between enthymematic and syllogistic forms of representing an argument."

51 For the 'Ficino volgare,' see now Tanturli (2006); Toussaint (2013). For the relationship between Tuscan Platonism and Ficinian Platonism, see also Storey (2003).

52 For the recent reappraisal of the Ficinian *amor humanus* (intermediary between bestiality and divinity) and for the reassessment of the 'amore volgare' (in balance between humanity and bestiality), see Ebbersmeyer (1998, 210–1); Boulègue (2007); Lüdemann (2008, 132–3); Wurm (2008, 203–19); Leitgeb (2010). And for more bibliography: Gilbhard and Toussaint (2009); Gilbhard and Toussaint (2010).

53 Dempsey (1992, 17).

54 Skepticism about iconological programs is determinant in Dempsey's as well as Bredekamp's essays. On the notion of program and system in Renaissance art and decor, see Hochmann (2008).

55 "Was für lange Zeit als Signum dieses Zeitalters galt, wirkt heute eigenartig fremd: Obzwar noch immer spürbar, scheint der Neuplatonismus seine Leitfunktion für die Deutung der Renaissancekunst verloren zu haben. [...] Seine Geltung ist weniger ein Problem der kunstgeschichtlichen Wirklichkeit als vielmehr der Wissenschaftsgeschichte [...] Angesichts dieses Hintergrundes schmerzt die Erkenntnis, dass die genannten Ikonologen mit ihrer Flucht in den Neuplatonismus die falsche Burg gewählt haben. [...] In ihrem neuplatonischen Zwangscharakter waren die Sternstunden der Ikonologie unfreiwillig die Wegweiser in eine Sackgasse." Bredekamp (1986/1992, 39, 40, 44), my translation (see Bredekamp 1986/1992, 71, 75, 77; and Appendix p. 216, 217, 221). For criticism of Bredekamp's thesis, see Leuker (2007).

56 "Neuplatonismus geriet zum Zauberwort des gebildeten Kunsthistorikers. Das höchste Ziel, der Himmel der Interpretation schien erreicht, wenn es gelungen war, das Kunstwerk mit der Aura des Neuplatonismus aufscheinen zu lassen [...]" Bredekamp (1986/1992, 41), my translation (see Bredekamp 1986/1992, 78–9; and Appendix p. 219).

57 Bredekamp (1986/1992, 44), my translation (see Bredekamp 1986/1992, 83; and Appendix). For an alternative political interpretation of Botticelli's painting, see also: Bredekamp (1988/2002/2009).

58 Lightbown (1978/1989: 142–3).

59 This letter has also recently been translated and studied by Leitgeb (2006, 14–23, 81–92).

60 Lightbown (1978/1989, 143).

61 Ames-Lewis (2002, 333). However, the author also observes how Ficino's Phaedran charioteer "works admirably visually" in some possible examples of Quattrocento sculptures.

62 Zöllner (2005, 24).

63 Cropper (1976), where Ficino is mentioned briefly on p. 388 (in relation to Neoplatonism and the *Dolce Stil Novo*), p. 390 (in relation to Leonardo), and also on p. 394, note 108; Cropper (1986): no mention of Ficino. See also De Gerolami Cheney (2000).

64 "[...] *effictio* is one of the two species of *descriptio personarum* and refers to the outer physical appearance or *superficiales* of a person. The second species of *descriptio personarum* is *notatio*, which refers to the qualities making up a person's inner character, his or her *intrinsicae*" Dempsey (1992, 63).

65 See for example Di Stefano (2007, 35): on Ficinian "astratte speculazioni filosofiche" opposed to Alberti's visual concreteness.

66 After Dempsey, Poliziano's patronage has been reasserted by Rubinstein (1997, 251). For an attempt to harmonize Ficino and Poliziano: Ferruolo (1955, 17–25).

67 DePrano (2004, esp. 72–118); DePrano (2008); DePrano (2010). On the intellectual milieu of the Tornabuoni, see Van der Sman (2010); and Chrzanowska (2016).

68 Maria DePrano (2010, 21).

69 Holberton (1982, 208, note 31).

70 Warburg (1932, vol. 1, 139 and 147–8: "Francesco Sassettis letztwillige Verfügung," 1907; and vol. 2, 527–531: "Heidnisch-antike Weissagung in Wort und Bild zu Luthers Zeiten," 1920).

71 Warburg (1999, 426–7); Warburg (1932, vol. 1, 327: addendum to *Der 'Frühling,'* 1893, 55): "'Geburt' und 'Reich der Venus' können entschlossener in die Sphäre der platonisch-magischen Praktiken einbezogen werden. Marsilio Ficino's erstes aus dem Griechischen übersetztes Werk waren die Homerischen und Orphischen Hymnen, die er 1462 all'antica sang. (Cf. Della Torre 1902, 537 und 789.) Und Pico della Mirandola verweist in seinen Konklusionen zu den Orphischen Hymnen auf die Venus und Grazien, als Arcanum der orphischen Theologie. [...] Ganz abgesehen von seinem *Kommentar* zu Benivienis *Canzone d'amore*, wo sie ebenfalls vorkommen (Libro II, Cap. XV) [...]."

72 Warburg (1999, 641); Warburg (1932, vol. 2, 526–7): "Der florentinische Philosoph und Arzt Marsiglio Ficino schlug gegen sie [schwere Melancholie] ein gemischtes Vefahren von seelischer, wissenschaftlich-medizinischer und von magischer Behandlung vor: Seine Mittel sind innere geistige Konzentration auf der einen Seite; durch diese kann der Melancholische seinen unfruchtbaren Trübsinn umgestalten zum menschlichen Genie. Andererseits ist, abgesehen von rein medizinischen Massregeln gegen die Verschleimung, den 'Pfnüsell' [= *De vita*, I, 3], zu dieser Gallenumwandlung erforderlich, dass der gütige Planet Jupiter dem gefährlichen Saturn entgegenwirkt."

73 Warburg (1999, 645); Warburg (1932, vol. 2, 530): "Zirkel und Kreis (und also die Kugel) sind nach den alten Übersetzungen des Ficino das Denksymbol der Melancholie." The Latin text of *De vita libri tres*, I, 4, says: "Naturalis autem causa esse videtur, quod ad scientias praesertim difficiles consequendas necesse est animum ab externis ad interna tamquam a circumferentia quadam ad centrum sese recipere, atque dum speculatur in ipso (ut ita dixerim) hominis centro stabilissime permanere. Ad centrum vero a circumferentia se colligere figique in centro maxime terrae ipsius est proprium, cui quidem atrabilis persimilis est" Ficino (2002a, 112). On melancholy in Ficino and the *De vita*, see Wittstock (2011, 56–76).

74 On the physiological causes of melancholy see now: Hankins (2011). On the topos "ad centrum a circumferentia," see Panofsky and Saxl (1923, 51, note 2).

75 Ficino (2002a, 345–7).

76 "Laudamus frequentem aspectum aquae nitidae, viridis rubeive coloris [...]"; Ficino (2002a, 134, line 55). "Post oraculum nobis cogitandum mandat rerum viridium naturam, quatenus virent, non solum esse vivam, sed etiam iuvenilem, humoreque prorsus salubri et vivido quodam spiritu redundantem. [...]"; Ficino (2002a, 204, lines 16–45). "Sunt vero tres universales simul et singulares mundi colores: viridis, aureus, sapphyrinus, tribus coeli Gratiis dedicati"; Ficino (2002a, 344, lines 30–32).

77 Ficino (2002a, 343–9, 346, lines 44–49). For the planetary clock see: Chastel (1954/1996, 105 and 107, note 16); Toussaint (2002); Neumann (2010, 150–155); Götze (2010, 133).

78 Warburg (1999, 758); Warburg (1932, vol. 2, 644: addendum to "Italienische Kunst und internationale Astrologie im Palazzo Schifanoia zu Ferrara," 1912, 478): "Das chthonische Element wird ätherisch, *denn* Botticellis Idealsphäre durchweht das πνεῦμα Platons und Plotins."

79 Warburg (1999, 733); Warburg (1932, vol. 2, 628: addendum to "Italienische Kunst und internationale Astrologie im Palazzo Schifanoia zu Ferrara," 1912, 465): "Katharsis der monströsen Weltanschaaung durch astrische 'Kontemplation' (= *Umzirkung*); die Metamorphose vom Kampf mit dem opferheischenden Monstrum (Placatio) zur Kontemplation zukunftsoffenbarender Schicksalshieroglyphen; vom Monstrum zur Idee."

80 See Panofsky (1924, 55), my translation.

81 Klibansky, Panofsky and Saxl (1964, 346).

82 For some exceptions, see Hemsoll (1998) and Allen (2006, 6).

83 Toussaint (2002, 315).

84 Gombrich (1948, 179): "There is no weirder aspect of our problem than the evidence which suggests that […] allegory and demonology had indeed a common frontier." See also Gombrich (1948, 170–176) on Ficino's *De vita* and the *vis figurae*. Morel (2008, 69–70) has convincingly insisted on the validity of Gombrich's reading.

85 However, Panofsky was very receptive to Chastel on Platonic humanism, particularly in Chastel (1959): "There is practically no page in your book with which I do not violently agree, so to speak […]" (Letter to André Chastel), in: Panofsky (2001–14, vol. 4, 600). See now Toussaint (2015, 212).

86 Panofsky (1960, 188).

87 Ficino (1990, 38, letter 14): "Marsilius Ficinus Sismundo Stufe consolationem dicit. / Si quisque nostrum id maxime est, quod in nobis est maximum, quod permanet semper idem, quo nos ipsi capimus, certe animus homo ipse est; corpus autem est hominis umbra. Quisquis igitur usque adeo delirat ut hominis umbram hominem esse putet, hic miser in lachrimas instar Narcissi resolvitur. Tunc desines, Sismunde, flere, cum desiveris Alberiam tuam Albitiam in nigra eius umbra querere atque ceperis eam in alba sui luce sectari; tunc enim illam tanto reperies pulchriorem quam consueveris, quanto ab umbra deformi remotiorem. Secede in animum tuum, precor: ibi animam illius speciosissimam tibique carissimam possidebis; immo ex animo tuo in Deum te recipe: illic ideam pulcherimam, per quam divinus artifex Alberiam tuam creaverat, contemplabere; et quanto formosior illa in opificis forma est quam in se ipsa, tanto eam ibi beatius amplecteris. Vale. Primo Augusti 1473, Florentie." English translation, slightly modified, from Ficino (1975–, vol. 1, 54–55).

88 Ficino, *Epistolarum familiarum liber V*, letter 46, in: Ficino (1495/2011, 234–5, c. CXv–CXIr): "Homines autem non alia prorsus esca quam humanitate capi. Eam cave ne quando contemnas, forte existimans humanitatem humi natam., coelesti origine nata aethereo ante alias dilecto deo. Siquidem eius anima spiritusque sunt amor et charitas. Oculi eiusdem gravitas et magnanimitas. Manus praeterea liberalitas atque magnificentia. Pedes quoque comitas et modestia. Totum denique temperantia et honestas, decus et splendor. O egregiam formam, o pulchrum spectaculum." English translation, slightly modified, from Ficino (1975–, vol. 4, 63), my italics.

89 See Tröger (2016, 218–26) for penetrating remarks (on this and other *Ficini epistolae*) in convergence with my past and present inquiries on *Humanitas* and Ficinian beauty (for instance: Toussaint 2008, 53–7, 293–6).

90 "Or *descriptio* of physical qualities," Cropper (1976, 388). See also below, notes 98 and 101.

91 Marsilio Ficino, *Epistolarum familiarum liber V*, letter 51, in: Ficino (1495/2011, 236, c. CXIv): "Pictura pulchri corporis et pulchrae mentis. Marsilius Ficinus Florentinus familiaribus suis. Rursus Laurentio Medici. Item Bernardo Bembo. / Multa philosophi disputant, oratores declamant, poetae canunt, quibus homines exhortentur ad verum virtutis amorem. Haec laudo equidem et admiror. Alioquin (nisi bona laudarem) essem ipse non bonus. Sed puto virtutem ipsam si quando producatur in medium multo facilius meliusque quam verba hominum ad se capessendam cunctos adhortaturam. Frustra puellam adolescentis auribus laudas verbisque describis, quo stimulos illi amoris incutias, ubi ipsam pulchrae puellae formam adolescentis oculis queas offere. Monstra (si potes) formosam digito, nihil amplius hic tibi opus est verbis. Dici enim non potest quanto facilius vehementiusque pulchritudo ipsa, quam verba provocet ad amandum. Ergo si mirabile virtutis ipsius speciem in conspectum hominum proferamus haud opus erit suasionibus nostris ulterius. Ipsamet citius quam cogitari possit persuadebit. Finge hominem vegetissimis perspicacissimique sensibus praeditum, robusto corpore, prospera valetudine, forma decora, congrua membrorum amplitudine, proceritate decenti. Finge hunc prompte sese moventem et dextere, ornate loquentem, dulce canentem, gratiose ridentem, neminem amabis usque neminem admiraberis si virum eiusmodi (cum primum videris) non ames, non admireris." English translation, slightly modified, from Ficino

(1975–, vol. 4, 66). This should be read in close connection with *Dell'amore*, V, 6: "Certamente [la bellezza] è uno certo acto, vivacità e gratia risplendente nel corpo per lo influxo della sua idea. Questo splendore non discende nella materia, s'ella non è prima aptissimamente preparata. E la preparatione del corpo vivente in tre cose s'adempie: ordine, modo e spetie; l'ordine significa le distantie delle parti, el modo significa la quantità, la spetie significa lineamenti e colori. Perché imprima bisogna che ciascuni membri del corpo abbino el sito naturale, e questo è che gli orecchi, gli occhi e'l naso e gli altri membri sieno nel luogo loro; e che gli occhi amenduni equalmente sieno propinqui al naso, e che gli orecchi amenduni equalmente sieno discosti dagli occhi. E questa parità di distantie che s'appartiene all'ordine ancora non basta se non vi si aggiugne el modo delle parti, el quale attribuisca a qualunque membro la grandezza debita, attendendo alla proportione di tutto el corpo […]" Ficino (1987, 91–2).

92 Baldini (1988, 46): "Lo stesso Ficino aveva del resto altra volta asserito che la visione diretta della virtù avrebbe persuaso a seguirla più di ogni altra esaltazione verbale. *Si apriva quindi la possibilità che allo stesso fondatore della nuova filosofia fosse da ricondurre il tema figurativo del Botticelli. La Venere della Primavera non era solo la dea dell'idillio polizianesco. Personificava il principio stesso del sistema filosofico ficiniano: l'Amore […]*" (my italics).

93 Ficino's letter is also quoted by Zöllner (1998, 11).

94 See Hemsoll (1998, 67–8), who refers to Chastel (1954/1996, 87–114), to Chastel (1959, 279–88, 299–319), and to Trinkaus (1970, vol. 2, 461–504).

95 For a recognition limited to music: Boccadoro (2012, 247–63).

96 On Ficino's possible influence on portraying ideal (young) men, see Koos (2006, 120).

97 Ficino (1975–, vol. 4, 67); Ficino, *Epistolarum familiarum liber V*, letter 51, in: Ficino (1495/2011, 236, c. CXIv): "Age igitur ut facilius divinam animi speciem ex congrua pulchri corporis similitudine cogites redde singula singulis."

98 For the concept of "philosophical painting," see Leinkauf (2010, esp. 56–61) on Ficino.

99 See, for example, Sebregondi and Parks (2011, 228–9, no. 7.20). Cropper's remark fits well with our context: "Many portraits of unknown beautiful women are now characterized as representations of ideal beauty in which the question of identity is immaterial" Cropper (1986, 178).

100 See Caglioti (2007).

101 See Kohl (2014); Zöllner (2005) is in favour of a late execution (1470s) of the bust under the direct influence of Ficino's *Commentary* on Plato's *Phaedrus*. On the hypothetical influence of Ficino's thought on the bust, see Freedman (1989). See Jeanette Kohl's contribution to this volume.

102 Cropper (1986, 189). See also Dempsey (1992, 147–8): "Elizabeth Cropper has shown how the paradoxical problems of representing the beauties, not of a particular woman per se, but of the beloved, derive from the ancient rhetorical tradition of *descriptio personarum* […]" It seems Ficino, too, was well aware of these "paradoxical problems."

103 Gombrich (1948, 178).

104 "[…] ordine, modo e spetie; l'ordine significa le distantie delle parti, el modo significa la quantità, la spetie significa lineamenti e colori" Ficino (1987, 91). Compare with Alberti's canon in *De pictura*, II, § 36: "Conviensi in prima dare opera che tutti i membri bene convengano. Converranno quando e di grandezza e d'offizio e di spezie e di colore e d'altre simil cose corrisponderanno ad una bellezza" Alberti (1980, 62).

105 Longhi (1913/1980, 29–30).

106 Erwin Panofsky, *Idea*, in Krois (2008, 74–81).

107 *Ennead*, I, 6: *On beauty*, in: Plotinus (1966, 233).

108 Formulated by another question: "[…] ἄλλου ὄντος τοῦ σώματα εἶναι, ἄλλου δὲ τοῦ καλά. Τί οὖν ἐστι τοῦτο τὸ παρὸν τοῖς σώμασι," thus translated by Ficino: "[…] aliud sit esse corpus, aliud esse pulchrum. Quid ergo id est potissimum quod pulchra corpora sua praesentia facit?" Plotinus (1580/2009, 50). For an insightful survey of Ficino's translation and commentary of *Ennead*, I. 6, see Maspoli Genetelli and O'Meara (2002).

109 On Plotinus and the myth of Narcissus, see Hadot (1976).

110 See Pfisterer (2001), and most recently Seretti (2015b, 298–300).

111 On Narcissus and Ficino: Glanzmann (2006, 82–6), with this essential remark: "Narziss macht nach Ficino nicht den Fehler sich selbst zu sehr zu lieben, sondern sich selbst nicht richtig zu lieben." See Ficino's letter to Bembo: "Alas foolish Narcissus, what are you losing? Unhappy man, you are totally losing your own self […]," in Ficino (1975–, vol. 6, 8); Wells (2007, 53–8). See also the analysis by Kodera (2010, 65–73, esp. 67–8); and Carman (2012, 21–2).

112 "Εἰ γάρ τις ἐπιδράμοι λαβεῖν βουλόμενος ὡς ἀληθινόν, οἷα εἰδώλου καλοῦ ἐφ᾽ ὕδατος ὀχουμένου […]," thus translated by Ficino: "Si quis enim ad haec [simulachra] proruat, quasi vera capescens, quae tamen velut formosae imagines apparent in aqua […]" Plotinus (1580/2009, 56).

113 Ficino (2002b, 194–5).

114 For a synthetic approach to Ficino's concept of human beauty, see Jäger (1990, 75–8), where the author is aware that "andererseits schien sich Ficino nicht für eine platte Leibfeindlichkeit einzusetzen." See also Oehlig (1992, 70–7).

115 As Dombrowski (2010, 436–7) has it: "Bei Ficino wird ein Grundakt der Natur selbst als *mimesis* verstanden, insofern sie die ihr inwohnenden 'rationes' selbst abbildet; der Künstler wird also nicht die sichtbare Natur 'verdoppeln', sondern versuchen, die ihr zugrundeliegenden Ideen gleichsam an die Oberfläche zu holen."

116 "We walked around enough in Plotinus' very beautiful book on beauty, and with great freedom" Plotinus (1580/2009, 47), my translation.

117 Plotinus (1580/2009, 46–7).

118 Panofsky (1924, 94, note 133) neither reports the sentence "accedit ut congruens" on the universal influence of beauty upon our soul nor the precedent sentence "Voluptate animum affici compertum habemus quando re quadam sibi congrua tangitur, duciturque ad bonum" on the voluptuous experience of "congruous" beauty. Dominic O'Meara (Maspoli Genetelli and O'Meara 2002, 4–5) rightly sees Ficino expanding on Plotinus in two opposite directions: "la subordination qu'opère Ficin du Beau au Bien s'écarte du traité plotinien" and "Ficin souligne, dans l'expérience de la beauté […] sa force, sa violence, sa volupté […] qui n'ont pas autant d'importance dans le traité." For Ficino's epitomizing strategy based on concentric circles in the ms. Riccardiano, 92, containing a collection of excerpts from Plotin's *De pulchro*, see Di Dio (2016, 600–1). And for Ficino's obsession with circular geometry see Toussaint (2000).

119 A Latin summary of the *De pulchro*, prepared for the redaction of the *De amore* (1469), is found in the ms. Riccardiano, 92, 109r–113v; see Di Dio (2016) and Gentile, Niccoli and Viti (1984, 59, no. 45).

120 Chines and Guerra (2005, 72–74: "Ma certo il mio Simon fu in Paradiso […]"); Petrarch (2002, 77).

121 *Il Petrarcha, colla spositione di misser Giovanni Andrea Gesualdo*, Venice 1533, p. CX. Gesualdo's long commentary gives no less than 24 explicit references to Plato and many implicit quotes of Ficino and Bembo. On Gesualdo's Platonism, see Belloni (1990, 152); Alfano (2006, 155–8).

122 *Il Gello accademico fiorentino, sopra que' due sonetti del Petrarca, che lodano il ritratto della sua M. Laura*, Florence 1549, 38; my italics.

123 *Ibidem*, 28: "[…] secondo che riferisce Alcinoo Platonico tradotto di greco in latino da il nostro dottissimo Marsilio Ficino cittadino e canonico fiorentino in quel libro che egli fa de *Dogmate Platonis*, tenne che i principi delle cose naturali fussino solamente Idio la materia e le idee." The text is republished in: Huss, Neumann and Regn (2002, 105, 183–4)

124 Ficino (1576/2014, vol. 2, 1429): "Nota rursus Deum naturalis unius speciei unam tantum specie expressisse ideam, in ipso intelligibili mundo, *puta speciei humanae idealem humanitatem* […]" My italics.

125 Ficino (2002b, 102): "Sic et ad hominem aliquem ordinis mundani membrum afficimur, presertim cum in illo perspicue divini decoris scintilla est […] *quia hominis apte compositi speties et figura cum ea humani generi ratione* […] aptissime congruit" (my translation).

126 Ficino (2002a, p. 252, book III, chapter 2): Saturnian jasper and chalcedony; (278, book III, chapter 8): jasper, chalcedony and the Fixed Stars; (300, book III, chapter 12): chalcedony associated with Venus is used "against the delusions of black bile"; (302, book III, chapter 12): jasper associated with Saturn can "stop blood." For a good introduction to magic in *De vita*: Copenhaver (1987). For a careful inquiry and balanced report on Ficino's sources: Robichaud (2017).

127 Ficino, *Epistolarum familiarum liber X*, letter 14, in: Ficino (1495/2011, 345, c. CLXVr): "Accepi nuper tuo nomine thecam cultellariam manubriis gemmeis et aureis exornatam, munus non philosophicum tantum sed et regium, regio nimirum animo tuo dignum. Mihi praeterea quam gratissimum, praesertim quoniam hoc dono eundem mihi tibique praesse genium plane perspexi. Nam cum compertum haberem calcedonium quidem subesse Aquario praesertim medio, iaspidem vero Saturno Aquarii domino, mihi autem eo gradu Saturnus

ascenderit, utrumque lapidem ardenter optabam. Votum ergo meum genio meo notum, tibi subito notum, declarat eodem nos genio gubernari. Quid vero quod Autumno superiore affectare talia coepi [?] Tu interim, ut conjicio, eodem tempore de mittendo ad nos dono deliberare [...]" (my translation).

128 As Capodieci (2012) rightly pointed out, a talisman responds to exact astrological configurations and precise rituals. Nonetheless, artifacts could be considered magical by their owners without necessarily being conceived as talismans. For a good example, see Sass (2012). In our case, the box is not devoid of an "addressative" scope, to use the terminology of Nicolas Weill-Parot (2002, 169), who defines a "magical 'addressative' act [...] as an act by means of which the magician addresses a sign to a separate intelligence (a demon, an angel or some other spirit or intelligence)." It is probable that Marsilio considered the box as a demonic *medium* of communication with Uranius.

129 On gems in Early Renaissance culture, see Castelli (1977). On Ghirlandaio and gems, see Busse (1999, 320–21); Sessin (2014, 16–7).

130 Toussaint (2002). To this I should add the case of Giovan Paolo Gallucci (1538–1621), analyzed by Rossi (2009, esp. 49–50: on Ficino and Archimedes). Gallucci re-edited Ficino's *De vita* in his own *De cognoscendis et medendis morbis ex corporum coelestium positione libri IIII*, Venice 1584. See my Toussaint (2017).

131 See the letter by Fritz Saxl to Giovanni Gentile of 13 April 1932: "Per esempio, il Platonismo del Rinascimento [...] si comprend e sufficientemente soltanto sotto l'aspetto del problema più vasto e, per così dire, comprensivo Firenze e l'antichità [*sic*]." Cit. from Di Donato (2009, 162–3).

132 Allen (2017, 117).

133 Allen (1999, esp. 107–44: on Platonic and Jovian prophecy); Vanhaelen (2010).

134 Dombrowski (2010, 9 and 26–30).

135 "Vidimus Florentiae Germani opificis tabernaculum, in quo diversorum animalium statuae ad pilam unam connexae atque libratae, pilae ipsius motu simul diversis motibus agebantur, aliae ad dextram currebant, aliae ad sinistram, sursum atque deorsum, aliae sedentes assurgebant, aliae stantes inclinabantur, hae illas coronabant, illae alias vulnerabant. Tubarum quoque et cornuum sonitus, et avium cantus audiebantur, aliaque illic simul fiebant et similia succedebant quam plurima, uno tantum unius pilae momento. Sic Deus per ipsum esse suum [...] facillimo nutu vibrat quicquid inde dependet" Ficino (2001–6, vol. 1, 200–1; English translation slightly modified). See also Chastel (1954/1996, 67) and Grafton (2009, 91–2).

136 On this theme of utmost importance, see Snyder (2011, 139–55) and also Larmon Peterson and Snyder (2015, esp. 301) on "a growing body of scholarship that tempers an other-worldly reading of Ficino according to which the Florentine Platonist was not engaged with questions concerning the soul's embodiment and the difficulties it produces." I thank the two authors for sending me their papers.

137 See Kodera (2004, 79). On Ficino and imagination see now: Giglioni (2010, 1–5, 17–20); Corrias (2012); Klemm (2013, 178–81); Ansaldi (2013, 61–118).

138 See, as a point of interest, Boccadoro (2000). The question of visual perception, *simulacra*, *idolum animae* or *vehiculum animae* cannot be treated adequately here. See at least: Tambrun-Krasker (1999); Toussaint (2011, 107–8), with further bibliography. On a more philosophical level (Ficino's conception of images and of the kind of truths they are informed with), chapters 4 and 5 of Allen (1989) have demonstrated that the Platonic foundation of Ficino's visual theory rested on some arresting commentaries linked to Plato's *Sophist* (see esp. pp. 168–204).

139 See the classic study by Ruvoldt (2004), *passim*.

140 On the multilayered notion of materiality in art history, see the essential paper by Badagliacca (2016).

Bibliography

Alberti, Leon Battista. 1980. *De pictura*, edited by Cecil Grayson. Bari: Laterza.

Albl, Stefan, and Angiola Canevari. 2014. "Pietro Testa e Socrate." In *I pittori del dissenso: Giovanni Benedetto Castiglione, Andrea de Leone, Pier Francesco Mola, Pietro Testa, Salvator Rosa*, edited by Stefan Albl, Anita Viola Sganzerla, and Giulia Martina Weston, 185–201. Rome: Artemide.

Alfano, Giancarlo. 2006. "'Una filosofia numerosa et ornata': filosofia naturale e scienza della retorica nelle letture cinquecentesche delle 'Canzoni Sorelle'." *Quaderns d'Italià* 11:147–179.

Allen, Michael J. B. 1989. *Icastes: Marsilio Ficino's Interpretation of Plato's Sophist*. Berkeley: University of California Press.

Allen, Michael J. B. 1999. *Nuptial Arithmetic: Marsilio Ficino's Commentary on the Fatal Number in Book VIII of Plato's Republic*. Berkeley: University of California Press.

Allen, Michael J. B. 2006. *Paul Oskar Kristeller and Marsilio Ficino: Kristeller Reconsidered: Essays on His Life and Scholarship*, edited by John Monfasani, 1–18. New York: Italica Press.

Allen, Michael J. B. 2017. "Marsilio Ficino, Levitation, and the Ascent to Capricorn." In *Studies in the Platonism of Marsilio Ficino and Giovanni Pico*, edited by Michael J. B. Allen. 117–134. London: Routledge.

Ames-Lewis, Francis. 2002. "Neoplatonism and the Visual Arts." In *Marsilio Ficino: His Theology, His Philosophy, His Legacy*, edited by Michael J. B. Allen, Valery Rees, and Martin Davis, 327–338. Leiden: Brill.

Ansaldi, Saverio. 2013. *L'imagination fantastique: images, ombres et miroirs à la Renaissance*. Paris: Belles Lettres.

Armstrong, A. Hilary. 1988. "Platonic Mirrors." In *Spiegelung in Mensch und Kosmos*, edited by Rudolf Ritsema, 147–181. Frankfurt am Main: Insel Verlag.

Badagliacca, Vanessa. 2016. "On Matters, Materiality, and Materialism: Entanglements with Art History." *North Street Review* (15 April 2016): https://northstreetreview.com/2016/04/15/on-ma tters-materiality-and-materialism-entanglements-with-art-history/ [28 February 2020].

Baldini, Umberto. 1988. *Botticelli*. Florence: Il Fiorino.

Belloni, Gino. 1990. "Les commentaires de Pétrarque." In *Les Commentaires et la naissance de la critique littéraire: France/Italie (XV–XVI siècles)*, edited by Gisèle Matthieu-Castellani and Michel Plaisance, 147–155. Paris: Aux Amateurs de Livres.

Boccadoro, Brenno. 2000. "Marsilio Ficino, the Soul and the Body of Counterpoint." In *Number to Sound: The Musical Way to the Scientific Revolution*, edited by Paolo Gozza, 99–134. Dordrecht: Kluwer.

Boccadoro, Brenno. 2012. "Musique des éléments, éléments de musique: Métaphores biologiques dans le pythagorisme de Ficin." *Medicina e Storia* 1–2:247–263.

Boulègue, Laurence. 2007. "L'*amor humanus* chez Marsile Ficin: entre ideal platonicien et morale stoïcienne." *Dictynna* 4: http://dictynna.revues.org/144 [18 February 2020].

Bredekamp, Horst. 1986/1992. "Götterdämmerung des Neuplatonismus." *kritische berichte* 14, 4: 39–48. Repr. with minor revisions 1992 in *Die Lesbarkeit der Kunst: Zur Geistes-Gegenwart der Ikonologie*, edited by Andreas Beyer, 75–83. Berlin: Wagenbach.

Bredekamp, Horst. 1988/2002/2009. *Sandro Botticelli – La Primavera: Florenz als Garten der Venus*. Frankfurt am Main: Fischer. Repr. 2002 and 2009. Berlin: Wagenbach.

Busse, Till. 1999. *Madonna con Santi – Studien zu Domenico Ghirlandaio's mariologischen Altar-retabeln: Auftraggeber, Kontext und Ikonographie*. PhD diss., Universität Köln: http://kups.ub. uni-koeln.de/volltexte/2003/486/ [18 February 2020].

Caglioti, Francesco. 2007. "Desiderio da Settignano: I profili di eroi ed eroine del mondo antico." In *Desiderio da Settignano: La scoperta della grazia nella scultura del Rinascimento*, edited by Marc Bormand, Beatrice Paolozzi Strozzi, and Nicholas Penny, 87–101. Milano: 5 Continents Editions.

Capodieci, Luisa. 2012. *Medicæa Medæa: art, astres et pouvoir à la cour de Catherine de Médicis*. Geneva: Droz.

Carman, Charles H. 2012. "Vision in Ficino and the Basis of Artistic Self Conception and Expression: Narcissus and Anti-Narcissus." *Studi rinascimentali* 10:21–30.

Carson, Rebekah A. 2010. *Andrea Riccio's Della Torre Tomb Monument: Humanism and Anti-quarianism in Padua and Verona*. PhD diss., University of Toronto.

Castelli, Patrizia. 1977. "Le virtù delle gemme: Il loro significato simbolico e astrologico nella cultura umanistica e nelle credenze popolari del Quattrocento: Il 'recupero⊠ delle gemme antiche." In *L'Or-eficeria nella Firenze del Quattrocento*, edited by M. G. Ciardi Duprè dal Poggetto, 307–364. Florence: Studio per Edizioni Scelte.

Castelli, Patrizia. 2006. "La metafora della pittura nell'opera di Marsilio Ficino." In *Marsilio Ficino: Fonti, testi, fortuna*, edited by Sebastiano Gentile and Stéphane Toussaint, 215–239. Rome: Edizione di Storia e Letteratura.

Caye, Pierre. 2001. "Alberti et Ficin: de la question métaphysique de l'art." In *Marsile Ficin: Les platonismes à la Renaissance*, edited by Pierre Magnard, 125–138. Paris: Vrin.

Chastel, André. 1954/1996. *Marsile Ficin et l'art*. 3rd ed. Geneva: Droz.

Chastel, André. 1959. *Art et Humanisme au temps de Laurent le Magnifique*. Paris: Presses Universitaires de France.

Chines, Loredana, and Marta Guerra, eds. 2005. *Petrarca: profilo e antologia critica*. Milan: Mondadori.

Chrzanowska, Agata Anna. 2016. "Ghirlandaio, Ficino and Hermes Trismegistus: The *Prisca Theologia* in the Tornabuoni Frescoes." *Laboratorio dell'ISPF* 13:1–28, http://www.ispf-lab.cnr. it/2016_CHG.pdf [18 February 2020].

Cieri Via, Claudia. 1994. *Nei dettagli nascosto: per una storia del pensiero iconologico*. Rome: La Nuova Italia.

Cole, Michael. 2002. "The *Demonic Arts* and the Origin of the Medium." *Art Bulletin* 84:621–640.

Copenhaver, Brian. 1987. *Iamblichus, Synesius and the 'Chaldean Oracles' in Marsilio Ficino's Supplementum Festivum: Studies in Honor of Paul Oskar Kristeller*, edited by James Hankins, John Monfasani, and Frederick Purnell, 441–455. Binghamton, NY: Center for Medieval and Early Renaissance Studies.

Corrias, Anna. 2012. "Imagination and Memory in Marsilio Ficino's Theory of the Vehicles of the Soul." *The International Journal of the Platonic Tradition* 6:81–114.

Cropper, Elizabeth. 1976. "On Beautiful Women, Parmigianino, Pertrarchismo, and the Vernacular Style." *Art Bulletin* 58:374–394.

Cropper, Elizabeth. 1986. "The Beauty of Woman: Problems in the Rhetoric of Renaissance Portraiture." In *Rewriting the Renaissance: The Discourse of Sexual Difference in Early Modern Europe*, edited by Margaret W. Ferguson, Maureen Quilligan, and Nancy J. Vickers, 175–190. Chicago: University of Chicago Press.

D'Ancona, Cristina. 2008. "Le rapport modèle-image dans la pensée de Plotin." In *Miroir et savoir: la transmission d'un thème platonicien, des Alexandrins à la philosophie arabo-musulmane*, conference proceedings Leuven 2005, edited by Daniel de Smet, Meryem Sebti, and Godefroid de Callataÿ, 1–48. Leuven: Leuven University Press.

De Gerolami Cheney, Liana. 1985. *Quattrocento Neoplatonism and Medici Humanism in Botticelli's Mythological Paintings*. Lanham, NY: University Press of America.

De Gerolami Cheney, Liana. 1993. *Botticelli's Neoplatonic Images*. Potomac: Scripta Humanistica.

De Gerolami Cheney, Liana. 2000. *Giorgio Vasari'sNeoplatonism and Western Aesthetics*, edited by Aphrodite Alexandrakis and Nicholas J. Moutafakis, 99–113. Albany, NY: State University of New York Press.

De Gerolami Cheney, Liana, and John S. Hendrix, eds. 2002. *Neoplatonism and the Arts*. Lewiston, NY: Edwin Mellen Press.

De Gerolami Cheney, Liana, and John S. Hendrix, eds. 2004. *Neoplatonic Aesthetics: Music, Literature & the Visual Arts*. New York: Peter Lang.

De Majo, Ginevra. 2007. "Le Marsile Ficin et l'Art d'André Chastel." *Accademia* IX:57–81.

De Smet, Daniel, ed. 2008. *Miroir et Savoir: La transmission d'un thème platonicien des Alexandrins à la philosophie arabo-musulmane*. Leuven: Leuven University Press.

Della Torre, Arnaldo. 1902. *Storia dell'Accademia Platonica di Firenze*. Florenz: Carnesecchi.

Dempsey, Charles. 1968. "Mercurius Ver: The Sources of Botticelli's Primavera." *Journal of the Warburg and Courtauld Institutes* 31:251–273.

Dempsey, Charles. 1992. *Portrayal of Love: Botticelli's Primavera and Humanist Culture at the Time of Lorenzo the Magnificent*. Princeton: Princeton University Press.

Dempsey, Charles. 2001. *A Hypothesis Concerning the Opere e giorni: studi su mille anni di arte europea dedicati a Max Seidel*, edited by Klaus Bergoldt and Giorgio Bonsanti, 349–354. Venice: Marsilio.

Dempsey, Charles. 2012. *The Early Renaissance and Vernacular Culture*. Cambridge, MA: Harvard University Press.

DePrano, Maria. 2004. *The Art Works Honoring Giovanna degli Albizzi: Lorenzo Tornabuoni, The Humanism of Poliziano and the Art of Nicolò Fiorentino and Domenico Ghirlandaio*. PhD diss., University of California, Los Angeles.

DePrano, Maria. 2008. "Castitas, Pulchritudo, Amor: The Three Graces on Niccolò Fiorentino's Medal of Giovanna degli Albizzi." *The Medal* 53:21–31.

DePrano, Maria. 2010. "To the Exaltation of His Family: Niccolo Fiorentino's Medal for Giovanni Tornabuoni and his Family." *The Medal* 56:14–25.

Di Dio, Rocco. 2016. "'Selecta colligere': Marsilio Ficino and Renaissance Reading Practices." *History of European Ideas* 42, 5:595–606.

Di Donato, Riccardo. 2009. "Dopo Warburg. La 'Scienza della Cultura' e l'Italia 1929–1932. Appendice I con una nota di Claudia Ceri Via." In *Aby Warburg e la cultura italiana: Fra sopravvivenze e prospettive di ricerca*, edited by Claudia Ceri Via and Micol Forti, 162–163. Milan: Mondadori.

Di Stefano, Elisabetta. 2007. "Leon Battista Alberti e l''Idea' della bellezza." In *Leon Battista Alberti teorico delle arti e gli impegni civili del 'De re edificatoria'*, 2 vols., edited by Arturo Calzona, Francesco P. Fiore, Alberto Tenenti, and Cesare Vasoli, vol. 1, 33–45. Florence: Olschki.

Dombrowski, Damian. 2010. *Die Religiösen Gemälde Sandro Botticellis: Malerei als pia philosophia*. Berlin: Deutscher Kunstverlag.

Ebbersmeyer, Sabrina. 1998. *Die Blicke der Liebenden: Zur Theorie, Magie und Metaphorik des Sehens in Blick und Bild im Spannungsfeld von Sehen, Metaphern und Verstehen*, edited by Tilman Borsche, Johanna Kreuzer, and Christian Strub, 197–211. Munich: Fink.

Efal, Adi. 2016. *Figural Philology: Panofsky and the Science of Things*. London: Bloomsbury Academic.

Ferruolo, Arnolfo B. 1955. "Botticelli's Mythologies: Ficino's *De amore*, Poliziano's *Stanze per la Giostra*. Their Circle of Love." *The Art Bulletin* 37:17–25.

Ficino, Marsilio. 1495/2011. *Epistole Ficini*. Venice: Hieronymus Blondus. Facsimile reprint 2011, introduced by Stéphane Toussaint. Lucca: Société Marsile Ficin, San Marco Litotipo.

Ficino, Marsilio. 1576/2014. *Opera*. Basileia: ex officina Henricpetrina. Repr. 2014 with an introduction by Stéphane Toussaint. Lucca: Société Marsile Ficin, San Marco Litotipo.

Ficino, Marsilio. 1975–. *The Letters of Marsilio Ficino*, 10 vols. to date, translated from Latin by members of the Language Department of the School of Economic Science, London. London: Shepheard-Walwyn.

Ficino, Marsilio. 1987. *El libro dell'amore*, edited and translated by Sandra Niccoli. Florence: Olschki.

Ficino, Marsilio. 1990. *Lettere, vol. 1: Epistolarum familiarum liber I*, edited by Sebastiano Gentile. Florence: Olschki.

Ficino, Marsilio. 2001–6. *Platonic Theology*, 6 vols. edited and translated by Michael J. B. Allen and James Hankins. Cambridge, MA: Harvard University Press.

Ficino, Marsilio. 2002a. *Three Books on Life*, A Critical Edition and Translation by Carol V. Kaske and John R. Clark. Tempe: Arizona Center for Medieval and Renaissance Studies / The Renaissance Society of America.

Ficino, Marsilio. 2002b. *Commentaire sur Le Banquet de Platon, De l'amour – Commentum in Convivium Platonis, De amore*, edited and translated by Pierre Laurens. Paris: Les Belles Lettres.

Freedman, Luba. 1989. "Donatello's Bust of Youth and the Ficino Canon of Proportions." In *Il ritratto e la memoria: materiali*, edited by Augusto Gentili, vol. 1, 113–132. Rome: Bulzoni.

Gebhart, Émile. 1908. *Sandro Botticelli*. 2nd ed. Paris: Hachette.

Gentile, Sebastiano, Sandra Niccoli, and Paolo Viti, eds. 1984. *Marsilio Ficino e il ritorno di Platone*, exhib. cat. Florence: Le Lettere.

Ghelardi, Maurizio. 1998. "Recondite armonie: *Idea* di Erwin Panofsky." In Erwin Panofsky, *Idea: Contributo alla storia dell'estetica*. Florence: La Nuova Italia.

Giglioni, Guido. 2010. "The Matter of the Imagination: The Renaissance Debate over Icastic and Fantastic Imitation." *Camenae* 8:1–21.

Gilbhard, Thomas, and Stéphane Toussaint. 2009. "Bibliographie Ficinienne – Mise à jour 2007–2009." *Accademia* 11:9–26.

Gilbhard, Thomas, and Stéphane Toussaint. 2010. "Bibliographie Ficinienne – Mise à jour 2010." *Accademia* 12:7–12.

Ginzburg, Carlo. 1989. "From Aby Warburg to E. H. Gombrich." In Carlo Ginzburg, *Clues, Myths and the Historical Method*, translated by John Tedeschi and Anne C. Tedeschi, 17–59. Baltimore: Hopkins University Press.

Glanzmann, Sibylle. 2006. *Der Einsame Eros: Eine Untersuchung des Symposion-Kommentars 'De amore' von Marsilio Ficino*. Tübingen: Francke.

Gombrich, Ernst. 1945. "Botticelli's Mythologies: A Study in the Neoplatonic Symbolism of His Circle." *Journal of the Warburg and Courtauld Institutes* 8:7–60.

Gombrich, Ernst. 1948. "Icones symbolicae: The Visual Image in Neo-Platonic Thought." *Journal of the Warburg and Courtauld Institutes* 11:163–192.

Götze, Oliver. 2010. *Der öffentliche Kosmos: Kunst und wissenschaftliches Ambiente in italienischen Städten des Mittelalters und der Renaissance*. Munich: Utz.

Grafton, Anthony. 2009. *Worlds Made by Words: Scholarship and Community in the Modern West*. Cambridge, MA: Harvard University Press.

Gress, Thibaut. 2015. *L'oeil et l'intelligible: essai sur le sens philosophique de la forme en peinture*. Paris: Éditions Kimé.

Hadot, Pierre. 1976. "Le mythe de Narcisse et son interprétation par Plotin." *Nouvelle Revue de Psychanalyse* 13:81–108.

Hankins, James. 2011. "Monstrous Melancholy: Ficino and the Physiological Causes of Atheism." In *Laus Platonici Philosophi: Marsilio Ficino and His Influence*, conference proceedings London 2004, edited by Stephen Clucas, Peter J. Forshaw, and Valery Rees, 25–43. Leiden: Brill.

Hatfield, Rab. 2009. "Some Misidentifications In and Of Works by Botticelli." In *Sandro Botticelli and Herbert Horne: New Research*, edited by Rab Hatfield, 7–61. Florence: Syracuse University in Florence.

Hemsoll, David. 1998. "Beauty as an Aesthetic and Artistic Ideal in Late Fifteenth-Century Florence." In *Concepts of Beauty in Renaissance Art*, edited by Francis Ames-Lewis and Mary Rogers, 66–79. Aldershot: Ashgate.

Hendrix, John S. 2010. "Perception as a Function of Desire in the Renaissance." In *Renaissance Theories of Vision*, edited by John S. Hendrix and Charles C. Carman, 99–115. Farnham: Ashgate.

Hettner, Hermann. 1879. *Italienische Studien: Zur Geschichte der Renaissance*. Braunschweig: Vieweg.

Hochmann, Michel. 2008. "A propos de la cohérence des programmes iconographiques de la Renaissance." In *Programmes et inventions dans l'art de la Renaissance*, edited by Michel Hochmann et al., 83–94. Rome: Académie de France.

Hocke, Gustav René. 1957. *Die Welt als Labyrinth: Manier und Manie in der europäischen Kunst, von 1520 bis 1650 und in der Gegenwart*. Hamburg: Rowohlt.

Holberton, Paul. 1982. "Botticelli's Primavera: che volea s'intedesse." *Journal of the Warburg and Courtauld Institutes* 45:202–210.

Holly, Michael Ann. 1984. *Panofsky and the Foundations of Art History*. Ithaca, NY: Cornell University Press.

Hub, Berthold. 2005. "… e fa dolce la morte: Love, Death, and Salvation in Michelangelo's Last Judgment." *Artibus et Historiae* 26, 51:103–130.

Hub, Berthold. 2008. "Material Gazes and Flying Images in Marsilio Ficino and Michelangelo." In *Spirits Unseen: The Representation of Subtle Bodies in Early Modern European Culture*, edited by Christine Göttler, 93–120. Leiden: Brill.

Huss, Bernhard, Florian Neumann, and Gerhard Regn, eds. 2002. *Lezioni sul Petrarca: Die Rerum vulgarium fragmenta in Akademievorträgen des 16. Jahrhunderts*. Münster: Lit.

Jäger, Michael. 1990. *Die Theorie des Schönen in der italienischen Renaissance*. Cologne: Dumont.

Klemm, Tanja. 2013. *Bildphysiologie: Wahrnehmung und Körper in Mittelalter und Renaissance.* Berlin: Akademie-Verlag.

Klibansky, Raymond, Erwin Panofsky, and Fritz Saxl. 1964. *Saturn and Melancholy: Studies in the History of Natural Philosophy, Religion and Art.* London: Nelson.

Kodera, Sergius. 2002. "Narcissus, Divine Gazes and Bloody Mirrors: The Concept of Matter in Ficino." In *Marsilio Ficino: His Theology, His Philosophy, His Legacy,* edited by Michael J. B. Allen and Valery Rees with Martin Davies, 285–306. Leiden: Brill.

Kodera, Sergius. 2004. "Schattenhafte Körper, erotische Bilder: Zur Zeichentheorie im Renaissance-Neuplatonismus bei Marsilio Ficino." In *Kunst, Zeichen, Technik: Philosophie am Grund der Medien,* edited by Marianne Kubaczek, Wolfgang Pircher, and Eva Waniek, 63–86. Münster: LIT.

Kodera, Sergius. 2010. *Disreputable Bodies: Magic, Medicine and Gender in Renaissance Natural Philosophy.* Toronto: Centre for Reformation and Renaissance Studies.

Kohl, Jeanette. 2014. *Sublime Love: The Bust of a Renaissance Love: Eros, Passion and Friendship in Italian Art around 1500,* edited by Jeanette Kohl, Marianne Koos, and Adrian W. B. Randolph, 133–148. Munich: Deutscher Kunstverlag.

Koos, Marianne. 2006. "Amore dolce-amaro: Giorgione und das Ideale Knabenbildnis der Venezianischen Renaissancemalerei." *Marburger Jahrbuch für Kunstwissenschaft* 33:113–174.

Kristeller, Paul Oskar. 1951. "The Modern System of the Arts: A Study in the History of Aesthetics, Part I." *Journal of the History of Ideas* 12:496–527.

Kristeller, Paul Oskar. 1952. "The Modern System of the Arts: A Study in the History of Aesthetics, Part II." *Journal of the History of Ideas* 13:17–46.

Kristeller, Paul Oskar. 1958. "Review of Chastel 1954." *The Art Bulletin* 40:78–79.

Krois, John Michael, ed. 2008. *Ernst Cassirer, Eidos und Eidolon & Erwin Panofsky, Idea.* Hamburg: Philo Fine Arts.

Labalme, Patricia H. 2006. "Paul Oskar Kristeller and the Fine Arts: Vivid Recollections." In *Kristeller Reconsidered: Essays on His Life and Scholarship,* edited by John Monfasani, 153–161. New York: Italica Press.

Larmon Peterson, Janine, and James G. Snyder. 2015. "The Galenic Roots of Marsilio Ficino's Theory of Natural Changes." *Viator* 46, 3:301–316.

Leinkauf, Thomas. 2006. "Kunst als 'proprium humanitatis': Zum philosophischen Verständnis künstlerischer Gestaltung in der Renaissance." In *Erzählende Vernunft,* edited by Günter Frank, Anja Hallacker, and Sebastian Lalla, 221–235. Berlin: Akademie-Verlag.

Leinkauf, Thomas. 2010. "Ut philosophia pictura – Beobachtungen zum Verhältnis von Denken und Fiktion." In *Kann das Denken malen? Philosophie und Malerei in der Renaissance,* edited by Inigo Bocken and Tilman Borsche, 45–69. Munich: Wilhelm Fink.

Leitgeb, Maria-Christine. 2006. *Tochter des Lichts: Kunst und Propaganda im Florenz der Medici.* Berlin: Parthas.

Leitgeb, Maria-Christine. 2010. *Concordia mundi: Platons Symposion und Marsilio Ficinos Philosophie der Liebe.* Wien: Holzhausen.

Leporatti, Roberto. 2002. "Venere, Cupido e i poeti d'amore." In *Venere e Amore: Michelangelo e la nuova bellezza ideale,* exh. cat., edited by Franca Falletti and Jonathan Katz Nelson, 64–89. Florence: Giunti.

Leuker, Tobias. 2007. *Bausteine eines Mythos: Die Medici in Dichtung und Kunst des 15. Jahrhunderts.* Köln: Böhlau.

Lightbown, Ronald. 1978/1989. *Sandro Botticelli,* 2 vols. London: Paul Elek. 2nd ed., London: Thames and Hudson.

Longhi, Roberto. 1913/1980. "Mattia Preti." *La Voce 5,* 41:1171–1175. Repr. 1980 in: Roberto Longhi, *Scritti giovanili, 1912–1922,* vol. 1, 29–45. Firenze: Sansoni.

Lüdemann, Peter. 2008. *Virtus und Voluptas: Beobachtungen zur Ikonographie weiblicher Aktfiguren in der venezianischen Malerei des frühen Cinquecento.* Berlin: Akademie-Verlag.

Maspoli Genetelli, Silvia, and Dominic O'Meara. 2002. "Le commentaire de Marsile Ficin sur le traité du Beau de Plotin: notes et traduction de l'*argumentum*." *Freiburger Zeitschrift für Philosophie und Theologie* 49:1–32.

Mazzucco, Katia. 2011. "The Work of Ernst Gombrich on the Aby M. Warburg Fragments." *Journal of Art Historiography* 5:1–26.

McDonald, Grantley. 2012. "Music, Magic, and Humanism in Late Sixteenth-Century Venice: Fabio Paolini and the Heritage of Ficino, Vicentini, and Zarlino." *Journal of the Alamire Foundation* 4:222–248.

Meltzoff, Stanley. 1987. *Signorelli and Savonarola: Theologia poetica and Painting from Boccaccio to Poliziano*. Florence: Olschki.

Morel, Philippe. 2002. "Manilius et Marsile Ficin à Schifanoia." In *Marsile Ficin ou les mystères platoniciens: Actes du XLIIe Colloque International d'Etudes Humanistes, CESR, Tours, 7–10 juillet 1999*, edited by Stéphane Toussaint, 123–135. Paris: Belles Lettres.

Morel, Philippe. 2008. *Mélissa: Magie, astres et démons dans l'art italien de la Renaissance*. Paris: Hazan.

Morel, Philippe. 2009. "Le règne de Pan de Signorelli." In *Images of the Pagan Gods: Papers of a Conference in Memory of Jean Seznec*, edited by Rembrandt Duits and François Quiviger, 309–328. London: Warburg Institute.

Morel, Philippe. 2015. *Renaissance dionysiaque: inspiration bachique, imaginaire du vin et de la vigne dans l'art européen (1430–1630)*. Paris: Le Félin.

Mozzati, Tommaso. 2008. *Giovanfrancesco Rustici: Le compagnie del paiuolo e della cazzuola. Arte, letteratura, festa nell'età della maniera*. Firenze: Olschki.

Nagel, Alexander. 2011. *The Controversy of Renaissance Art*. Chicago: University of Chicago Press.

Neumann, Hans-Peter. 2010. "Machina machinarum: Die Uhr als Begriff und Metapher zwischen 1450 und 1750." In *Transitions and Borders Between Animals and Machines, 1600–1800*, edited by Tobias Cheung, 122–192. Leiden: Brill.

Oehlig, Ute. 1992. *Die Philosophische Begründung der Kunst bei Ficino*. Stuttgart: Teubner.

Olszaniec, Wlodzimierz. 2012. "The Latin Inscriptions in Sandro Botticelli's and Filippino Lippi's Five Sibyls." *Neulateinisches Jahrbuch* 14:233–240.

Panofsky, Erwin. 1924. *Idea: Ein Beitrag zur Begriffsgeschichte der älteren Kunsttheorie.* [Studien der Bibliothek Warburg 5] Leipzig: Teubner.

Panofsky, Erwin. 1960. *Renaissance and Renascences in Western Art*. Stockholm: Almqvist & Wiksell.

Panofsky, Erwin. 1972. *Studies in Iconology: Humanistic Themes in the Art of the Renaissance*. New York: Harper & Row.

Panofsky, Erwin. 2001–14. *Korrespondenz 1910 bis 1968*, 5 vols. edited by Dieter Wuttke. Wiesbaden: Harrassowitz.

Panofsky, Erwin, and Fritz Saxl. 1923. *Dürers 'Melencolia I': Eine quellen- und typengeschichtliche Untersuchung*. Leipzig: Teubner.

Paolozzi Strozzi, Beatrice. 2005. "Amore e Attis." In *Il ritorno d'Amore: L'Attis di Donatello restaurato*, exh. cat., Museo Nazionale del Bargello, edited by Beatrice Paolozzi Strozzi, 11–16. Florence: Museo Nazionale del Bargello.

Petrarch. 2002. *Canzoniere*, translated by J. G. Nichols. New York: Routledge.

Pfisterer, Ulrich. 2001. "Künstlerliebe: Der *Narcissus*-Mythos bei Leon Battista Alberti und die Aristoteles-Lektüre der Frührenaissance." *Zeitschrift für Kunstgeschichte* 64:305–330.

Plato. 1925. *Lysis – Symposium – Gorgias (Plato in Twelve Volumes, vol. 3)*, translated by W. R. M. Lamb [Loeb Classical Library 166]. Cambridge, MA: Harvard University Press.

Plotinus. 1580/2009. *Plotini Opera Omnia cum latina Marsilii Ficini interpretatione et commentatione*. Basilea: Perna. Repr. with an introduction by Stéphane Toussaint. Lucca: Société Marsile Ficin, San Marco Litotipo.

Plotinus. 1966. *Enneads I. 1–9*, translated by Arthur H. Armstrong [Loeb Classical Library]. Cambridge, MA: Harvard University Press.

Porter, James I. 2009. "Is Art Modern? Kristeller's 'Modern System of Arts' Reconsidered." *British Journal of Aesthetics* 49:1–24.

Rieber, Audrey. 2009. "Des présupposés philosophiques de l'iconologie: rapport de Panofsky à Kant et à Hegel." *Astérion* 6: http://asterion.revues.org/1524 [18 February 2020].

Robb, Nesca A. 1935. *Neoplatonism of the Italian Renaissance*. London: George Allen & Unwin.

Robichaud, Denis. 2017. "Ficino, on Force, Magic and Prayer: Neoplatonic and Hermetic Influences in Ficino's *Three Books on Life*." *Renaissance Quarterly* 70:44–87.

Rossi, Massimiliano. 2009. "Mente, libro e cosmo nel tardo Cinquecento: il ruolo mnemonico dell'illustrazione nella produzione editoriale di Giovan Paolo Gallucci." In *Memory and Invention: Medieval and Renaissance Literature, Art and Music*, edited by Anna Maria Busse Berger and Massimiliano Rossi, 37–57. Florence: Olschki.

Rubinstein, Nicolai. 1997. "Youth and Spring in Botticelli's Primavera." *Journal of the Warburg and Courtauld Institutes* 60:248–251.

Ruvoldt, Maria. 2004. *The Italian Renaissance Imagery of Inspiration: Metaphors of Sex, Sleep, and Dreams*. Cambridge: Cambridge University Press.

Sass, Maurice. 2012. "Gemalte Korallenamulette: Zur Vorstellung eigenwirksamer Bilder bei Piero della Francesca, Andrea Mantegna und Camillo Leonardi." *kunsttexte.de*, 1:1–53.

Schlott, Michael. 1993. *Hermann Hettner: Idealistisches Bildungsprinzip versus Forschungsimperativ. Zur Karriere eines 'undisziplinierten' Gelehrten im 19. Jahrhundert*. Tübingen: Niemeyer.

Schneider, Steffen. 2012. *Kosmos, Seele, Text: Formen der Partizipation und ihre literarische Vermittlung. Marsilio Ficino, Pierre de Ronsard, Giordano Bruno*. Heidelberg: Winter.

Sebregondi, Ludovica, and Tim Parks, eds. 2011. *Denaro e Bellezza: I banchieri, Botticelli e il rogo delle vanità*. Florence: Giunti.

Seretti, Marina. 2015a. "Le sommeil et la nuit: la Sagrestia Nuova de Michel-Ange." *Accademia* 17:93–115.

Seretti, Marina. 2015b. *Figures d'endormis & théories du sommeil de la fin du Moyen Âge à l'aube de l'époque moderne: le sommeil profond et ses métaphores dans l'art de la Renaissance*. PhD diss., Université Paris-Sorbonne.

Sessin, Serenella. 2014. *Gems in Renaissance Material Culture*. MA thesis, University of London.

Shearman, John. 1975. "The Collections of the Younger Branch of the Medici." *Burlington Magazine* 117, 862:12–27.

Smith, Webster. 1975. "On the Original Location of the *Primavera*." *Art Bulletin* 57, 1:31–40.

Snyder, James. 2011. "Pregnant Matter: Ficino's Theory of Natural Change 'From Within' Matter." *Rinascimento* 51:139–155.

Storey, Christina. 2003. "The Philosopher, The Poet and The Fragment, Ficino, Poliziano and *Le Stanze per la giostra*." *Modern Language Review* 98:602–619.

Tambrun-Krasker, Brigitte. 1999. "Marsile Ficin et le Commentaire de Pléthon sur les Oracles Chaldaïques." *Accademia* 1:9–48.

Tanturli, Giuliano. 2006. "Marsilio Ficino e il volgare." In *Marsilio Ficino: Fonti, testi, fortuna*, edited by Sebastiano Gentile and Stéphane Toussaint, 183–213. Rome: Edizione di Storia e Letteratura.

Tirinnanzi, Nicoletta. 2000. *Umbra naturae: l'immaginazione da Ficino a Bruno*. Rome: Edizioni di Storia e Letteratura.

Toussaint, Stéphane. 2000. "Ficino's Orphic Magic or Jewish Astrology and Oriental Philosophy? A Note on Spiritus, the *Three Books on Life*, Ibn Tufayl and Ibn Zarza." *Accademia* 2:19–31.

Toussaint, Stéphane. 2002. "Ficino, Archimedes and the Celestial Arts." In *Marsilio Ficino: His Theology*, edited by Michael J. B. Allen and Valery Rees with Martin Davies, 307–326. Leiden: Brill.

Toussaint, Stéphane. 2005. "Leonardo filosofo dei contrary: Appunti sul Chaos." In *Leonardo e Pico: Analogie, contatti, confronti: Atti del convegno di Mirandola, 10 maggio 2003*, edited by Fabio Frosini, 13–35. Florence: Olschki.

Toussaint, Stéphane. 2006. "L'*ars* de Marsile Ficin entre esthétique et magie." In *L'art de la Renaissance entre science et magie, actes du colloque international de Paris, 20–22 juin 2002*, edited by Philippe Morel, 453–467. Paris: Somogy.

Toussaint, Stéphane. 2008. *Humanismes, antihumanismes: de Ficin à Heidegger*. Paris: Belles Lettres.

Toussaint, Stéphane. 2011. *Zoroaster and The Flying Egg: New Sources in Ficino's Laus Platonici Philosophi: Marsilio Ficino and His Influence (University of London, 17–18 September 2004)*, edited by Stephen Clucas, Peter J. Forshaw, and Valery Rees, 105–116. Leiden: Brill.

Toussaint, Stéphane. 2013. "Volgarizzare il segreto e divulgare l'esoterismo nel Ficino e nel Benci." In *Platonismus und Esoterik in byzantinischen Mittelalter und italienischer Renaissance*, edited by Helmut Seng, 263–280. Heidelberg: Winter.

Toussaint, Stéphane. 2015. "Ars Platonica: Chastel entre Kristeller et Garin." In *André Chastel: méthodes et combats d'un historien d'art*, edited by Sabine Frommel, Michel Hochmann, and Philippe Sénéchal, 209–227. Paris: Picard.

Toussaint, Stéphane. 2017. "Magie und Humanismus (Ficino, Pico, Paolini und Gallucci)." In *Marsilio Ficino in Deutschland und Italien: Renaissance-Magie zwischen Wissenschaft und Literatur*, conference proceedings Berlin 2015, edited by Jutta Eming and Michael Dallapiazza, 19–34. Wiesbaden: Harrassowitz.

Trinkaus, Charles. 1970. *In Our Image and Likeness*, 2 vols. Chicago: University of Chicago Press.

Tröger, Ursula. 2016. *Marsilio Ficinos Selbstdarstellung: Untersuchungen zu seinem Epistolarium*. Berlin: De Gruyter.

Van den Doel, Marieke. 2008. *Ficino en het voorstellingsvermogen: fantasia en imaginatio in kunst en theorie vanaf de Renaissance*. PhD diss., University of Amsterdam.

Van den Doel, Marieke. 2010. *Ficino, Diacceto and Michelangelo's The Making of the Humanities: Early Modern Europe*, edited by Rens Bod, Jaap Maat, and Thijs Weststeijn, 107–131. Amsterdam: Amsterdam University Press.

Van der Sman, Gert Jan. 2009. *Lorenzo e Giovanna: Vita e arte nella Firenze del Quattrocento*. Florence: Mandragora.

Vanhaelen, Maude. 2010. "L'entreprise de traduction et d'exégèse de Ficin dans les années 1486–1489: Démons et prophétie à l'aube de l'ère savonarolienne." *Humanistica* 5:125–136.

Warburg, Aby. 1932. *Gesammelte Schriften, vol. 1–2: Die Erneuerung der heidnischen Antike. Kulturwissenschaftliche Beiträge zur Geschichte der europäischen Renaissance. Mit einem Anhang unveröffentlichter Zusätze*, edited by Gertrude Bing. Leipzig: Teubner.

Warburg, Aby. 1999. *The Renewal of Pagan Antiquity: Contributions to the Cultural History of European Renaissance*, introduced by Kurt W. Forster, translated by David Britt. Los Angeles: Getty Research Institute.

Weill-Parot, Nicolas. 2002. "Astral Magic and Intellectual Changes (Twelfth-Fifteenth Centuries) 'Astrological Images' and the Concept of 'Addressative' Magic." In *The Metamorphosis of Magic: From Late Antiquity to the Early Modern Period*, edited by Jan N. Bremmer and Jan R. Veenstra, 167–188. Leuven: Peeters.

Wells, Marion. 2007. *The Secret Wound: Love-Melancholy and Early Modern Romance*. Stanford, CA: Stanford University Press.

Weststeijn, Thijs. 2008. *The Visible World: Samuel van Hoogstraten's Art Theory and the Legitimation of Painting in the Dutch Golden Age*. Amsterdam: Amsterdam University Press.

Wittstock, Antje. 2011. *Melancholia translata: Marsilio Ficinos Melancholie-Begriff im deutschsprachigen Raum des 16. Jahrhundert*. Göttingen: V&R Unipress.

Wurm, Achim. 2008. *Platonicus amor: Lesarten der Liebe bei Platon, Plotin und Ficino*. Berlin: De Gruyter.

Zambrano, Patrizia, and Katz Nelson, Jonathan. 2004. *Filippino Lippi*. Milan: Electa.

Zöllner, Frank. 1997. "Zu den Quellen und zur Ikonographie von Sandro Botticellis Primavera." *Wiener Jahrbuch für Kunstgeschichte* 50:131–157.

Zöllner, Frank. 1998. *Botticelli: Toskanischer Frühling*. Munich: Prestel.

Zöllner, Frank. 2005. "The Motion of the Mind in Renaissance Portraits: The Spiritual Dimension of Portraiture." *Zeitschrift für Kunstgeschichte* 68:23–40.

3 Seeing and the Unseen

Marsilio Ficino and the Visual Arts

Valery Rees

Marsilio Ficino prefaces his master work on Platonic Theology with a visual metaphor: "In the sphere of moral philosophy, one must purify the soul until its eye becomes unclouded and it can see the divine light and worship God." Just as the eye relies for vision on the light of the sun, he explains, so does our mind rely for understanding on divine light. We are well equipped for the task, he adds, for man's soul is "like a mirror, in which the image of the divine countenance is readily reflected."[1] Seeing, picturing and imagining are important faculties for him, as noted more than sixty years ago by André Chastel, who characterized Ficino as one of those thinkers who need image and myth to stimulate the spirit to its proper work while yet needing to pass altogether beyond image and myth to another more abstract realm.[2]

Visual references abound in his work, from the craft of Apelles, Praxiteles and Zeuxis[3] to the gardens of the Academy depicted in the Preface to his commentaries on Plato[4] and a series of *Apologi*, or fables, populated with figures as if from a ballet scene or masque – Chastel called these Ficino's "smiling inventions."[5] On more than one occasion Ficino likens the soul taking on an embodiment to the striking visual image of a flame flaring on contact with sulphur.[6] He conjures up imaginary beasts and mythical personae.[7] He alludes to the paintings on the walls of his own academy – scenes of Democritus laughing and Heraclitus weeping at the ways of the world;[8] and occasionally he mentions the frescoes and decorations in the churches where he preached.[9] Ficino also had strong ideas about color, which are expressed in his *Three Books on Life*.[10] There is even something visual in his recurrent figure of creation being ranged over five levels, with the soul occupying the middle level of the five.[11]

Yet it has been notoriously difficult to establish what the relationship was between the ideas expressed so lucidly by Ficino and the works produced by the various painters and sculptors within his circle. Whilst we know he displayed great sensitivity as a musician from contemporary accounts, no contemporaries describe his reaction to art, leading even Edgar Wind to conclude that "Ficino's own visual sensibility was slight, and he speaks of painting as though he were a stranger to it,"[12] while Ronald Lightbown throws doubt on the whole idea that the commission of a painting need necessarily reflect any philosophical point of view.[13] It is certainly true that when Ficino proclaims in his *De amore* that love is the master of the arts, the arts he has in mind are medicine, gymnastics, agriculture, music, astronomy, and religion – not painting and sculpture.[14] Yet against this stands his deep conviction that anyone looking at the universe in which we live who cannot see and honor its architect has lost the "eye of reason."[15]

Only in the literary field has any real progress been made in tracing the specific influence of Ficino's writings.[16] But it is hard to believe that any of these fields of artistic endeavor can truly be considered in isolation from one another. Certainly, Ficino himself reminds us, in a much-quoted letter, that all the arts were flourishing together:

This golden age has brought back to light the liberal arts which were almost extinct: grammar, poetry, oratory, painting, sculpture, architecture, music and the ancient art of singing hymns to the Orphic lyre; and all this in Florence.[17]

With regard to painting, early attempts to discern a Platonic iconology in Botticelli's *Primavera*, related to specific passages in Ficino's letters that were thought to be connected with the commissioning or completion of the work, were subsequently overturned.[18] The timing of the letters was questioned, the identity of the recipient challenged, new discoveries were made about the original location of the picture, and from early claims that Ficino had provided a philosophical program that Botticelli rendered into figures on a panel, it became Poliziano's *Giostra* that was said to provide every detail of the happenings in the glade, down to the smallest flower and blade of grass.[19] It appeared to pass largely without comment that the ear that is attuned to Ficino may hear echoes in Poliziano's verse of conversations between the two.[20] The Platonic iconology so confidently championed at first became a field where art historians feared to tread.[21] As early as 1970, Gombrich was in cautious retreat. Nevertheless, he did continue to maintain that it was the Neoplatonic approach to ancient myth which succeeded in "opening up to secular art emotional spheres which had hitherto been the preserve of religious worship."[22]

But what if we turn the question round the other way? Let us ask not what influence artists drew from Ficino but what he drew from them. This will not take the form of a discussion of art theory, or of individual works of art, because the evidence is very limited.[23] Instead, we shall consider the way in which Ficino uses visual images in his philosophic discourse. This will involve an examination of his use of allegory and his approach to mystery, as well as some Neoplatonic interpretations of ancient myth. It will also include some comments on color, light, and picture symbolism. There will be no sign of a disjuncture between secular art and religious worship as mentioned by Gombrich, because any such separation would have been far from Ficino's intent. Nevertheless, it is true that Ficino's devoutly Christian adoption of the work of Plato, Plotinus and other late Platonic texts allowed others to feel a greater degree of comfort with the allegorical figures of antiquity, with the gods and goddesses, nymphs and cupids, altars and groves which increasingly populate the canvases of artists and the vision of architects as well as poetic works.

Ficino himself tells us that in philosophy, which is a search for causes, "the final object of our search into them should be the cause of causes, and once we find it we should venerate it."[24] I shall try to show how his visual allegories and figurative descriptions contribute to that search. They are not occasional "extras" or mere *divertimenti* but are intimately linked to other more conventionally philosophical forms of reasoning. He distinguished between the two types of exposition but used them both in pursuit of one end. While some of his works, such as the *Platonic Theology* and *De christiana religione*, proceed by logical argumentation, Socratic elenchus, Aristotelian reasoning, or even a somewhat scholastic piling up of arguments, even they resort to imagery and imagination from time to time, while other works rely more heavily on image and imagination.

One example of this is an open letter of 1478 addressed to his *familiares*– that is, everyone in his circle. He finds three different ways to say how much more powerful an image is than words. He then invites the reader to "picture a man endowed with the most vigorous and acute faculties, a strong body, good health, a handsome form, well-proportioned limbs and a noble stature. Picture this man moving with alacrity and skill, speaking elegantly, singing sweetly, laughing graciously."[25]

Anyone, he says, would love and admire such a man. But conjuring up a picture is not enough. One also has to reflect on the picture and refer each physical correspondence to an aspect of the mind:

> For the body is the shadow of the soul; the form of the body, as best it can, represents the form of the soul. Thus liveliness and acuteness of perception in the body represent, in a measure, the wisdom and far-sightedness of the mind; strength of body represents strength of mind; health of body, which consists in the tempering of the humors, signifies a temperate mind. Beauty, which is determined by the proportions of the body and a becoming complexion, shows us the harmony and splendor of justice; size shows us liberality and nobility; and stature, magnanimity [...] Finally, gracious laughter represents serene happiness in life and perfect joy.[26]

These attributes should then all be brought together into a whole, and this whole will be a "spectacle to be admired and venerated," for it will be an image of Virtue, in her divine ideal form, and it will work to draw us towards her. Similarly, one could produce an image of Vice, which would "immediately terrify by its deformity and drive everyone away."[27]

A couple of years later, Ficino does attempt to draw an equivalent picture of Vice, though the effort is not sustained for long before he reverts to happier images:

> Lorenzo, the soul corrupted by evil conduct is like a wood dense with tangled thorns, bristling with savage beasts, infested with poisonous snakes. Or is it like a swelling sea, tossed by battling winds, waves and wild storms? Or like a human body misshapen without and tortured within by excruciating pains in every joint?[28]

Besides being unusual in Ficino's writings, this passage warns us of an underlying methodological problem. The reader schooled in literature may immediately recall Dante's *selva oscura* filled with wild beasts (*Inferno* I, 2 and 32–53), the thorns and nettles of Proverbs (24:30–1), or thickets and groves from Ovid or Poliziano. But Ficino may equally have had in mind a painting, or the actual woods of the Mugello or Fiesole. Likewise, Ficino's "swelling sea" could be drawn from paintings, poetry, or travelers' tales. Since he himself appears never to have traveled further than Bologna or Montevarchi, his knowledge of the sea is surely indirect, but while art historians may think of paintings to compare, those schooled in literary tools think first of literary sources and make the leap to sources in the visual arts less often and with less confidence.

Meanwhile, the mention of poisonous snakes takes us to the *Apologi*. In the first of these, written in 1481, not long before the *Primavera* was painted, Lucilia, daughter of Phoebus, forgets her father's good advice and wanders off into the meadows, gathering flowers. She is so intent on the delights that she does not see the snake that bites her. Lucilia's name is then changed to Flora, child of Venus.[29] Her father rebukes her, "Be off to your Venus, wicked Flora, go at once," though he will relent if she lays aside "those alluring false colors and seductive attire."[30]

Venus, in another of these fables, is also wandering among the flowery orchards when, with Apollo's help, Mercury catches her, under a laurel tree. From their union a child is born, combining Mercury's wit and wisdom, Venus's charm and Apollo's splendor. This child is "Apologus," meaning fable incarnate, and is a brother to Cupid. He then is pictured – and we can easily imagine this young putto – wandering in the nearby woods where shepherds find him and feed him on acorns and chestnuts before Apollo comes to

lead him back home. Home is the Pythian Gardens, Apollo's home at Delphi, or equally it is the Borgo Pinti, where Bartolomeo Scala, that other great fable-writer, had his house. Ficino has fashioned a response to Scala's fables which is itself a picture-story of great charm.[31]

In a third fable, we see Cupid running about looking for his mother. Alamanno deftly catches him and soothes him. Together, they set off for Careggi.[32] Again, Ficino is paying a visually conceived compliment, this time both to Alamanno Donati and to Lorenzo de' Medici.[33]

Moving to more sustained visual allegory on Ficino's part, the most important topics are without doubt the sun and wings. Their significance has already been noted by others. Francis Ames-Lewis discusses representations of the Phaedran charioteer on a medallion on a bust by Donatello (sometimes attributed to Desiderio da Settignano) and on Rossellino's tomb for the Cardinal of Portugal in San Miniato. He argues that the soul's ascent is also thematic in the frieze of Villa Medici at Poggio a Caiano with its two contrasting charioteers and may even be read into the wing that appears to rise from Goliath's helmet under the foot of Donatello's *David*.[34] I would add that there is also an angelic aspect to any consideration of wings: in the churches of Florence, winged angels abound, ready to carry the prayers of humans straight up to heaven or bring heavenly messages down to earth.[35]

The wings described in Plato's *Phaedrus*, which grow or wilt according to the soul's disposition and action, were without doubt a visual reality for Ficino. He reverts to them often, sometimes calling them intellect and will, sometimes love and reason, sometimes devotion to God and duty towards neighbor.[36] Curiously, he generally presents them as two that are different and must be balanced, like the two horses of Plato's Phaedran chariot, rather than a perfectly matching pair.

The wings are a potent image in the anagogical interpretation of myth. Anagogy has two degrees of meaning. It is normally defined as spiritual or mystical interpretation – that is, an interpretation moving beyond the literal, allegorical or moral sense. But it may also be defined with greater precision in a meaning now obsolete but especially relevant to Ficino – as "rapture or elevation of the soul to things celestial and eternal."[37] How can a philosopher describe the actual experience of separation of mind from body and its rapture into the world of ideal forms? Plato had said it would be "a matter for utterly superhuman and long dis-course, but it is within human power to describe it briefly in a figure";[38] hence, his Jovian cavalcade, leading to the brink of the formal universe, where pure minds can gaze upon pure ideas and drink deeply again of their own divine reminiscences – of wisdom and beauty.[39] The wings relate to the moment of rapture from the individual's point of view. By the practice of human virtues, a person can grow, or re-grow, their own wings and join in the cavalcade, or even return directly to the heavenly homeland.

In 1492, Ficino selected Plato's description of Socrates's absorption in the Sun, backed up with material found in the writings of Dionysius, an acknowledged Christian source, and a host of references from the Egyptian and Greek sources and Arab astrologers, to produce a short book on the Sun.[40] It was a theme he had tackled before, expounding the sixth book of Plato's *Republic* in his *Symposium* commentary, *De amore*, and in his *Orphic Comparison of the Sun to God*.[41] Now, in 1492, it begins as a letter to the Count of Württemberg, building on the earlier material that compared the Sun to God in terms of an Orphic meditation,[42] now expanded and made explicitly Platonic. This was then published together with an enlarged version of an earlier work on light (one of the nine short Platonic treatises collected into Book II of his *Letters*) as *De sole et lumine*, printed in Florence by Antonio Miscomini in 1493. He warns us at the outset that we are to take this work as allegorical and anagogical.

In it, he takes the Sun as a symbol of centrality, the source of heat and light and of all the virtues.[43] Ficino's vision of centrality may not have been enough to inspire Copernicus – no direct evidence has been adduced – but if there were a link, it would be through this work.

> The philosophers of old [...] all place the Sun as lord in the middle of the universe, although for different reasons. The Chaldaeans put the Sun in the middle of the planets, the Egyptians between two five-fold worlds: the five planets above, the Moon and the four elements below. [...] According to another theory, the very prosperity of the planets declares that the Sun is in middle place. For them to prosper, their disposition to the Sun must be such that Saturn, Jupiter and Mars rise before it and Venus, Mercury and the Moon after it, making the Sun like a king in their midst as they progress [...]
>
> But let us return to the ancients. The old natural scientists called the Sun the heart of heaven. Heraclitus called it the source of celestial light. Most of the Platonists located the world soul in the Sun. Filling the whole sphere of the Sun, it pours out its rays through that fire-like globe, as though it were the heart. Through those rays, like spirits, it imparts life, perception and motion from there, through everything in the universe.[44]

Thus the Sun is filled with the world-soul, and our intellectual soul comes to us from the Sun, bringing life, the power of the senses, feeling and motion. While covering the astrological implications of the sun's path through the signs and the relationships of the planets to the sun, Ficino's main focus remains on the steadiness of the sun as a source of life and light. Light, he says, is a mysterious thing, "the vision of the heavenly soul," or "the action of vision reaching out to exterior things, but acting from a distance, not leaving the heavens, but ever continuing there unmixed with external things."[45] If we want to understand the angelic world or the world of unseen powers, rather than endless discussions, he says:

> Just look up at the heavens, I pray, O citizen of a heavenly homeland. [Look up at] the heavens made by God in the most orderly and open way for the very purpose of making all this clearly evident. And as you look up, on the instant, the heavenly bodies looking down on you will declare to you the glory of God through the rays of the stars, as through their own glances and nods, and the firmament will show you His handiwork.[46]

For Ficino, everything is linked in great Proclan chains of being: the sun, the swan, the hawk, the cock, the lion, gold, frankincense and heliotrope are all related to and all remind us of solar rays as expressions of the one light in different forms, not as separate things or objects.[47]

The light of the sun also creates colors, giving them the power to be seen and giving the eyes the power to see them.[48] As the sun transcends light and color, so does absolute good, or God, transcend the sun. Ficino invites the reader to ascend from the image to the original. Remove the material part of the sun and its fixed extent but keep the light, and keep its might. What remains is the light of consciousness, filling immense space with its presence. This light surpasses intelligence, and through it "you will appear to have almost reached God from the Sun, God who has set his tabernacle in the Sun."[49]

In the same chapter, he likens the physics of light, and its power to penetrate, to the action of divine love. Light penetrates crystal but not wool or a leaf. Similarly, "Divine light shines even in the darkness of the soul, but the darkness does not comprehend it."[50] And in another trope to which he will return both in his letters and in his St Paul commentary, he says, "God first plants the knowledge of divine things in angelic and blessed minds and thereupon kindles love; however he kindles love, which purifies and transforms, in us faithful souls down here, before he bestows the understanding of divine things."[51] This is because transparent and pure natures will be illumined on the instant, but denser ones will first be warmed, kindled and refined and only then illumined. The warmth makes them weightless, and the light makes them transparent, so they may then be lifted high aloft, into that upper world.[52]

The moon is presented as the sun's mirror. This gives especial potency to his use elsewhere of the image of moon as mind, for if the moon's light is the light of the sun reflected, the light of the mind is a reflection of God's light.

That light was the very first thing to be created (Genesis 1:3 "Let there be light"), and it is the light of pure intellect, filling the incorporeal heavens but emanating from there in many forms. The sun in the sky owes its brilliance to the fact that it has two measures of light: its own astral light ordained at the moment of its creation, and a further measure of divine light which it transmits, as it were, as the representative of the source of all light and intelligence.[53]

In chapter 12, the sun is the symbol of the One, the three, and the nine – that is, one God, the Trinity, and the nine superior gods, Muses or orders of angels. Finally, in chapter 13, he reminds us that the sun in the sky is only the symbol of what he is really talking about, for it moves through the sky, whereas the real source is unmoving. Socrates would not have been lost in contemplation of the sun in the sky that he saw rise every morning but only of another seen beyond – that is, the "Father of lights with whom is no variation or shadow of turning."[54]

Even while developing the visual analogies provided by the sun and the stars, Ficino is aware of the limitations of this method. Referring specifically to both *De sole et lumine* and *De vita*, he contrasts their approach with his more formal commentaries:

> By confusing what belongs to poetry with what to philosophy, I have, I admit, at times dilated too freely and with perhaps too much license. In my work on Plotinus I conduct myself in more sober and disciplined fashion.[55]

Moreover, as was noted at the outset, he sometimes proposes mind-emptying techniques to allow the intellect to contemplate the divine without image, without discursive thought, and certainly without mental perturbation.[56] But where rational discourse may fail, it is often the visual approach to which he turns to convey philosophical meanings that can be grasped by the imagination.

Some visual images have a power of their own: in *De vita*, he reports ancient views on the astrological talismans engraved with pictures of gods that harness the gods' power; he does not endorse such beliefs, but he does endorse belief in the unity and vitality of the cosmos, implying the validity of active correspondences between one part and another.[57] Colors play a part in this.[58] Green, the color of Venus, is restorative, not just because nature delights in it, but through the physiology of seeing. It gives rest from over-stimulation without having to withdraw totally from light.

The nature of sight is bright and friendly to light but volatile and easily dissipated. And on this account, while it dilates itself through light as through a friend, at the same time, through excess of too much light it is absolutely carried off and dissolved by great dilation. Darkness, however, it flees as an enemy and therefore draws in its rays to a narrow angle.[59]

Green is presented as a mean between white and black. Green things are also tender and soft, soothing "the liquid rays of the eyes."[60] Green is full of hidden light, hence green paint when thinned out resolves into croceum – a golden yellow, associated with Jupiter and the Sun.[61] In the third book, while discussing the making of a figure of the universe – an image to be constructed in bronze with silver gilding – he speaks of three universal colors: green, gold, and sapphire blue.[62] Green (being "moist") is associated with Venus and the Moon, with mothers and babies. Gold, of course, is associated with the Sun but also with Jupiter and Venus. Sapphire blue is special to Jupiter, though it is not clear how light or dark a blue Ficino had in mind: was it Gozzoli's azure sky? Or the deep blue of evening light before the stars appear? In fact, sapphires come in all shades, but the name sapphire may sometimes indicate lapis lazuli, which is often a deep vibrant blue, flecked with green and gold, carrying Jupiter's rays.[63] The colors themselves capture the gifts of the celestial graces.

Such an astronomical model when constructed (and he refers to two that have been constructed – one present, and one long past)[64] should not just be looked at but reflected on deeply. He also proposes constructing a chamber within one's own home, "vaulted and marked with these figures and colors, and he should spend most of his waking hours there and also sleep there." This will sharpen one's appreciation of the universe as a whole rather than the individual things of daily life. It will cultivate an orderly mind and temperate thoughts.[65]

Ficino also notes that the creation of the world was completed on a Friday, the day of Venus, signifying the perfect beauty of the work.[66] Beauty is not just a "gateway to the divine" but a prime motive force enabling the flow of love, which pours forth from God to the world, to turn and complete its cycle.[67] This is the beauty that for Edmund Spenser stands even higher than heavenly love.[68] In the letter to Lorenzo di Pierfrancesco that has been so often linked with the *Primavera*, Venus, the goddess of beauty, stands for human nature – *humanitas* – the ultimate 'bait' by which we can be caught and enraptured. She is a nymph of surpassing beauty:

> She was born of a heavenly origin and was beloved above others by an ethereal god. For indeed, her soul and spirit are love and kinship; her eyes are majesty and magnanimity; her hands are liberality and greatness in action; her feet, gentleness and restraint. Finally, her whole is harmony and integrity, honor and radiance.[69]

Love is often defined by Ficino as the "yearning for beauty",[70] and beauty is grace. Grace seems to be particularly connected with Apollo, Venus, and Mercury:

> For through the grace of harmony in music Apollo entices those listening; through the grace of color and form Venus captivates those watching; and through the wonderful grace of intelligence and eloquence Mercury turns men to himself [...] and fires them with love of divine contemplation and beauty. [...] It is through the yearning for this divine beauty that the mind, regaining its wings, flies back to its true home.[71]

These last two quotations certainly suggest that beauty is paramount. But are there fixed correspondences between these mythological figures or any of Ficino's allegorical symbols and their referents? On the contrary, Ficino is a master of the polysemous approach, allowing both writer and reader to develop layer upon layer of meaning.[72] As he puts it,

> The Christian theologians observe four senses in the divine Scriptures, the literal, moral, allegorical, and anagogical, and [...] they [...] pursue one sense here and another there. In the same way, the Platonists have four ways of multiplying the gods and spirits; and they pursue one way of multiplying here, another there, according to the occasion. I too have been accustomed in my commentaries similarly to interpreting and distinguishing the spirits, using one way here, another there, as context requires.[73]

What are the implications of this for interpretations of his thought in relation to the arts? Recent years have seen new studies moving beyond iconology to wider questions including art theory and artists of the early sixteenth century. In a series of studies presented to the Renaissance Society of America, though as yet unpublished, Cristina Neagu has explored Ficino's imagery with a view to discovering a theory of symbolic iconography in relation to Giordano Bruno's emblems, diagrams, and figures. She then found Ficino's concept of *furor divinus* reflected in several works of Albrecht Dürer, being used to imply extraordinary talent, communion with a transcendental world, and originality of inspiration. A further study noted connections between Leonardo's studies of proportion, Francesco Giorgi's ideas on microcosm, and Ficino's propositions about man's ascent towards God. She regards Ficino as one of the most articulate promoters of emblematic imagery and visual symbols used in the context of discursive enquiry. His symbols, she suggests, derive from cosmic laws and magically embody celestial essences with which the reader who rises to the challenge can connect.[74]

Marieke van den Doel contributed an important study on the influence of Ficino's discussion of imagination and divine frenzy upon artists and art theorists across two centuries through Lomazzo, Francesco de Holanda, Joachim von Sandrart and Samuel van Hoogstraten. She also underlined the popularity among them of Ficino's Hermes translations. In her view, Ficino's Platonic accounts are most perfectly embodied in Michelangelo's drawing *Dream of Human Life*, dating from 1533.[75] Maria-Christine Leitgeb weaves visual resonances into her interpretation of Ficino's Commentary on Plato's *Symposium* and his philosophy of Love.[76]

Even in iconology, the Platonic case was effectively restated by Francis Ames-Lewis in relation to works of the 1470s and 1490s,[77] and there is even perhaps still more to be said about the *Primavera* (see Figure 7.1 on page 138). As Gombrich predicted, "the files on this entrancing painting are never likely to be closed."[78] In recent years, it has been interpreted as an ambivalent discourse on Zephyr, daemons, inspiration, and the renewal of pagan ideas;[79] as a visual guide to the stages of spiritual ascent;[80] as an allegory of Choice, between earthly pleasures and the three gifts of faith, hope, and love, with Theology pointing the way;[81] and as an *imago mundi* of the sublunary and the supralunary worlds with Luna as the central figure.[82] All of these recent interpretations take Ficino's writings as their base, while some also give due recognition to Cristoforo Landino's commentaries as a source for many of the mythological referents. This is a useful step, since Landino worked in close collaboration with Ficino over many years.

To add my own small observation on the painting, I feel insufficient attention has so far been paid to the importance of the light behind the dark wood (itself reminiscent of Dante's *selva oscura*).[83] Whatever is going on between Zephyr, Chloris and Flora in the material realm, or the three Graces whose ethereal dance approaches Mercury in the realm of mind, the central figure, who seems to preside over the activities of the rest, is seen against a light that is external to the wood. Perhaps the central figure (Venus) also stands for soul, observing the play of thoughts, fears, and aspirations – both higher and lower – that unfolds within the mind. Her robe and that of Mercury are related by their coloring, and the little flame motifs on his are no doubt significant too. But the important thing is the light. Perhaps this is the nearest a painter can come to depicting the *lux* behind the *lumen* that lights the world, a distinction that Ficino was at pains to convey in his repeated allegories of the sun behind the sun in the sky. And perhaps Botticelli's depiction of a scene so filled with symbols of love and abundance played its part in assisting the spread of ideas on love articulated by the philosopher.

I have tried to outline some ways in which words and images enjoyed a reciprocal interaction in Ficino's writing, especially during the 1480s, around the time of the painting of the *Primavera*, and on into the 1490s. Some examples of allegory, from the light-hearted fables to the more profound allegories of the soul's ascent on wings and the role of the Sun as a source of light and life, symbolizing God's presence in the world, show how visual Ficino's thinking is at times. Ficino's sensitivity to color and image was also noted. If this has shed any light on how permeable the borders were between the visible and invisible worlds, it will have made a small contribution to the continuing debate surrounding the relevance of iconography to the study of art.

Notes

1 *Platonic Theology*, Proem, 1–2.
2 Chastel (1954/1975/1996, 49): "Il est de ces philosophes qui ont besoin des images et de myths pour stimuler le travail de l'esprit, tout en admettant que l'effort ultime de la conscience consisterait à s'en détacher." Chastel adds to this Ficino's instruction, given in the introduction to his Plotinus commentary, to "let go of matter, let go of sense perception, let go even of discursive reason. Be of that higher mind – first, your own higher mind, then divine mind." ("Dimitte materiam, dimitte sensum, dimitte rursus et rationem, intellectualis esto, atque intellectus primo tuus, deinde divinus." *Opera omnia*, 1576, 1641). I shall return to this later.
3 *Platonic Theology*, 3.1.14; 13.3.1. Although these references have a literary source (Pliny's *Natural History*), Ficino does not simply repeat them. For instance, in 3.1.14 he attempts to analyze what Apelles experienced when he embarked upon the painting of a meadow, distinguishing the moment of inspiration from the subsequent activity of observing and painting.
4 Ficino's *Preface* to his commentaries on Plato, Ficino, *Opera omnia*, 1576, 1129–30. See also *Letters*, 7:9–12.
5 Chastel (1954/975/1996, 53). The *Apologi* are in *Letters*, 6:17–22; 6:36–8 and 9:50–60; see also Allen (1995, VI). For the background to his writing them, see Letters 7:5–6.
6 Ficino's Plotinus commentary at *Ennead* IV, 8 (1580, 468), *De vita*, III, 26 (for all *De vita* references, see Ficino, *Three Books on Life*, ed. Kaske and Clark, 1989), *Platonic Theology*, XIII, 4. See also Toussaint (2011, 105–15); Rees (2011b, 122–8).
7 On beasts, see for example *Letters*, 3:59–62, based on Plato, *Republic*, IX, 588c–589c. The personae of ancient mythology are referred to throughout his writings.
8 *Letters*, 1:104 [74].
9 A fresco of S. Cristofano is mentioned in *Letters*, 8:28–9; the crucifix and newly restored frescoes of S. Maria degli Angeli, in *Letters*, 7:60–1.
10 E.g. *De vita*, II.14; III.11, 17, 19.
11 E.g. *Platonic Theology*, 1.1.3.

12 Wind (1958/1980, 127).

13 Lightbown (1989, 142).

14 *De amore*, III.3.

15 *Letters*, 6:32.

16 His influence on Lorenzo de' Medici's poetry is obvious and uncontroversial. See, for example, *L'altercazione*, translated as *The Supreme Good*, in *Selected Poems and Prose*, ed. Thiem (1991, 65–96) and the Commentary on his sonnets, *ibid.* (105–6). With Cristoforo Landino there was a rich mutual exchange of ideas. Ficino's interactions with Pico della Mirandola remain the object of intense study: Brian Copenhaver's recent work (2011 and 2019) sets straight the record that was deliberately skewed by Pico's nephew Gianfrancesco, his first biographer. On Ficino's pupils, for Giovanni Nesi, see Celenza (2001), and on Francesco Cattani da Diacceto, Fellina (2017). Reassessing the effects of Ficino's work on poets in France, Hungary and England continues in numerous works, including Ford (1997), Vasoli (2002), Jankovits (2006), Rees (2009). For Spain, see Byrne (2015). On the physical presence of Ficino's work in sixteenth-century England, see Rees (2009, 98–124).

17 *Letters*, 10:51.

18 The important initial stages in this debate can be followed through Panofsky (1939/1962) and Gombrich (1945/1972/1985). Wind (1958/1980) then modified the interpretation with a new Neoplatonic reading, but both were radically challenged by Horst Bredekamp (1986/1992).

19 Dempsey (1968), Lightbown (1989), Levi d'Ancona (1983) and others outlined alternative approaches. A new orthodoxy has prevailed since Dempsey (1992), which builds on the contribution of Aby Warburg in his dissertation of 1893 (1932/1999) and still accords prime importance to Poliziano. But see Gombrich (1945/1972/1985, 31–5). Rebecca Zorach, in a perceptive article highlights political considerations relating both to the painting and its interpreters. She reminds us of the absence of Apollo from this scene, proposing several plausible reasons for his omission (2007, 209). Against this, however, I shall suggest below that Apollonian light of inspiration is not altogether absent from the painting.

20 Ames-Lewis (2002) is an honourable exception to this. The fact that Ficino and Poliziano remained close friends despite their differences is shown by a letter written by Poliziano to Ficino in the summer of 1494, Ficino, *Letters*, 8:53–5. In it, Poliziano explains why he dislikes the epithet Hercules that Ficino keeps attaching to him but invites him to escape the summer's heat in his cottage in Fiesole, conjuring up a charming scene of rustic solitude.

21 Undeterred, some enthusiastic followers of Gombrich and Wind continued to uphold a Neoplatonic interpretation, including De Girolami Cheney (1985) and Foster and Tudor-Craig (1986, 41–56). By contrast, Ames-Lewis (2002) accepted non-Platonic interpretations of the *Primavera* but found compelling evidence for earlier Platonic art in Florence.

22 This phrase from Gombrich's original article of 1945 was endorsed by Panofsky and reiterated in the "Postscript as Preface" to the reprint of the article in *Symbolic Images*, 1972.

23 The examples already given in n. 3, 4 and 10 above include the picture (or pictures) that hung on the walls of Ficino's Academy, depicting Democritus laughing and Heraclitus weeping at the ways of the world (*Letters*, 1:104 [74]), passages on Praxiteles and Apelles (*Platonic Theology* 3.1.14; 13.3.1), and the frescoes of S. Maria degli Angeli and S. Cristofano in Novoli (*Letters*, 8:28 and *Letters*, 7:60–1); see also three passages on astronomical clocks: *Platonic Theology*, 13.3.1; *De vita* 3.19; *Letters*, 10:51.

24 *Platonic Theology*, Proem. 1.

25 *Letters*, 4:66–7. Copies were also addressed and sent to Lorenzo de' Medici and Bernardo Bembo.

26 *Ibid.*

27 *Ibid.* A literary parallel of this is found in the cantos of Book I of Spenser's *Faerie Queene*: the characters Una and Duessa represent virtue and vice and propel the narrative by inspiring the knights to action. Duessa has power to inspire only because her deformity is at times disguised.

28 *Letters*, 5:68. This letter was addressed to Lorenzo de' Medici in the earliest manuscript, though later manuscripts and printed editions refer it to Lorenzo di Pierfrancesco de' Medici.

29 Lucilia means 'little light,' indicating the human soul.

30 *Letters*, 6:22. Venus is here the goddess of sensual love or lust.

31 *Letters*, 6:17–8. Bartolomeo Scala wrote his first collection of 100 fables in 1481, with further collections in 1482, 1484, and 1494. See Brown (1997, 305–37 and 364–93).

32 *Letters*, 6:20–1.

33 These fables have also given birth to further responses of a visual kind, and some recent examples were included as illustrations to *Letters*, 6, published in the quincentenary year of Ficino's death. These include an oil painting by Jeffery Courtney capturing the rural idyll of Cupid's search for Venus, and Tanya Russell's bas-relief illustrating the fable of the Sun and Mercury. Other oil paintings by Jeffery Courtney and Charles Hardaker illustrate the other four *apologi* in this volume; a bronze plaque of *Philosophy* in the gardens of the Platonic Academy by Nathan David (1993) was inspired by Ficino's preface to his Plato commentaries, and a letter on the philosophic tradition inspired a further painting by Charles Hardaker.

34 Ames-Lewis (2002). For more on the Phaedran wings, see below. For the Phaedran charioteer, see Ficino, *Phaedrus* commentary (ed. Allen, 2008). On the frieze at Poggio a Caiano, see Acidini-Luchinat (1991 and 1993).

35 A study of variations in the representation of angels' wings around this time might yield interesting results. For example, while some angels are utterly ethereal, Michelangelo's muscular angel candelabrum, made in 1495 for the Ark of St Dominic in Bologna, looks strong enough to carry up human beings body and soul. See Rees (2013, 101–3).

36 See Rees (2008).

37 *Oxford English Dictionary*, 2004 citing *Chambers' Cyclopaedia*, 1727–51.

38 Plato, *Phaedrus* 246a.

39 Plato, *Phaedrus*, 246–9; Ficino (2008, 66–81); Allen (1984, 86–143).

40 *De sole*, see Rabassini (2005).

41 Plato, *Republic*, VI, 507d–509b; Ficino, *De amore*, 2.2; *Letters*, 5:44–7.

42 *Letters*, 5:44–7.

43 *De Sole* 6, *Opera*, 968–9.

44 *Ibid*. In this passage, Ficino does seem to be moving from the idea of a middle position in an array to a definition of true centrality.

45 *De sole*, 2, *Opera*, 966.

46 *Ibid*.

47 *De vita*, III, 1, 94–107.

48 *De sole*, 9, *Opera*, 971.

49 *Ibid*.: "Quoniam vero ab imagine ad exemplar partim adimendo quod deterius est, partim addendo quod melius, ascendere licet, de me si placet Soli, cui materia subtraxit Averrois, tu certam similiter quantitatem, sed interea cum luce relinque virtutem, ut supersit lumen ipsum mirifica virtute refertum, nec quantitate certa, nec figura aliqua definitum, ideoque immensum imagination spatium sua circum praesentia tangens. Ita nunc excedens intelligentiam, sicut in seipso nunc exuperate aciem oculorum. Hac ferme ratione Deum, qui in Sole posuit tabernaculum suum, ac Sole pro viribus invenisse videberis."

50 *Ibid*.: "Ita divinum lumen etiam in tenebris animae lucet, sed tenebrae non comprehendunt." Cf. St John 1:5.

51 *Ibid*.: "Quod Deus angelicis beatisque mentibus scientiam divinorum prius inserit, mox amorem. Animus vero nostris hic untrunque credentibus amorem accendit purgantem atque convertentem, antequam divinorum intelligentiam la[r]giatur."

52 *De sole*, 9, *Opera*, 971. See Ficino, *St Paul Commentary*, Preface, *Opera*, 425.

53 *De sole*, 11, *Opera*, 972.

54 *De sole*, 13, *Opera*, 975, citing Epistle of James 1:17.

55 *Letters*, XII, *Opera*, 958: "Denique tam in libris de vita quam de Sole & lumine cum Philosophicis poetica miscens, liberius sum interdum & forte licentius evagatus, cum Plotino parcius severius ago, ut mihi tandem non ingratum sit futurum, Astrologica portent fuisse a Pico nostro Mirandula singulariter confutata." This letter to Poliziano is an important statement about Ficino's use of astrology. See Chastel (1954/1975/1996, 54) and Rees (2016).

56 See n. 2 above. Other instances include *Letters*, 5:25. *Platonic Theology* 6.2.4, St Paul Commentary, *Opera*, 425. See also Plotinus, *Enneads*, 5.8.9.

57 *De vita*, III.18–20 (1989, 332–55) and its *Apologia* (1989, 394–401), published also in *Letters*, 8:37–41.

58 Ficino's remarks on color are spread through the second and third books of *De vita*. As far as I know, no one has yet connected his views on color with the painters' craft. This would be a difficult task, since much of what he conveys in *De vita* is taken from older traditions. His

views are not as comprehensive as Telesio's attempt to define color some decades later in *Libellus de coloribus*, 1528, but they are still informative. Part of Ficino's *De vita* was sometimes published with that book.

59 *De vita*, II, 14 (1989, 205). For more on Ficino's physiology of sight, see Kodera (2002) and Albertini (1997).

60 *De vita*, II, 14 (1989, 205).

61 *De vita*, II, 14 (1989, 207).

62 *De vita*, III, 19 (1989, 342–9).

63 Sapphire is identified in Ezekiel 1:26 and 10:1 as the color of God's throne, though modern commentators have asserted that the Hebrew סַפִּיר (*saffir*), rendered in the Septuagint as σάπφειρος, was almost certainly lapis lazuli, which also comes in a wide range of hues. Sapphires can also be yellow, greenish or even pink, though deep pink or red sapphire is known as ruby.

64 The recent model he refers to was by Lorenzo della Volpaia, on whom see Toussaint (2002) and Brusa (1994). The earlier model was that of Archimedes: *Platonic Theology*, 13.3.1. See Cicero, *De republica*, 1.14. Cicero suggests that there were two models in ancient times but describes here the more detailed one.

65 *De vita*, III, 19 (1989, 347). Such a chamber was constructed for King Matthias Corvinus in the palace at Buda, see Rees (2011a, 142). Unfortunately it did not survive.

66 *De vita*, III, 19, 23.

67 Gombrich (1945/1972/1985, 43).

68 *Fowre Hymnes*. Rees (2009, 86–8).

69 *Letters*, 4:63. For Gombrich (1945/1972/1985), this letter was the key to interpreting the painting. For Thomas Moore (1982), it is the key to a whole system of archetypal psychology.

70 Following Diotima's formulation in Plato, *Symposium*, 206. This view pervades Ficino's writings, but see esp. *Letters*, 1:84–5 [54–5]; 6:55–6; *Phaedrus Commentary* and *De amore* (passim).

71 *Letters*, 6:56.

72 Besides two distinct Venuses, two forms of Bacchus and a Saturn who is harsh and demanding on the one hand but liberating and supportive on the other, Ficino's interpretations encourage a whole range of possibilities. For Venus and Saturn, see, for example, Allen (2008 and 2010).

73 Ficino, *Phaedrus* Commentary, X.1 (tr. Allen, 2008, 81–83).

74 "Woodcuts and Magic: Ficino's Theory of the Image and Giordano Bruno," "Drawing the Text: the concept of Ficino's *furor divinus* as Reflected in the Works of Albrecht Dürer" and "Reading Between the Lines: Ficino and the Vitruvian man," presented to the Annual Meetings of RSA in 2006, 2010 and 2012 respectively.

75 Van den Doel (2008).

76 Leitgeb (2010).

77 Ames-Lewis (2002).

78 Gombrich (1945/1972/1985, Bibliographical Note to the Third Edition, x).

79 Berry (2005).

80 Van den Doel (2008). She emphasizes evidence relating to the twin powers of the imagination, which connect the soul with matter and carry it to the divine.

81 Poncet (2008). The choice – whether of Lorenzo or, equally, the painting's viewer – leads to contemplation. Poncet proposes Simonetta Cattaneo (as an embodiment of Dante's Beatrice) as the model for the central figure, here taken as a personification of theology.

82 Dee (2013). Dee's interpretation also embodies choice and connects with Dante, but in his view the entire tableau centres on Luna, or Isis, not Venus or humanity. He does, however, interpret Luna as the moving mind, following Ficino's letter to Lorenzo di Pierfrancesco (*Letters*, 4:63).

83 *Divine Comedy*, Inferno, 1.2.

Bibliography

Acidini-Luchinat, Cristina. 1991. "La Scelta dell'Anima: la vita dell'iniquo e del giusto nel fregio di Poggio a Caiano." *Artista* 3:16–25.

Acidini-Luchinat, Cristina. 1993. "In the Sign of Janus." In *Renaissance Florence The Age of Lorenzo de' Medici, 1449–1492*, exhibition catalogue. London, 1993–1994, edited by Cristina Acidini-Luchinat, 139–141. London and Milan: Charta.

Albertini, Tamara. 1997. *Marsilio Ficino: Das Problem der Vermittlung von Denken und Welt in einer Metaphysik der Einfachheit*. Munich: Fink.

Allen, Michael J. B. 1984. *The Platonism of Marsilio Ficino: A Study of his Phaedrus Commentary, its Sources and Genesis*. Berkeley: University of California Press.

Allen, Michael J. B. 1995. *Plato's Third Eye: Studies in Marsilio Ficino's Metaphysics and its Sources*. Aldershot: Variorum.

Allen, Michael J. B. 2008. "The Birth Day of Venus. Pico as Platonic Exegete in the *Commento* and the *Heptaplus*." In *Pico della Mirandola: New Essays*, edited by Michael V. Dougherty, 81–113. Cambridge: Cambridge University Press.

Allen, Michael J. B. 2010. "Marsilio Ficino on Saturn, the Plotinian Mind, and the Monster of Averroes." *Bruniana & Campanelliana* XVI, 1:11–29.

Ames-Lewis, Francis. 2002. "Neoplatonism and the Visual Arts." In *Marsilio Ficino: His Theology, His Philosophy, His Legacy*, edited by Michael J. B. Allen and Valery Rees with Martin Davies, 327–328. Leiden: Brill.

Berry, Philippa. 2005. "The Voice of the Daemon: Inspiration and the Poetic Arts in Botticelli's *Primavera*." *Sillages critiques* 7:13–26.

Bredekamp, Horst. 1986. "Götterdämmerung des Neuplatonismus." *kritische berichte* 14, 4:39–48. Reprinted 1992 in *Lesbarkeit der Kunst. Zur Geistes-Gegenwart der Ikonologie*, edited by Andreas Beyer, 75–83. Berlin: Wagenbach.

Bredekamp, Horst. 1988. *Botticelli Primavera: Florenz als Garten der Venus*. Frankfurt am Main: Fischer.

Brown, Alison. 1997. *Bartolomeo Scala: Humanistic and Political Writings*. Tempe: Medieval & Renaissance Texts & Studies.

Brusa, Giuseppe. 1994. "L'Orologio dei Pianeti di Lorenzo della Volpaia." *Nuncius* 9:645–649.

Byrne, Susan. 2015. *Ficino in Spain*. Toronto: University of Toronto Press.

Celenza, Christopher. 2001. *Piety and Pythagoras in Renaissance Florence: The Symbolum Nesianum*. Leiden: Brill.

Chastel, André. 1954/1975/1996. *Marsile Ficin et l'Art*. Geneva: Droz. Repr. 1975 and 1996.

Copenhaver, Brian P. 2011. "Studied as an Oration: Readers of Pico's Letters, Ancient and Modern." In *Laus Platonici Philosphi: Marsilio Ficino and His Influence*, edited by Stephen Clucas, Peter J. Forshaw, and Valery Rees, 151–198. Leiden: Brill.

Copenhaver, Brian P. 2019. *Magic and the Dignity of Man: Pico della Mirandola and His Oration in Modern Memory*. Cambridge and London: Harvard University Press.

De Girolami Cheney, Liana. 1985. *Botticelli's Neoplatonic Images*. Potomac: Scripta Humanistica.

Dee, John. 2013. "Eclipsed: An overshadowed Goddess and the Discarded Image of Botticelli's *Primavera*." *Renaissance Studies* 27, 1:4–33.

Dempsey, Charles. 1968. "*Mercurius Ver*: The Sources of Botticelli's *Primavera*." *Journal of the Warburg and Courtauld Institutes* 31:251–273.

Dempsey, Charles. 1992. *The Portrayal of Love: Botticelli's Primavera and Humanist Culture at the Time of Lorenzo the Magnificent*. Princeton: Princeton University Press.

Fellina, Simone. 2017. *Alla scuola di Marsilio Ficino: Il pensiero filosofico di Francesco Cattani da Diacceto*. Pisa: Scuola Normale Superiore.

Ficino, Marsilio. 1493. *Liber de sole et lumine*. Florence: Antonius Mischominus. Repr. 1576 in *Opera omnia musicula*, vol. 1, 965–975.

Ficino, Marsilio. 1561/1576. *Opera omnia*, 2 vols. Basel: ex officina Henricpetrina. Repr. Turin, 1959, 1962, 1979, 1983; Paris, 2000.

Ficino, Marsilio. 1975–. *The Letters of Marsilio Ficino*, translated by members of the Language Department of the School of Economic Science, London, 10 vols. to date. London: Shepheard-Walwyn. [Letters are cited by volume and page number of this version, unless they are not yet in print, in which case the book is indicated by its Latin sequence, with a page number from the *Opera omnia*. A revised edition of vol. 1 was published in 2018, and page references to this are given in square brackets after those of the first edition.]

Ficino, Marsilio. 1989. *Three Books on Life: A Critical Edition and Translation*, edited and translated by Carol V. Kaske and John R. Clark. Binghamton: Center for Medieval & Early Renaissance Studies.

Ficino, Marsilio. 2001–6. *Platonic Theology*, translated by Michael J. B. Allen and edited by James Hankins and William Bowen, 6 vols. [I Tatti Renaissance Library]. Cambridge, MA: Harvard University Press.

Ficino, Marsilio. 2002. *Commentaire sur le Banquet de Platon, de l'Amour* [De amore], edited and translated by Pierre Laurens. Paris: Les Belles Lettres.

Ficino, Marsilio. 2008. *Commentaries on Plato. Vol. 1: Phaedrus and Ion*, edited and translated by Michael J. B. Allen [I Tatti Renaissance Library 34]. Cambridge, MA: Harvard University Press.

Ford, Philip. 1997. *Ronsard's Hymnes: A Literary and Iconographical Study*. Tempe: Medieval & Renaissance Texts & Studies.

Foster, Richard, and Pamela Tudor-Craig. 1986. *The Secret Life of Paintings*. Woodbridge: Boydell Press.

Gombrich, Sir Ernst H. 1945/1972/1985. "Botticelli's Mythologies: A Study in the Neoplatonic Symbolism of His Circle." *Journal of the Warburg and Courtauld Institutes* 8:7–60. Repr. 1972 with a new Preface in Ernst H. Gombrich. *Studies in the Art of the Renaissance, vol. 2: Symbolic Images*, 31–81. London: Phaidon. 2nd ed. 1985 with a new bibliographical note. London: Phaidon.

Hankins, James. 2007. "Ficino, Avicenna and the Occult Powers of the Soul." In *Tra antica sapienza e filosofia naturale: La magia nell'Europa moderna*, 2 vols., edited by Fabrizio Meroi with Elisabetta Scapparone, vol. 1:35–52.

Hankins, James. 2008. "Marsilio Ficino and the Religion of the Philosophers." *Rinascimento* n.s. 48:101–121.

Jankovits, László. 2006. "Plato and the Muses at the Danube: Platonic Philosophy and Poetry in Janus Pannonius's *Ad Animam Suam*." In *Acta Conventus Neo-Latini Bonnensis*, edited by Rhoda Schnur, 379–87. Tempe: Medieval & Renaissance Texts & Studies.

Kodera, Sergius. 2002. "Narcissus, Divine Gazes and Bloody Mirrors: The Concept of Matter in Ficino." In *Marsilio Ficino: His Theology, His Philosophy, His Legacy*, edited by Michael J. B. Allen and Valery Rees with Martin Davies, 285–306. Leiden: Brill.

Leitgeb, Marie-Christine. 2010. *Concordia mundi: Platons Symposion und Marsilio Ficinos Philosophie der Liebe*. Vienna: Holzhausen.

Levi d'Ancona, Mirella. 1983. *Botticelli's Primavera: A Botanical Interpretation including Astrology, Alchemy and the Medici*. Florence: Leo S. Olschki.

Lightbown, Ronald W. 1989. *Sandro Botticelli: Life and Work*. London: Thames and Hudson.

Medici, Lorenzo de'. 1991. *Selected Poems and Prose*, edited by Jon Thiem. University Park, PA: Pennsylvania State University Press.

Moore, Thomas. 1982. *The Planets Within: Marsilio Ficino's Astrological Psychology*. Lewisburg: Bucknell University Press.

Panofsky, Erwin. 1939/1962. *Studies in Iconology: Humanistic Themes in the Art of the Renaissance*. New York: Harper & Row. Repr. 1962.

Plato. 1914. *Phaedrus*, edited and translated by Harold North Fowler [Loeb Classical Library]. Cambridge, MA: Harvard University Press.

Plotinus. 1580/2005. *Opera omnia*. Basel: Ad Perneam Lecythum. Repr. 2005. Villiers-sur-Marne: Phénix Ed.

Plotinus. 1966–1988. *Enneads*, edited and translated by A. H. Armstrong, 7 vols. [Loeb Classical Library]. Cambridge: Harvard University Press.

Poncet, Christophe. 2008. "The Judgment of Lorenzo." *Bruniana & Campanelliana* XIV, 2:541–561. [Expanded in 2012 as *La Scelta di Lorenzo: La Primavera di Botticelli tra Poesia e Filosofia*. Pisa: Serra.]

Rabassini, Andrea. 2005. "L'Analogia Platonica tra il sole e il bene nell'interpretazione di Marsilio Ficino." *Rivista di storia della filosofia* 60:609–630.

Rees, Valery. 2008. "*A bono in bonum omnia diriguntur*: Optimism as a Dominant Strain in the Correspondence of Marsilio Ficino." *Accademia* 10:7–27.

Rees, Valery. 2009. "Ficinian Ideas in the Poetry of Edmund Spenser." *Spenser Studies* XXIV:73–134.

Rees, Valery. 2011a. "Marsilio Ficino and the Rise of Philosophic Interests in Buda." In *Italy & Hungary: Humanism and Art in the Early Renaissance*, edited by Péter Farbaky and Louis A. Waldman, 127–148. Milan: Officina Libraria.

Rees, Valery. 2011b. "The Sulphur and the Flame." *Temenos Academy Review* 14:117–135.

Rees, Valery. 2013. *From Gabriel to Lucifer: A Cultural History of Angels*. London: Tauris.

Rees, Valery. 2016. "Celestial Bodies in the Writings of Marsilio Ficino." In *Heavenly Discourses*, edited by Nicholas Campion, 111–117. Ceredigion, Wales: Sophia Centre Press.

Toussaint, Stéphane. 2002. "Ficino, Archimedes and the Celestial Arts." In *Marsilio Ficino: His Theology, His Philosophy, His Legacy*, 307–326. Leiden: Brill.

Toussaint, Stéphane. 2011. "Zoroaster and the Flying Egg: Psellos, Gerson and Ficino." In *Laus Platonici Philosophi: Marsilio Ficino and His Influence*, edited by Stephen Clucas, Peter J. Forshaw and Valery Rees, 105–115. Leiden: Brill.

Van den Doel, Marieke. 2008. *Ficino en het Voorstellingsvermogen: Phantasia en Imaginatio in Kunst en Theorie van de Renaissance*. Amsterdam: St. Hoofd-Hart-Handen.

Vasoli, Cesare. 2002. "Sugli inizi della fortuna di Ficino in Francia: Germain e Jean de Ganay." In *Marsile Ficino ou Les Mysteres Platoniciens: Actes du XLIIe Colloque international d'études humanistes, Centre d'études supérieures de la Renaissance, Tours 7–10 juillet 1999*, edited by Stéphane Toussaint, 299–312. Paris: Les Belles Lettres.

Warburg, Aby. 1893/1932/1999. *Sandro Botticellis 'Geburt der Venus' und 'Frühling': Eine Untersuchung über die Vorstellungen von der Antike in der italienischen Frührenaissance*. Hamburg and Leipzig: Leopold Voss. Repr. 1932 in Aby Warburg, *Die Erneuerung der heidnischen Antike: Kulturwissenschaftliche Beiträge zur Geschichte der europäischen Renaissance*, vol. 1, 1–58. Leipzig: Teubner. English translation 1999 as "Sandro Botticelli's 'Birth of Venus' and 'Spring': An Examination of Concepts of Antiquity in the Italian Early Renaissance." In *The Renewal of Pagan Antiquity: Contributions to the Cultural History of the European Renaissance*, translated by David Britt, 223–262. Los Angeles: Getty Research Inst. for the History of Art and the Humanities.

Wind, Edgar. 1958/1980. *Pagan Mysteries in the Renaissance*. London: Faber and Faber. Rev. ed. 1980. Oxford: Oxford University Press.

Zorach, Rebecca. 2007. "Love, Truth, Orthodoxy, Reticence; or, What Edgar Wind Didn't See in Botticelli's *Primavera*." *Critical Inquiry* 34:190–224.

4 Negotiating Neoplatonic Image Theory

The Production of Mental Images in Marsilio Ficino and Giovan Battista della Porta's Magic Lamps

Sergius Kodera

This article discusses selected aspects of image-making in traditional erudite Renaissance natural magic, focusing on the sixteenth-century transformation of a set of prominent theories synthesized in the last decades of the fifteenth century by Marsilio Ficino. Ficino's works on magic, especially the *De vita libri tres* (1489),[1] had their biggest impact on various intellectual cultures of the Renaissance in approximately the hundred years that followed. Cases in point are Giovan Battista della Porta's numerous books on natural magic and physiognomics, where he adapted Ficino's ideas, albeit towards different practical ends. Ficino's sophisticated intellectual magic, and his elaborate theories concerning the crucial role of signs and their production,[2] were inserted by Della Porta into a context that effectively subverted Ficino's contemplative intentions, given that Della Porta highlighted certain practical and manipulative applications of a natural magic that Ficino had sought to elide.[3] The following, therefore, emphasizes less the coherence of this tradition in erudite magic,[4] focusing instead upon the drastic revisions in perspective that *Magia naturalis* underwent at Della Porta's hands – revisions which were nevertheless still in basic, or rather complementary, accordance with Ficino's theories.

In doing this, I will examine one particular instance where the process of image-making becomes linked to a set of material objects – magic lamps. Whereas for Ficino such objects constituted a rather vague analogy for illustrating the intricate workings of demons who influence the minds of their victims, Della Porta's *Magia naturalis* describes in great detail their practical use towards actively manipulating human perception.[5] Looking at Porta's recipes, we can assess the extent to which Ficino's sophisticated theories become translated into a different intellectual, social and historical context. Della Porta's approach is characterized by a constant attention to the physical preconditions allowing for histrionic, spectacular manifestations of the portentous qualities inherent in certain physical bodies – whether human, animal, or vegetable. In their *Wonders and the Order of Nature*, Lorraine Daston and Katherine Park have pointed to both Della Porta's deep interest in the marvelous and his concern with demonic arts.[6] Della Porta belonged to an influential group of what Daston and Park have labeled "preternatural philosophers."[7] Within this tradition, Della Porta developed a "sublime science" catering to a courtly environment: "[...] wonder became a reflection not of ignorance but of virtuosity and connoisseurship: the product not only of great experience and erudition, but also of impeccable taste."[8] Della Porta's *scienza* accordingly emphasizes practical instructions, recipes, remedies, and devices of various kinds.[9] Indeed, his insistence on a categorically somatic foundation of experience seems to me a strikingly cohesive thread along which his scientific as well as his literary work can be understood.[10]

In contrast to Della Porta's magic, Ficino's *De vita* may be characterized as a health regimen for elderly scholars.[11] In general, Ficino was concerned with the creative powers of the human soul to shape (and therefore be responsible for) its *own* body. Therapy consisted largely of various habitual forms of auto-suggestion and dietary regimes, while its main goal was the spiritual improvement of the individual human soul, and secondarily the well-being of the vessel or prison it inhabits, the body. Ficino developed a sophisticated theoretical account for his magic-medical practices, which highlighted the solely natural efficacy of certain talismans and amulets.[12] In the *De vita*, as well as for instance in Books 13 and 18 of the *Theologia Platonica*, Ficino elaborated an intricate theory of images – communication at a distance, as it were – explaining how celestial figures, planetary images, signs and vapors (as their more material manifestations and vehicles) could be used in non-demonic ways to improve one's own health, also including an account of such phenomena as divination in sleep.[13] Ficino believed that these pneumatic images influenced the imagination, which he considered a low faculty of the human soul. In the imagination, these magical images materialize in a vaporous subtle body, the most refined product of the blood, the so-called *spiritus*. Existing in different degrees of refinement in human beings, the *spiritus* was believed to be responsible for transmitting all manner of forms, from divination to contagious diseases such as infatuation and the shapes of future children. According to Ficino, *spiritus* has the power to shape the body it inhabits according to the habits of a particular soul.[14]

Ficino contends that it is the task of the learned magus to know and to exploit these occult relationships, thereby channeling astrological influx into the body. Such transactions were confined to the material part of the human soul, whereas the divine and immortal soul – which was at least theoretically independent of any material constraints – remained free. This is why our immortal souls can be held accountable for their deeds. In his *Disputatio contra iudicium astrologorum*, written in 1477, probably immediately after the publication of his *Theologia Platonica*, Ficino writes:

> The body acts directly only onto another body and by physical virtue. But the intellect and the will are immaterial virtues; which is evident because they are entirely abstract and tie themselves to the material world only abstractly. Therefore I maintain that the heaven does not act upon them directly. But it acts directly on the body, and indirectly on the sense, because the latter is physical, but [the heaven] in none of these ways acts on the intellect. Even so, intellect and will may assent to the inclinations of the senses.[15]

This is a clear expression of an anti-determinist stance on astrology; and from the perspective of potential ecclesiastical censorship, such ideas seem to be quite orthodox. Ficino advocates a form of 'natural astrology' that is opposed to the (illicit) form of judicial astrology (which makes definite predictions of future human actions and destiny).[16]

Ficino's Pneumatic Hell

Ficino also applies his theory of demonic illusions within another context. In his account of the retribution for sins in the next world, products of the human imagination become the decisive factor. In a well-known (yet still mind-boggling) passage from the eighteenth book of the *Theologia Platonica*, Ficino maintains that after death, sinful immortal human souls will be vexed by their own *phantasmata*:[17] accordingly, hell is the product

of an individual's own fancy. It is a fitting place for souls which, while they were still alive, were not willing to observe the divine laws' abstract splendor, instead coming under the sway of shadowy, seductive images of the physical world – the very images the stars and the demons employ towards enticing the lower parts of our souls in the hope that our minds will follow their physical inclinations. Ficino explains this process in an unusual way: he says that when an individual dies, the soul commences rebuilding a fine vaporous body – the medium in which the terrifying *phantasmata* appear having obsessed the human being while she/he was still alive. Now dead and left without sensory organs, the soul is still capable of a kind of hallucinatory perception.[18] But what *kind* of images would the soul encounter in this phantasmatic hell? Ficino has an interesting answer:

> If one asks what is the shape of that [vaporous] body, our reply will be that, according to the Magi, various images of various animals are shaped from such vapors. For the [intemperate] soul imitates the life of any one animal in its manner of living, and whatever that animal's shape is, such primarily is the shape it fashions for itself. [...] And thus perchance we must understand the transformation among the ancients of men into beasts. [...] The first such perturbations of this soul resemble the perturbations of those who deliriously rage in a fever or are made subject to fear by a melancholic humor.[19]

More generally speaking, Ficino's idea that hell is a phantasmagoric experience interlocks neatly with the belief – again Platonic in origin – that our souls have a capacity to constitute their own physical appearance by means of *spiritus*. Spiritus/pneuma is the instrument by means of which souls control the constitution (*complexio*) of their bodies – that is, the mixture of the bodily fluids which shape the outward appearance of the individual.[20] Therefore, and conversely, our outward appearance is indicative of our inclinations, the latter being most characteristically expressed in the shapes of animals. In a feat of circular reasoning generally characteristic for magical discourses, the shapes of animals thus become the most salient signs for the physical and emotional dispositions of humans; this idea is also reflected on a macrocosmic level, since the world itself is considered to be a huge animal.[21] Moreover, Ficino's vision of an individual, pneumatic hell conveniently accounts for the (notoriously difficult) Platonic doctrine of the transmigration of human souls into the bodies of animals.[22] From the above quote we also learn that in rages and fevers, the animal nature of the human individual comes to the fore.

For Ficino as well as for Plato, these porous boundaries between the human and animal realms constituted an important corollary and confirmation of the art of physiognomy.[23] Yet, as we have seen, Ficino believed that the contemplative soul could effectively shun (at least to a certain degree) those physical inclinations transmitted by alluring images. Even so, the embodied human being is in no position to completely elide these signifiers; they are a necessary precondition for souls entering into a relationship with the physical world. The soul is lured into a body because of its beauty – an idea crucial to the practice of natural magic: namely, most (if not all) of the natural magic outlined by Ficino consists in creating certain baits (*escae*),[24] which are carefully arranged material substances designed to attract the attention of certain higher beings (humans, stars, demons), who then would impress their occult powers into that object. This object could be a talisman but also a fetus, or the human *spiritus*, the medium of the human imagination. Due to its volatility, the *spiritus* was considered to be especially malleable and therefore susceptible to external influence.[25] Indeed, Ficino seems to have believed

that this pattern of communication did not only apply to humans but also to higher beings, such as demons. In his *Iudicium* against astrology, one reads an interesting account of how certain demons are capable of producing such phantasmatic images. Referring to the ninth book of Augustine's *Civitas Dei*, Ficino writes:

> Be aware that the demon cannot disclose future events or teach anything else from what is poured in[to our minds] by a species or by the intelligible light; [he rather communicates with us] by putting together, by separating and by transforming the *phantasmata* above the light of his active intellect, as though he would illuminate them by a lamp which has certain colors put in front of it. The soul, illuminated by phantasmata in such ways is thus moved to what the demon wants to show, yet in order to perceive this, [the soul] has to direct its intention above [the realm of] the phantasmata and to connect them with the intellectual species.[26]

Here, Ficino explains how demons communicate with human beings. In the preceding pages, he had sought to prove that our soul may act independently from its deceptive *phantasmata*, since the higher parts of the human soul are in direct communication with angelic minds; therefore, all planetary demons can do is to influence our independent minds through more or less sophisticated *physical* means. With interesting echoes of the light projections from Plato's cave myth (*Republic* 514–18), Ficino here demonstrates how the crafty display of images may move human beings to certain actions. Spectacular in the true sense of the word, the demon is somehow converting his soul into a (magic) lamp. Hence, the demon also diverts his intellectual energy to this lamp – to what we would call today a slide projector depicting seductive *phantasmata* (although, as we shall presently see, this is a slightly misleading analogy). Thus demons attempt to influence our mental disposition by means of visual effects. Yet in order to understand these light-shows, the human mind must make use of its own cognitive powers, and is thus not unconditionally subjected to the potentially malign influence of demonic communication. I would suggest that Ficino aims at creating what Aby Warburg would have called a *Denkraum*, a space for reflection and for negotiation that allows the beholder to enter into a relationship with powerful and therefore potentially deceiving images. Like Ficino, Warburg emphasizes that this process does not necessarily entail immediate identification with that image – a state of mind which for both authors would signify a kind of psychotic hell.[27] As we shall see presently, Della Porta aims at creating just such hallucinatory states, where it becomes impossible for the beholder to step back.

Ficino's ideas are related to a broader conceptual framework: the infusion of intellectual light, developed by Augustine and later becoming influential in Florentine Quattrocento philosophy through Bonaventura's version.[28] In other instances, Ficino refers to the opinion of the Chaldean Magi, according to whom some souls have the capacity of producing a luminous body that would in turn lift their own bodies up into the sky.[29] However, Ficino's attribution of this idea to the ninth book of the *Civitas Dei* is incorrect; there is no passage that even remotely refers to these remarkable ideas on the nature of demons – not even in the eighth book, which concerns demons in the proper sense. The same is true of Augustine's opusculum *De divinatione daemonum*, to which Thomas Aquinas also refers.[30] There, Augustine merely remarks that demons are lacking in the divine and eternal wisdom of angels and that they are only capable of dealing with mutable things in time.[31] I take this conspicuous absence from the *Civitas Dei* as evidence that Ficino considered his outline of demonic communication to be crucial (which would also be why he ascribed it to

this most important church father) – but at the same time, his reference to Augustine may also indicate he was aware that his detailed account of illicit and heretic practices was controversial.[32]

Be that as it may, Ficino's account of demonic communication fits well into his description of hell: just as the damned soul suffers from images of its own making, so the demon transforms itself into a magic lamp, a medium for (more or less) seductive and impressive images.[33] We find ourselves here in a thicket of assumption and analogies creating a veritable *schlitterlogik*, in Aby Warburg's famous term.[34]

This mode of reasoning was intertwined with the ceremonial use of certain material objects, in this case magical lamps. In this context, it is important to keep in mind that the Neoplatonic tradition of Renaissance magic generally subscribed to a theory of vision that is quite different from ours. In the *De vita*, the analogy between demonic soul and magical lamp is echoed by Ficino's notion of how the stars communicate their messages: the celestial bodies function as eyes that do not only see but also are emitting rays which are in turn the causes of occult properties in both material objects and human beings.[35] The idea that eyes do not only receive visual rays but also emit fine particles is Platonic in origin (*Timaeus*, 45 CD), which will recur later in this article. An important corollary to this ancient theory of vision is that such rays may assume very different forms: not only synonymous with demons in some instances, rays may also become visible – for instance, as intense vapors – due to their affinity with *spiritus*.[36] Celestial rays are endowed with this amazing capacity because they are alive, and hence able to act directly upon the human *spiritus*, the medium in which our imaginations acquire a semblance of material body. Ficino contends that since these rays are alive, they are therefore unlike lamplight (*non enim inanimati sunt sicut lucernae radii*).[37]

Despite this disclaimer, it is worthwhile trying to reconstruct Ficino's theory of cosmic interaction by looking at the concrete objects to which this set of elusive analogies refer –namely, lamps and the optical phenomena that were believed to be caused by them.

Della Porta's Magic Lamps

Like the majority of his contemporaries, who considered themselves to be learned natural magicians, Della Porta was aware of the most sophisticated Renaissance treatise on Neoplatonic magic;[38] indeed, he plagiarized significant passages from the *De vita*[39] into his *Magia naturalis*. Yet as far as I can see, that occurs only in the second edition of Della Porta's *Magia naturalis*; the first version (comprising four books and appearing in 1558) had become a bestseller without this theoretic apparatus.[40] In what follows, I refer mainly to this first edition of the *Magia*. Lamps were indeed important magical objects, and in order to emit a kind of light that differed from ordinary lamps, they had to be prepared in pre-determined ways for ritual uses.[41] It comes as no surprise that such lamps also constitute an important subject in the first edition of Della Porta's *Magia naturalis*, which has a long and instructive series of chapters on this topic.[42] Yet the context is different: as opposed to Ficino, Della Porta's main goal is to describe the *mise-en-scene* of marvelous events and objects which are designed to produce extraordinary physical effects in the spectators. Della Porta begins his account of magical lamps with instructions for how to color faces in various ways. In order to produce green faces, the *Magia naturalis* recommends the use of lamps fueled by extracts of dead green animals, such as toads or green plants. A modern reader would probably ask why the author does not mention stained glass. And indeed, as we shall presently see, Della Porta's illusions are

not exclusively caused by what we would understand as optical effects. Rather, they are created by the transmission of forms via *spiritus*: in order to be rendered visible, they require a kind of physical, pneumatic contact with the beholder. As in Ficino's *De vita*, ordinary lamps will not do the trick, because their light is not alive. In order to render it an effective magical tool, Della Porta mixes the lamp oil with essences he has extracted from various animals, just as he does in a series of decidedly more spectacular recipes immediately following in the *Magia*:

> But if you wish people to have heads of horses or of asses, you are embarking on a difficult work; nevertheless painstaking attention will help you to overcome the difficulty of this issue. Cut off the head of a horse or of an ass that are alive – in order that the virtue [of it] be not feeble – and have a pot prepared that is large enough to fit [the head] in, fill it to the brim with oil and lard, and close [the pot] with a strong clay, and expose it for three days to a gentle fire, in order for the oil to form a broth and the boiled meat to be absorbed by the oil until the bones [the cranium] lay bare; crush them in a mortar and mix the powder with the oil; with it, you have to anoint thoroughly the heads of the bystanders. Similarly fill the lamps with that oil and put into their center some thin wicks made of coarse flaxen, neither too far apart nor too near, but as you need them, and you will see that they will appear with monstrous faces. And from this you can learn how to put together many things, but it appears to me to have said enough, for an attentive reader.[43]

These instructions are followed by a very similar recipe stipulating a freshly severed human head; instead of visions of animals with human heads, bystanders will appear as humans with animal heads.[44] Such recipes were apparently very well known, but they were also contested – eliciting, for instance, the scorn of one expert magus, Heinrich Cornelius Agrippa von Nettesheim, who in his famous *Declamation on the Vanity of All Arts and Sciences* scathingly remarks that certain jugglers cause sense deceptions through natural means, thereby fooling their audiences by "changing men into asses."[45] Della Porta's comedies also contain ironic illusions to such techniques.[46] And indeed, as recent research has shown, these kinds of magical experiments had a ludic character: they were a form of "social play,"[47] taking their place in a genre of party-gags-after-dinner shows by tricksters – familiar since classical antiquity.

Still, Della Porta's experiments with lamps also supply an eerie echo to Ficino's notion of a personalized form of hell. As in Ficino's hell, the soul is vexed by hallucinations depicting men turned beasts and beasts turned men. Della Porta's techniques for creating compulsive visions may indeed be read as exemplary of the ways Ficino believed that demons – through such compulsive visions – attempt to influence human minds to commit certain actions. As we shall presently see, Della Porta's recipes for such hallucinations go back at least to Pliny – which makes it not improbable that Ficino was also aware of them. If so, Ficino may have consciously or unconsciously modeled his notion of a pneumatic hell upon the same tradition of recipes Della Porta expounded.

It is useful to put these gruesome recipes into a historical context: even though decidedly too long for one of Jamie Oliver's cooking classes, they are of course typical Renaissance recipes, somewhere in the middle between medical prescription (electuary) and cookbook – albeit with a very different intention. Della Porta's concoction neither instructs us how to heal or how to nourish a needful body, nor is it a sort of spargyric medicine; instead, it is about creating hallucinations. The idea that certain magic lamps

could do such tricks is very old indeed. Della Porta mentions one Anaxilaus as a source for such magical lamps,[48] and indeed Pliny's *Naturalis Historia* refers to the same author. Pliny reproduces a very rudimentary instruction for creating appearances using lamps fueled by "the fluid that comes from mares when covered" (though not with the 'essences' of human or animal heads).[49] This passage is quoted in Agrippa von Nettesheim's *De occulta philosophia*, already one of Della Porta's important sources in his first edition of the *Magia naturalis*. There, the substance that creates the hallucination is considered a powerful *materia magica*.[50]

As far as I can see, the immediate source in the medieval Western magical tradition for this special kind of magical lamp is the Byzantine *Cyranides* or *Liber Kyrranidarum*, which stipulates that in order to see people with asses' heads one must burn the "tears of an ass" in a lamp.[51] The passage is quoted for instance in Thomas Cantimpratensis *Liber de natura rerum*, with one addition: that guests "at the banquet" will appear in the lamplight with heads of asses – indicating the use of this recipe as a party gag.[52] Thorndike reports that a version of the same recipe is referred to several times in medieval and even in seventeenth-century natural magic.[53] Another important source was the Pseudo-Albertine *De mirabilibus mundi liber*,[54] an enormously popular collection of recipes containing one long section covering a wide range of magical lamps.[55] Here we find another version of our recipe: "If you want that human heads appear as asses' heads, take from the sperm of asses and rub it onto the human head."[56]

From this outline of precedents for Della Porta's recipe, a few interesting details emerge. The older recipes prescribe 'essences' naturally produced by the animals in question: male and female sperm but also tears[57] to be used as lamp fuels for inducing visions of this particular animal. Other recipes used a different method: here, the active substance (sperm of asses) is applied directly to the body of the beholder by rubbing it onto his or her scalp. Della Porta combined both methods: his recipes prescribe both burning the essence of the animal and simultaneously rubbing it onto the foreheads of his audiences.[58] Unlike Pseudo-Albertus, Della Porta does not use sperm but rather an extract of animal (or human) brains to cause the illusion. Thus, his recipes are a quite sophisticated combination of different magical traditions; instructions stipulate that the practitioner must be an expert in the production of essences (which are more powerful than the natural thing, just as wine spirit is more powerful than wine).[59] Moreover, he arranges the lanterns' wicks in special ways, presumably in order to improve the quality of the optical illusion created by the essences.

Apart from improving the traditional recipes, Della Porta's versions thereof systematically apply Renaissance Neoplatonic image theory. Ficino also holds that the quintessence of certain animals can be used to medicate the human body; in the *De vita*, he maintains that these essences can be distilled from different forms of matter, and he also explicitly mentions the use of brains – but he recommends this with the intention of strengthening our cerebral faculties rather than creating illusions in the style of Della Porta.[60] Hence, distillation constitutes one important aspect of the process; vision is the other. The perceptive phenomena described by Della Porta are not caused exclusively by optical illusions: his magical lamps function beyond what we would call today slide projectors. Hallucinatory vision originates from substances with occult properties that are meant to be rubbed into the scalp and simultaneously burned in the lamps in order to create the desired hallucinatory visual effects. When considered against the backdrop of the Platonic theories of vision that were endorsed and propagated by Ficino, Della Porta's gruesome recipes can be more easily understood as a systematic application of that

doctrine to practical ends. Both authors believed that visual perception is possible through an exchange of two kinds of rays – one entering the eye, the other being emitted in the form of a "stream of vision." Visual perception, therefore, comes about in the course of an exchange between material rays, vapors of some kind that are entering and exiting the cranium.[61] Visual perception is a form of touch.[62] Ficino and Della Porta both held that it is this material exchange of subtle yet material substances that is accountable for falling in love, for the transmission of diseases, and for the *malocchio* (evil eye) in general.[63] Strictly speaking, vision is thus an exchange of small material particles that are constantly emitted from all objects (this idea of course being Lucretian in origin).[64] According to Ficino, the emissions of *spiritus* may materialize in different degrees of refinement; they may, for instance, become odors, the products of fumigations, or any other kind of dense, even poisonous air. These vapors transmit a low form of the essence or the species of the objects from which they originate. When assessed in their proper context, Della Porta's beliefs that essences when transmitted to the beholder via lamp-light and direct contact will generate particular hallucinations make perfect sense.[65]

Against this conceptual backdrop, we are now in a position to understand why Della Porta maintains that he can influence the visual perceptions of his audiences (or rather, of his victims). He not only employs a lantern with many wicks fueled by the essence of the object his audience is meant to perceive (humans with asses' heads or vice versa); this essence is also applied to the heads of the spectators. Della Porta's recipes describe the production of essences (a kind of material species) derived from the heads of animal cadavers or human corpses with the highly concentrated essence of a horse's head thus creating kindred hallucinations when burned then rubbed on spectators' heads: the fumigation of a horse's head carries some kind of image with itself. Hence, Della Porta aims at short-circuiting and thus controlling the process of vision (which consists, as previously noted, in an exchange of rays). He does so by exposing the beholder to essences of one animal from the two sources of our perceptions – the brain, and the original cause of our perceptions (i.e., the vapors emitted by the magic lantern).

What emerges from Della Porta's gruesome kitchen? A potion that, due to its natural affi-nities with one animal, causes what we would call today hallucinations, visions of humans with animal heads or animals with human heads – at the very least, a spectacular, somewhat disreputable party gag. It is particularly remarkable that Della Porta's recipes for magical lamps promise to give the beholder not merely hallucinations but very definite apparitions: animals with human heads or the other way round. I would also cautiously suggest that these transactions via images employing various sorts of magical lamps could be incorporated into our understanding of Renaissance visual art. By this, I do not only mean we should be aware of the sophisticated methods of projection or illumination employing optical tools that some Renaissance artists seem to have used. With Panofsky's understanding of iconology in mind,[66] I would also like to point to the possibility that some contemporary art works (such as Car-avaggio's) could be taken to represent human beings under the influence of their individual temperamental/somatic dispositions – dispositions which could in turn be altered, at least temporarily, through the recipes we have just encountered.[67] Following this line of argument, I perceive such art works as the projections of an individual's complex interior somatic states onto an outside medium and vice versa – just as so many Renaissance physiognomists descri-bed the process in their texts. I can only mention in passing that Della Porta was one of the foremost theoreticians (and, if one believes him, practitioners) of the art of physiognomy in his day – and that mares and asses play a very peculiar role in his ideas on the cross-breeding between those animals and human beings.[68]

To sum up: in Ficino's terms, Della Porta is raising hell on earth, with the soul not vexed by horrifying images of animals that are the products of its own sinful inclinations. Della Porta behaves as the demon in Ficino's account, with the goal of altering his audience's perceptions and thus moving them to certain actions. I read this complex of ideas and related magical practices as exemplifying the Platonic doctrine of soul transmigration or an enactment of what demons do as according to Ficino. His demons' souls, as well as those of the damned, must use their own bodies and intellectual energy to perform their (voluntary or involuntary) acts of delusion.

For Della Porta, the magus does not use his *own* body to create these apparitions; instead, he employs material substances to produce hallucinatory optical phenomena. The magus thus outsources, as it were, those very capacities Ficino had identified as the result of an individual soul's interior and creative process. Della Porta's recipes cohere with Ficino's theories of pneumatic sensation, and their approaches to and uses of these pneumatic theories are complementary. Ficino developed his sophisticated account of natural magic in the context of a contemplative philosophy, seeking personal answers to questions of his own physical health from this life to the next with its imaginary hells (or noetic paradises). What will (hopefully) have become clear is the distance that separates Ficino's and Della Porta's approach to those images. We could say that Ficino's sophisticated account of Platonic theories of vision, demonic communication, *spiritus* and the *phantasmata*, a century after their publication, still lent credibility to dubious recipes, *segreti*, simply because they were appearing in a theoretically coherent form.[69] Given the long tradition of Della Porta's recipes for magical lamps, it is very likely that Ficino was aware of them and that his ideas about a pneumatic and individual inferno where human souls are endowed with animal natures are modeled on those recipes.

Notes

1 On the *De vita*, see Caske and Clarke's introduction to Ficino (1989), and Weill-Parot (2013, 638–75).
2 For a brilliant introduction to the topic in general, see Copenhaver (2007), which qualifies the thesis of Copenhaver (1984); see also the discussion in Weill-Parot (2013, 645–9).
3 Copenhaver (1998, 455–6) has pointed out that Della Porta, in fact, inherited many of these ideas from Agrippa von Nettesheim's *De occulta Philosophie* (1533); on this topic, see also Zambelli (2007, 30–1).
4 See Zambelli (2007, 13–34).
5 Ficino is generally very reluctant to divulge magical recipes, see for instance *De vita*, III, 21; Ficino (1989, 354–5): "Itaque ad duos ardentissimo quodam amore conciliandos imaginem sub Luna coeunte cum Venere in Piscibus vel Tauro fabricabant, multis interim circa stellas verbaque curiosius observatis, quae referre non est consilium; non enim philtra docemus sed medicinas."
6 Daston and Park (1998, 160): "The objects of preternatural philosophy coincided with the traditional canon of marvels. They included both the results of occult action, such as magnetic attraction and the reputed power of the amethyst to repel hail [...] and rare individual phenomena, such as bearded grape vines, celestial apparitions, and rains of frogs and blood." *Ibid.*, 162: "Demonology was in some ways the alter ego of preternatural philosophy, for demons also worked marvels."
7 Daston and Park (1998, 159–64).
8 Daston and Park (1998, 170).
9 On the magician as artisan, see Eamon (1994, 217); on Porta's recipes, Eamon (1994, 219–21). The term *segreto* alters in meaning from an anti-rationalist notion of "divinely revealed secret" to the "technical recipes that exploit the occult forces of nature without understanding" them,

to the seventeenth-century experimenters' program of actively and systematically uncovering the hidden workings of nature and its laws; see Blair (1996, 178).

10 On Della Porta's concept of the imagination, see Kodera (2018).

11 This is in accordance with the Platonic tradition, see *Timaeus*, 88A-E.

12 Walker (1958b, 38–50).

13 On the doctrine of images, see *Theologia Platonica* 13, 2, 11–23 and 13, 5, 4 (Ficino 2001–6, vol. 4: 134–48, 212–4); Ficinos *Commentaria in Platonis Sophistam*, in: Allen (1989, 275): "Synesius autem Platonicus noster in libro de somniis apertius expressisse. Vult enim in corpore sensibilem speciem esse cum materia simul extentam adeo ut, dum materia quaedam vaporalis per meatus exhalat, interim cum hac et species mixta procedat; hinc igitur effectum esse ut, sicut species ipsa Graece dicitur idos, sic et effluxus e corpore speciali idolon appelletur, quasi ex specie specimen speciesve tenuis." See also Michael Allen (1989, 185–6) for illuminating comments. See Kodera (2010, 86–8); Kodera (2009, 168–9); Felinella (2010, 270–9).

14 *Spiritus* has paradoxical qualities: it is neither entirely spiritual nor utterly material. *De vita* III, 3; Ficino (1989, 256): "Ipse [sc. spiritus] vero est corpus tenuissimum, quasi non corpus et quasi iam anima, item quasi non anima et quasi iam corpus." For Ficino's doctrine of *spiritus*, as more or less embodied garments of the soul, see introduction to Ficino (1989, 41–2), Walker (1958b, 4–8, 12–14, 48–50), Walker (1958a), Bolzoni (2001, 131–78), Kodera (2004), Kodera (2009). On the rather elusive distinctions between the different ancient concepts of vision and Ficino's precarious relationship to Lucretius' materialistic theory of vision, see Allen (1989, 193–5), with references; Hub (2008).

15 Ficino (1937, 74): "Corpus non agit directe nisi in corpus et virtutem corporalem. Intellectus autem et voluntas sunt virtutes immateriales, quod patet quia abstahunt omnia et abstracta diligunt. Ergo celum non agit in ista, dico directe. Agit autem directe in corpus, reflexe in sensum quia corporalis, in intellectum vero neutro modo. Sed potest intellectus et voluntas sensui inclinato assentiri." For another passage on the ways in which the heavens communicate with inferior regions "quasi litteris" (by letters, as it were), thereby leaving our free will intact, see *Theologia Platonica*, 9, 5, 18; Ficino (2001–6, vol. 3, 52–4). For the larger context of this quote, see also *De vita*, III, 1; Ficino (1989, 244), where Ficino maintains that the soul is allured by certain baits, beautiful or well-arranged bodies: "Nemo rursum miretur per materiales formas animam quasi allici posse, siquidem escas eiusmodi sibi congruas ipsamet, quibus allicetur, efficit, et semper libenterque habitat in eisdem. Neque in mundo vivente toto quicquam reperitur tam deforme, cui non absit anima, cui non insit et animae munus. Congruitates igitur eiusmodi formarum ad rationes animae mundi Zoroaster divinas illices appellavait, quas et Synesius magicas esse illecebras confirmavit." On the (central) idea of well-prepared matter as a precondition for the channeling of astrological influence into talismans as well as human beings, see also the interesting remarks on Pietro d'Abano made by Weill-Parot (2013, 524–5).

16 Illicit because this form was believed to be available to human beings only through the intercession of demons. Yet the distinction between these two forms of divination remained elusive, and it was difficult to enforce a ban on these arts, especially in the latter half of the sixteenth century, when attempts at regulation became more intensive. See Baldini (2001, esp. 83–5).

17 The chapter was long ago brilliantly presented by Klein (1960) and was more recently the topic of a series of exciting papers by Allen (1984, 218–20), Allen (2002). See also Hankins (2005).

18 Let me mention only in passing that this is the archetypal narcissistic predicament. On Ficino's ideas about Narcissus, see for instance *De amore*, VI, 17; Ficino (1956, 235). See Kodera (2010, 65–73).

19 *Theologia Platonica*, 18, 10, 12–13; Ficino (2001–6, vol. 6, 192–4): "Si quaeratur qualis sit corporis illius figura, respondebimus secundum Magos varia simulacra diversorum animalium ex huiusmodi vaporibus fieri. Qualis enim quaelibet animalis vitam moribus imitata est, talem in primis sese facit, talisque omnino eius affectio et dispositio appareret, si sensu aliquo cerneretur. Talem quoque figuram quodammodo in umbroso ipsius corpore fingit, si modo ex affectu et habitu animae vehementi colorari possit leve corpus et figurari. [...] Atque ita forte intelligenda est apud veteres hominum in bestias transformatio. [...] Tales sunt enim primae animae huius perturbationes, quales sunt eorum qui delirant phrenesi propter febrem, aut eorum qui melancholico terrentur humore." See also Kristeller (1964, 359–64); Weill-Parot (2013, 500–31).

20 See for instance, *Theologia Platonica*, 13, 4, 6 (Ficino 2001–06, vol. 4, 190) with *Timaeus*, 44 B–C, and 86 D–E.

21 On that idea in Ficino, see below n. 39.

22 See *Timaeus*, 91–2.

23 See *Timaeus*, 90E–92B.

24 On the concept of baits, see n. 15 above.

25 *De Vita*, III, 20; Ficino (1989, 352). See also the presentation in Weill-Parot (2013, 664–7).

26 Ficino (1937, 27): "Nota quod demon non potest vel relevare futura vel alia docere ex eo quod speciem aliquam vel lumen intellectui infundat, sed quia phantasmata componit et dividit et transformat super ipsa lumen sui intelectus agentis quasi per lucernam quandam coloribus appositam illustrat. Ita per phantasmata illuminata animam ad ea que vult monstrare movet, cui tamen ad hoc ut percipiat necessaria est intentio convertens se super phantasmata et coniungens spetiem intellectui." On this passage, see also Zambelli (1991, 133).

27 On the concept of *Denkraum*, see Warburg (2010, 629). See Russel (2007, 29–30), with many references; Zumbusch (2004, 120–1).

28 For a relevant passage, see, for instance, *Theologia Platonica*, 18, 8, 21 (Ficino 2001–6, vol. 6, 146) where Ficino explains the difference between the human mind's natural ray (*radius naturalis*) and a light poured in from the divine (*lumen infusum divinitus*). The light used by the demon is thus presumably generated by the *radius naturalis*. For a short introduction to Bonaventura's philosophy of light, see, for instance, Luscombe (1997, 11 and 92).

29 *Theologia Platonica*, 13, 4, 15–6; Ficino (2001–6, vol. 4, 204–6). On this passage and on the concept of levitation in Ficino in general, see Toussaint (2011, 108–12).

30 See, for instance, *Summa Theologiae*, I, q. 89, a. 7, arg. 2–5, and, in general, the questions 85–89 in the *Prima pars*.

31 *Civitas Dei*, 9, 22 (*Patrologia Latina*, vol. 41, col. 274): "Daemones autem non aeternas temporum causas et quodammodo cardinales in Dei Sapientia contemplantur; sed quorundam signorum nobis occultorum majore experientia multo plura quam homines futura pospiciunt. Dispositiones quoque suas aliquando praenuntiant. Denique saepe isti, nunquam illi omnino falluntur. Aliud enim est temporalibus temporalia et mutabilibus mutabilia conjectare, eisque temporalem et mutabilem modum suae voluntatis et facultatis inserere, quod daemonibus certa ratione permissum est; aliud autem in aeternis atque incommutabilibus Dei legibus, quae in eius Sapientia vivunt, mutationes temporum praevidere […]."

32 The following passage from Ficino's paraphrase of Michael Psellus *De daemonibus* (in Ficino 1576, 1941 [941]) is indicative of the optical tricks (*res specularius*) that demons use to deceive human beings: "Sicut enim aer praesente lumine colores, et formas accipiens traducit in illa, quae naturaliter accipere possunt; sicut apparet in speculis, rebusque quasi specularibus: sic et daemonica corpora suscipientia ab ea, quae intus est, essentia phantastica figuras, atque colores, et quas[i]cunque ipsi voluerunt formas in ipsum animalem, nostrumque spiritum transmittunt, multa nobis negotia praebent, voluntates, et consilia suggerentes […]."

33 This is also reminiscent of Ficino's ideas that the Magus is using his own body like a mirror. As Michael Allen has shown in connection with the *Sophistes* commentary; Allen (1989, 170–2).

34 See Warburg (2010, 642). See Gombrich (1948, 176), Gombrich (1978, 173).

35 On the relationship of this set of ideas to Empedocles' metaphor of the eye as a lamp (Fragment 84, ed. Diehls) and Aristotle's rejection of this same idea (as well as of Platonic theories of vision in general), see Vasiliu (1997, 162–83).

36 See, for instance, *De vita*, III, 23; Ficino (1989, 376): "Hi [scil. sfrenati et imprudenti] namque malorum pleni daemonum vel radiorum malefici sunt, et tanquam leprosi pestilentesque non solum tactu nocent, sed propinquitate etiam et aspectu. Sane propinquitas ipsa corporum animatorum putatur esse contactus propter efficacem vaporum exhalationem foras a calore, spiritu, affectu manantem." See *De vita*, III, 20; Ficino (1989, 352).

37 *De vita*, III, 16; Ficino (1989, 322): "Sed quis nesciat virtutes rerum occultas, quae speciales a medicis nominantur, non ab elementali natura fieri, sed coelesti? Possunt itaque (ut aiunt) radii occultas et mirabiles ultra notas imaginibus imprimere vires, sicut et caeteris inserunt. Non enim inanimati sunt sicut lucernae radii, sed vivi sensualesque tanquam per oculos viventium corporum emicantes, dotesque mirificas secum ferunt ab imaginationibus mentibusque coelestium vim quoque vehementissimam ex affectu illorum valido motuque corporum rapidissimo; ac proprie maximeque in spiritum agunt coelestibus radiis simillimum."

38 On the reception of Ficino's work by the Neapolitan intellectual community, see Soranzo (2011), who traces the controversial ways in which Ficino's ideas were received from early on and gives an overview of the scholarship on the topic.

39 See Zambelli (2007, 28–33) for a list of many other plagiarisms committed by Della Porta in the *Magia naturalis*. Here is just one important example: *De vita*, III, 26; Ficino (1989, 386): "Quo quidem attractu secum ipso devinciri mundum testantur sapientes Indi, dicentes mundum esse animal passim masculum simul atque feminam, mutuoque membrorum suorum amore ubique coire secum, atque ita constare; [...]. Hinc Orpheus naturam ipsam mundi Iovemque mundanum marem appellat et feminam. Usque adeo mutui partium suarum coniugii ubique mundus est avidus. Esse vero masculinum sexum feminino ubique commixtum, declarat illinc quidem ordo signorum, ubi praecedens perpetuo deinceps ordine masculinum est, subsequens femininum [...]." See Della Porta (1589/1650, 23).

On the world as one huge animal that comprises within itself a multitude of living beings, see *Timaeus*, 30C. As Kaske and Clarke (editors and English translators of the *De vita*) have noted, this passage is remarkable for Ficino because "[...] whereas in his earlier work, the cosmic love, like the human love was a spiritualized homosexual one of the like-for-like, in the *De vita* [Ficino] has made love one of heterosexual opposites which lasciviously attract. [...] A notion which one misses in the *De vita*, if one comes to it fresh from Ficino's *Commentary on the Symposium*, is his famous rediscovery, the doctrine of 'Platonic Love,' the idea that affection between two friends, a non-orgasmic love of the sort he attributes to Plato [...] can be spiritually uplifting." Ficino (1989, 29–30). On the history of the analogy between microcosm and macrocosm, see Ficino (1989, 40).

40 On the wide diffusion, numerous translations into vernacular languages, and differences between the two editions of the *Magia naturalis*, see Balbiani (2001).

41 See, for instance, the late medieval classic text on magic, *Clavicula Salomonis*, II, 12 (1909, 104–5). On that text, see, for instance, Boudet (2010, 127–9).

42 See Della Porta, *Magia naturalis*, II, 17 (1561, fol. 64r–67r) and below.

43 Della Porta, *Magia naturalis*, II, 17 (1561, fol. 65r–65v): "Si vis autem, vt Equina, vel asinina videantur astantium capita, Difficile aggrederis opus: vincat tamen operis, sedulitas rei difficultatem: Equo abscinde caput vel asino, non mortuo, ne languida sit virtus, eiusdemque capacitatis fictilem fabricato ollam, oleo plenam, suique pinguedine, vt supermineat: os operculo, tenacique munias luto, ignem sub lentum, vt planè bulliens tribus servetur diebus oleum, elixataque caro in oleum currat, vt nuda spectentur ossa: pila tundito, pulvisque oleo permisceatur, quibus astantium capita perungantur: similiter in lampadibus stupei funiculi in medio statuantur, nec propè, nec longè vt res postulat, & monstruoso spectaberis vultu. Ex iis multa discas componere: satis enim dixisse videor, si diligens fuerit intuitior."

44 Della Porta, *Magia naturalis*, II, 17 (1561, fol. 65v): "Ex humano vpite [sic: capite] recenter obtruncato electum oleum, animalibus faciem hominis inducit, sic variis animalium capitibus, monstrosiora reddes corpora, si iis accensis liciis illustretur domus, quod fido claude pectori, nam vti arcana ab antiquis celabantur, nec ita faciliter ex eorum eruitur dictis."

45 Agrippa von Nettesheim (1584, unpaginated), cap. 48, *De praestigiis*: "Huc spectat enim quidquid de hominum transmutationibus legitur decantatum à poetis creditum ab historicis, [...] Sic apparent homines asini vel equi, vel alia animalia oculis fascinantis, quod perturbato medio, idque arte naturalis." For the uses of human body parts in Renaissance medicine, see Sugg (2011, 9–37).

46 Della Porta (2000–3, vol. 3, 337), *Astrologo*, act 1, sc. 3: "Fa nascere [il mago] in un subito in testa ad uno uomo un par di corna più grade di uno cervo. – Ogni donna maritiata lo sa fare. – Fa diventare li uomini bestie, asini e becchi, e le donne vacche e scrofe. – Ci diventano senza l'arte ogni giorno."

47 Dupré (2007, 83–4), with many references. Dupré explains that "The jocular and the demonic were mutually complementary forces in Renaissance culture" (84).

48 Della Porta, *Magia naturalis*, II, 17 (1561, fol. 65v): "ALITER tamen docet Anaxilaus nec irritè: Equorum virus à coitu accipitur, novisque lampadibus ellychniis accensum, hominum capita, equina visui monstrifice repræsentat: de asinis sic quoque proditur."

49 *Naturalis historia*, 28, 49, 181; Pliny (1963, vol. 8 124–5): "Equarum virus a coitu in ellychniis accensum Anaxilaus prodidit equinorum capitum visus repraesentare monstrifice, similiter ex asinis. [Anaxilaus has informed us that the fluid coming from mares when covered, if ignited on lamp wicks, reveals weird appearances of horse's heads, and similarly with asses.]"

50 Agrippa supplies a long list of authors who wrote on magical lamps in his *Occulta philosophia*, 1, 49; Agrippa von Nettesheim (1991, 178–9): "Fiunt etiam artificialiter lumina quaedam per lampades, lychnos, candelas et eiusmodi ex certis quibusdam rebus et liquoribus, ad stellarum normam opportune electis et ad eorundem congruitatem inter se compositis; quae, quando accendentur atque solae lucent, solent nonnullos mirabiles et coelestes producere effectus, quos saepe homines admirantur, quemadmodum ex Anaxilao narrat Plinius equarum virus a coitu in lychnis accensum equinorum capitum visum monstrifice repraesentare; simile etiam fieri ex asinis […]. Et dicunt 'Quando uvae sunt in flore, si quis circumligarit illis phialam plenam oleo et dimiserit ita donec fuerint maturae, illuminato illas postea in lampade, facit videre uvas'; idem valere etiam in caeteris fructibus […] Huiusmodi plures consimiles lychnos et lampades narrant Hermes et Plato et Chyrranides et ex posterioribus Albertus in quodam tractatu de hoc singulari."

51 *Liber Kyrranidarum*, Book II, Letter O, *Peri Onoi* (On the ass); Mély (1902, vol. 3, Fasc. 1, 88): "Après avoir mélangé des larmes d'âne à l'huile, verse-la dans une lampe et allume-la, tu verras ceux qui seront attablés avec une tête d'âne, et ils se verront de même entre eux." For a succinct introduction to this collection of magical texts and its use, see Copenhaver (2006, 529–31); see also Weill-Parot (2013, ch. 2).

52 *Natura rerum*, 4, 2; Thomas Cantimpratensis (1973, 108): "Lacrima eius [sc. Asini] cum oleo concussa et mixta in lucernam et accensa, omnes in convivio videbunt haere capita asinina."

53 Thorndike (1923–58, vol.7, 599) reports that Gaspar Schott in his *Magia universalis*, I, 206, 37 (Bamberg: Schönwetter, 1677) cites William of Auvergne (*De universo*), who "teaches that, if a banquet is lighted solely by a candle made of the semen of an ass and wax, all guests will seem to have the heads of asses. Actually William expresses scepticism to this." I wish to thank Berthold Hub for this reference. On the structural analogy between distilled essences (especially *aqua ardens*) to semen, see Kodera (2012, 145–6), with references.

54 Pseudo-Albertus, *De mirabilibus* (1598, 286–327). The earliest surviving manuscripts are from the late thirteenth century. The text may have been composed by a student of Albertus; see Thorndike (1923–58, vol. 4, 722–3 and 729).

55 See Pseudo-Albertus, *De mirabilibus* (1598, 221–34) for all sorts of recipes for magical lamps, and this is what Agrippa probably has called an "entire treatise" on the subject (see n. 50 above). For instance, Pseudo-Albertus has a recipe with the faces of animals in a lamp (221) and a recipe with serpent's fat that will cause the spectator to see a house full of snakes (232).

56 Pseudo-Albertus *De mirabilibus* (1598, 222): "Si vis ut caput hominis caput asini videatur; tolle de segmine [sic] aselli, & unge hominem in capite."

57 See Siraisi (1990, 110). On tears as the product of a physiological distillation process, see Kodera (2012, 146).

58 On the connection between distilled substances and sperm in alchemical treatises, see Kodera (2012, 145–6).

59 On Della Porta's ideas on distillation, see Kodera (2012, 144–148).

60 *De vita*, III, 1; Ficino (1989, 246): "Potest autem quinta haec essentia nobis intus magis magisque assumi, si quis sciverit eam aliis elementis immixtam plurimum segregare, vel saltem his rebus frequenter uti, quae hac abundant puriore praesertim; […] Praeterea sicut alimenta rite in nobis assumpta per se non viva rediguntur per spiritum nostrum ad vitae nostrae formam […] Si volueris ut alimentum rapit prae caeteris formam cerebri tui […] simile quantum potes accipe alimentum, id est, cerebrum, […] animalium ab humana natura non longe distantium."

61 *Timaeus*, 45C–46B. For a recent and well-informed reconstruction of the material nature of vision in classical philosophy, see Hub (2008, 302–15). *Timaeus*, 45 B-E reads in Plato (2009, 1173): "And the organs they first contrived the eyes to give light, and the principle according to which they were inserted was as follows. So much of fire as would not burn, but gave a gentle light, they formed into a substance akin to the light of everyday life, and the pure fire which is within us and related thereto they made to flow through the eye in a stream smooth and dense, compressing the whole eye and especially the center part, so that it kept out everything of a coarser nature and allowed to pass only this pure element. When the light of day surrounds the stream of vision, then like falls upon like, and they coalesce, and one body is formed by natural affinity in the line of vision, wherever the light that falls from within meets with an external object. And the whole stream of vision, being similarly affected in virtue of similarity, diffuses the motions of what is touches or what touches it over the whole body, until they reach the soul, causing that perception which we call sight. But when night comes on and the external and kindred fire departs, then the stream of vision is cut off, for

going forth to an unlike element it is changed and extinguished, being no longer of one nature with the surrounding atmosphere which is now deprived of fire, and so the eye no longer sees, and we feel disposed to sleep." Ficino presents this passage in a long commentary in *Appendix in Timaeum*, ch. 30; Ficino (1576, 1472–4).

62 For an elegant discussion of the Aristotelian origins of this idea and its contexts in Renaissance magic, see Copenhaver (2006, 534–5). See also *Occulta philosophia*, I, 16 and 50; Agrippa von Nettesheim (1991, 36 and 180–2). This Platonic theory of vision stands in opposition to the "perspectivist" medieval tradition, which originated in the West with the influence of Alhazen, whose approach worked simply with intromission of rays. See Lindberg (1976, 58–86).

63 See, for instance, Ficino, *Theologia Platonica*, 13, 4, 8–9 (2001–6, vol. 3, 192–6). On the medieval medical tradition, see Cabré and Salmón (1998); on this and the Renaissance, see Hub (2016).

64 See for this and the following, *De rerum natura*, IV, vv. 54–64 and 687–731.

65 *De vita*, III, 20; Ficino (1989, 352): "Ego vero odores quidem tanquam spiritui aerique natura persimiles, et, cum accessi sunt, stellarum quoque radiis consentaneos arbitror […] non solum in proprium corpus agere, sed propinquum, praesertim natura conforme quidem, sed debilius, et consimili quadam afficere qualitate." On different kinds of odours and their effects, *Appendix in Timaeum*, ch. 60–1; Ficino (1576, 1476–7). See also Kodera (2010, 166).

66 Panofsky had argued that iconology is about iconography in a deeper sense, that is "The discovery and interpretation of these 'symbolical' values (which are generally unknown to the artist himself and many even emphatically differ from what he consciously intended to express) is the object of what we may call iconography in a deeper sense: […] or a method of interpretation which arises as a synthesis rather than an analysis." For a discussion of this and Panofsky's own wavering attitude towards iconology, see the introduction to this volume.

67 On the use of hallucinatory drugs in Della Porta, see also Kodera (2015a).

68 Kodera (2013 and 2015b).

69 Reginald Scot approvingly refers to Della Porta's recipe in 1584; see the discussion in Dupré (2007, 86–7). Dupré is overlooking the fact that the *segreti* in question are not instructions for optical devices, as we have shown. One cannot help but surmise that some extract of belladonna in these unctions actually did the trick, lending the experiment some credibility. This was one of the ingredients Della Porta had identified in his infamous witch's unguent. Already in the first edition of the *Magia naturalis*, he had accordingly concluded that the witch's sabbath was actually a hallucination caused by a powerful drug (an observation that got Della Porta into lifelong troubles with the inquisition). For a thorough discussion of that passage and comparison with Cardano's recipe for the witch's unguent, see Balbiani (2001, 59–61). For another recipe involving hare's fat, see Kodera (2006, 55–61).

Bibliography

Agrippa von Nettesheim, Heinrich Cornelius. 1584. *De incertitudine et vanitate scientiarum declamatio*. Cologne: Apud Theodorum Baumium.

Agrippa von Nettesheim, Heinrich Cornelius. 1991. *De occulta philosophia libri tres*, edited by V. Perrone-Compagni. Leiden: Brill.

Allen, Michael J. B. 1984. *The Platonism of Marsilio Ficino: A Study of his Phaedrus Commentary, its Sources and Genesis*. Berkeley: University of California Press.

Allen, Michael J. B. 1989. *Icastes: Marsilio Ficino's Interpretation of Plato's Sophist: Five Studies and a Critical Edition with Translation*. Berkeley: University of California Press.

Allen, Michael J. B. 2002. "Life as a Dead Platonist" In *Marsilio Ficino, His theology, His Philosophy, His Legacy*, edited by Michael J. B. Allen and Valery Rees, 159–178. Leiden: Brill.

Allen, Michael J. B. 2007. "*Quisque in sphaera sua*: Plato's Statesman, Marsilio Ficino's Platonic Theology and the Resurrection of the Body." *Rinascimento* 47:25–48.

Balbiani, Laura. 2001. *La Magia naturalis di Giovan Battista Della Porta: Lingua, cultura e scienza in Europa all'inizio dell'età moderna*. Bern and New York: Lang.

Baldini, Ugo. 2001. "The Roman Inquisition's Condemnation of Astrology: Antecedents, Reasons and Consequences." In *Church, Censorship and Culture in Early Modern Italy*, edited by Gigliola Fragnito, translated by Adrian Belton, 79–110. Cambridge: Cambridge University Press.

Blair, Ann. 1996. "Review of Eamon 1994." *Renaissance Quarterly* 49:177–179.

Bolzoni, Lina. 2001. *The Gallery of Memory: Literary and Iconographic Models in the Age of the Printing Press*, translated by Jeremy Parzen. Toronto: University of Toronto Press.

Boudet, Jean. 2010. "Lumière et vision dans la magie et la divination Médievale." In *Lumière et vision dans les sciences et arts*, edited by Michael Hochman and Danielle Jacquard, 119–137. Geneva: Droz.

Cabré, Monserrat, and Fernando Salmón. 1998. "Fascinating Women: The Evil Eye in Medical Scholasticism." In *Medicine from the Black Death to the French Disease*, edited by Roger French, 53–84. Aldershot: Ashgate.

Cantimpratensis, Thomas. 1973. *Liber de natura rerum*. Berlin: De Gruyter.

Clavicula Salomonis [*The Key of Solomon the King*]. 1909. Translated and edited by S. Liddell MacGregor Mathers. London: K. Paul, Trench, Trübner.

Copenhaver, Brian P. 1984. "Scholastic Philosophy and Renaissance Magic in the *De Vita* of Marsilio Ficino." *Renaissance Quarterly* 37:523–584.

Copenhaver, Brian P. 1988. "Astrology and Magic." In *The Cambridge History of Renaissance Philosophy*, edited by Charles B. Schmitt*et al.*, 264–299. Cambridge: Cambridge University Press.

Copenhaver, Brian P. 1998. "The Occultist Tradition and its Critics." In *The Cambridge History of Seventeenth Century Philosophy*, edited by Daniel Garber and Michael Ayers, vol.1, 454–512. Cambridge: Cambridge University Press.

Copenhaver, Brian P. 2006. "Magic." In *The Cambridge History of Science: Vol. 3: Early Modern Science*, edited by Katherine Park and Lorraine Daston, 518–540. Cambridge: Cambridge University Press.

Copenhaver, Brian P. 2007. "How to do Magic and Why: Philosophical Prescriptions." In *The Cambridge Companion to Renaissance Philosophy*, edited by James Hankins, 137–169. Cambridge: Cambridge University Press.

Daston, Lorraine, and Katharine Park. 1998. *Wonders and the Order of Nature, 1150–1750*. New York: Zone Books.

Della Porta, Giovan Battista. 1558. *Magiae naturalis, sive, De miraculis rerum naturalivm libri IIII*. Naples: Matthias Cancer; 1561, Antwerp: Christopher Plantin.

Della Porta, Giovan Battista. 1589/1650. *Magia naturalis libri XX*. Rothomagia [Rouen]: Johannes Berthelin.

Della Porta, Giovan Battista. 2000–3. *Teatro*, 4 vols. Edited by Raffaele Sirri. Naples: Edizione Scientifica Italiana.

Dupré, Sven. 2007. "Images in the Air: Optical Games, Magic and Imagination." In *Spirits Unseen: The Representation of Subtle Bodies in Early Modern European Culture*, edited by Christine Göttler and Wolfgang Neuber, 71–91. Leiden: Brill.

Eamon, William. 1984. "The *Accademia Segreta* of Girolamo Ruscelli: A Sixteenth-Century Italian Scientific Society." *Isis* 75:327–342.

Eamon, William. 1985. "Science and Popular Culture in Sixteenth Century Italy: The 'Professors of Secrets' and Their Books." *Sixteenth Century Journal* 16:471–485.

Eamon, William. 1994. *Science and the Secrets of Nature: Books of Secrets in Medieval and Early Modern Culture*. Princeton, NJ: Princeton University Press.

Eamon, William. 2010. *The Professor of Secrets: Mystery, Magic and Alchemy in Renaissance Italy*. Washington, D.C: National Geographic.

Felinella, Simone. 2010. "Cristoforo Landino e Marsilio Ficino sull'origine dell'anima." *Rinascimento* 50:263–298.

Ficino, Marsilio. 1576. *Opera omnia*. Basel: Heinrichpetri.

Ficino, Marsilio. 1937. "Disputatio contra iudicium astrologorum." In *Supplementum Ficinianum*, edited by Paul Oskar Kristeller, vol. 2, 11–76. Florence: Olschki.

Ficino, Marsilio. 1956. *Commentaire sur le Banquet de Platon Marsile Ficin: De amore*, edited and translated by Raymond Marcel. Paris: Les Belles Lettres.

Ficino, Marsilio. 1989. *Three Books on Life: De vita libri tres*, edited, translated and introduced by Carol V. Kaske and John R. Clark. Binghamton, NY: Medieval & Renaissance Texts & Studies.

Ficino, Marsilio. 2001–6. *Platonic Theology: Theologia Platonica*, edited, translated and annotated by James Hankins, William Bowen, Michael J. B. Allen, and John Warden, 6 vols. Cambridge, MA: Harvard University Press.

Gombrich, Ernst. 1948. "*Icones Symbolicae*: The Visual Image in Neo-Platonic Thought." *Journal of the Warburg and Courtauld Institutes* 11:163–192.

Gombrich, Ernst. 1978. *Symbolic Images*. Oxford: Phaidon.

Hankins, James. 2005. "Marsilio Ficino on 'reminiscentia' and the transmigration of souls." *Rinascimento* 45:3–17.

Hub, Berthold. 2008. *Die Perspektive der Antike: Archäologie einer symbolischen Form*. Frankfurt am Main: Peter Lang.

Hub, Berthold. 2007. "Material Gazes and Flying Images in Marsilio Ficino and Michelangelo." In *Spirits Unseen: The Representation of Subtle Bodies in Early Modern European Culture*, edited by Christine Göttler, 93–120. Leiden: Brill.

Hub, Berthold. 2016. "Aristotle's 'Bloody Mirror' and Natural Science in Medieval and Early Modern Europe." In *The Mirror in Medieval and Early Modern Culture*, edited by Nancy Frelick, 31–71. Turnhout: Brepols.

Klein, Robert. 1960. "L'énfer de Marsile Ficin." In *Umanesimo e esoterismo: Atti del V convegno internazionale di studi umanistici*, edited by Enrico Castelli, 47–84. Padua: A. Milani.

Kodera, Sergius. 2004. "Schattenhafte Körper, erotische Bilder: Zur Zeichentheorie im Renaissance Neuplatonismus bei Marsilio Ficino." In *Kunst, Zeichen Technik: Philosophie am Grund der Medien*, edited by Marianne Kubaczek, Wolfgang Pircher, and Eva Waniek, 63–86. Münster: LIT.

Kodera, Sergius. 2006. "Der Magus und die Stripperinnen: Giambattista della Portas indiskrete Renaissance-Magie." In *Rare Künste: Zur Kultur- und Mediengeschichte der Zauberkunst*, edited by Brigitte Felderer and Ernst Strouhal, 55–78. Vienna: Springer.

Kodera, Sergius. 2009. "*Ingenium*: Marsilio Ficino über die menschliche Kreativität." In *Platon, Plotin und Marsilio Ficino, Studien zu Vorläufern und zur Rezeption des Florentiner Neuplatonismus*, edited by Maria-Christina Leitgeb, Stéphane Toussaint, and Herbert Bannert, 155–172. Wien: Österreichische Akademie der Wissenschaften.

Kodera, Sergius. 2010. *Disreputable Bodies: Magic, Gender, and Medicine in Renaissance Natural Philosophy*. Toronto: Centre for Reformation and Renaissance Studies.

Kodera, Sergius. 2012. "The Art of the Distillation of 'Spirits' as a Technological Model for Human Physiology: The Cases of Marsilio Ficino, Joseph Duchesne and Francis Bacon." In *Blood, Sweat and Tears: The Changing Concepts of Physiology from Antiquity into Early Modern Europe*, edited by Helen King, Manfred Horstmannshof, and Claus Zittel, 139–170. Leiden: Brill.

Kodera, Sergius. 2013. "Humans as Animals in Giovan Battista della Porta's scienza." *Zeitsprünge* 17:414–432.

Kodera, Sergius. 2015a. "Kleine artifizielle Höllen vor Publikum: Giovan Battista della Portas naturmagische Trance." *Zeitschrift für Kulturwissenschaften* 2:73–80.

Kodera, Sergius. 2015b. "Bestiality and Gluttony in Theory and Practice in the Comedies of Giovan Battista Della Porta." *Renaissance and Reformation / Renaissance et Réforme* 38: 83–113.

Kodera, Sergius. 2018. "Giovan Battista Della Porta's Imagination." In *Image, Imagination, and Cognition Medieval and Early Modern Theory and Practice*, edited by Christoph Lüthy, Claudia Swan, Paul J. J. M. Bakker and Claus Zittel, 117–146. Leiden: Brill.

Kristeller, Paul Oskar. 1964. *The Philosophy of Marsilio Ficino*, translated by Virginia Conant. New York: Columbia University Press.

Lindberg, David C. 1976. *Theories of Vision from al-Kindi to Kepler*. Chicago: University of Chicago Press.

Luscombe, David Edward. 1997. *Medieval Thought*. Oxford: Oxford University Press.

Mély, Fernand D., ed. 1902. *Les lapidaires de l'antiquité et du moyen age: 1er fasc. Les lapidaires grecs*. Paris: Ernst Léroux.

Patrologiae cursus completus, series Latina. 1844–64. Edited by J.-P. Migne, 221 vols. Paris: Vrayet.

Plato. 2009. *Timaeus*, translated by Benjamin Jowett. In *The Collected Dialogues of Plato*, edited by Edith Hamilton and Huntington Cairns, 1151–1211. Princeton, NJ: Princeton University Press.

Pliny. 1963. *Natural History*, vol. 8, Libri 28–32, 10 vols., with an English translation by W. H. S. Jones. Cambridge, MA: Harvard University Press.

Pseudo-Albertus. 1598. "De mirabilibus mundi liber." In *De secretis mulierum libellus*, 186–237. Paris: Antoine De Harsy.

Russel, Mark A. 2007. *Between Tradition and Modernity: Aby Warburg and the Public Purposes of Art in Hamburg*. New York and Oxford: Berghahn.

Siraisi, Nancy G. 1990. *Medieval and Renaissance medicine: An Introduction to Knowledge and Practice*. Chicago: University of Chicago Press.

Soranzo, Matteo. 2011. "Reading Marsilio Ficino in *Quattrocento* Italy: The Case of Aragonese Naples." *Quaderni d'Italianistica* 32, 2:27–46.

Stephens, Walter. 2002. *Demon Lovers: Witchcraft, Sex and the Crisis of Belief*. Chicago: University of Chicago Press.

Stephens, Walter. 2010. *Habeas Corpus: Demonic Bodies in Ficino, Psellus, and The Body in Early Modern Italy*, edited by Julia Hairston and Walter Stephens, 74–91. Baltimore: The Johns Hopkins Press.

Sugg, Richard P. 2011. *Mummies, Cannibals, and Vampires: The History of Corpse Medicine from the Renaissance to the Victorians*. London: Routledge.

Thorndike, Lynn. 1923–58. *A History of Magic and Experimental Science*, 8 vols. New York: Columbia University Press.

Toussaint, Stéphane. 2011. "Zoroaster and the Flying Egg: Psellos, Gerson and Ficino." In *Laus Platonici philosophi: Marsilio Ficino and his Influence*, edited by Stephen Clucas, Peter J. Forshaw, and Valery Rees, 105–116. Leiden: Brill.

Vasiliu, Anca. 1997. *Du diaphane: Image, milieu, lumière dans la pensée Antique*. Paris: Vrin.

Walker, Daniel Pickering. 1958a. "The Astral Body in Renaissance Medicine." *Journal of the Warburg and Courtauld Institutes* 21:119–133.

Walker, Daniel Pickering. 1958b. *Spiritual and Demonic Magic from Ficino to Campanella*. London: Warburg Institute.

Warburg, Aby. 2010. *Werke in einem Band*, edited and annotated by Martin Treml *et al.* Frankfurt am Main: Suhrkamp.

Weill-Parot, Nicolas. 2013. *Points aveugles de la nature: la rationalité scientifique médiévale face à l'occulte, l'attraction magnétique et l'horreur du vide (XIIIe-milieu du XVe siècle)*. Paris: Les Belles Lettres.

Zambelli, Paola. 1991. *L'ambigua natura della magia. Filosofi, streghe, riti nel Rinascimento*. Milan: Il Saggiatore.

Zambelli, Paola. 2007. *White Magic, Black Magic in the European Renaissance*. Leiden: Brill.

Zumbusch, Cornelia. 2004. *Wissenschaft in Bildern: Symbol und dialektisches Bild in Aby Warburgs Mnemosyne-Atlas und Walter Benjamins Passagen-Werk*. Berlin: Akademie Verlag.

5 In Quest of Beauty

Gender Trouble in the *Orlando Furioso*

Marlen Bidwell-Steiner

In the Renaissance rivalry between painting and poetry commonly known as *ut pictura poesis*,[1] "Ariosto pittore"[2] became one of the few authors acknowledged to decide the competition for the latter. As I will show in the following, the iconic quality of Ariosto's text is not a mere ludic element but a structural principle to grasp the dynamic of his time.

Reading the *Orlando Furioso* inspires bad dreams; one gets lost in a compelling pattern of kaleidoscopic images that are constantly shifting their meaning. These confusing permutations owe their power to a double structural foundation replete with gaps, blanks, and tensions. The most obvious doubling in the *Orlando Furioso* concerns the mingling of romance and epic. For some critics, the tension between the two literary modes remains irreconcilable; others contend that in the course of the poem, romance becomes overruled by epic closure.[3] One of the few scholars to emphasize the entanglement of the two genres as a gendered program is J. Chimène Bateman. She bases her thesis upon the prominence of the female warriors Bradamante and Marfisa, whose "ambiguous gender identity is described through the common metaphor of a *nodo*, or knot. However, in each episode, the 'knot' in question turns out to be a knot that involves genre as well as gender."[4]

In the past few years, the interdependence of genre and gender, evident in their common Latin root *genus*, has become a focus for feminist literary studies.[5] To elaborate on this hypothesis, the Renaissance has become a prominent period for investigation, since it provides a rich archive of blurred genre *and* gender boundaries. The *Orlando Furioso* is a significant case in point because its oscillation between the 'masculine' genre of the epic and the 'feminine' genre of romance entails an oscillation in the manliness or womanliness of its characters.

Chiastic Chimeras

In the following, I will trace less obvious textual knots or − as I would prefer to conceptualize them − chiasms in order to corroborate the claim that a fusion of the two genres is not only intentional but necessary for Ariosto's subtle (or, for that matter, not so subtle) subversion of their shared body politics. In the *Orlando Furioso*, the mutual dependence of epic and romance is exposed precisely because the functional principles of the two genres are constantly undercut by crisscrossing strategies. Hence, one of the most haunting impressions in reading the *Orlando Furioso* is the doubling on different levels of the narrative and the text − such as twin characters, twin scenes, and twin devices.

The character Orlando is ostensibly the figurehead of the interwoven plots of the poem. However, as hero or protagonist he faces "harsh rivalry" with Ruggiero, to imitate the poem's terminology. Ruggiero represents the genealogical father of the Este dynasty; he is

thus an important link to the extra-literary context because Ippolito Este, to whom the text is dedicated, is Ariosto's patron. While this poetic *telos* of the character Ruggiero becomes quite clear at the very beginning, in the epic plotline he remains part of the bad gang, the Saracens, until the poem's very last Canto.

The poem's structure of duplications offers different options for action in a pluralistic and contingent worldview – options that comply variously with the different horizons of expectation in the two genres. However, none of these options seems to be privileged. In my reading, the epic tendencies towards worldly heroic action and the romance ventures of love melancholy are allusions to the much-debated interplay between body and soul,[6] inasmuch as they reflect the two options of *vita activa* and *vita contemplativa*. In the *Orlando Furioso*, they are woven into chiastic formations. Hence, they point to a mediating agent, which in medical and philosophical texts of the time would be the *spiritus*. In Ariosto's poetic text, this agent can be equated with the narrator.

And in fact, against the backdrop of epic and romance, Ariosto is tackling the question of poetic inspiration and freedom; a question that owes its pressure to contemporaneous Neoplatonic iconological obsessions. Yet, the way Ariosto ties together narrative threads – only to unravel them, shift to new ones, or loosen them – denies any poetic flight towards a Neoplatonic emanation of the ultimate beautiful or good. There is no final message regarding life or love or literature but rather the call to continue the quest, to keep on moving. Aby Warburg describes how an affectively charged narrative or occurrence is cast into a (bodily) image that becomes the formula of other affectively charged occurrences for a given culture. Hence, to some extent, Ariosto's text is a version of Warburg's *pathosformel*[7] in its most radical form, as recurring body images between death and *eros* is all there is!

Most interpretations of the *Orland Furioso* tie together narrative threads to whole episodes, which in the text are constantly interrupted by *entrelacements* reminiscent of the subplots of a soap opera. In contrast, I will first try to reconstruct the different narrative sequences from Canto 7 to Canto 11 to outline their discursive entanglement. Such an interrelated series of the poem's double features helps to trace Ariosto's all-embracing subversion and thereby to understand his aesthetic program employing elaborations of *pathosformeln*. But in order to elaborate on the hypothesis that the "contamination" of the two genres is due to Ariosto's subversion of their shared horizon of meaning, I must pursue the text's vertiginous byways. One recurrent motive in the poetic ups and downs of these interwoven sequences is the myth of Perseus and Andromeda, enacted by the two protagonists, Orlando and Ruggiero.

As I will show, in this illusionary Christian universe, Orlando remains the most reliable old-fashioned knight, and his later *furor* is a logical reaction for someone who has internalized the chivalric code of honor.

It is thus quite disturbing that in a decisive moment in Canto 8 Orlando ignores his loyalty towards his king to pursue his blond angel Angelica.

> Did not I have reason to make a stand? Aye, and supposing Charles had stood his ground? Well, supposing he had – who could have forced my hand? Who was going to take you away in the teeth of my opposition? Could I not have fought, sword in hand, or made them first tear my heart out of my breast? Neither Charles nor all his henchmen together were capable of wresting you from me by force.[8]

His later performance of extreme amorous melancholy is already symbolized at this early stage through a dark – and pagan – dress of armor. Nevertheless, he is still able to

display his chivalric virtues in several adventures in the Northern countries, thereby aiding the empire of the fair princess Olimpia.

Meanwhile our other hero, Ruggiero, undergoes a breathtaking process of maturity between magical paternal care and magical female education. His tutor, Atlante, who is acquainted with all kinds of necromantic arts, first tried to save him from his foreseen fate of being murdered by a Christian after marrying Bradamante. To this end, Atlante created two different sorts of a "hall of mirrors" (see Canto IV, and later Canto XIII) where the larger story's dramatic sweep is played out in a nutshell, as it were, or in a *mise en abyme*; all the inmates of the spellbound castle are consumed by the quest for an object of desire, which appears to them in the persona of Atlante. But soon the outer world intrudes on this ludic microcosm; Bradamante, the female warrior and foremother of the Estes, rescues her beloved Ruggiero with the help of the sorcerers Merlin and Melissa, both of dubious reputation. A magic ring, one recurring feature in the poem, tears down the mock-up mirror castle (Canto IV, 39). To adapt Mieke Bal's model of *travelling concepts*,[9] the ring acts as a 'travelling *leitmotiv*,' for rather than a concept, the ring is a trope that "represents the structure of allegory itself as revelation which both unveils and obscures truth."[10]

However, after a short embrace between these historically significant lovers, Atlante makes Ruggiero mount the hippogriff. On the back of this fabulous melding between horse and raptor, Ruggiero literally leaves Atlante behind as he experiences a *rite de passage* in Africa that recalls Marsilio Ficino's model of two Venuses. In *De amore* 2.7, he warns the reader not to abuse love's dignity in preferring the form of the body to the beauty of the soul:

> If anyone, through being more desirous of procreation, neglects contemplation or attends to procreation beyond measure with women, or against the order of nature with men, or prefers the form of the body to the beauty of the soul, he certainly abuses the dignity of love.[11]

Ruggiero lands on the Island of the sorceresses Alcina and Logistilla (Canto VII). The narrator and his narrating double, the bewitched Astolfo, describe Alcina as a nymphomaniac and cruel Circe, and Logistilla as her wise and virtuous sister. Instructed by Astolfo, who is talking out of a tree (as he is under Alcina's spell), Ruggiero heads for Logistilla. But in this very moment, two handsome maidens ask him to rescue them from the claws of the giantess Eriphyla (the "Quarrelsome"). Ruggiero is lost. Soon afterwards, the outstanding beauty of Alcina stuns him. His sojourn in Alcina's castle is depicted as overwhelming sensual delight. This is clearly a case for Bradamante's Mercurial female helper Melissa, who enters the scene disguised as Atlante and reminds Ruggiero of his promise to Bradamante. With the magic ring, Melissa opens Ruggiero's eyes to (presumably) the truth behind the shiny appearances in Alcina's realm; Alcina is in fact an old hag and the earthly paradise is a wasteland:

> She was whey-faced, wrinkled, and hollow-cheeked; her hair was white and sparse; she was not four feet high; the last tooth had dropped out of her jaw; she had lived longer than anyone on earth, longer than Hecuba or the Cumaean Sibyl. But she made such use of arts unknown in our day that she could pass for young and fair.[12]

So, did our hero learn his Neoplatonic lesson that sensual pleasure is fraught with corruption, loss, and death? One is inclined to believe so, for he consequently successfully

reaches Logistilla's land, described to him by a Charon figure on the river between the two realms as the sublimate good in Neoplatonic terms. Logistilla instructs him how to rein the hippogriff, which may be read as a reference to Plato's myth of the charioteer, *Phaidros* (242d).[13] Hence, one would assume that after reaching Logistilla and safety, Ruggiero would take the shortest way back to fulfil his destiny. But another obstacle blocks his way: the blond, beautiful and bare Angelica. Tied to a rock, she is a gorgeous victim for the virgin-devouring monster orca. Ruggiero vanquishes the monster by blinding it with his magic mirror-like shield.

Yet in the very moment of his victory, he reverts back to an earlier developmental state where he is incapable of cooling his temper. He pointlessly stabs the already immobile monster so that Angelica has to reprove him to not waste time. And after a pleasant ride on the hippogriff where Ruggiero turns to kiss her and to fondle her breasts, he is once again overwhelmed by his affects and tries to rape her. In a kind of distorted echo of Logistilla's education on the art of reasoning, he dissociates from the woman in front of him by recalling the image of Bradamante. Yet Ruggiero's violent intentions are stymied by his difficulties in removing his armor. While doing so, he loses the magical objects of his patron Atlante and of his lover's protectors; Angelica recognizes the magic ring on his hand and uses it to escape. And the hippogriff strives off its harness and flies away. In this crucial moment, Ruggiero forfeits his destiny as Bradamante's husband – symbolized by the ring – *and* his potential for a self-fashioning process towards poetical sublimation, symbolized by the hippogriff.

Soon afterwards, when Ruggiero sees Bradamante fighting with two giants, he does not only fail to recognize the armored Amazon, he also neglects his chivalric duty to help what he is bound to perceive as a distressed knight.

Meanwhile, Orlando sails to the islands of virgin victims in search of his Angelica. He indeed encounters a blond, beautiful and bare lady tied onto the rock: Olimpia. Let me briefly quote the quite expressive portrayal of her physical appearance, since it is crucial in my further analysis:

> Olympia's beauties were of a rare perfection: beauty resided not merely in her forehead, her eyes, cheeks, and hair, her nose and lips, shoulders and throat; but, to carry on down from her breasts, the parts normally concealed by a tunic were so excellently formed they could have been more perfect than any in the world.
>
> They were whiter than virgin snow and to the touch smoother than ivory. The small rounded breasts were like beads of milk newly pressed from a reed. They were so set apart, they resembled two little hillocks and between them a pleasant shady dell in the season when winter snow still lies in the hollows.[14]

Orlando in turn defeats the monster *and* the people of the island, who are kidnapping virgins ubiquitously to pacify the orca. And furthermore, while meeting his Irish fellow knight Oberto, he not only tries to protect Olimpia's body but also arranges a marriage between the two of them.

What do the two versions of the Perseus-Andromeda myth show? Orlando remains consumed by the unattainable image of his absent Angelica to such an extent that he even becomes immune to a beauty that is depicted in such drastic, non-Petrarchan and thus immanent images. Unperturbed, Orlando acts according to the code of honor of an ideal knight and gentleman. Hence, his poetic scope of action clearly obeys epic patterns.

Ruggiero – who seems to have enjoyed a painstaking double education: empirical through Alcina and intellectual through Logistilla – behaves like a protagonist of late romance, as in the second part of the *Roman de la rose*.[15] He is splitting the erotic impulse into an immediate *triebabfuhr*[16] and a transcendent image of his beloved lady.

A comparison of the parallel scene with classical myths exemplifies the chiastic strategy of the text. At a first glance, Ruggiero may seem to be an incarnation of Perseus; he uses his magic shield as Perseus uses the head of Medusa, since both have the power to paralyze the viewer; instead of Perseus' helmet he dons the magic ring to become invisible. Yet in the Greek myth, Atlas is not Perseus' mentor but one of the hero's enemies. Unlike Ruggiero, Perseus acts in accordance with a hero's repertoire of virtues; he marries Andromeda. But there exists another classic mythological variation of Andromeda and Perseus, the narration of Hesione and Heracles.[17] After having served the queen Omphale, Heracles regains his wits. He then comes to an island and liberates Hesione from a sea monster by swimming into the monster's body – in a similar way as Orlando fights his beast. Yet it was not Orlando who was enslaved and depraved of his mind by a foreign empress but Ruggiero in Alcina's realm. And in contrast to Heracles, Orlando has not regained his wits but will instead lose them.[18] Thus, Ariosto combines two prominent Greek myths in reversed parallelisms – chiasms – which are dismantled of their semantic context and thereby lose their original truth claim. And in fact, the narrator later tells us quite confidently that history is nothing but stories, kaleidoscopic pictures drawn by gifted poets:

> Aeneas was not as devoted, nor Achilles as strong, nor Hector as ferocious as their reputations suggest. There have existed men in their thousands who could claim preference over them. What has brought them their sublime renown have been the writers honored with gifts of palaces and great estates donated by these heroes' descendants.[19]

Breaking Flowers

However, there is another very important detail explaining the two different configurations, a detail constituting the collective obsession in Ariosto's knightly universe: virginity. For the detailed description of Olimpia's sexualized body is certainly indebted to the fact that she has already lost this precious attribute. She was formerly married to a swindler, who abandoned her for a younger virgin (Canto X, 10–20).

Albert Ascoli has examined the *Orlando Furioso* for the outstanding significance of its "key thematic configuration in which the ideally unpenetrated state of the chaste female body, that is, virginity, is paired off with an idealized projection of the impenetrable male body in the form of armour."[20] I would like to link this observation to the question of genre. On the text's surface, the tension between epic and romance is expressed in the binary contrast between dark and devastated battlefields and light pastoral landscapes, or elsewhere between desert and terrestrial Eden and, of course, between impermeable and bestial armors and the bodies of shining white, ethereally pure women.

Some scholars have emphasized the poem's particularly graphic depiction of war scenes. In fact, the minute descriptions of mutilated body parts and seas of blood become all the more hyperbolic as the rivaling forces maintain some positive, vital relationships; the most prominent one is the love between Ruggiero and Bradamante. Furthermore, the warriors on both sides often forget their duties and deliberately involve themselves in all kinds of playful adventures. Thus, the epic *telos* of the poem – the re-conquest of the

center of Christendom by the *Milites Christi* – becomes marginalized. In its place, the *Orlando Furioso* reveals a void of meaning and an exposure of the protagonists' outdated spiritual values.

For the ideal medieval knight, the emblem of faith is his Lady, onto whom the better parts of himself are projected or, to put it in less psychoanalytical terms, outsourced. In a way, the knight's presence as prototypical masculine war-machine is necessarily counterbalanced by the absence of a remote, delusive and angelical Otherness, an untouchable female deity. From a contemporary perspective, this concept perhaps recalls the sweet hereafter of the jihad warrior. For Ariosto, this medieval providential Christian world system hinges on such bipolar extremes: hypertrophic purity on the one side and fantasies of aggressive conquest on the other.

But in the *Orlando Furioso*, this medieval rubric exhibits significant flaws; Angelica, the pivotal figure of desire, has changed from the emblem of an absent female deity into a "wayward woman."[21] She is thus collapsing the strictly male scenery with her futile but therefore all the more disturbing presence. In contrast to Olimpia, Angelica offers all the features of the Petrarchan catalogue of immaculate femininity, but she hits the battle-grounds like a vulgar sutler à la Mutter Courage. Therefore, the idea of a contest among the bravest warriors from both sides to pluck the precious flower of her virginity requires considerable cooperation from the reader in terms of *verisimilitudine*; even the narrator does not fail to admit so in the first Canto:

> This may have been true, but scarcely plausible to anyone in his right mind; to him it seemed quite possible, however, lost as he was in a far deeper illusion.[22]

The recurring metaphor for virginity corroborates Ascoli's thesis, as it turns out to be the one and only aim of the errant knights (see e.g. Canto I, 39–9; Canto V, 64; X, 95; XIX, 33 …).

This distortion of an epic program echoes the shift of meaning in an earlier and extremely popular vernacular text to which I have already referred: the *Roman de la rose*. The discursive change between the two parts of the *Roman* reflects the rupture of the old courtly ideals by the formation of a proto-bourgeois society.[23] In my opinion, Ariosto's text confirms that Jean de Meung's re-elaboration of the courtly *chanson* as a misogynist song of violation is simply the inevitable result of a value system relying on martial virtues under less exclusive conditions. I believe Ariosto sets up an arc of tension between phantasmatic virginity and penetrated knightly armor in order to flesh out the underlying aporia of two mutually dependent genres and/or world visions; in the same way that the soldiers devastate the ideal holy landscapes they pretend to protect, their quest for purity aims at penetration and thus misses its goal in the very moment of fulfilment.

As Marion A. Wells was able to show, the metaphor of the plucked flower as ultimate whiteness – virginity – reoccurs in its bloodstained version in a gruesome trope describing Orlando's slaughtered friend Brandimarte at the very end of the epical combat. Wells discusses such textual movements as "transition from Romance melancholy to epic mourning."[24]

Losing Wits: Losing Words

The metaphor of the wilted flower for a dying friend is one of the subtler examples of gender trouble in the *Orlando Furioso*. I want to conclude with gendered transgressions by the protagonists Orlando and Angelica (ostensibly untainted by such troubles), which I will loop back to the above outlined sequences.

Orlando's madness, which occurs in the very center of the text, is triggered by signs left behind by his "sweet virgin angel." After deciding to make her way back home, Angelica stumbles in Canto XX over a severely wounded body. Being an Indian princess, she is familiar with herbal remedies, and thus undertakes to cure the young Saracen knight in the hut of a shepherd's family who shelters them. While attending to the wounded man, she falls into a veritable *amor hereos*.[25] Nevertheless, her suffering is soon alleviated because the recovered Medoro returns her affection. The couple spend their honeymoon in this pastoral *locus amoenus* and soon afterwards leave for India. The dramaturgy of the arising love is quite interesting, since Medoro is blond, beautiful and – more or less – bare because he is wounded.

If we think of the generic pairing of impermeable males and virgins to be penetrated outlined above, it is quite remarkable that in this scene the gaze of the *wounded* Medoro penetrates Angelica. But this reference to Ficino's interpretation of the myth of Narcissus (*De amore* 6.17) goes beyond a simple splitting of sensual and intellectual delight; Angelica is not only the one to be looked at, but she achieves the power of gaze herself and thus autonomous desire as well as the status of subject: "The play of words, wounds and gazes between the two lovers [...] suggests a reciprocal, back-and-forth exchange of the subject and object position in desire."[26] To put it in reverse-anachronistic terms, an ideal love relationship only becomes possible with the intersection of race, class, and gender, since Angelica's and Medoro's enjoyment of one another is not only sensual. Moreover, the pagan and quite humble Medoro is able to sublimate and recount their experience in an Arab love poem, which, fatally enough, the lovesick and erudite Orlando will decipher soon afterwards.

Three Canti later, Orlando enters the symbolically supercharged pastoral scenery formally inhabited by Angelica and Medoro. After having decided to give up his quest for Angelica, Orlando is heading back to his king and stops for a rest near the shepherd's house. He notices the carvings in the surrounding trees:

> He saw 'Angelica' and 'Medor' in a hundred places, united by a hundred love-knots. The letters were so many nails with which Love pierced and wounded his heart. He searched in his mind for any number of excuses to reject what he could not help believing; he tried to persuade himself that it was some other Angelica who had written her name on the bark.[27]

This time, Orlando is receiving his lesson in empirics. Against the backdrop of this unambiguously ambiguous symbolic penetration, our hero mobilizes amazing hermeneutical skills in order to avoid a literal reading of the bare facts. His attempt to deny Angelica's 'handwriting' is followed by his wishful thinking that Medoro was only a poetic pseudonym for himself, and finally he tries to believe that somebody fooled Angelica through slander. Confronted with the Arab poem, he develops the catalogue of symptoms of paradigmatic paralysis following an affective overload of psychic-physical pressure that can be found in medical accounts on *amor hereos*. But Orlando is an erudite patient. Hence, he finds a final explanation: the Arab verses were only written to excite his own jealousy. This reading follows the tradition of rhetorics inasmuch as it focuses on the control of emotions; it helps Orlando to cool down and ride to the next refuge. But his coping strategies are soon shattered by the shepherd, who tries to cheer up his ill-tempered guest by telling him the story of Angelica and Medoro and shows him the bracelet the Indian princess left him as a token of her gratitude. After finally realizing

that he is spending the night in the same bed where the couple had been making love, Orlando flees civilization and more or less intentionally falls into the state of a wild animal, observing his own decline as a doctor might:

> I am not who my face proclaims me; the man who was Orlando is dead and buried, slain by his most thankless lady who assailed him by her betrayal. I am his spirit sundered from him, and wandering tormented in its own hell, so that his shade, all that remains of him, should serve as an example to any who place hope in Love.[28]

Orlando's process of degradation is a reaction to the failure of his erudite hermeneutics from literal to tropological meaning back to a literal and third-person narrative by the shepherd. When Orlando has to acknowledge the truth behind the signs carved onto the trees, he then uproots their material basis, the trees themselves (Canto XXIII, 124–125).

Let me now briefly point to the further elaboration of Ariosto's doubles: Angelica and Orlando are both willing to return to (reinvest in) their previous identities when in that moment the scope of those very identities experiences a radical shift.

It is noteworthy that the liminal experience of both our heroes, Orlando and Ruggiero, is initiated by an oral story, which recalls Socrates' alleged approval of oral didactics over written didactics. But while Ruggiero stumbles into a phantasmatic sensual paradise, Orlando consciously withdraws from his power of signification, from the symbolic sphere.

The Italian term *viso* in the above stanza not only means face; it also alludes to the sense of sight, which in medical and Neoplatonic texts likewise represents one important gateway for the passions. And in fact, the stanzas that prepare this crucial climax seem to illustrate the medical doctrine of passions.[29] Therefore, it is highly ironical that in this passage, instead of representing the medical vehicle of soul, the *spiritus animialis, spirto* mutates to an errant shadow, while the substance of Orlando is buried in the earth. Within the Neoplatonic discourse of melancholy, one could argue that Orlando's shadow is moving through immanence while his sublime soul is ready for contemplation in higher – divine – spheres.[30] Not so in Ariosto's text: we learn later that Orlando's wit has been stored on the moon. There, all sorts of chimera are to be found: forgotten thoughts, broken vows of love, abandoned ideals – in short, phantasms. The moon as a secondhand depository becomes a travesty of the Platonic theory of ideas *and* of the Christian doctrine of salvation.

Orlando identifies with his spirit but becomes a beastlike creature. He enacts the cruelest version of the early modern melancholic, the *lupinositas*, the behavior of a wild wolf;[31] he follows his primary drives, and if withheld from immediate satisfaction, he plays havoc with whomever comes his way. Only once does he experience affects that recall human desire: on a beach near Barcelona, he again meets Angelica. Some part of him identifies her and lies in ambush. To escape, Angelica uses the magic ring, but she falls from her horse, which Orlando ultimately catches. Then, the narrator tells us graphically how Orlando ravishes the mare and rides it relentlessly until it perishes of hunger. Orlando then heaves it onto his shoulder and drags it along for several days (Canto XXIX, 69–72). This distorted and displaced *trauerarbeit* makes for a strong and stirring picture that seems to demand psychoanalytical interpretation, since Orlando's crisis is anticipated by a dream in Canto 8. And in fact, Marcia Wells maintains that Orlando's *amor hereos* exhibits all the traits of a melancholic disorder in modern psychoanalytical terms:

> My argument thus far has suggested that romance as a mode is organized around an anti-elegiac refusal to acknowledge the loss of a beloved object and a subsequent internalization (incorporation) of the object within a powerful, but occluded, phantasmic world. Epic, by contrast, develops its closural strategies around the elaborate ritual acknowledgment of loss.[32]

This interpretation seems very suggestive and inspiring. However, I would like to add some objections and modifications. First, if we simply compare their activities, the deeds of Orlando the shadow and Orlando the hero are not clearly distinguishable: both relentlessly devastate, kill and plunder in an idyllic landscape. Orlando the hero supposedly acts for a higher cause, but his king betrayed this chivalric cause by taking Angelica from him in the first place. On the other hand, and this is my second contention, Orlando never maintained a real relationship with Angelica. Rather, Angelica is the fetish stabilizing the dynamics of meaningless warfare, endowing it with a subverted, pure transcendence. In psychoanalytical theory, a fetish veils difference and hinders castration.[33] But Orlando experienced castration when the king took away his war prize, Angelica, to give her to another nobleman. With the loss of his fetish, Orlando also loses his value system. The same phantasmatic character underlies Orlando's love for Angelica and the noble cause of the holy war. Orlando's desire focuses more on an obsolete ideal of the minstrel than on a vital relationship and therefore remains self-referential. When he can no longer uphold his picture of Angelica, Orlando's identity as ideal warrior collapses. Consequently, deprived of their symbolic investment with the *Milites Christi*, his actions can be perceived as what they really are: arbitrary killing. In his scene with the mare, Orlando the shadow acts with far more authenticity than Orlando the hero, in his drive satisfaction *and* in his mourning.

Therefore, it seems only logical that within this all-embracing breakdown of the symbolic sphere Orlando becomes incapable of signifying. His metamorphosis into a beast is enacted as a divestment of the symbolic; after having lost his speech, he strips off his armor and his clothes – that is to say, his whole persona – and uproots the phallic trees that bear the fatal inscriptions. From a perspective of gender theory, Orlando becomes feminized because traditionally it is women who do not share in the symbolic sphere. But in Ariosto's "poetic knots," this situation becomes even worse; as a result of a sentimental crisis, which is a generic impossibility in epic, Orlando – at least temporarily – drops out of humankind.

At the same time, Angelica, in her love to Medoro, comes closest to reaching a terrestrial Eden. However, she pays the price for this by dropping out of history, disappearing from the further plotline. And this might be the only reliable 'message' in Ariosto's poem: there is no such thing as Christian revelation of eternal truth, Neoplatonic sublimated ideas, or everlasting happiness …

In the poem, the shining virtue of purity lacks transcendent meaning in the same way as the mirror-like surfaces of the magic architectures of the text: they do not reflect anything but surfaces. Nothing is as it appears, but appearance is everything there is:

> The *Furioso* is not a work of restoration but of simultaneity and inclusion, a *varia tela* that 'shows' more than it 'tells,' and for that reason is both hospitable to 'iconographic' examination and inimical to the exegete.[34]

The only transcendence available to us is to shuffle the deck of human affairs to constantly new fates, new stories, or to create consistently new permutations of images. Hence, the aim of poetics is not epic or some other generic closure but the creation of a

singular and quite subjective *denkraum*. The constructive principle of this subjective space is the most radical version of the *pathosformel*: a subversion of Neoplatonic metaphysics by its own means of an elaborate iconographic program.

Notes

1 For this topos in the *Orlando*, see Bolzoni et al. (2014); Bolzoni (2010, 183–232); for the history of this Horatian topos, see Lee (1940, 197–269).

2 This reputation goes back to the *Apologia contra ai detrattori dell'Ariosto* by Ludovico Dolce, which came as an appendix of a 1535 Venetian edition of the text and an eulogy by Pietro Aretino. See Ferretti (2016, 166–7).

3 To name but a few scholars debating the question of genre in the *Orlando*: Zatti (2006), Martinez (1999), Javitch (1999), Beecher, Ciavolella and Fedi (2003).

4 Chimène Bateman (2007, 3).

5 See, e.g., Poor and Schulman (2007).

6 Pietro Pomponazzi with his *De immortalitate animae* 1516 became the figurehead of this so-called "immortality debate," which was basically a controversy on the power of significance between Thomist church members and the prospering sciences. Pomponazzi lectured and worked at Ferrara between 1509 and 1511. See Ingegno (1988, 242–7).

7 See Warburg (2010, 176–86).

8 Canto VIII, 74: "Non aveva ragione io di scusarme? / e Carlo non m'avria forse disdetto: / se pur disdetto, e chi potea sforzarme? / chi ti mi volea torre al mio dispetto? / non poteva io venir più tosto all'arme? / lasciar più tosto trarmi il cor del petto? / Ma né Carlo né tutta la sua gente / di tormiti per forza era possente." Translation by Guido Waldman in Ariosto (2008, 79).

9 Bal (2002).

10 Ascoli (1987, 230).

11 *De amore*, II, 7; Ficino (1985, 54): "Si quis generationis avidior contemplationem deserat aut generationem preter modum cum feminis vel contra nature ordinem cum masculis prosequatur aut formam corporis pulchritudini animi praeferat, is utique dignitate amoris abutitur." Ficino (1956, 155).

12 Canto VII, 73: "Pallido, crespo e macilente avea / Alcina il viso, il crin raro e canuto, / sua statura a sei palmi non giungea: / ogni dente di bocca era caduto; / che più d'Ecuba e più de la Cumea, / ed avea più d'ogn'altra mai vivuto. / Ma sì l'arti usa al nostro tempo ignote, / che bella e giovanetta parer puote." Ariosto (2008, 69).

13 See Allen (1984).

14 Canto XI, 67–8: "Le bellezze d'Olimpia eran di quelle / che son più rare: e non la fronte sola, / gli occhi e le guance e le chiome avea belle, / la bocca, il naso, gli omeri e la gola; / ma discendendo giù da le mammelle, / le parti che solea coprir la stola, / fur di tanta eccellenza, / ch'anteporse / a quante n'avea il mondo potean forse. // Vinceano di candor le nievi intatte, / ed eran più ch'avorio a toccar molli: / le poppe ritondette parean latte / che fuor dei giunchi allora tolli. / Spazio fra lor tal discendea, qual fatte / esser veggiàn fra picciolini colli l'ombrose valli, / in sua stagione amene, / che 'l verno abbia di nieve allora piene." Ariosto (2008, 114).

15 The first part, the medieval courtly song, was written by Guillaume de Lorris (1230); the semantic shift towards a misogynic proto-bourgeois entertainment is the work of Jean de Meung (1275). For further investigation see Jauss (1968), McWebb (2003).

16 The Freudian term is hardly translatable, as 'drive discharge' sounds a bit too technical.

17 See Graves (1960, 167–8).

18 For the different characterization of the involved women, see Mac Carthy (2007, 130).

19 Canto XXXV, 25: "Non sì pietoso Enea, né forte Achille / fu, come è fama, né sì fiero Ettorre; / e ne son stati e mille e mille e mille / che lor si puon con verità anteporre: / ma i donati palazzi e le gran ville / dai descendenti lor, gli ha fatto porre / in questi senza fin sublimi onori / da l'onorate man degli scrittori." Ariosto (2008, 425).

20 Ascoli (2010, 143).

21 See Shemek (1998).

22 Canto I, 56: "Forse era ver, ma non però credibile / a chi del senso suo fosse signore; / ma parve facilmente a lui possibile, / ch'era perduto in via più grave errore." Ariosto (2008, 7).

23 See n. 13.
24 Wells (2007, 120–1).
25 For the significance of this specific form of melancholy in Western culture, see Wack (1990), Wells (2007). The following interpretation partly follows Bidwell-Steiner (2017, 197–210).
26 Shemek (1998, 71).
27 Canto XXIII, 103: "Angelica e Medor con cento nodi / legati insieme, e in cento lochi vede. / Quante lettere son, tanti son chiodi / coi quali Amore il cor gli punge e fiede. / Va col pensier cercando in mille modi / non creder quel ch'al suo dispetto crede: / ch'altra Angelica sia creder si sforza, / ch'abbia scritto il suo nome in quella scorza." Ariosto (2008, 278).
28 Canto XXIII, 128: "Non son, non sono io quel che paio in viso: / quel ch'era Orlando è morto et è sotterra; / la sua donna ingratissima l'ha ucciso: / sì, mancando di fé, gli ha fatto guerra. / Io son lo spirto suo da lui diviso, / ch'in questo inferno tormentandosi erra, / acciò con l'ombra sia, che sola avanza, / esempio a chi in Amor pone speranza." Ariosto (2008, 281).
29 See Siraisi (2007), Walker (1958).
30 See Allen (2008).
31 Calabritto (2001, 62).
32 Wells (2007, 127).
33 See Freud (1927, 309–17), Pontalis (1970).
34 Shapiro (1983, 331).

Bibliography

Allen, Michael J. B. 1984. *The Platonism of Marsilio Ficino: A Study of His Phaedrus Commentary, Its Sources and Genesis*. Berkeley: University of California Press.

Allen, Michael J. B. 2008. *Marsilio Ficino: Commentaries on Plato: Volume I: Phaedrus and Ion* [The I Tatti Renaissance Library 34]. Cambridge: Harvard University Press.

Ariosto, Ludovico. 2008. *Orlando Furioso*, translated with an Introduction by Guido Waldman. New York: Oxford University Press.

Ascoli, Albert R. 1987. *Ariosto's Bitter Harmony: Crisis and Evasion in the Italian Renaissance*. Princeton: Princeton University Press.

Ascoli, Albert R. 2010. "Like a Virgin: Male Fantasies of the Body in Orlando furioso." In *The Body in Early Modern Italy*, edited by Julia L. Hairston and Walter Stephens, 142–158. Baltimore: The Johns Hopkins University Press.

Bal, Mieke. 2002. *Travelling Concepts in the Humanities: A Rough Guide*. Toronto: University Press.

Beecher, Donald, Massimo Ciavolella, and Roberto Fedi. 2003. *Ariosto Today: Contemporary Perspectives*. Toronto: University of Toronto Press.

Bidwell-Steiner, Marlen. 2017. *Das Grenzwesen Mensch: Vormoderne Naturphilosophie und Literatur im Dialog mit postmoderner Gender Theorie*. Berlin and Boston: Walter de Gruyter [Mimesis. Romanische Literaturen der Welt65].

Bolzoni, Lina. 2010. *Il cuore di cristallo: ragionamenti d'amore, poesia e ritratto nel Rinascimento*. Torino: Einaudi.

Bolzoni, Lina, et al. 2014. *L'Orlando furioso nello specchio delle immagini*. Rome: Istituto della enciclopedia italiana.

Calabritto, Monica. 2001. *The Subject of Madness: An Analysis of Ariosto's "Orlando Furioso" and Garzoni's "L'Hospedale de' pazzi incurabili"*. PhD diss., City University of New York.

Chimène Bateman, J. 2007. "Amazonian Knots: Gender, Genre and Ariosto's Women Warriors." *Modern Language Notes* 122:1–23.

Ferretti, Francesco. 2016. "Ariosto pittore: Sulla natura figurativa del Furioso." In *Carlo Magno in Italia e la fortuna dei libri di cavalleria: Atti del convegno internazionale, Zurigo, 6–8 maggio 2014*, edited by Johannes Bartuschat and Franca Strologo, 163–192. Ravenna: Longo.

Ficino, Marsilio. 1956. *Commentaire sur le Banquet de Platon*, edited by Raymond Marcel. Paris.

Ficino, Marsilio. 1985. *Commentary on Plato's Symposium on Love*, translated by Sears Jayne. Dallas: Spring Publications.

Freud, Sigmund. 1927. "Fetischismus." In *Gesammelte Werke*, vol. XIV, 309–317. Frankfurt am Main: Fischer.

Graves, Robert. 1960. *Greek Myths*, vol. II. London: Penguin.

Ingegno, Alfonso. 1988. "The New Philosophy of Nature." In *The Cambridge History of Renaissance Philosophy*, edited by Charles B. Schmitt and Quentin Skinner, 242–247. Cambridge University Press.

Jauss, Hans Robert. 1968. "Entstehung und Strukturwandel der allegorischen Dichtung." In *Grundriß der romanischen Literaturen des Mittelalters VI*, 1: 146–244. Stuttgart: Winter Universitätsverlag.

Javitch, Daniel. 1999. *The Grafting of Virgilian Epic in Renaissance Transactions: Ariosto and Tasso*, edited by Valeria Finucci, 56–77. London: Duke University Press.

Kisacky, Julia M. 2000. *Magic in Boiardo and Ariosto*. New York: Peter Lang2000.

Lee, Rensselaer W. 1940. "*Ut Pictura Poesis*: The Humanistic Theory of Painting." *The Art Bulletin* 22, 4:197–269.

Mac Carthy, Ita. 2007. *Women and the Making of Poetry in Ariosto's Orlando furioso*. Leicester: Troubador Publishing.

McWebb, Christine. 2003. "Heresy and Debate: Reading the 'Roman de la Rose'." *Aevum* 77:545–556.

Martinez, Ronald L. 1999. *Two Odysseys: Ronaldo's Po Journey and the Poet's Homecoming in the Renaissance Transactions: Ariosto and Tasso*, edited by Valeria Finucci, 17–56. London: Duke University Press.

Pontalis, Jean-Bertrand. 1970. *Objets du fétichisme*. Paris: Gallimard.

Poor, Sara S., and Jana K. Schulman. 2007. *Women and Medieval Epic: Gender, Genre, and the Limits of Epic Masculinity*. New York: Palgrave Macmillan.

Shapiro, Marianne. 1983. "From Atlas to Atlante." *Comparative Literature* 35:323–350.

Shemek, Deanna. 1998. *Ladies Errant: Wayward Women and Social Order in Early Modern Italy*. London: Duke University Press.

Siraisi, Nancy G. 2007. *History, Medicine, and the Traditions of Renaissance Learning*. Michigan: University Press.

Walker, Daniel P. 1958. "The Astral Body in Renaissance Medicine." *Journal of the Warburg and Courtauld Institutes* 21:119–133.

Wallace, William A. 1988. "Traditional Natural Philosophy." In *The Cambridge History of Renaissance Philosophy*, edited by Charles B. Schmitt *et al.*, 201–236. Cambridge: University Press.

Wack, Mary Frances. 1990. *Lovesickness in the Middle Ages: The Viaticum and Its Commentaries*. Pennsylvania: University Press.

Warburg, Aby. 2010. "Dürer und die italienische Antike (1905)." In *Werke in einem Band*, edited by Martin Treml, Sigrid Weigel, and Perdita Ladwig, 176–186. Berlin: Suhrkamp.

Wells, Marion A. 2007. *The Secret Wound: Love Melancholy and Early Modern Romance*. Stanford University Press.

Zatti, Sergio. 2006. *The Quest for Epic: From Ariosto to Tasso*. Toronto: Toronto University Press.

6 Neoplatonism and Biography

Michelangelo's *Ganymede* before and after Tommaso de' Cavalieri

Berthold Hub

A closer examination of Michelangelo's poems quickly shows that a large number of them feature Neoplatonic concepts, and that these Neoplatonic motifs are clearly influenced by Marsilio Ficino. Michelangelo's poems are written in the tradition of Dante, Petrarch, and Tuscan verse, but they cannot be fully appreciated without the new quality that Neoplatonism achieved through Ficino in Florence.[1]

It is notable, however, that although the influence of Florentine Neoplatonism is a constant element in Michelangelo's poetic work, it by no means appears consistently; in some years it increases, while in others it declines, depending on Michelangelo's situation and his circle of acquaintances. Admittedly, this cannot always be established absolutely clearly, as many of the poems cannot be precisely dated. But at least in connection with Tommaso de' Cavalieri (around 1532 and in the following years), as well as Cecchino Bracci (in 1544) and Vittoria Colonna (*c*. 1538–47), there is evidence for an increased clarity in the contours of Michelangelo's Neoplatonism that parallels biographical events.

Although Michelangelo's poems are literary constructs, full of topical phrases,[2] they still provide unique source material for the artist's thought and feelings. And yet, they receive hardly any attention in the literature on Michelangelo (or are used inappropriately) – so that Neoplatonism as well plays hardly any role (or only an improper one that consequently gives rise to objections). This deficiency may be explicable in the case of commentaries and interpretations on individual works of art, to the extent that art historians do not concern themselves with the poetry more intensively, or only very hesitantly; but it seems inexcusable in the numerous biographies of Michelangelo.

This essay is concerned with the fact that although Michelangelo's poetry shows evidence of having been deeply influenced by Florentine Neoplatonism – right down to verbal correspondences with *De amore*, Marsilio Ficino's commentary on Plato's *Symposium* – biographies of Michelangelo ignore the significance of Neoplatonism in his life. It simply plays no part in them. And this applies not only to older biographies, where it might be understandable – they are almost exclusively based on the *Vite* of Michelangelo written by his contemporaries Ascanio Condivi and Giorgio Vasari, and on Michelangelo the Younger's manipulated edition of his great-uncle's poems – but also to modern ones and even to the most recent biographies, in which the authors might have known better.

The following discussion is in three parts. Initially, we shall examine the most important biographies of Michelangelo for the extent to which they take Neoplatonism into account, as well as Michelangelo's poetry and his relationship to Tommaso de' Cavalieri. The second part is concerned with the *Ganymede* drawing that Michelangelo gave Tommaso de' Cavalieri in 1532, and it raises the hypothesis that it was the way in which art history has analyzed this drawing – despite its indisputably Neoplatonist iconography – that was responsible for the

rejection of and continuing disregard for the influence of Neoplatonism on Michelangelo. In the third part, I contrast the *Ganymede* drawing given to Tommaso de' Cavalieri with other, earlier depictions of Ganymede and Leda by Michelangelo, and I try to explain its completely different style of depiction on the basis of the evolution of Michelangelo's Neoplatonism during the course of his life.

Biographies

I shall mention here only a couple of examples from the older literature and a couple from the most recent literature on Michelangelo. In Herman Grimm's *Leben des Michelangelo*, published in 1879, the words Platonism, Neoplatonism and Ficino do not appear, and Michelangelo's acquaintance with Tommaso de' Cavalieri is discussed in just under two pages.[3] The indecent aspects of the poem dedicated to Cavalieri that is quoted in the passage are explained away in the revised edition of 1864 using a kind of climatic theory, which limits the relationship between the two to an intellectual exchange of views. The fact that the ageing Michelangelo was so intensively concerned with the much younger Cavalieri should not surprise the Northern reader, Grimm claims; it is simply the case that "the spirit [...] develops more rapidly and brilliantly in the South," so that young men were already able to carry out serious philosophical discussions with mature men there, just as the youthful Alcibiades had already done with Socrates.[4]

In Carl Justi's biography of Michelangelo, subtitled "Contributions to an Explanation of the Works and the Man" and first published in 1900, there is no mention of Neoplatonism and Ficino is only mentioned once – and of all things in the section on "Biblical Studies," which claims that Ficino and Michelangelo shared a purely typological view of the Old Testament.[5] This is all the more remarkable in that Carl Justi graduated in theology and philosophy in Berlin in 1859 with a dissertation on "The Aesthetic Elements in Platonic Philosophy" before he turned to art history.[6]

In Walter Rothe's *Renaissance in Italien: Michelangelo*, published in 1912 in a series entitled "World History in Character Sketches," the word Neoplatonism simply does not appear, although the author himself uses a trite Platonism of Ideas to euphemize Michelangelo's attraction to men: their beauty is said to have "stimulated his imagination to create the ideal."[7] Far from harboring any sensual desires, Michelangelo was more concerned with a "supreme and pure recognition of the 'Beautiful and Good', contemplated in imagination and referred to reality."[8] Ficino is again only mentioned on a single occasion, and of all things as evidence of the fact that "despite the scientific efforts of Humanists, the mental life remained in close inner connection with the older Christian worldview."[9] And this is incidentally the author's intention: to depict Michelangelo, and with him the whole of the Italian Renaissance, as being Catholic in the orthodox sense and thus morally healthy – in contrast to the Protestant North in the Renaissance and the contemporary world.

John Addington Symonds's *The Life of Michelangelo* (1893), based on research in the archives of the Buonarroti family at Florence, is an exception here to some extent.[10] Michelangelo's poems are cited here extensively for the first time, and their significance as biographical documents is discussed. Their Neoplatonic content is recognized, and Plato's *Phaedrus* and *Symposium*, as well as Ficino's commentary on the *Symposium*, are named as sources, although without detailed comparisons being made.[11] Symonds, a homosexual himself although married, was determined to have the world know that Michelangelo was homosexual. On the other hand, he insisted that Michelangelo never physically acted on the inclination.

Much more influential, however, was Irving Stone's *The Agony and the Ecstasy: A Biographical Novel of Michelangelo*, first published in 1961.[12] Despite a detailed chapter on Michelangelo's youth in the household of Lorenzo de' Medici and in his sculpture garden, there is again no mention of Neoplatonism here either. The book is dominated by the cliché of the unworldly, misunderstood artistic genius who has to overcome countless obstacles. Nor is there any mention of relationships between men; instead, the young artist falls eternally in love with the Contessina de' Medici, Lorenzo's youngest daughter. This invention was unforgettably dramatized in the Hollywood version a few years later (Carol Reed, 1965), with Charlton Heston and Diane Cilento.[13]

A propos of the Medicis' garden and house, where the young Michelangelo first came into contact not only with Angelo Poliziano, Cristoforo Landino, and others, but also with no less a figure than Marsilio Ficino himself: even in exhibition catalogues and anthologies concerned with Michelangelo's youth in general and his period at the Medici court in particular, his contact with the leading thinkers of the Florentine Renaissance is marginalized.[14] Interest again focuses purely on Michelangelo as a fine artist and his encounters with ancient works of art and with contemporary artists. The authors seem to assume that the one has nothing to do with the other.

Nothing in this unsatisfactory situation has changed even with the most recent biographers of Michelangelo – on the contrary. Antonio Forcellino, William Wallace and Volker Reinhardt all attempt to correct the one-sided image of the artistic genius by analyzing the letters and what are known as the *Ricordi*, mainly records of income and expenses of various types, in order to penetrate behind the image staged by the artist himself and by others and reveal "Michelangelo the man" as conditioned by his social milieu.[15] In the process, the poems are eliminated as possible sources, and with them Neoplatonism as well. None of these three extensive biographies makes any mention of Neoplatonism. Although Forcellino, Wallace and Reinhardt mention Michelangelo's early contacts with the leading Renaissance thinkers in the Medicis' garden and house, they never return to the subject again later in their biographies – and in addition, the circle's Neoplatonism is not discussed. They obviously consider that these contacts were in no way influential, or at least of no significance for Michelangelo's later thought and work.

In addition, in German historiography, there has been an increasing rejection of Neoplatonist interpretations of individual works by Michelangelo, especially following the attack by Horst Bredekamp in 1986 and 1992.[16] In the Anglo-Saxon countries, by contrast – despite the fundamental objections raised by Charles Dempsey[17] – Neoplatonic interpretations of individual art works by Michelangelo continued to appear, without, however, convincingly demonstrating the connection between his art and Neoplatonism.[18]

Despite all this, there is at least one work for which even today a Neoplatonic interpretation, also drawing on the poems and on Michelangelo's biography, is generally accepted: Michelangelo's drawing *The Rape of Ganymede*.

Ganymede

Michelangelo's *Ganymede* drawing belongs to a group that he presented as a gift to a young Roman noble, Tommaso de' Cavalieri.[19] In addition to *The Rape of Ganymede* (Figure 6.1), Vasari mentions *The Punishment of Tityus* (Figure 6.2), *The Fall of Phaeton*, a *Bacchanal of Children* (*baccanalia di putti*) and *Divine Heads* (*teste divine*).[20] While the other Cavalieri drawings have survived intact, the *Ganymede* is presumed lost and is now known only from a number of copies. However, in two of them, most probably contemporary, the size,

arrangement on the page, and details of the anatomy are so similar that for purposes of iconographic analysis we can be confident that at least the principal motif in both – Ganymede and the eagle – is an accurate reproduction of the original drawing given to Cavalieri.[21] Michelangelo, then aged 57, probably first visited the handsome and cultivated young noble Tommaso de' Cavalieri towards the end of 1532 in his house in Rome.[22] Cavalieri was probably about seventeen years old at the time.[23] Several letters that have survived mention this first meeting and testify to Michelangelo's immediate and fervent attachment to the young Cavalieri, who became the proverbial, albeit largely unfulfilled, love of his life.[24] I agree with Christopher Ryan, who concluded that "one senses in the poised language of his [Cavalieri's] three extant letters from this period to Michelangelo [...] the reserve of one who reciprocated the admiration, but not the passion."[25]

However, Michelangelo poured out his feelings for Cavalieri in a series of allegorical confessional drawings on mythological themes, which he presented to him as gifts, and in a long series of passionate love poems. The surviving letters also provide indirect evidence that *The Rape of Ganymede* (Figure 6.1) was probably presented to Cavalieri as a gift along with *The Punishment of Tityus* (Figure 6.2) as its companion piece.[26] To punish his unbridled love for Leto, the mother of Apollo and Diana, the Titan Tityus has been shackled to a rock in the underworld, where a vulture is pecking at his eternally regenerated liver (the seat of the passions).

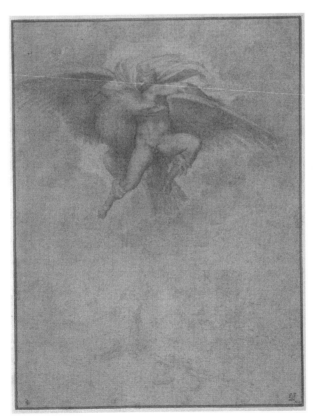

Figure 6.1 Copy after Michelangelo, *The Rape of Ganymede*, c. 1533. Black chalk. 361 x 270 mm. Source: Cambridge, MA, Harvard Art Museums, Fogg Museum, 1955–75. Harvard Art Museums/ Fogg Museum, Gifts for Special Uses Fund. Photo: © President and Fellows of Harvard College.

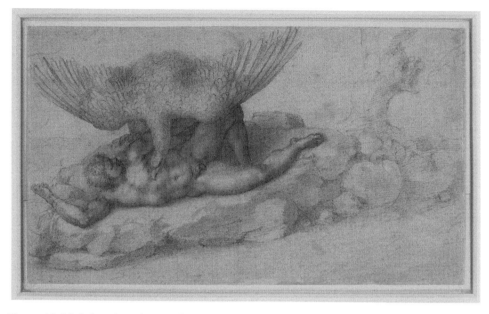

Figure 6.2 Michelangelo, *The Punishment of Tityus*, c. 1533. Black chalk. 190 x 330 mm.
Source: Windsor Castle, Royal Library, RCIN 912771 r. Royal Collection Trust / © Her Majesty Queen Elizabeth II 2020.

The fact that the two drawings were conceived as companion pieces is also suggested by the similar features of both the bird of prey and the youth. Tityus and Ganymede are clearly assimilated to each other through the choice of the same size in the figures, the same physical qualities, and the same curly hair. Tityus' body is in almost the same position and has only been rotated by ninety degrees. In addition, the power dominating both of them is the same on both sheets – an eagle with the same size and shape, although in the case of Tityus all of the literary sources mention a vulture.

The naked Ganymede, shown in a frontal view, has been captured by a mighty eagle with its wings spread wide but inclined slightly downwards. Ganymede's calves are being clasped from behind by the eagle's claws, with the right leg, which is almost fully outstretched, being grasped from the outside, and the left leg bent at a sharp angle from the inside. The embrace has spread the youth's thighs, and his genitals are clearly visible. In this position, his body twists to the left and thus turns towards the eagle's puffed-up breast, running parallel to it. In turn, the eagle has stretched its head so far downwards and to the right that it has come to rest over the youth's heart. His torso thus appears to be trapped and supported between the eagle's head and its left wing. The youth's head is inclined towards his left shoulder as a result of the turn, and the right shoulder is hidden behind the eagle's neck. His left, outstretched arm is lying on the eagle's right wing and his right arm encircles the eagle's neck and reappears at the arch of the left wing. The youth's eyes are closed, and his mouth appears to be slightly smiling. His curls are blowing in the wind, as is his cloak, which is no longer clothing him and is only visible above or behind the group, where it serves as a foil for the youth's head.

The eagle and Ganymede are thus placed in direct analogy with each other: the legs to the claws, the arms to the wings, torso to torso and head to head. The two figures form a unit to such an extent that if one looks only at the silhouette of the group, the two bodies

have become one. Ganymede's head is positioned precisely where the eagle's head would be expected, for example. The youth's arms also fuse with the bird's wings to such an extent that he seems to be flying himself.

Michelangelo was evidently not concerned with the sequence or drama of the story – the eagle would hardly have been able to fly in this position – but rather with the youth's complete helplessness relative to the eagle, which he does not resist but instead abandons himself to, as the closed eyes and relaxed position of the right hand reveal. While the eagle's iron grip on his legs forces the youth into passive immobility, the position of his arms, the posture of his head, and his facial expression convey the submissive yielding of someone in a trance or even asleep, sleep being the best metaphor for complete acceptance.

Perfectly reflecting this Ganymede, Michelangelo's poems abound in images of flight upwards, often involving birds and/or feathers, images of perfect union between lovers' souls and of celestial bliss. Poem no. 59, addressed to Cavalieri, for example, reads: "If one soul in two bodies is made eternal, / raising both to heaven with similar wings [...]."[27] Sometimes, paralleling the *Tityus*, they include binary oppositions concerning earthbound love – usually related to sexuality, bondage, and torment. Poem no. 260, for example, reads: "One love draws toward heaven, the other draws down to earth; / one dwells in the soul, the other in the senses, / and draws its bow at base and vile things."[28] This led Panofsky to conclude that "Ganymede, ascending to Heaven on the wings of an eagle, symbolizes the ecstasy of Platonic love, powerful to the point of annihilation, but freeing the soul from its physical bondages and carrying it to a sphere of Olympian bliss."[29] The *Tityus*, by contrast, as the negative counterpart to *Ganymede*, is said to embody the agonies of the physical passions. While the genuine loving soul, which is Platonic in the real sense of the word, is carried away to its origin and acquires immortality, Tityus has forever failed and is condemned to hell due to his uncontrolled physical lust. The two figures from ancient mythology are thus allegories, archetypal embodiments of human beings and their fate – not of a specific person, but of mankind as such. There are two fundamental choices for each human soul. Panofsky sees the duality as a moralizing division between *amor sacro e profano* and concludes that Michelangelo identified his own passion exclusively with Ganymede as the positive pole of Neoplatonic *amor sacro*.

To De Tolnay, by contrast, the pair exemplifies the ecstasy and suffering inherent in any individual experience of love: "The two drawings show the two aspects of Michelangelo's love for Cavalieri: Tityus the tortures of love, and Ganymede the mystic union and rapture."[30]

In principle, this ought to satisfy me as a champion of Neoplatonic interpretations. Yet I am convinced that the Neoplatonic interpretation of the Ganymede drawing in particular is partly or even mainly responsible for the disregard and even direct rejection of the relevance of Neoplatonism to the interpretation of art and ultimately, as a result, for the rejection of iconology as a method in art history. There are three reasons for this, in my view.

1. Poetry

The first reason for the rejection of Neoplatonism (and of iconology) is the fact that Michelangelo's extensive literary work has been reduced to the status of a quarry for suitable short quotations. Such short quotations make Michelangelo's Neoplatonism appear as a mere Platonism in the modern sense, as mere clichés from the tradition of Tuscan love poetry or as fig leaves to which Michelangelo only resorted – as they had Neoplatonic implications – in order to present his homosexual inclinations to his lover in a potentially innocuous form. This leaves interpretations with that sort of basis open to attack and in fact must inevitably lead to them being contradicted and to a reverse trend setting in.

However, a closer and more detailed examination of Michelangelo's poems shows that their Neoplatonism is a firm component of a philosophical Christian worldview. It is only when seen within this integrated thinking that what the Ganymede myth symbolized for Michelangelo, when he chose it as the subject of a drawing presented as a gift to Tommaso de' Cavalieri, can be understood.[31]

2. Catamite

The Neoplatonic interpretation à la Panofsky, however, is too smooth, too unrefracted, too clean, as it were, and consequently ought to give rise to vehement objections. It ignores the actually quite obvious erotic aspect of the depiction. Yes, *The Rape of Ganymede* and its companion piece, *The Punishment of Tityus*, do make use of established meanings in moral and Neoplatonic thought – but at the same time, it is of course a matter of the sexual desire of an older man for a younger one.[32] The fact that Ganymede hardly defends himself, with his right arm resting limply on the eagle's mighty wing, with a relaxed facial expression, smiling mouth and closed eyes, are all signs not only of mental rapture but also of physical pleasure and passive sexual devotion – the sexual passivity that traditionally defines the role of the 'catamite,' a word derived from the Latin 'catamitus,' a corrupt form of the (Greek) name Ganymede.[33]

The question of whether or not the eagle's position behind Ganymede "recalls common homosexual practices involving anal intercourse," as some interpreters have considered, may be left open.[34] In any case, homosocial liaisons were such a pervasive aspect of life in Renaissance Florence that the possibility that a contemporary observer would have seen *only* the ascent of the soul to God is improbable, or can even be excluded completely.[35] As James Hall has rightly observed: "It is often said that the Ganymede and the Tityus represent, respectively, sacred and profane love, but one might equally argue that they suggest the elevated nature of homosexual love, and the base nature of heterosexual love."[36]

The extent to which Michelangelo acted on his preferences physically remains conjectural, but many people evidently assumed that he was actively homosexual. For example, when Michelangelo was working on the Tomb of Pope Julius II in 1514, the father of a prospective apprentice offered the boy's services in bed as an added incentive.[37] There is also considerable evidence connected to Michelangelo and Cavalieri themselves (in the letters, poems and in Condivi) that they were well aware of the ambivalence of their relationship in general and of the depiction of the rape of Ganymede in particular. James Saslow has collected and discussed these materials at length.[38]

The ambivalence of the Ganymede drawing is of course related not only to the nature of the depiction but also to the interpretative and iconographic tradition. A full consideration of the drawing's iconography also has to take numerous appearances of the myth into account that emphasize the physical, rather than the spiritual, aspect of Jupiter's love for the beautiful young boy. Throughout antiquity, the Middle Ages and also the Renaissance, in addition to the Neoplatonic-type interpretations, depictions of the Ganymede myth are also found that show no evidence of any further meaning beyond the erotic aspect.[39]

The edition of Dante's *Divina Commedia* by Cristoforo Landino, first published in 1481 and including a Neoplatonic commentary, was undoubtedly extremely important for the Renaissance.[40] In Canto 9 of the Purgatory, Dante compares his entrancement in a dream with the abduction of Ganymede by the eagle – illustrated by Botticelli in his cycle of illustrations for the *Divina Commedia* in 1480–1495.[41] According to Landino's commentary, the eagle signifies *la divina charità*. Ganymede symbolizes the spirit (*mens*), in

contrast to the lower tendencies of the human soul, and his abduction signifies the ascent of the spirit via the *anima vegetativa* of plants and the *anima sensitiva* of animals to a state of entranced contemplation.[42] The soul thus becomes independent of the sensitive and vegetative parts of the body in order to devote itself wholly to the worship and contemplation of God.[43]

Angelo Poliziano, on the other hand – although, or perhaps precisely because, he was a Neoplatonist – overtly translated homosexual feelings into erotic expression, not least using the theme of Ganymede on several occasions.[44] In his *Greek Epigrams*, a series of erotically charged epistles to various young men, Poliziano openly describes his desires toward them, once specifically comparing his feelings to Jupiter's love for Ganymede.[45] His verse drama, *L'Orfeo*, written in 1480, praises homosexuality as "the superior sex" and adduces a list of mythological precedents as sanction for male homosexuality, including Ganymede.[46]

In Landino, Botticelli, and Poliziano, we have three individuals who were personally known to Michelangelo during his period at the Medici court between 1489–90 and 1496.

3. *The Faun in the Garden*

The third reason for the rejection of Neoplatonic interpretations is the fact that Panofsky and his followers failed to trace the paths of possible links between Michelangelo and Ficino in greater detail.

The genesis of Michelangelo's Neoplatonism cannot be found in any explicit testimony. There are no documents that provide direct information about Michelangelo reading this or that dialogue by Plato, or this or that text by his Neoplatonic contemporaries. In addition, Michelangelo did not have the necessary familiarity with Greek and Latin to be able to read the original texts or the commentaries written in Latin. Marsilio Ficino's commentary on Plato's *Symposium*, written in 1468–69, was only published in an Italian translation in 1544 – after the period of Michelangelo's passion for Cavalieri. However, Ficino had already been working on the vernacular edition shortly after writing the Latin version, or even simultaneously, and it had been circulating in manuscript form at least since 1474.[47]

An initial early contact between Michelangelo and Ficino's Neoplatonic concepts took place in the years 1489/90–96. Michelangelo initially spent the years 1489/90–92 in Lorenzo de' Medici's household, in Palazzo Medici in Via Larga, and the sculpture garden at San Marco; in 1494, he was welcomed into the household of Piero de' Medici, Lorenzo's son; and finally in 1495–96, we find him closely linked with Lorenzo di Pierfrancesco de' Medici.[48] A large number of myths have grown up particularly about his first period at the court of Lorenzo the Magnificent, following on from his contemporary biographers Ascanio Condivi and Giorgio Vasari. But there can be no doubt about the existence of the sculpture garden and the fact that Michelangelo was part of the Medici household, residing in Palazzo Medici. There is equally little doubt that he met numerous central figures in the Neoplatonic movement there. The Medici circle into which Lorenzo the Magnificent, himself author of Neoplatonic poems,[49] welcomed the 14- or 15-year-old Michelangelo at that time included Marsilio Ficino himself. His student Girolamo Benivieni wrote a verse summary of Ficino's commentary on the *Symposium* in his canzone *De lo amore celeste*.[50] Benivieni's poem in turn became, as *Canzona de amore*, the subject of a commentary by another of Ficino's pupils, Giovanni Pico della Mirandola.[51] The Medici circle also included Angelo Poliziano and Cristoforo Landino. The direct influence of Poliziano on the young Michelangelo is described by Condivi. In his biography, authorized by Michelangelo, he reports that

"recognizing in Michelangelo a superior spirit," Poliziano "loved him very much and [...] continually urged him on in his studies, always explaining things to him and providing him with subjects."[52] Cristoforo Landino's qualities are praised by Michelangelo himself in the second of the dialogues recorded by Donato Giannotti.[53] It can be assumed that Landino, as the author of a Neoplatonic commentary on Dante's *Divina Commedia* (1481), encouraged the young Michelangelo to read Dante during the years they spent together at the Medici court, and that he thus also instructed him in his own interpretation of the work.[54]

Both of these authors were mentioned here earlier on as evidence for the ambivalence of the Ganymede motif during the Renaissance in general. The immediate Medici circle was also marked by the same ambivalence. While Ficino and Landino preached chaste love between men as a way of liberating the soul from the body and leading it to ascend to God, there are at least justified suspicions that several members of the Medici circle also practiced the physical form of this love. I am thinking here of the passionate friendships between Ficino and the young Giovanni Cavalcanti, to whom Ficino dedicated his *De amore*, or between Girolamo Benivieni and Pico della Mirandola, who wrote passionate poems to each other.[55] Finally – as we have already seen – Poliziano was more or less openly homosexual. He was twice implicated in sodomy investigations in Florence,[56] and he reportedly died on 28 September 1494 of a fever brought on by an insatiable passion for a youth.[57] Incidentally, the circle around Jacopo Galli in Rome that Michelangelo entered in 1496 shared the same type of ambiguity.[58]

In any case, from 1489/90 to 1496 – a period of 7 years, *nota bene*, when Michelangelo was between 14/15 and 21 years of age – he was associated with the Medici and their ambivalent cultural milieu. Michelangelo had probably already met Ficino, Landino and Poliziano even earlier, in 1488–89, when he was working in Ghirlandaio's workshop. A fresco cycle containing portraits of them (as a group of *familiari* of Lorenzo de' Medici, also including Gentile de' Becchi, engaged in discussion with each other) was at that time executed by Domenico Ghirlandaio and his assistants for the Tornabuoni chapel in Santa Maria Novella, completed in 1490.[59]

This first direct encounter with Neoplatonism in the 1490s was followed by a second, which was no less important.[60] In 1515, Pope Leo X – born in 1475 as Giovanni de' Medici, Lorenzo's son, in the same year as Michelangelo, and acquainted with him since his time in Lorenzo's household in the early 1490s – founded the *Accademia Sacra dei Medici* as a continuation of Ficino's "Platonic Academy." The focal point for the new academy was Francesco Cattani da Diacceto, a close friend of Ficino's and his most loyal pupil.[61] As a member of the academy, Michelangelo certainly knew Diacceto personally. In 1519, the academy was asked by Cardinal Giulio de' Medici to commemorate the death of Lorenzo de' Medici the Younger. Diacceto delivered the funeral oration and Michelangelo executed the tomb in the New Sacristy of San Lorenzo.[62] However, Michelangelo had probably already met Diacceto in the 1490s. There is evidence of Diacceto's connection with Ficino and the Medici household starting in 1492.[63] In any case, Michelangelo was able to study Diacceto's major writings in Italian translations. The *Panegirico all'amore*, finished in 1508, which sums up (and also waters down) Ficino's Neoplatonic ideas about love and beauty, was printed in Rome in 1526 as the first of Diacceto's publications.[64]

But did Michelangelo even have to read anything at all? The importance of verbal communication for Renaissance culture should not be underestimated. Today's thinking, distorted by modern written culture and burdened with floods of information, can lead to a tendency to disregard the importance of conversations and lectures in earlier periods. "Two years in the Medici household, guided in his studies by such humanists as Agnolo Poliziano, Marsilio Ficino, and Cristoforo Landino, was worth more than a college

education," writes William Wallace – but unfortunately without drawing any conclusions from this for his biography of "Michelangelo the man."[65]

Leda, circa 1504

In the remainder of this essay, I would like to look back at the earlier history of Michelangelo's *Ganymede* for Tommaso de' Cavalieri and to place Michelangelo's interest in the rape of Ganymede that is evident in it in connection with the closely related subject of Leda and the Swan.

There are two sketches very similar to the *Ganymede* in a preliminary study for the "Battle of Cascina" (Figures 6.3–6.5), a painting that was never executed.[66] Michelangelo's lost cartoon was made in 1505–1506 for a commission from the government of Florence for a mural fresco in the Sala del Gran Consiglio in the Palazzo Vecchio.[67]

Michelangelo evidently first worked on an overall sketch for the cartoon and then rotated the sheet by 180 degrees before adding, in empty areas on the sheet on the outer left and in the center, two small sketches that have nothing to do with the "Battle of Cascina." The sketch in the left corner (Figure 6.4) is approximately 70 mm high, and the second sketch in the center of the marginal strip (Figure 6.5) is 65 mm high. At first sight, they appear to be depictions of the Ganymede–eagle group – and they have also been identified as such recently by Marcella Marongiu and Achim Gnann.[68] But in both cases, it appears to be a female body rather than a male one and a swan rather than an eagle, so that what we are looking at is not a "Rape of

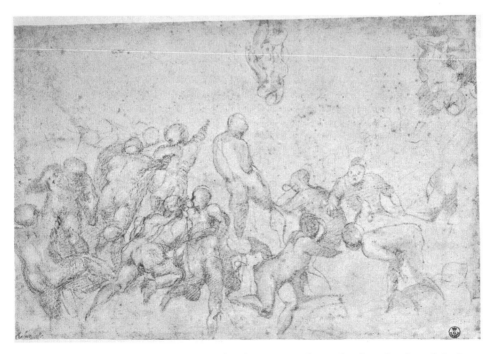

Figure 6.3 Michelangelo, *Study for The Battle of Cascina, and two sketches of Leda and the Swan*, c. 1504. Black chalk and silver point. 239 x 356 mm.
Source: Florence, Uffizi, Gabinetto Disegni e Stampe, Inv. 613 E r. Su concessione del Ministero per i beni e le attività culturali e per il Turismo.

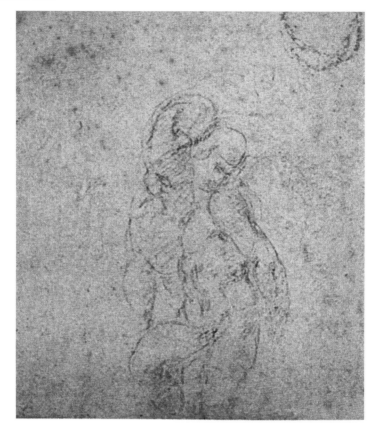

Figure 6.4 Detail of Figure 6.3.
Source: Su concessione del Ministero per i beni e le attività culturali e per il Turismo.

Ganymede" but rather a "Leda and the Swan." Admittedly, the two sketches are small and poorly preserved, so they are difficult to read, but the interpretation as "Leda and the Swan" is confirmed by another sketch.

A very similar group is found with clearer execution on a sheet which may again be a drawing for the abortive "Battle of Cascina" project in Florence (and therefore datable to around 1505; Figure 6.6).[69] At right angles to a lightly sketched military subject, we see a much more finished vertical nude figure that is being grasped from behind by a large bird. The scene is approximately 105 mm high. This depiction again is not a Ganymede–eagle group, as Marcella Marongiu saw it,[70] but a Leda–swan group – and more clearly this time. The human body is obviously female, in contrast to the male soldiers. And the bird is plainly different from an eagle. Its long, flexible neck, the shape of its beak, and its plumage, characterized by compact overlapping longer feathers, in contrast to the short feathers protruding away from each other that the eagle has – all of this undoubtedly indicates a swan. The swan is embracing Leda, who is softly nestling into it, with its spread wings, and it appears to be caressing her neck. With her left arm around the swan's neck, the young woman appears to be drawing it towards her, while her head inclines to the side in sweet surrender. The couple form a compact static unit while at the same time appearing to be in motion. On the one hand, the figure's legs, which appear to be hanging in space, and the hatching surrounding the group, which could be interpreted as clouds,

Figure 6.5 Detail of Figure 6.3.
Source: Su concessione del Ministero per i beni e le attività culturali e per il Turismo.

emphasize the impression of an ascent. On the other hand, the couple form a cohesive group, rather than one that opens up and spreads as would be needed for an ascent into the heights.

It has repeatedly been claimed that the model Michelangelo used for his depiction of Ganymede was one of the two famous Roman marble groups, probably copies of a bronze original from the fourth century B.C. by Leochares, as mentioned by Pliny, which at an unknown date entered the collection of the Grimani family in Venice and the Vatican collection, respectively.[71] However, as these sketches for the design of the "Battle of Cascina" from 1505–1506 show, the invention of the figural composition probably not only predates the discovery or purchase of the Leochares pieces but also begins with a different, although related subject – Leda and the Swan.

Leonardo

The fact that it is Leda is suggested or explained by the biographical context. The sketches reminded me that there is also a Leda on one of Leonardo da Vinci's sketches for his battle

Figure 6.6 Michelangelo, *Studies for The Battle of Cascina, and Leda and the Swan,* c. 1504. Black chalk and silver point. 211 x 242 mm.

Source: Florence, Uffizi, Gabinetto Disegni e Stampe, Inv. 18737 F r. Su concessione del Ministero per i beni e le attività culturali e per il Turismo.

depiction, *The Battle of Anghiari,* for the same Sala del Gran Consiglio in the Palazzo Vecchio in Florence.[72] Leonardo had already been commissioned by the Florentine government to create a fresco a year before Michelangelo.[73] The two artists worked alongside each other on the same project for about a year – Leonardo on *the Battaglia d'Anghiari* and Michelangelo on the wall beside or opposite it on the *Battaglia di Cascina.*

Leonardo was working on two Leda projects at the time, one of which, the "kneeling Leda," is attested to by three autograph sketches, while the other, the "standing Leda," is only found in copies by other artists.[74]

Leonardo's first surviving ideas for a Leda are found on a sheet in Windsor (Figure 6.7) alongside and below the figure of a rider on a rearing horse, which recurs in a similar form in other sketches for the *"Battle of Anghiari."*[75] In this case, it is a crouching Leda, although it anticipates the arm movement in the standing Leda as seen in various copies of the lost painting.[76] In this sketch, Leonardo has concentrated on the Leda figure, and the swan has been omitted, as in Gianpietrino's copy in Kassel.[77] The swan is then added in the two later drawings (Figure 6.8).[78]

The two artists, Michelangelo and Leonardo, were thus working alongside each other in the Sala Grande of the Palazzo Pubblico at the time when they were both interested in

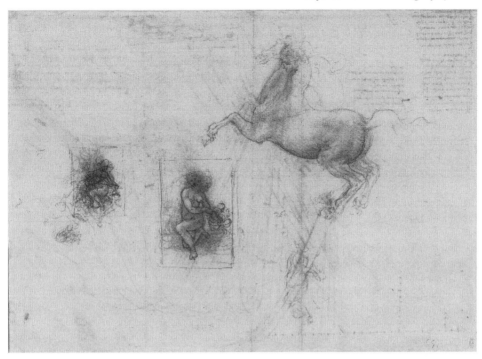

Figure 6.7 Leonardo da Vinci, *Studies for The Battle of Anghiari, and Leda*, c. 1504. Black chalk, pen, and ink. 287 x 405 mm.
Source: Windsor Castle, Royal Library, RCIN 912337 r. Royal Collection Trust / © Her Majesty Queen Elizabeth II 2020.

Leda. Since, firstly, Leonardo was at this time the older (born 1452) and more respected artist; and, secondly, was working on two specific projects, or perhaps even commissions, while in Michelangelo's case only these three initial sketches have survived – it can be concluded that Michelangelo first concerned himself with Leda in the wake of Leonardo and thus in tacit or open competition with him. Or perhaps one should not draw on the cliché of competing artists; Leonardo's concern with "Leda" spontaneously inspired Michelangelo to put his own idea on paper playfully.[79]

The subject is the same in Michelangelo's and Leonardo's "Ledas." However, the way in which they approach the subject could hardly be more different. Leonardo shows Leda as the central figure, with a swan (later) added as an attribute. By contrast, Michelangelo gives the swan the dominant role. He appears to be wanting to capture a quite different moment. The two figures nestle into each other with great familiarity, as if they had already known and loved each other for some time. They form a compact compositional unit. Leonardo also depicts the Dioscuri, with the twins sitting in front of the egg from which they have hatched. As Claudia Echinger-Maurach rightly observes, "Showing loveplay along with its result is directed more at the viewer's intellect, rather than his immediate perception."[80] In Michelangelo, by contrast, all narrative elements are lacking. He is only interested in the love scene.

We are reminded of one of Michelangelo's first poems, no. 4, which is found on the reverse of a letter written to him in 1507, when he was in Bologna. In the poem, addressed to a woman, Michelangelo expresses envy first of the flowers of the garland in

Figure 6.8 Leonardo da Vinci, *Study for Kneeling Leda*, c. 1504. Pen and brown ink and black chalk. 160 x 139 mm.
Source: Chatsworth, Devonshire Collection, Inv. 717.

her hair, and then of her golden locks, and finally of her dress and its ribbons; he envies them for being able to kiss and clasp her all day long, and he ends with the exclamation, "And her simple belt that's tied up in a knot / seems to say to itself, 'Here would I clasp forever!' / What then would my arms do?"[81]

It is impossible to say whether the poem is acknowledging an actual love or whether it is merely an exercise in a traditional Petrarchan conceit. The sensuous cataloguing of items of the woman's clothing may also be derived from Poliziano's *Stanze*.[82] In any case, the poem is devoid of any Neoplatonism.

Incidentally, Condivi notes regarding this period that "he [Michelangelo] remained for some time [in Florence] doing almost nothing in these arts, dedicating himself to the reading of vernacular poets and orators and to writing sonnets for his own pleasure [...]."[83] In connection with the "poeti et oratori volgari," we may possibly think of Angelo Poliziano or Lorenzo de' Medici, whose personal acquaintance with Michelangelo dating from his youth would certainly have offered a special stimulus to reading.

This appears to me to be the background to the two sketches of Leda: Leonardo's work on the same subject and Michelangelo's simultaneous reading of love poetry and his first efforts in the genre.

Ganymede, circa 1530

There is another drawing in the Uffizi that is closely related but involves a completely different conception and mood (Figure 6.9).[84] This drawing does actually show the rape of Ganymede – and literally, with a struggle and resistance. The sheet's attribution to Michelangelo used to be repeatedly dismissed, but more recently the attribution has become established.[85] As in the drawing in the Fogg Art Museum (Figure 6.1), the eagle–Ganymede group here occupies about three-quarters of the sheet. Once again, the group has already ascended from the ground. But the two protagonists' relationship with each other could not be more different. Far from showing blissful rapture and ecstasy, Ganymede is vehemently resisting his attacker. His arms are no longer lying relaxed on the eagle's wings but are trying to push the wings and beak away from him. Instead of laying its neck lovingly around the youth and approaching his heart with its beak, the eagle is

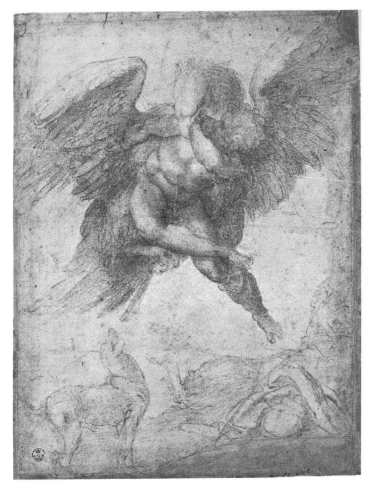

Figure 6.9 Michelangelo, *The Rape of Ganymede*, before October 1530. Red chalk. 310 x 255 mm.
Source: Florence, Uffizi, Gabinetto Disegni e Stampe, Inv. 611 E r. Su concessione del Ministero per i beni e le attività culturali e per il Turismo.

gripping the youth not only with his claws on the left lower leg but also with his sharp beak on his wrist in order to pull him towards it and hold him by force. The youth's facial expression also corresponds to these gestures expressing violence and resistance.

The two drawings thus also differ in the possible interpretations they offer. The depiction of struggle, violence and resistance excludes a moralizing, Neoplatonic interpretation of the depiction such as the one claimed by Panofsky for Michelangelo's entire oeuvre, or at least for his treatment of mythological subjects.

It is unlikely that Michelangelo was concerned in any way with the reprehensibility of the act. He is more likely to have been interested, as an exercise, in the depiction of the motif of movement resulting from the struggle between the eagle and the youth – in the same way that the motif of the struggle of Laocoön and his sons stimulated artists, including Michelangelo himself, to produce studies of their bodies.[86]

Another argument for the attribution to Michelangelo, incidentally, is the fact that on the reverse of the sheet there is a study for the Leda, the authenticity of which is not disputed (Figure 6.10).[87] The *terminus ante quem* for the sketch is October 1530, as the corresponding painting was completed at that point.

The two sides of the sheet, recto and verso, "Ganymede" and "Leda," are strangely always considered separately from each other. This even applies to Charles De Tolnay, who – besides the catalogue of the Gabinetto Disegni e Stampe of the Uffizi – in his *Corpus* of

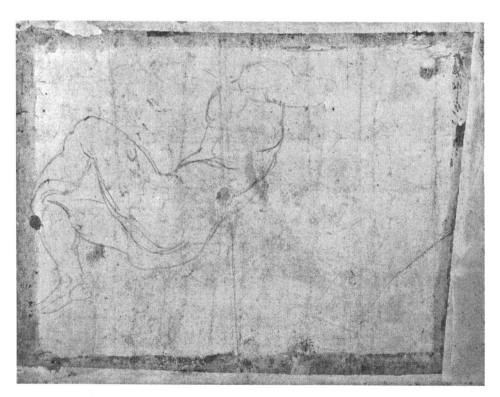

Figure 6.10 Michelangelo, *Study for the Leda*, before 1530. Red chalk. 310 x 255 mm.
Source: Florence, Uffizi, Gabinetto Disegni e Stampe, Inv. 611 E v. Su concessione del Ministero per i beni e le attività culturali e per il Turismo.

Michelangelo drawings is the only one to illustrate them together, involuntarily, so to speak. De Tolnay is obliged to date the "Leda" on the verso page to 1530. By contrast, he dates the *Ganymede* drawing to 1533 because he regards it as a preliminary study for the drawing presented to Cavalieri as a gift.[88]

When Michelangelo interrupted his work on the Medici tombs for a time in 1529–30 (the statue of *Night* awaited its final touches), he painted a *Leda and the Swan* for Alfonso d'Este, which has not survived in the original but has been preserved in copies in several paintings, drawings and engravings (Figure 6.11).[89]

As William Wallace has persuasively shown, the Leda for Alfonso was not (only) owed to Michelangelo's ambition to compete with Titian (and with antiquity), as a romantic version of art history restricted to art alone would have it.[90] Instead, Michelangelo's offer was part of the Florentine Republic's fruitless attempt to persuade Alfonso to provide military support.[91]

The relationship of the *"Leda"* to the *"Night"* in the Medici Chapel is unmistakable, but the *"Night"* was not the sole or original model. Instead, both depictions – *"Leda"* and *"Night"* – go back to a common source, a depiction dating from antiquity of *"Leda with the Swan"* that is known from several Roman sarcophagi, and in particular a sarcophagus which in the fifteenth and sixteenth centuries was located in the ruins of the palace of the ancient family of the Cornelii on the Quirinal.[92]

It has also been proposed that Michelangelo's figure was based on a famous antique gem. This cameo, which is now in the Museo Archaeologico Nazionale in Naples, was in the collection of Lorenzo de' Medici in Florence after 1471, and later in the collection of Clemens VII and the Farnese, and must therefore also have been known to Michelangelo.[93] However,

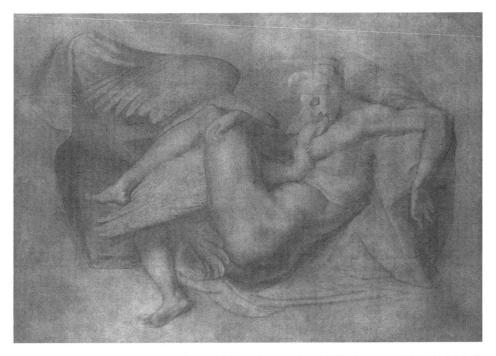

Figure 6.11 Rosso Fiorentino (?), after Michelangelo's, *Leda and the Swan*, c. 1538. Black chalk. 175 x 254 cm.
Source: London, Royal Academy of Arts, Inv. 04/282. © Royal Academy of Arts, London.

the link between "Leda" and "*Ganymede*" on the sheet (Figures 6.9 and 6.10) and the sarcophagus (Figure 6.12) suggests that Michelangelo's starting point was the sarcophagus rather than the cameo. Although the Ganymede type there is quite different, it may have inspired Michelangelo to draw a Ganymede as well when he was borrowing the depiction of Leda. In favor of this view is certainly the fact that the two motifs appear both on the sarcophagus and on the sheet in the Uffizi. But also the fact that the sketch on the reverse of the Uffizi sheet is clearly not for the "*Night*" but for the "*Leda*" corroborates this pedigree. *The Rape of Ganymede* (Figure 6.9) is therefore an earlier treatment of the subject by Michelangelo, from a period before he knew Tommaso de' Cavalieri – explaining the quite different approach to the theme used.

Conclusion

Authors such as Leonard Barken have regarded the depiction of the rape of Ganymede as being "as explicit an image of anal penetration as a sixteenth-century picture could be."[94] Some psychoanalytic authors, such as Kurt Eissler and Robert Liebert, have gone even further and stated that Michelangelo has given the boy a vagina, so that the penis we see is actually that of the eagle penetrating him.[95] Nathan Leites, however, claimed that Michelangelo suffered from a fear of penetration.[96] And James Saslow regards the depiction as elaborating Michelangelo's relationship to his father or his desire for a powerful, loving father.[97]

What appears to me to be more interesting from the psychological point of view, however, is the fact that in the relationship with Tommaso de' Cavalieri there was a precise reversal of the situation in which Michelangelo had found himself forty years earlier – or a repetition of it the other way round.[98] Homosocial liaisons were a pervasive aspect not only of life in Renaissance Florence in general but also in the immediate Medici circle. In the Medici household, Michelangelo found himself among a group of learned and cultivated Neoplatonists with homosexual inclinations – not only philosophically, but also physically. Michelangelo was most probably not the initiator of relations but rather the passive recipient of their attentions. In the early 1490s, Michelangelo was between fifteen and eighteen years of age. As Michael Rocke has shown, ninety percent of the passive partners in homosexual relationships were eighteen or under

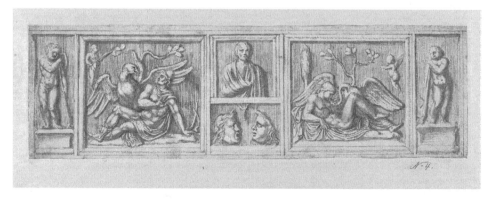

Figure 6.12 Codex Coburgensis, f. 4: *Ganymede and Leda*, mid sixteenth century. Brown ink and grey brush. 121 x 422 mm.
Note: Kunstsammlungen der Veste Coburg, Hz.002.Nr.004.

eighteen, with the mean age being sixteen.[99] He would thus have been precisely the age when it was common for a young man to become the object of attention and affection from older men. In age, wisdom, and fame, Michelangelo was to Cavalieri what Lorenzo de' Medici or Agnolo Poliziano had once been to the young artist. Michelangelo's relationship with Tommaso thus repeats the situation at the Medici court, only the other way round. And this led to the activation of Neoplatonism.

Notes

1 See, for example, De Vecchi (1963), Kovačić-Laule (1978), Hub (2005), Hub (2008).
2 See, for example, the contributions in Folliero-Metz and Gramatzki (2013). See also Summers (1981, 11–17).
3 Grimm (1860–63, vol. 2, 455–7).
4 Grimm (1860–63, vol. 2, 624–7, 626). Numerous reissues, most recently Paderborn: Salzwasser, 2012.
5 Justi (1900, 77). Numerous reissues, most recently Munich: Borowsky, 1992.
6 Justi (1860).
7 Rothes (1912, 35).
8 Rothes (1912, 35). See Thode (1902–13), who describes the feelings expressed by Michelangelo in his letters and poems to Tommaso de' Cavalieri as "raptures belonging purely to the intellectual sphere"; in his relationship to Tommaso, "the cult of beauty in Michelangelo's imagination," "his imaginary love" took "its fullest flight" (vol. 1: *Das Genie und die Welt*, 153). Although Von Einem (1959, 107–12), in connection with Tommaso de' Cavalieri and the gift of drawings also briefly mentions Michelangelo's poems, in which "the effect of Platonic–Neoplatonic ideas and views is felt," he makes no mention of Ficino or other contemporaries, and "Neoplatonism" is limited to beauty as a "mirror and reflection of the celestial beauty that rests in God" (107).
9 Rothes (1912, 65).
10 Symonds (1893). Numerous reissues, most recently Philadelphia: University of Pennsylvania Press, 2002. See Ostermark-Johansen (1998). In 1623, when Michelangelo the younger, son of Michelangelo's nephew Leonardo, printed a selection of Michelangelo's poems, he changed male dedicatees and word endings to female ones and added explanatory paraphrases that transformed obvious male–male passions into chaste allegories. This was only corrected in 1863, when Cesare Guasti published all the poetry and reprinted Michelangelo the Younger's emendations alongside the archival transcriptions of each poem; Michelangelo (1863). However, Guasti also believed that Tommaso de' Cavalieri was only a fictional name used to conceal the identity of Vittoria Colonna. Gotti (1876, I, 229–44), according to whom the letters to Cavalieri were actually addressed to Vittoria Colonna, also takes a similar position. See Parker (2005, 114–5). John Addington Symonds was the first to strongly oppose these camouflages. The only German-speaking historian of this period who discusses Michelangelo's poems and his love for Tommaso de' Cavalieri and the Platonic-Neoplatonic context is Von Scheffler (1892). However, although Scheffler was himself probably homosexual, he stays entirely on German lines and describes Michelangelo's *Amor* as "one that was purely intellectual, refraining completely from sexual love" (91–2), etc.
11 Symonds (1893, vol. 2, 125–79).
12 Stone (1961).
13 For this and other film biographies of Michelangelo, see Antoccia (1999).
14 For example, Barocchi (1992); Weil-Garris and Acidini Luchinat (1999). The latter volume includes an essay by James Hankins on the "Ambiente mediceo nella Firenze del tardo Quattrocentro," but it defends the dubious hypothesis that Ficino's Neoplatonism no longer played any role at the Medici court in the years when Michelangelo belonged to it (25–29). See also Barolsky (1994); Beck (1999, 25): "The impact of Michelangelo's part of rubbing shoulders with these intellectuals at the Medici 'court' is easily overestimated. He was not only totally preoccupied with the challenges of his art but was very young and relatively uneducated by their standards […]"; or Spike (2010); and the first part of the most recent biography by Michael Hirst (2011, 11–22; cf. 260–3, where Michelangelo's acquaintance with Tommaso de' Cavalieri is discussed accordingly in a few pages).

15 Forcellino (2005), Wallace (2010), Reinhardt (2010). The same applies to Barkan (2010, 295: "The drawings [...] not only [...] expose the precise sequence of steps that might have taken Michelangelo from the Neoplatonic idea to the completed work; even more gravely, they run the risk of revealing that there may not be any Neoplatonic idea. It is possible, in other words, that genius is all process and nothing but process.").

16 Bredekamp (1986/1992). Bredekamp's objections are based on general principles, but they are aimed particularly against Neoplatonist interpretations of Michelangelo's works (see esp. 79–80). For a rejection of any influence of Neoplatonism on Michelangelo, see also Garin (1999, 529: "[...] gli unici testi da leggere sono i prodotti stessi dell'arte: quadri, statue, edifici [...]").

17 Dempsey (1992). See the articles by Stéphane Toussaint and Angelika Dressen in the present volume.

18 See, for example, Balas (1989), Balas (2004); or Snow-Smith (1998).

19 See De Tolnay (1975–89, vol. 2, 102–10, cat. 332–45); and, for example, Zöllner, Thoenes and Pöpper (2007, 256–61 and 586–601), with bibliography. See Hirst (1988, 105–18, ch. 10: "The Making of Presents") and Regan (2012).

20 Vasari (1962, I, 118).

21 The first drawing, Figure 6.1 here, is in the Fogg Art Museum in Cambridge, Massachusetts (inv. no. 1955.75) and measures 27 × 38 cm. It shows the Ganymede–eagle group on the upper half of the sheet and in the lower part an unfinished landscape with a dog looking up at its master, an abandoned shepherd's crook and bundle, and two sheep. By contrast, the second sheet, which is in Windsor (inv. no. 13036), lacks the lower half of the depiction, so that it is only 26 × 19.2 cm and only shows the group with the main protagonists – who are otherwise the same as in the Fogg Art Museum drawing, however, including in their size. Since Hirst's 1975 essay, the drawing in the Fogg Art Museum has usually been regarded as the original gift to Tommaso de' Cavalieri. See Hirst (1975, 166) and Hirst (1978, vol. 2, 253–60); following Hirst, for example: De Tolnay (1975–89, vol. 2, 109–10, 344r). Most recently, however, Achim Gnann has presented good arguments that it is a copy. See Gnann (2010, 276–80, cat. 83), with bibliography. The horizontal-format sheet in Windsor was initially for a long time thought to be the original but has recently generally been declared a copy and sometimes attributed to Giulio Clovio. See, for example, Joannides (1996b, 72–4, cat. 15).

22 For Michelangelo and Tommaso de' Cavalieri, see esp. Frommel (1979). See Liebert (1983, 270–311), Perrig (1967), and Perrig (1991, 75–85), who unconvincingly ascribe several drawings which are generally seen as Michelangelo's drawings or copies of them to Cavalieri. See, for example, Joannides (1992, 265–6).

23 Tommaso de' Cavalieri's exact date of birth is not known. See Panofsky-Soergel (1984), according to whom Cavalieri was only twelve or thirteen years old when he met Michelangelo in 1532. However, 1520 is only the *terminus ante quem* for Cavalieri's birth.

24 Michelangelo (1965–79, IV, nos. DCCCXCIX, CM, CMVI, CMXVI-CMXIX, CMXXXII). See, for example, Frommel (1979, 14–21), Wallace (2010, 176–80), Marongiu (2002, 70–3 and 78–9, cat. 16, 17, and 20).

25 Ryan (1998, 95).

26 De Tolnay (1975–89, vol. 2, 110, 345r); Gnann (2010, 272–5, cat. 82), with bibliography.

27 Michelangelo (1991, 152, no. 59). See poems nos. 15, 39, 49, 61, 80, 89, 107, 154, 166, 168, 251, 260, 267. Unlike the presentation drawings for Tommaso de' Cavalieri, in his lyrics he does almost completely without mythological metaphors. Only the motif of the Phoenix (which at first has to die in the fire (of love) in order to be renewed and ascend to heaven) frequently recurs in his poems as a symbol for the transformative power of love. See nos. 43, 52, 61, 62, 100, 108, 217.

28 Michelangelo (1991, 440, no. 260). See, for example, nos. 43 or 83. See Ryan (1998).

29 Panofsky (1939/1962, 212–8). Many followed Panofsky in this interpretation – e.g., Panofsky's student Cromwell Mayo (1967, 107–9), or Frommel (1979, 39–45).

30 De Tolnay (1948, 112). Similarly, for example, Kempter (1980, 85–90).

31 See above, n. 1.

32 See, in particular, Saslow (1986, 17–62) and Leonard Barkan (1991, 78–98).

33 See Saslow (1986, 4).

34 Zöllner (2005, 150); see Zöllner, in Zöllner, Thoenes and Pöpper (2007, 260). See also Saslow (1986, 39), Barkan (1991, 89).

35 For homosexuality as a pervasive aspect of life in Renaissance Florence, see, in particular, Rocke (1996), also Saslow (1986), Saslow (1990), Sternweiler (1993).

36 Hall (2005, 185).

37 Michelangelo (1965–79, I, 150, no. CXIV). See Wallace (2010, 42–46, 46).

38 Saslow (1986, 17–62). For a balanced discussion of Michelangelo's homosexuality, see also Saslow (1988/1992) and Saslow (2004).

39 See for example Saslow (1986, 55, Fig. 1.15: Polidoro da Caravaggio, before 1543, Ganymede, embraced by Zeus, holds a set of male genitals); 134, Fig. 3.27 (Raffaelle da Montelupo, c. 1550, *Jupiter Kissing Ganymede*, Ashmolean Museum, Oxford, in the nineteenth century ascribed to Michelangelo); 138, Fig. 3.30 (Giulio Romano, *c.* 1530); 146, Fig. 4.1 (Benvenuto Cellini, 1548); Orgel (2004), Fig. 14 (Lelio Orsi, 1557); Fig. 15 (Damiano Mazza, 1575); Fig. 16 (Giovanni Battista Palumba, "Master I. B.," first half of the sixteenth century). See Mayo (1967, 127–41); Kruszynski (1985, 38–44); Morganti (2005). For the Middle Ages, see Boswell (1994, especially 217, 243–66, 381–98, 392–8) and Crompton (2003, 178–83). Ganymede was already an ambivalent figure even in antiquity. In the *Phaedrus*, Plato used Ganymede as a symbol of the "freshly inspiring" power of love and the incremental ascent to divine knowledge (*Phaedrus*, 255; cf. *Symposium*, 210 a–212 a). In the *Laws*, on the contrary, Plato invoked a "universal accusation" against the Cretans for having "invented" the tale of Ganymede in order to mythologically legitimize "surrender to lust of pleasure" by two males, which he pronounces "contrary to nature" and a "crime" (*Laws*, I, 636 c). Xenophon (*Symposium*, VII, 28–30) used Ganymede's elevation to heaven as an allegory representing the ascent of the pure soul toward knowledge of the divine. Euripides, on the contrary, in several of his plays (*Orestes*, 1390–92; *Cyclops*, 581–586; *Iphigenia in Aulis*, 1050–57), or Martial (*Epigrams*, XI, 22, 26, 43, 104) frankly identified Ganymede as the Jupiter's catamite. See also Tarán (1979, 7–51, Ch. 1 "Erotic Epigrams: The Motif of Ganymede"). Accordingly, ancient representations of Ganymede and Jupiter conform to both possibilities. For Ganymede as catamite, see, for example, Sichtermann (1988, esp. no. 7–51: Ganymede, depicted as a naked youth, is pursued, caught, and sometimes also kissed by Zeus personally – i.e., shown as an older man). For Ganymede as a symbol of ascent and immortality, see, for example, Engemann (1973, 15–59). See Mayo (1967, 1–58).

40 Landino (2001). See Lentzen (1971), Gilson (2005, part. 199–211).

41 Dante, *Divina Commedia*, Purgatorio, IX, 13–27. Schulze Altcappenberg (2001, 154–5: Codex Hamilton 201).

42 Landino (2001, vol. 3, 1180–4). See Panofsky (1939/1962, 214–5).

43 Another point indicating the influence of Landino on Michelangelo is that his commentary includes the topic of Tityus alongside the Ganymede myth. For Tityus, see *Inferno*, V, 25–45 and XXXI, 115–129; Landino (2001, vol. 1, 449–52 and vol. 2, 980–2); Phaeton, *ad indicem*.

44 Saslow (1986, 29–31).

45 Poliziano (2002, 117–9, no. XXVI; cf. nos. V, VII, VIII, X, XXIII, XXIX). See Saslow in Wilhelm (1995, 309).

46 Poliziano (1986): "From now on I shall only pluck new flowers, the springtime of the superior sex, when they are comely and lithe, for this is the sweetest and mildest love." (161, verse 270–273); and: "Jove took this as his credo, for he enjoys Ganymede's wiles in the heavens, tied in his sweet amorous knot." (162–3, verse 285–7). Quoted after Poliziano (2004, 273). Poliziano expands on Ovid's cursory treatment of Orpheus's abandonment of females for males (*Metamorphoses*, X, 79–85). See Orgel (2004, 485–90). Stanza 107 is also devoted to the amorous abduction of Ganymede: Poliziano (1954, 51). See also Poliziano's anecdotes on sodomy in Poliziano (1983, nos. 99, 136, 184, 228, 242, 302, 303, 306, 371, 404, 408).

47 See Ficino (1987, v, Introduzione). See Gentile (1992, 744–6), Tanturli (2006, 190–1).

48 See esp. Pernis (1993, 143–61). See also Joannides (1996b).

49 See Buck (1936), Gentile (1993, 23–48), also Nelson (1958, 44–52).

50 Girolamo Benivieni, "Canzona d'Amore," in Pico della Mirandola (1942/2004, 451–8). See Nelson (1958, 52–4). Benivieni explicitly notes that his nine stanzas sum up Marsilio Ficino's commentary on Plato's Symposium in a few lines: "Una mia Canzone, nella quale invitato dall'amenissima lezione degli eruditi commentari del nostro Marsilio Ficino sopra il Convito di Platone, io aveva in pochi versi ristretto quello, che Marsilio in molte charte elegantissimamente descrive." Quoted after Buck (1965, 38, n. 81).

51 Giovanni Pico della Mirandola, "Commento sopra una canzone de amore composta da Girolamo Benivieni," in Pico della Mirandola (1942/2004, 443–581), Pico della Mirandola (1984). See Nelson (1958, 54–63).

52 Condivi (1976, 14–5).

53 Giannotti (1968, 79).

54 Paolo Procaccioli lists seven editions of the *Commedia* with Landino's commentary printed before 1500. See Landino (2001, I, 173–81).

55 Saslow (1986, 29–31), see Saslow (1998, 227–9). By contrast, Kristeller (1972, 259–71) insists that Ficino's love for his friends was purely platonic. See John C. Nelson (1958, 70–3).

56 Rocke (1996, 198 and 202). Also Sandro Botticelli was accused of sodomy; Rocke (1996, 139).

57 See Dionisotti (1985). See Stewart (1997). See Ludovico Ariosto's verse letter to Pietro Bembo, *Satira*, VI, 25: "Senza quel vizio son pochi umanisti […]," and VI, 31–33: "Ride il volgo, se sente un ch'abbia vena / di poesia, e poi dice: – È gran periglio / a dormir seco e volgierli la schiena"; Ariosto (2002, 179 and 180). The other pole of the conflict in which Michelangelo found himself during the 1490s (and later) is represented by the Dominican Girolamo Savonarola, who lived just next to the sculpture garden, in the monastery of San Marco established by the Medici. In his sermon of 1 November 1494, for example (shortly after Poliziano's death, possibly from syphilis), Savonarola exhorted the Florentines: "[…] lasciate, dico, quel vizio indicibile, lasciate quel maledetto vizio che tanto ha provocato l'ira di Dio sopra di voi, che guai, guai a voi!"; and on 14 December 1494 he demanded a tightening of the laws: "Item, è necessario che la Signoria faccia legge contra quello maledetto vizio della soddomia, del quali tu sai che per tutta Italia Firenze ne è infamata […]; fanne una legge, dico, che sia senza misericordia, cioè che tali persone siano lapidate e abruciate." Savonarola (1965, 20 and 220). See also Savonarola (1969/1974, 164: 3 May 1495).

58 See Saslow (1998, 229–31).

59 Poliziano is also depicted in Ghirlandaio's frescoes in Cappella Sassetti in Santa Trinità. See, for example, Kecks (1997, 135 and 188–90), or Cadogan (2000, 78, Fig. 72, and 97, Fig. 91). Compare these authentic portraits of the Medici court to the depictions of Lorenzo the Magnificent in the circle of his artists, which are already influenced by Vasari – i.e., by art history – in which the artists are conceived in isolation from the thinkers of the Renaissance: Giovanni Stradano, *Lorenzo de'Medici and His Artists in the Loggia of the Sculpture Garden*, 1571, tapestry, commissioned by Cosimo I for a room in the Florentine Palazzo Vecchio (modelled after Vasari's *Duke Cosimo I de' Medici and his Artists*, 1556–62, ibid.); and Ottavio Vannini, *Lorenzo de' Medici and his Artists in the Loggia of the Sculpture Garden*, 1635, fresco in the Sala di Giovanni da San Giovanni of Palazzo Pitti (placed next to a fresco by Francesco Furini depicting Ficino's so called "Platonic Academy"). For illustrations, see for example Cox-Rearick (2013, I, 322–32, 326–7, Fig. 4–7).

60 Frommel (1979, 33–4); Van den Doel (2010).

61 Kristeller (1946, 260–304); Nelson (1958, 108–12).

62 Pernis (1993, 151).

63 Pernis (1993, 150).

64 Diacceto (1563, 130–8). There is only a modern German translation of the *Panegirico all'amore*: "Lobrede auf die Liebe," in Frommel (1979, 98–111). See also Diacceto (1986); see Celenza (2007).

65 Wallace (2010, 42).

66 De Tolnay (1975–89, I, 56, 45r); Gnann (2010, 70–4, cat. 15). The larger of the figures on the other side of the sheet could also be a Leda, although without a swan. De Tolnay (1975–89, I, 56, 45v: Uffizi, 613 E v); Gnann (2010, 74, cat. 15v). De Tolnay considers the two sketches on the front to be a Leda with the swan, and the sketch on the back, in contrast, to be a later preliminary study for the 1532 Ganymede. Gnann believes the group of figures is an early draft for a scene from the "Battle of Cascina." De Tolnay also regards two sketches on a sheet now in the Teyler Museum in Haarlem (inv. A 38v) as preliminary studies for Ganymede; however, not only the attribution to Michelangelo but also the identification of the figures is extremely questionable (De Tolnay 1975–89, I, 78, 84v). Another drawing that shows two nude men, the younger of whom is sitting on the left thigh of the older one and stretching his right leg over the older one's right leg was also attributed by De Tolnay (1975–89, vol. 3, 41–2, 375r) to Michelangelo, dated to the time of his first acquaintance with Tommaso de' Cavalieri and identified as *Jupiter and Ganymede*. However, it is more likely to be "Apollo and Hyacinthus" if a mythological subject is intended at all, quite apart

from the fact that the attribution and dating are controversial. For Apollo and Hyacinthus, see, for example, Dunand and Lamarchand (1977–99, vol. 2, 463, Fig. 844: Jacopo Caraglio). For the "Battle of Cascina," see most recently Keizer (2011).

67 A copy of the cartoon made by Bastiano da Sangallo is now in the collection of the Earl of Leicester in Holkham Hall, UK. See Zöllner, Thoenes and Pöpper (2007, 55–7 and 443); or Gnann (2010, 70–4, 71, cat. 15). See below, n. 73.

68 Marongiu (2002, 66); Gnann (2010, 71).

69 De Tolnay (1975–89, I, 55–6, 44r: Leda).

70 Marongiu (2002, 32 and 66–7, cat. 14).

71 Pliny, *Naturalis historia*, XXXIV, 79. Sichtermann (1988, vol. IV.1, 166, no. 251: Vatikan and vol. IV.2, 95, no. 253: Grimani), or Kempter (1980, Fig. 1: Vatican and Fig. 30: Grimani). See, for example, Hekler (1913, 218–22); most recently Gnann (2010, 278). See Regan (2012, 287–9). The latter group has recently returned from the Museo Archeologico Nazionale in Venice to its original site in the Tribuna of the Palazzo Grimani. See, for example, De Paoli (2000), Favaretto and De Paoli (2010, Fig. 6). On the Neoplatonic significance of Ganymede in the context of the decoration of the Palazzo Grimani (erected starting in 1556), see De Paoli (2004, 98–128). Apart from the formal differences from Michelangelo's drawing, it is not certain whether the sculpture group was already in the Grimanis' collection in the 1530s. In the case of the group in the Vatican collection, it is also not known where it was in Michelangelo's time; it only entered the Vatican collection in 1790.

72 The essay by Echinger-Maurach only came to my attention while I was completing the present article: Echinger-Maurach (2002). We have reached very similar conclusions independently of each other.

73 See, for example, Zöllner (2007, 160–75), or Melani and Pedretti (2012). See Pedretti (2006), Verspohl (2007), Echinger-Maurach (2013).

74 Dalli Regoli, Nanni and Natali (2001); Nanni (2007), Zöllner (2007, 184–90, 246–7, 288–91). See Rossoni (2002) and Dalli Regoli (2006).

75 Dalli Regoli, Nanni and Natali (2001, 110–1, cat. II.3).

76 Dalli Regoli, Nanni and Natali (2001, 15, Fig. 9; 40, Fig. 24; 60–1, Fig. 46–8; 140–5, cat. III.5 and III.6), Zöllner (2007, 184–5).

77 Giovan Pietro Rizzoli, called il Giampietrino, *c*. 1508–13, Kassel, Staatliche Museen, Gemälde-galerie Alter Meister, Schloss Wilhelmshöhe, Inv. 966. Dalli Regoli, Nanni and Natali (2001, 116–9, cat. II.6), Zöllner (2007, 189).

78 Figure 6.8 reproduces the version in Chatsworth. The other drawing, which slightly varies the composition, is in the Museum Boijmans Van Beuningen of Rotterdam, inv. I 466. See Dalli Regoli, Nanni and Natali (2001, 112–3, cat. II.4: Rotterdam, 114–115, cat. II.5: Chatsworth), Zöllner (2007, 289).

79 For further examples of Leonardo inspiring Michelangelo during this period (with no mention of the Leda sketches), see Wilde (1953, 65–77).

80 Echinger-Maurach (2002, 270).

81 Poem, no. 4; Michelangelo (1991, 69).

82 See Clements (1966, 204–5).

83 Condivi (1976, 28).

84 De Tolnay (1975–89, vol. 2, 85, 298r), Marongiu (2002, 32–3 and 68–9, cat. 15).

85 Hirst (1975, 256), De Tolnay (1975–89, vol. 2, 85, 298r), Marongiu (2002, 32–3 and 68–9, cat. 15).

86 Michelangelo had been present at the discovery of the Laocöon, and the extent to which he was still able to recall it at this period, when he was working on the tombs in the Medici Chapel, can be seen from a sketch of a head on the wall of what is known as the *Stanza Segreta*, underneath the Sacristia Nuova of San Lorenzo. See Andreae (1988, 31–9) and Dal Poggetto (2012, 40–1).

87 De Tolnay (1975–89, vol. 2, 85–6, 298v).

88 De Tolnay (1975–89, vol. 2, 85–6, 298v). See Petrioli Tofani (1986–87, I, 272–3).

89 For Michelangelo's "*Leda*" and the copies made after it, see, for example, Wilde (1957, 270–80), Carroll (1987, 318–27), Falletti and Katz Nelson (2002, 172–83).

90 See, for example, Goffen (2002, 306–16). According to this view, Michelangelo created his "*Leda*" for Alfonso d'Este in competition with works in Ferrara by Titian and Leonardo's "*Leda*."

91 Wallace (2001, 473–99). See Ragionieri (2007).

92 Figure 6.12 reproduces Codex Coburgensis, fol. 4. The same drawing is also found in a manu-
script in the Staatsbibliothek Berlin, Codex Pighianus, fol. 301. See Sichtermann (1984, 43, Fig.
1), Sichtermann (1992, part 2, cat. 144 and pl. 115, Fig. 3). See Bober and Rubinstein (1986, 58,
no. 5), Kempter (1980, Fig. 24). Another drawing, probably of the same sarcophagus, was made
by a follower of Jacopo Bellini (Louvre R. F. 524). See Degenhart and Schmitt (1972, 154–6 and
158, Fig. 21) or Degenhart and Schmitt (1990, 551–3, cat. 725 and Plate 319); also Sichtermann
(1984, 45, Fig. 4). The sarcophagus has been linked to Michelangelo's "Leda" since Michaelis
(1885, 40–1). See, for example, Wilde (1957), Wind (1958/1980, 152–70, 152–3), Knauer (1969,
5–34). So far as I can see, however, no one has so far also linked the depiction of Ganymede on
the sarcophagus with Michelangelo (and accordingly, sometimes only the right side of the sar-
cophagus – i.e., only the Leda – has been shown in illustrations. See, for example, De Tolnay
(1975–89, vol. 2, 86). For examples of depictions of Ganymede that closely follow the model of
the sarcophagus, see Saslow (1986, 99, Fig. 3.3: Parmigianino, 100, Fig. 3.3: Giulio Romano), or
Morganti (2005, 10, Fig. 10: Giulio Bonasone). This sarcophagus was not the only surviving
example of this type. A similar sarcophagus, with the same motifs but with a slightly different
depiction in the case of Ganymede, is documented in Cassiano del Pozzo's *Museo Cartaceo*
(Windsor Castle, Royal Library). See Sichtermann (1992, part 2, cat. 144 and Plate 115, Fig. 4)
or Knauer (1969, 9, Fig. 10), Sichtermann (1984, 44, Fig. 2). A marble slab with a very similar
Ganymede–eagle group, which might also be from a Roman sarcophagus, is preserved in the
Museo Archeologico in Florence (Inv. 13724). See Marongiu (2002, 52–3, cat. 7), with biblio-
graphy. The significance of the Ganymede myth as a symbol of ascent and hope for immortality
could hardly have escaped Michelangelo when he was inspired by the motif of Leda and
Ganymede on the sarcophagus to create his own depictions. See Wind (1958/1980, 152–70). On
Ganymede depictions in Roman sepulchral sculpture in particular, see Engemann (1973, 15–59).
However, it admittedly only came to interest him at a later period, when his own life – his love
for Cavalieri – suggested this interpretation to him.

93 Third century, onyx, Naples, Museo Archeologico Nazionale, Inv. 25967/134. See Dacos (1973,
cat. 48, Fig. 53) or Bober and Rubinstein (1986, 56 and Plate 5b). See, for example, Falletti and
Katz Nelson (2002, 180–1, cat. 20), Dalli Regoli (2001, 156–7, cat. IV. 1), Nanni and Monaco
(2007, 130–2, Fig. 16).

94 Barkan (2010, 89). See above, n. 34.

95 Eissler (1961, 129–31). Liebert (1983, 173).

96 Leites (1986, 95–106).

97 Saslow (1986, 51–9).

98 See Wallace (2010, 42–6).

99 Rocke (1996, 96).

Bibliography

Andreae, Bernhard. 1988. "Michelangelo und die Laokoongruppe." In *Bathron: Beiträge zur
Architektur und verwandten Künsten für Heinrich Drerup zu seinem 80. Geburtstag*, edited by
Hermann Büsing, 31–39. Saarbrücken: Saarbrücker Druckerei u. Verl.

Antoccia, Luca. 1999. "Michelangelo: Il tormento e l'enfasi." *Art e dossier* 150:9–13.

Ariosto, Ludovico. 2002. *Satire*, edited by Alfredo D'Orto. Milan: Fondazione Pietro Bembo.

Balas, Edith. 1989. "Michelangelo's *Victory*: Its Rôle and Significance." *Gazette des Beaux-Arts* 131,
1441:67–80.

Balas, Edith. 2004. *Michelangelo's Double Self-Portraits*. Pittsburgh: Carnegie Mellon University Press.

Barkan, Leonard. 1991. *Transuming Passion: Ganymede and the Erotics of Humanism*. Stanford,
CA: Stanford University Press.

Barkan, Leonard. 2010. *Michelangelo: A Life on Paper*. Princeton: Princeton University Press.

Barocchi, Paola, ed. 1992. *Il giardino di San Marco: Maestri e compagni del giovane Michelangelo*,
exh. cat., Florence, Casa Buonarroti. Cinisello Balsamo: Silvana.

Barolsky, Paul. 1994. *The Faun in the Garden: Michelangelo and the Poetic Origins of Italian
Renaissance Art*. University Park, PA: Pennsylvania State University Press.

Beck, James H. 1999. "Michelangelo and Lorenzo il Magnifico." In James H. Beck, *Three Worlds of Michelangelo*, 11–76. New York: Norton.

Benivieni, Girolamo. 1942/2004. "Canzona d'Amore." In Giovanni Pico della Mirandola, *De hominis dignitate, Heptaplus, De ente et uno, e scritti vari*, edited by Eugenio Garin, 451–458. Florence: Vallecchi. Repr. 2004. Turin: Nino Aragno.

Bober, Phyllis Pray, and Ruth Rubinstein. 1986. *Renaissance Artists & Antique Sculpture: A Handbook of Sources*. London: Harvey Miller Publ.

Boswell, John. 1994. *Christianity, Social Tolerance, and Homosexuality: Gay People in Western Europe from the Beginning of the Christian Era to the 14th Century*. Chicago: University of Chicago Press.

Bredekamp, Horst. 1986/1992. "Götterdämmerung des Neuplatonismus." *kritische berichte* 14, 4:39–48. Repr. 1992 with minor revisions in *Lesbarkeit der Kunst: Zur Geistes-Gegenwart der Ikonologie*, edited by Andreas Beyer, 75–83. Berlin: Wagenbach.

Buck, August. 1936. *Der Platonismus in den Dichtungen Lorenzo de' Medicis*. Berlin: Junker und Dünnhaupt.

Buck, August. 1965. *Der Einfluß des Platonismus auf die Volkssprachliche Literatur im Florentiner Quattrocento*. Krefeld: Scherpe.

Cadogan, Jean K. 2000. *Domenico Ghirlandaio: Artist and Artisan*. New Haven: Yale University Press.

Carroll, Eugene Albert, ed. 1987. *Rosso Fiorentino: Drawings, Prints, and Decorative Arts*, exh. cat. Washington: National Gallery of Art.

Celenza, Christopher S. 2007. "Francesco Cattani da Diacceto's *De pulchro*, II.4, and the Practice of Renaissance Platonism." *Accademia* 9:87–98.

Clements, Robert J. 1966. *The Poetry of Michelangelo*. New York: New York University Press.

Condivi, Ascanio. 1976. *The Life of Michelangelo*, translated by Alice Sedgwick Wohl. Oxford: Phaidon.

Cox-Rearick, Janet. 2013. *Michelangelo's Renaissance Studies in Honor of Joseph Connors*, 2 vols., edited by Machtelt Israels and Louis A. Waldman. Milan: Officina Libraria.

Crompton, Louis. 2003. *Homosexuality & Civilization*. Cambridge, MA: Belknap Press.

Dacos, Nicole, Antonio Giuliano, and Ulrico Pannut. 1973. *Il Tesoro di Lorenzo il Magnifico, vol. 1: Le Gemme*. Florence: Sansoni.

Dal Poggetto, Paolo. 2012. *Michelangelo: La 'Stanza segreta': I disegni murali nella Sagrestia Nuova di San Lorenzo*. Firenze: Giunti.

Dalli Regoli, Gigetta. 2006. *Progetti di Leonardo per una L'opera grafica e la fortuna critica di Leonardo da Vinci*, edited by Pietro C. Marani, Françoise Viatte, and Varena Forcione, 67–84. Florence: Giunti.

Dalli Regoli, Gigetta, Romana Nanni, and Antonio Natali, eds. 2001. *Leonardo e il mito di Leda – Modelli, memorie e metamorfosi di un'invenzione*, exh. cat., Vinci. Cinisello Balsamo: Silvana.

De Paoli, Marcella. 2000. "Ratto di Ganimede." In *Restituzioni 2000: Capolavori restaurati*, edited by Fernando Rigon, 92–97. Vicenza: Banca Intesa.

De Paoli, Marcella. 2004. '*Opera fatta diligentissimamente*': *Restauri di sculture classiche a Venezia tra Quattro e Cinquecento*. Rome: L'Erma di Bretschneider.

De Tolnay, Charles. 1948. *Michelangelo, III: The Medici Chapel*, 5 vols. Princeton: Princeton University Press.

De Tolnay, Charles. 1975–89. *Corpus dei disegni di Michelangelo*, 4 vols. Novara: De Agostini.

De Vecchi, Pier Luigi. 1963. "Studi sulla poesia di Michelangelo." *Giornale storico della letteratura italiana* 80:370–402.

Degenhart, Bernhard, and Annegrit Schmitt. 1972. "Ein Musterblatt des Jacopo Bellini mit Zeichnunen nach der Antike." In *Festschrift Luitpold Dussler*, 139–168. Munich: Deutscher Kunstverlag.

Degenhart, Bernhard, and Annegrit Schmitt. 1990. *Corpus der Italienischen Zeichnungen 1300–1500, Teil II: Venedig, Jacopo Bellini*, vol. 8. Berlin: Mann.

Dempsey, Charles. 1992. *The Portrayal of Love: Botticelli's Primavera and Humanist Culture at the Time of Lorenzo the Magnificent*. Princeton: Princeton University Press.

Diacceto, Francesco Cattani da. 1563. *Opera omnia*. Basel: Henricus Petri and Petrus Perna.

Diacceto, Francesco Cattani da. 1986. *De pulchro libri III*, …, edited by Sylvain Matton. Pisa: Scuola Normale Superiore di Pisa.

Dionisotti, Carlo. 1985. "Considerazioni sulla morte di Poliziano." In *Culture et société en Italie du Moyen-Age à la Renaissance: Hommage à André Rochon*, 145–156. Paris: Université de la Sorbonne nouvelle.

Dunand, Louis, and Philippe Lamarchand. 1977–99. *Les amours des Dieux*, 3 vols. Lausanne: Institut d'Iconographie Ariétis.

Echinger-Maurach, Claudia. 2002. "Pictores Poetae: Leonardos und Michelangelos frühe Entwürfe für eine 'Leda mit dem Schwan'." In *Westfalen und Italien: Festschrift für Karl Noehles*, edited by Udo Grote, 257–283. Petersberg: Imhof.

Echinger-Maurach, Claudia. 2013. "Virtute vincere: Leonardos und Michelangelos 'Schlachten-bilder' im Rahmen der Ausstattung der Florentiner Sala grande del Consiglio im Palazzo Vecchio." In *Leitbild Tugend: Die Virtus-Darstellung in italienischen Kommunalpalästen und Fürstenresidenzen des 14. bis 16. Jahrhunderts*, edited by Thomas Weigel and Joachim Poeschke, 255–294. Münster: Rhema.

Eissler, Kurt R. 1961. *Leonardo da Vinci: Psychoanalytic Notes on the Enigma*. New York: International University Press.

Engemann, Josef. 1973. *Untersuchungen zur Sepulkralsymbolik der späteren römischen Kaiserzeit* [Jahrbuch für Antike und Christentum, Ergänzungsband 2]. Münster: Aschendorffsche Verlagsbuchhandlung.

Falletti, Franca, and Jonathan Katz Nelson, eds. 2002. *Venere e Amore: Michelangelo e la nuova bellezza ideale*, exh. cat., Florence, Galleria dell'Accademia. Florence: Giunti.

Favaretto, Irene, and Marcella De Paoli. 2010. "La tribuna ritrovata: Uno schizzo inedito di Federico Zuccari con l'antiquario dell'ill. Patriarca Grimani'." *Eidola* 7:97–135.

Ficino, Marsilio. 1987. *El libro dell'Amore*, edited by Sandra Niccoli. Florence: Olschki.

Folliero-Metz, Grazia Dolores, and Susanne Gramatzki, eds. 2013. *Michelangelo Buonarroti: Leben, Werk und Wirkung. Positionen und Perspektiven der Forschung*. Frankfurt a. M.: Lang.

Forcellino, Antonio. 2005. *Michelangelo: Una vita inquieta*. Rome: Laterza.

Frommel, Christoph Luitpold. 1979. *Michelangelo und Tommaso Cavalieri*. Amsterdam: Castrum Peregrini.

Garin, Eugenio. 1999. "Il Pensiero." In *Michelangelo: Artista - Pensatore - Scrittore*, 2 vols., edited by Mario Salmi, vol. 1, 529–541. Novara: De Agostini.

Gentile, Sebastiano. 1992. "Commentarium in Convivium de amore / El libro dell'Amore di Marsilio Ficino." In *Letteratura italiana: Le Opere, vol. I: Dalle Origini al Cinquecento*, 743–767. Torino: Einaudi.

Gentile, Sebastiano. 1993. "Ficino e il platonismo di Lorenzo." In *Lorenzo de' Medici: New Perspectives*, edited by Bernard Toscani, 23–48. New York: Peter Lang.

Giannotti, Donato. 1968. *Gespräche mit Michelangelo: Zwei Dialoge über die Tage in denen Dante Hölle und Fegefeuer durchwanderte*, edited by Joke Frommel-Haverkorn van Rijsewijk. Amsterdam: Castrum Peregrini.

Gilson, Simon A. 2005. *Dante and Renaissance Florence*. Cambridge: Cambridge University Press.

Gnann, Achim, ed. 2010. *Michelangelo: Zeichnungen eines Genies*, exh. cat., Albertina, Vienna. Ostfildern: Hatje/Cantz.

Goffen, Rona. 2002. *Renaissance Rivals: Michelangelo, Leonardo, Raphael, Titian*. New Haven: Yale University Press.

Gotti, Aurelio. 1876. *Vita di Michelangelo Buonarroti*, 2 vols. Florence: Tipografia della Gazzetta d'Italia.

Grimm, Herman. 1860–63. *Leben Michelangelo's*, 2 vols. Hannover: Rümpler.

Hall, James. 2005. *Michelangelo and the Reinvention of the Human Body*. London: Chatto & Windus.

Hekler, A. 1913. "Michelangelo und die Antike." *Wiener Jahrbuch für Kunstgeschichte* 7:201–233.

Hirst, Michael. 1975. "A Drawing of the Rape of Ganymede by Michelangelo." *The Burlington Magazin* 117:166.

Hirst, Michael. 1978. "A Drawing of the Rape of Ganymede by Michelangelo." In *Essays Presented to Myron P. Gilmore*, 2 vols., edited by Sergio Bertelli and Gloria Ramakus, vol. 2, 253–260. Florence: La Nuova Italia.

Hirst, Michael. 1988. *Michelangelo and His Drawings*. New Haven and London: Yale University Press.

Hirst, Michael. 2011. *Michelangelo, vol. 1: The Achievement of Fame, 1475–1534*. New Haven: Yale University Press.

Hub, Berthold. 2005. "*... e fa dolce la morte*: Love, Death, and Salvation in Michelangelo's Last Judgment." *Artibus et Historiae* 51:103–130.

Hub, Berthold. 2008. "Material Gazes and Flying Images in Marsilio Ficino and Michelangelo." In *Spirits Unseen: The Representation of Subtle Bodies in Early Modern European Culture*, edited by Christine Göttler, 93–120. Leiden: Brill.

Joannides, Paul, ed. 1992. "Amputating Michelangelo's Corpus." *Apollo* 135:265–266.

Joannides, Paul, ed. 1996a. *Michelangelo and His Influence: Drawings from the Windsor Castle*, exh. cat. Washington: National Gallery of Art.

Joannides, Paul, ed. 1996b. "Michelangelo and the Medici Garden." In *La Toscana al tempo di Lorenzo il Magnifico: Politica Economia Cultura Arte*, 3 vols., I: 23–36. Pisa: Pacini.

Justi, Carl. 1860. *Die aesthetischen Elemente in der Platonischen Philosophie*. Marburg: Elwert.

Justi, Carl. 1900. *Michelangelo: Beiträge zur Erklärung der Werke und des Menschen*. Leipzig: Breitkopf & Härtel.

Kecks, Ronald G. 1997. *Domenico Ghirlandaio*. Florence: Octavo.

Keizer, Joost. 2011. "Michelangelo, Drawing, and the Subject of Art." *The Art Bulletin* 93:304–324.

Kempter, Gerda. 1980. *Ganymed: Studien zur Typologie, Ikonographie und Ikonologie*. Köln: Böhlau.

Knauer, Elfriede R. 1969. "Leda." *Jahrbuch der Berliner Museen* 11:5–34.

Kovačić-Laule, Angelika. 1978. *Michelangelo als platonischer Dichter: Interpretationen ausgewählter Gedichte mit einer historischen Einführung*. Freiburg i. Br.: Krause.

Kristeller, Paul Oskar. 1946. "Francesco da Diacceto and Florentine Platonism in the Sixteenth Century." In *Miscellanea Giovanni Mercati, vol. 4: Letteratura classica e umanistica*, 260–304. Città del Vaticano: Biblioteca Apostolica Vaticana.

Kristeller, Paul Oskar. 1972. *Die Philosophie des Marsilio Ficino*. Frankfurt am Main: Klostermann. Kruszynski, Anette. 1985. *Der Ganymed-Mythos in Emblematik und mythographischer Literatur des 16. Jahrhunderts*. Worms: Wernersche Verlagsgesellschaft.

Landino, Christoforo. 2001. *Comento sopra la Comedia*, edited by Paolo Procaccioli, 4 vols. Rome: Salerno.

Leites, Nathan. 1986. *Art and Life: Aspects of Michelangelo*. New York: New York University Press.

Lentzen, Manfred. 1971. *Studien zur Dante-Exegese Cristoforo Landinos: Mit einem Anhang bisher unveröffentlichter Briefe und Reden*. Köln: Böhlau.

Liebert, Robert S. 1983. *Michelangelo: A Psychoanalytic Study of His Life and Images*. New Haven: Yale University Press.

Marongiu, Marcella, ed. 2002. *Il Mito di Ganimede prima e dopo di Michelangelo*, exh. cat., Casa Buonarroti, Florence. Florence: Mandragora.

Mayo, Penelope Cromwell. 1967. *Amor spiritualis et carnalis: Aspects of the Myth of Ganymede in Art*, PhD diss. New York University.

Melani, Margherita, and Carlo Pedretti. 2012. *Il fascino dell'opera interrotta: La Battaglia di Anghiari di Leonardo da Vinci*. Poggio a Caiano: CB Edizioni.

Michaelis, Adolf. 1885. "Michelangelos Leda und ihr antikes Vorbild." In *Straßburger Festgruß an Anton Springer zum 4. Mai 1885*, 33–43. Berlin: Spemann.

Michelangelo, Buonarroti. 1863. *Le Rime di Michelangelo Buonarroti pittore, scultore e architetto, cavate dagli autografi e pubblicate da Cesare Guasti*. Florence: Monnier.

Michelangelo, Buonarroti. 1965–79. *Il carteggio di Michelangelo*, 5 vols., edited by Paola Barocchi. Firenze: S.P.E.S.

Michelangelo, Buonarroti. 1991. *The Poetry of Michelangelo: An Annotated Translation*, edited and translated by James M. Saslow. New Haven: Yale University Press.

Morganti, Carol. 2005. "Il mito di Ganimede nei disegni e nelle incisioni del Rinascimento." *grafica d'arte* 16, 61:4–15.

Nanni, Romano. 2007. "Leonardo e Leda." In *Leda: Storia di un mito dalle origini a Leonardo*, edited by Romano Nanni and Maria Chiara Monaco, 193–251. Florence: Zeta Scopri Editore.

Nanni, Romano, and Maria Chiara Monaco, eds. 2007. *Leda: Storia di un mito dalle origini a Leonardo*. Florence: Zeta Scopri Editore.

Nelson, John C. 1958. *Renaissance Theory of Love: The Context of Giordano Bruno's Eroici furori*. New York: Columbia University Press.

Orgel, Stephen. 2004. "Ganymede Agonistes." *GLQ: A Journal of Lesbian and Gay Studies* 10:485–501.

Ostermark-Johansen, Lene. 1998. *Sweetness Strength: The Reception of Michelangelo in Late Victorian England*. Aldershot: Ashgate. Panofsky, Erwin. 1939/1962. *Studies in Iconology: Humanistic Themes in the Art of the Renaissance*. [1939] New York: Harper & Row.

Panofsky-Soergel, Gerda. 1984. "Postscriptum to Tommaso Cavalieri." In *Scritti di storia dell'art in onore di Roberto Salvini*, 399–405. Florence: Sansoni.

Parker, Deborah. 2005. "The Role of Letters in Biographies of Michelangelo." *Renaissance Quarterly* 58:91–126.

Pedretti, Carlo, ed. 2006. *Le mente di Leonardo al tempo della 'Battaglia di Anghiari'*, exh. cat., Gabinetto Disegni e Stampe degli Uffizi. Florence: Giunti.

Pernis, Maria Grazia. 1993. "The Young Michelangelo and Lorenzo de' Medici's Circle." In *Lorenzo de' Medici: New Perspectives*, edited by Bernard Toscani, 143–161. New York: Peter Lang.

Perrig, Alexander. 1967. "Bemerkungen zur Freundschaft zwischen Michelangelo und Tommaso Cavalieri." In *Stil und Überlieferung in der Kunst des Abendlandes*, 3 vols. Berlin: Mann.

Perrig, Alexander. 1991. *Michelangelo's Drawings: The Science of Attribution*. New Haven: Yale University Press.

Petrioli Tofani, Annamaria. 1986–87. *Gabinetto Disegni e Stampe degli Uffizi: Inventario. Disegni esposti*, 2 vols. Florence: Olschki.

Pico della Mirandola, Giovanni. 1942/2004. *De hominis dignitate, Heptaplus, De ente et uno, e scritti vari*, edited by Eugenio Garin. Florence: Vallecchi. Repr. 2004. Turin: Nino Aragno.

Pico della Mirandola, Giovanni. 1984. *Commentary on a canzone of Benivieni*, translated by Sears Jayne. New York: Peter Lang.

Poliziano, Angelo. 1954. *Stanze cominciate per la giostra di Giuliano de' Medici*, edited by Vincenzo Pernicone. Torino: Vincenzo Bona.

Poliziano, Angelo. 1983. *Detti piacevoli*, edited by Tiziano Zanato. Rome: Instituto della Enciclopedia italiana.

Poliziano, Angelo. 1986. *L'Orfeo del Poliziano…*, edited by Antonia Tissoni Benvenuti. Padova: Antenore.

Poliziano, Angelo. 2002. *Angeli Politiani Liber epigrammatum Graecorum*, edited by Filippomaria Pontani. Rome: Edizioni di storia e letteratura.

Poliziano, Angelo. 2004. "*The fable of Orpheus*: Orphic Origins of Masculine Love." In *Same-Sex Desire in the English Renaissance: A Sourcebook of Texts, 1470–1650*, edited by Kenneth Borris, 271–274. New York: Routledge.

Ragionieri, Pina. 2007. *Michelangelo: La Leda e la seconda Repubblica fiorentina*, exh. cat., Turin, Biblioteca di Palazzo Bricherasio & Bonn, Rheinisches Landesmuseum. Milan: Silvana.

Regan, Lisa K. 2012. "Give and Take: Michelangelo and the Drawings for Tommaso de' Cavalieri." In *Bilder der Liebe: Liebe, Begehren und Geschlechterverhältnisse in der Kunst der Frühen Neuzeit*, edited by Doris Guth and Elisabeth Priedl, 271–300. Bielefeld: transcript Verlag.

Reinhardt, Volker. 2010. *Der Göttliche: Das Leben des Michelangelo. Biographie*. Munich: Beck.

Rocke, Michael. 1996. *Forbidden Friendships: Homosexuality and Male Culture in Renaissance Florence*. New York: Oxford University Press.

Rossoni, Elena. 2002. *Il bianco e dolce cigno: Metafore d'amore nell'arte italiana del XVI secolo*. Nuoro: Ilisso.

Rothes, Walter. 1912. *Die Renaissance in Italien: Michelangelo*. Mainz: Kirchheim. [Weltgeschichte in Charakterbildern, 3. Abteilung: Übergangszeit.]

Ryan, Christopher. 1998. "Poems for Tommaso Cavalieri." In Ryan Christopher, *The Poetry of Michelangelo: An Introduction*, 94–128. Madison: Fairleigh Dickinson University Press.

Saslow, James M. 1986. *Ganymede in the Renaissance: Homosexuality in Art and Society*. New Haven: Yale University Press.

Saslow, James M. 1988/1992. "'A Veil of Ice between My Heart and the Fire': Michelangelo's Sexual Identity and Early Modern Constructs of Homosexuality." *Genders* 2:78–90. Repr. 1992 in *Studies in Homosexuality*, edited by Wayne R. Dynes and Stephen Donaldson, 135–148. New York: Garland.

Saslow, James M. 1990. "Homosexuality in the Renaissance: Behavior, Identity, and Artistic Expression." In *Hidden from History: Reclaiming the Gay and Lesbian Past*, edited by George Chauncey et al., 90–105. New York: Meridian.

Saslow, James M. 1998. "Michelangelo: Sculpture, Sex, and Gender." In *Looking at Italian Sculpture*, edited by Sarah Blake McHam, 223–245. Cambridge: Cambridge University Press.

Saslow, James M. 2004. "Inventing Michelangelo: The Historical Construction of the Creative Homosexual." In *Medusa's Gaze: Essays on Gender, Literature, and Aesthetics in the Italian Renaissance in Honor of Robert J. Rodini*, edited by Paul A. Ferrara, Engenio Giusti, and Jane Tylus, 65–90. Boca Raton, FL: Bordighera.

Savonarola, Girolamo. 1965. *Prediche sopra Aggeo*, edited by Luigi Firpo. Rome: Angelo Belardetti.

Savonarola, Girolamo. 1969/1974. *Prediche sopra i Salmi*, edited by Vincenzo Romano, 2 vols. Rome: Angelo Belardetti.

Schulze Altcappenberg, Hein-Thomas, ed. 2001. *Sandro Botticelli: Der Bilderzyklus zu Dantes Göttlicher Komödie*, exh. cat., Kupferstichkabinett, Berlin. Ostfildern: Hatje Cantz.

Sichtermann, Hellmut. 1984. "Leda und Ganymed." In *Symposium über die Antiken Sarkophage, Pisa 5.-12. September 1982*, edited by Bernard Andreae, 43–57. Marburg: Verlag des Kunstgeschichtlichen Seminars.

Sichtermann, Hellmut. 1988. "Ganymedes." In *Lexicon Iconographicum Mythologiae Classicae*, vol. IV.1, 154–170 and vol. IV.2, 75–97. Zürich: Artemis.

Sichtermann, Hellmut. 1992. *Die mythologischen Sarkophage* [*Die antiken Sarkophagreliefs*, edited by Bernard Andreae and Guntram Koch, vol. 12]. Berlin: Mann.

Snow-Smith, Joanne. 1998. *Michelangelo's Christian Neoplatonic Aesthetic of Beauty in His Early Concepts of Beauty in Renaissance Art*, edited by Francis Ames-Lewis and Mary Rogers, 147–162. Aldershot: Ashgate.

Spike, John T. 2010. "The Garden of the Medici." In John T. Spike, *Young Michelangelo: The Path to the Sistine*, 33–56. London: Duckworth Overlook.

Sternweiler, Andreas. 1993. *Die Lust der Götter: Homosexualität in der italienischen Kunst von Donattello zu Caravaggio*. Berlin: Verlag Rosa Winkel.

Stewart, Alan. 1997. "The Singing Boy and the Scholar: The Various Deaths of Politian." In *Eros et Priapus: Erotisme et obscénité dans la littérature néo-latine*, 45–63. Geneva: Librairie Droz.

Stone, Irving. 1961. *The Agony and the Ecstasy: A Biographical Novel of Michelangelo*. Garden City, NY: Doubleday.

Summers, David. 1981. *Michelangelo and the Language of Art*. Princeton, NJ: Princeton University Press.

Symonds, John Addington. 1893. *The Life of Michelangelo Buonarroti, Based on Studies in the Archives of the Buonarroti Family at Florence*, 2 vols. London: Nimmo.

Tanturli, Giuliano. 2006. "Marsilio Ficino e il volgare." In *Marsilio Ficino. Fonti, testi, fortuna. Atti del Convegno Internazionale, Firenze, 1–3 ottobre 1999*, edited by Sebastiano Gentile and Stéphane Toussaint, 183–213. Rome: Edizione di Storia e Letteratura.

Tarán, Sonya Lida. 1979. *The Art of Variation in the Hellenistic Epigram*. Leiden: Brill.

Thode, Henry. 1902–13. *Michelangelo und das Ende der Renaissance*, 6 vols. Berlin: Grote'sche Verlagsbuchhandlung.

Van den Doel, Marieke. 2010. *Ficino, Diacceto and Michelangelo's The Making of the Humanities, vol. 1: Early Modern Europe*, edited by Rens Bod, Jaap Maat, and Thijs Weststeijn, 107–131. Amsterdam: Amsterdam University Press.

Vasari, Giorgio. 1962. *La vita di Michelangelo nelle redazioni del 1550 and del 1568*, 5 vols., edited by Paola Barocchi. Milan: Ricciardi.

Verspohl, Frank-Joachim. 2007. *Michelangelo Buonarroti und Leonardo da Vinci: Republikanischer Alltag und Künstlerkonkurrenz in Florenz zwischen 1501 und 1505*. Göttingen: Wallstein.

Von Einem, Herbert. 1959. *Michelangelo*. Stuttgart: Kohlhammer.

Von Scheffler, Ludwig. 1892. "Der wahre Michelangelo in seinen Gedichten." In Ludwig von Scheffler. *Michelangelo: Eine Renaissancestudie*, 1–203. Altenburg: Stephan Geibel.

Wallace, William E. 2001. "Michelangelo's Leda: The Diplomatic Context." *Renaissance Studies* 15, 4:473–499.

Wallace, William E. 2010. *Michelangelo: The Artist, the Man, and His Times*. Cambridge, MA: Cambridge University Press.

Weil-Garris, Kathleen, and Cristina Acidini Luchinat, eds. 1999. *Giovinezza di Michelangelo*, exh. cat., Florence, Palazzo Vecchio. Florence: Artificio Skira.

Wilde, Johannes. 1953. "Michelangelo and Leonardo." *The Burlington Magazine* 95, 600:65–77.

Wilde, Johannes. 1957. "Notes on the Genesis of Michelangelo's Leda." In *Fritz Saxl, 1890–1948: A Volume of Memorial Essays from His Friends in England*, 270–280. London: Nelson.

Wilhelm, James T., ed. 1995. *Gay and Lesbian Poetry: An Anthology from Sappho to Michelangelo*. New York: Garland.

Wind, Edgar. 1958/1980. *Pagan Mysteries in the Renaissance*. London: Faber and Faber, revised ed. Oxford: Oxford University Press.

Zöllner, Frank. 2005. "Leonardo und Michelangelo: vom Auftragskünstler zum Ausdruckskünstler." In *Leonardo da Vinci all'Europa: Einem Mythos auf den Spuren*, edited by Maren Huberty and Roberto Ubbidiente, 131–167. Berlin: Weidler.

Zöllner, Frank. 2007. *Leonardo da Vinci 1452–1519: Sämtliche Gemälde und Zeichnungen*. Köln: Taschen.

Zöllner, Frank, Christof Thoenes, and Thomas Pöpper. 2007. *Michelangelo 1475–1564: Das vollständige Werk*. Köln: Taschen.

7 Botticelli's *Primavera* and Contemporary Commentaries[1]

Angela Dressen

As one of the first large panel paintings with symbolic content which revolutionized Tuscan painting during the 1480s, Botticelli's *Primavera* is – doubtless because of its complex iconography – also his most discussed painting (Figure 7.1). Many attempts have been made to decode the figural composition, relying mostly on ancient literary sources. However, it seems that the painter's literary choices were helped by contemporary philological commentaries on these sources, providing him with useful explanations and guidance for the understanding of these works, weaving antique and humanist ideas into a sophisticated allegorical web. Such secondary sources allowed artists to reflect on ancient topics in a newly considered Neoplatonic light. These commentaries were sometimes written in the vernacular, making them more accessible, both to painters and their patrons.

In this paper, I shall examine the role of two vernacular and two Latin Renaissance commentaries on classical literary sources and their influence on the *Primavera*. While some of the original sources have long been discussed with reference to the *Primavera*'s iconography, their interpretation in humanistic commentaries has until now been disregarded. I shall consider Cristoforo Landino's Latin commentary on Horace (published 1482) and Paolo Marsi's Latin commentary on Ovid (published 1482) and their relevance for the painting.[2] I will also examine vernacular commentaries, which will prove to be even more important. These are Marsilio Ficino's commentary on Plato's *Symposium*, titled *Libro dell'amore* (written in Florence in 1469) and Cristoforo Landino's commentary on Dante's *Divine Comedy* (published 1481).[3] Both commentaries attempt to introduce the up-to-date topics of Plato's *Symposium* and *Phaedrus*. Plato's two texts concern heavenly and earthly love, the birth of *Eros* and the meaning of beauty. Ficino's *Libro dell'amore* is probably the first of his vernacular texts, finished about 1469 or shortly after.[4] Patrons as well as artists could now easily read about Ficino's new Platonic theory of love, which provoked increasing dissemination at the end of the fifteenth and the beginning of the sixteenth century. Plato's and Ficino's texts strongly influenced Landino's Dante commentary, which was illustrated by Botticelli.[5] Whereas in his drawings Botticelli closely followed the text, in the *Primavera* the painter seems to have tried out his own interpretation of Landino's commentary.

Although the painting is commonly called "Primavera," there is no consent on the title, the content or the commission of the painting.[6] My reading through the commentaries does not challenge the most common interpretation of the nine allegorical figures in an idyllic setting with fruit trees and flowering green lawn, on which we see from left to right: Mercury, the three Graces, Venus with a Cupid above, Flora, Chloris, and Zephyr.[7] In the center, Venus inclines towards the three Graces, a group resembling a well-known ancient type. Above Venus, the blind Cupid purposely aims his bow at the middle Grace. At the far left, Mercury looks heavenwards and agitates the clouds with his *Caduceus*.

The story of the painting's commission is likewise disputed but shall here be presented in the most accepted version. The *Primavera* was executed for Lorenzo di Pierfrancesco de' Medici (1463–1503), cousin of Lorenzo il Magnifico, one of the painter's foremost patrons. In 1482, Lorenzo di Pierfrancesco married Semiramide Appiani, which may have provided an appropriate occasion for the commission. If the *Primavera* indeed can be related to the wedding of Lorenzo di Pierfrancesco de' Medici and Semiramide Appiani, it seems probable that the painting was placed in their bedroom, where it hung with two other mythologies by Botticelli. The palace inventory of Palazzo Medici mentions the *Primavera* in 1499 as near Botticelli's *Minerva with the Centaur*.[8]

The State of Research

Research has traditionally favored a Neoplatonic interpretation for the *Primavera*, reliant mostly on ancient Platonic texts, although there has been insufficient explanation about where the contemporary Neoplatonic aspect actually originated. About half of the scholars working on Botticelli's *Primavera* have expressed themselves directly in favor of Neoplatonic interpretations; a couple favored Neoplatonism indirectly, whereas a few have rejected it deliberately. Neoplatonism gained relevance in 1945 with Ernst Gombrich's introduction of Ficino's letters as relevant for the iconography of the painting.[9] Gombrich's thesis was taken up by Edgar Wind (1958), Jean Gillies (1981), and Marieke van den Doel (2008), referring to Ficino's letters, as well as to the early Neoplatonists Apuleius and Plotin;[10] and by Liana De Girolamo Cheney (1985), who referred to Ficino's letters and his commentary on Plato's *Symposium*.[11] Joanne Snow-Smith introduced in 1993 the concept of *prisca theologia*, as well

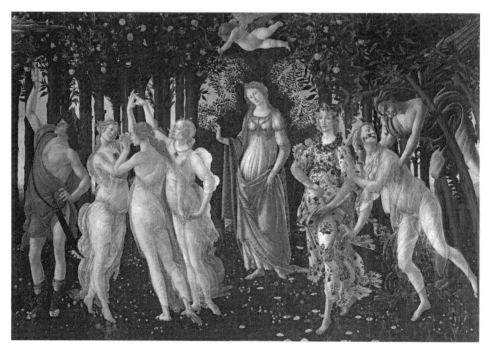

Figure 7.1 Sandro Botticelli, *La Primavera*, c. 1482. Tempera on wood. 203 x 314 cm.
Source: Florence, Galleria degli Uffizi.

as the enigmatic vision and hermeticism, referring to Ficino's translation of Hermes' *Corpus Hermeticum*, but also to Ficino's *Libro dell'amore* as the Platonic love theory, and ancient authors like Plato (but also Aristotle and others).[12] Claudia Villa (1998) concentrated on the early Neoplatonist Martianus Capella and his description of the liberal arts in his *De nuptiis Philologiae et Mercurii libri* (*On the Marriage of Philology and Mercury*).[13] This was taken up by Claudia La Malfa (1999, 2002), who emphasized the commentary by Remigio de Auxerre over Capella himself whilst also relying on Plato's *Symposium* and Landino's commentary on Dante.[14] Landino's commentary has also been a topic in Max Marmor (2003) combined with the concept of the *vita activa* and the *vita contemplativa* and the topos of the Earthly Paradise.[15] More recently, Christophe Poncet (2008, 2012) considered Landino's Dante and Horace commentaries as well as Ficino's *Libro dell'amore*.[16] Although Giovanni Reale (2007) relied mainly on Plato himself (*Symposium, Phaedrus*), he hinted occasionally also at Capella and Ficino.[17] The most recent article by John Dee (2013) returns to Ficino's letters, Landino's Earthly Paradise, and the early Neoplatonist Apuleius, with his main focus on a cosmological interpretation based on Ficino's letters.[18]

Apart from a couple of authors, who have not wished to align themselves with one direction or another, there are a few others who have taken a decisive step against Neoplatonism, mainly focusing on literature with naturalistic tendencies. This change of sources would not have necessarily needed to be an opponent to Platonism. Plato does himself have theories of nature, creation, and evolution, and so do his interpreters.[19] However, through this approach, the authors tried to reject Neoplatonic interpretations of the *Primavera* by using naturalism as the opposite of Neoplatonism.

The first to take this stance was Horst Bredekamp (1986/1992, 1988) with the introduction of the natural philosophy of Lucretius' *De rerum natura* (*On the Nature of Things*) as a source for the *Primavera*, relying on Epicurean philosophy – i.e., advice for conducting a life of happiness, pleasure, and self-sufficiency.[20] In his article "Götterdämmerung des Neuplatonismus," Bredekamp wanted to take a decisive step away from Neoplatonism, for he saw that Gombrich and other contemporaries publishing in the 1940s were rightly influenced by political doctrines, thus provoking a search for ideological distance through intellectually sophisticated and free interpretative solutions. Given these historical circumstances, Bredekamp wanted to show that there were interpretative means beyond Neoplatonism. He especially accused those of the following generations, where Neoplatonism was used to simply refer to sophisticated and encrypted meanings, with no further need of explanation, since they were 'Neoplatonic.' However, he did not exclude Neoplatonism itself from the iconographic palette, even while stressing other possibilities. After Bredekamp's article "Götterdämmerung," there was a drastic decline in Neoplatonic studies (especially in Germany), following his argument that Neoplatonic iconography had been something of a temporal fashion. But Bredekamp had spoken against an abuse and a simplified and categorical Neoplatonic iconography, not for a total rejection.

Other authors followed in the anti-Platonic vein but with different directions. Acidini Luchinat (2001), a firm opponent of a Neoplatonic interpretation, stressed on the one hand nature as a main topic of the painting, and flower iconography and a reference to Florence on the other.[21] One of the latest approaches to the painting by Charles Dempsey (1992, 2012) tries to eliminate both the Platonic and Neoplatonic approaches by proposing a late medieval literary tendency, while also recognizing a profound knowledge of classical culture.[22] Although, following his argument, this must have been interpreted in a late medieval key. Dempsey, who has studied vernacular influences on late medieval and early Renaissance Italian painting including Botticelli, looks for vernacular settings in

environments dominated by femininity, beauty, and naturalness. Dempsey's vernacular literary sources emerge from a different environment, starting with Petrarch, leading him to an unique, lyric interpretation of the vernacular, engaged closely with late medieval courtly life and its "lived experience" – in fact the opposite approach to the Neoplatonic. He thus wholly omits the other aspect of the vernacular, starting from the humanists' wish to make learning and knowledge accessible, when he writes:

> Latin is the language of the church, the university, and the chancery. The vernacular is the language of lived experience in the world. In poetry, vernacular is the means for expressing an idea of love in the world, an idea to which the poet, for good or ill, has dedicated his heart.[23]

However, when we look closer at Petrarch's *Canzoniere*, the differences of the Petrarchan and the Neoplatonic concept of love become evident: Petrarch's love theory presented in the *Canzoniere* is one of profound suffering for an unrealized love, where the woman is perceived as being distant but still appears as dominant, while the lover lives in solitude and tears. Therefore Amor is the herald of tears and sufferings.[24] The result is that Petrarch sees springtime around him but is not able to participate.[25] Another topic is the maturing of the body and old age.[26] Despite the fact that Petrarch's love story was widely known, the image of love and beauty he depicts is negative: to love means to accept suffering as its main goal, while the woman is unwilling and distant. Ficino, as we will see, has a positive idea of love and even renders Plato's love theory – where necessary – into something fertile and beneficent.

Dempsey's thesis, which may serve to decipher a painting by Giotto or Simone Martini, does not work for Botticelli as he wants us to believe – indeed, he acknowledges that Botticelli's *Primavera* and *Mars and Venus* are "rooted in the Florentine present."[27] To regard Petrarch as a source for the newly developing pictorial topic of love neglects the fact that artists in Trecento and Quattrocento did not always use the same sources. The Florentine present of the Medici circles was not primarily based on Petrarch, Boccaccio, and Dante (authors who themselves needed to be rediscovered by the humanists) but rather on Ficino's Platonic love theory.

This study will emphasize two important features which helped Renaissance artists to choose and compose their works. On the one hand, they benefited from the genre of the literary commentary, which transformed ancient, medieval or contemporary literary primary texts into a more easily accessible mode, whilst they also relied on vernacular translations or texts, since the vast majority of artists did not know classical languages. Both features helped the artist to confront topics otherwise beyond his expertise. That the choice of language and the need for explanation was a topic of interest among artists may also be recognized in the prominent example of Leon Battista Alberti's treatise on painting, written in Latin but rendered into the vernacular the following year (1435/1436).[28] It was Alberti himself, as someone with the highest educational standard, who proposed the literary competition "Certame coronario" of 1441, where he wished to further a new standing for the vernacular.[29] This occurred at a moment, when, after some initial attempts by Dante, humanists had turned almost by default to Latin, leaving the vernacular to a less educated audience. What then arose as a new vernacular initiative by Alberti, Leonardo Bruni and others was a vernacular initiated by the humanists themselves, elaborated contextually and linguistically to the same level as the classical language. These new texts obviously had nothing in common with Trecento vernacular lyric.

An Overview of Suggested Ancient and Contemporary Literary Sources

But before I introduce the interpretative changes in Renaissance commentaries on antique and medieval sources, I briefly want to give a summary of literary sources, mostly ancient, which have been presented so far for the reading of the painting. The following discussion of the commentaries reveals many common topoi about key figures in the painting, as some figures appear repeatedly both in ancient and contemporary sources.

In 1893, Warburg proposed Ovid's *Fasti* for the encounter of Zephyr with Chloris the nymph tending flowers in the Garden of the *Hesperides*.[30] Other alleged sources, also introduced by Warburg, are the *Odes* of Horace, Lucretius' *De rerum natura* and Poliziano's *Stanze*.[31] Poliziano's *Stanze* was well known in Medici Florence, and Poliziano himself served as a teacher for Lorenzo di Pierfrancesco de' Medici together with Marsilio Ficino from 1480. To the latter the illustrious student dedicated many letters, which were introduced by Gombrich.[32] In Ficino's letters, Mercury stands for *Ratio*, Venus for *Humanitas*, and love would emanate from the Graces.[33] Gombrich thus saw the main topic in the *Primavera* as *Venus-Humanitas*. He also pointed to Apuleius as an important source for the composition, especially for the appearances of Venus, Zephyr, and Flora and the wind fluttering her vestments.[34]

Bredekamp emphasized Ovid, Apuleius, Poliziano, and Lucretius, for him the main thrust deriving from the *ekphrasis* of Lucretius, especially where he introduces the motive of spring.[35] Lucretius' nature-inspired philosophy could help explain the composition of the painting, adding to Ovid's transformation of Chloris and the Graces. Finally, Virgil's *Aeneid* provided a possible source for Mercury and Zephyr.[36]

Scholars have also discussed the relevance of Dante's *Divine Comedy*: it was suggested by Gombrich, Bredekamp, La Malfa, and Marmor, who pointed to the three dancing Graces and compared them with Botticelli's female dancers in his *Divine Comedy* illustration.[37] But when Marmor suggested this in the context of Landino's interpretation, he only compared the three Graces with Botticelli's illustrations of Beatrice and Lethe to illustrate the concept of *vita activa* and *vita contemplativa*.[38] La Malfa, on the other hand, cited some passages of Landino's *Proemio* and the commentary to the *Inferno*, but only in order to emphasize the importance of Martianus Capella's *De nuptiis Philologiae et Mercurii libri* for the iconography of the *Primavera*.[39]

Starting with the complex interpretation of Joanne Snow-Smith, new layers of possible sources have either been introduced or developed and have consequently been taken up by other scholars. Snow-Smith sees as major sources for the narrative Augustine, Dante, and Ficino, and the latter mainly with his translation of the Hermetic text *Pimander* and the commentary on Plato's *Symposium*. Ficino's *Libro dell'amore* in its importance for the painting is seen mainly under the aspects of contemplation on beauty, divine beauty, and ultimately the elevation of the soul. In explaining the narrative of the painting as a setting of Zeus' garden, she compares sources in Plato, Plotin and Ficino, without, however, valuating these but relying on similarities more than characteristics.[40]

In the catalog of Acidini Luchinat's monograph, Federico Poletti is one of the few to mention Landino as a possible source for the *Primavera*.[41] Acidini Luchinat then refers to Landino as a possible consultant for the composition of the painting, whereas the individual motifs would come from Pliny. The introduction of Landino's commentary to Dante and the flowering city of Florence may have inspired the layout of the scene.[42] Barbara Deimling has recently shown the importance of Landino's commentary on the *Divine Comedy* for Botticelli's *Minerva and the Centaur*, identifying "Minerva" with Landino's description of the heroine Camilla.[43] In Poncet's *La scelta di Lorenzo* he develops the idea of analogies between

Landino's Dante commentary and the *Primavera* also in terms of Beatrice as a figure for wisdom, represented in Venus, and the motive of the black forest and the lawn of flowers (68–70). He also briefly refers to Landino's Horace commentary for the way the Graces are represented.[44]

In these last publications, some important connections have been made to testify the importance of Ficino and Landino. However, none of these authors have addressed the question of language, the advantages of contemporary literature and commentaries for both the artist and the patron. Since the approach in methodology has been rather additive, barely any critical reading has been done of the sources. Therefore, I wish to reintroduce Ficino and Landino, shedding light on their congruity as well as on their discrepancy.

Landino's and Ficino's Vernacular Commentaries on Plato and Dante

Landino's vernacular commentary on Dante's *Divine Comedy* has the invaluable advantage of not only interpreting the work of the greatest Florentine poet but also of linking his topics to the greatest ancient and contemporary authors.[45] Referring to Hesiod's *Theogony*, Landino describes the Graces as Zeus' three daughters.[46] Therefore, Landino gives these characters a meaning beyond their original context, drawing them into a precise Neoplatonic concept. Furthermore, Landino confronts the Graces also with the concept of divine grace, which was not included by the ancient authors. Divine grace had been introduced into Neoplatonism by early Christian authors such as Augustine, and it established itself as a concept which could help Christianize ancient topics as well as provide a summit of Christian virtue (comparable to the level of *sommo bene*). Grace is assigned only by God, illuminating the virtuous, who through the spirit of love can approach closer to God.[47] In Landino, the first grace is the most important because she is illuminated by divine grace; the second stands for happiness; and the third for the flowering nature of our virtues.[48] In the painting, the first grace stands closest to Mercury, who points heavenwards, the second happy grace links her sisters, while the third, flowering grace is set next to Venus and Flora.

The link with Landino's commentary can be further strengthened by consideration of the different kinds of love connecting *Ratio* and *Eros*. Therefore, we will now examine this text, along with Plato's treatises on *Eros*, and Ficino's related commentaries on Plato, all intimately connected with the overarching topic of love, aided by the Graces. After a short description of Hesiod's graces, Landino discusses *Ratio* while introducing the *ragione inferior e pratica* and the *ragione superior* illuminated by divine grace. The dividing choice would lie in following either vices or virtue. For example, Christian philosophers were given this illumination from God, a gift only coming from above and superior to any simple human effort (which explains why Early Christian philosophers like Augustine had such a high standing for the humanists).[49] Following humanist practice, Landino places Virgil in the sequence of pre-Christian sages as he who foretold Christian religion and its moral law, and had therefore a reputation close to Christian philosophers.[50]

Returning to the painting and the two outer figures, we recognize Zephyr as standing for *ragione inferiore* and dealing with *sensualità*, whereas his counterpart, Mercury, assumes the part of *Ratio*, occupied with *ragione superiore*, and who, like the pre-Christian figure Virgil, can only hint at divine illumination. In Dante's *Commedia*, Virgil had been interpreted by Landino as *Ratio*, the antithesis of *Eros*, chosen for divine inspiration. Landino continues by setting the two *ragioni* in opposition. Virgil demonstrated the path to salvation through divine grace, which helped *ratio superiore* to

transform *ratio inferiore*. Thus he foreshadows Christian doctrine, led by three women each interacting with one another. The first, sent from heaven, would help the second (Lucia) to find the *ragione inferiore* (Dante); the second would move the third to descend toward the *ragione superiore* (Virgil) and persuade him to be the wise guide of the *ragione inferiore* (Dante). As true theologians were convinced that man possessed free will (*libero arbitrio*) to choose between good and evil, no one could really cleanse himself and return to virtue without participating in divine grace.[51] Landino then adds that divine guidance for free will would come from the three Graces.[52] The first illuminates reason (*ragione*) and forms the virtue, which strengthens our determination to find and follow free will. As the first Grace is illuminated by the soul, Dante assigned her no name; the second, however, he termed *gratia illuminante* (Lucia), who helps us toward right conduct. These two Graces pray daily to God so that their actions are inspired by his guidance.[53]

In the painting, the first Grace sent by God appears next to Mercury, who glances upwards for divine inspiration. The second Grace, praying with the first, as Landino stated, gazes intensely at her. These two Graces are divinely illumined. The third Grace not only distances herself from the others by her hand gesture but also distantly observes the first one. Following Landino, the third Grace is the active one (*perficente*), who reflects human free will and helps the contemplation of the most virtuous state of mind (*sommo bene*). The third is called Beatrice, who Landino says gives us God's guidance; it is she who makes us happy, and she is the one worthy of love.[54] In the painting, the third Grace would thus symbolize love. She stands beside Venus, and like her is given a necklace of pearls, which she wears as a crown on her head. In this way, the transition from heavenly to earthly love between the second and the third Grace becomes manifest: the shift is stressed by the blindfolded Amor flying above the scene, who directs his arrows at the second Grace, who is still blind in love.

While Landino incorporates modern Platonic ideas about inspiration and love, he refers several times to Plato's exemplary book, the *Symposium*. He also makes precise alterations to Plato's theory. Although he knows that Ficino adopts the concept of the heavenly and the earthly Venus, Landino introduces three love goddesses. The first would be fathered by Zeus, while she herself produced Cupid and the three Graces. The second was born when Saturn took the member of Caelus and hurled it into the sea. She was born from the resulting foam and was also called Aphrodite, and also bore Cupid as her son. The third Venus, likewise a daughter of Zeus, bore the human Aeneas (who later became a God) as her son.[55] Following Landino's interpretation of the birth of Love through Venus, a story which he himself refers to as the concept of *favola* and the *historia* – probably following Alberti – the central figures of Botticelli's *Primavera* can be interpreted as the heavenly Venus, who procreates Cupid, and the three Graces, who occupy the center. Next to her on the right is the seaborn Venus, with scales covering her arms and vestments which apparently end in a fishtail. She is followed by the third, earthly Venus, who will guarantee human procreation. The three Graces and three Venuses in the painting, each taking a subsequent step between *Ratio* and *Eros*, follow Landino's concept of these opposing qualities in a way not developed in Plato's original.[56] How much the painting owes to Landino's Neoplatonic interpretation of Dante's text now becomes evident. This lessens the painting's debt to the original source, where these characters were not contextualized. This is partly because Landino's interpretation is deeply indebted to Ficino's commentary on Plato's *Symposium*.

Landino concentrates especially on two chapters, seven and eight, of Ficino's sixth book, where both classical interpretations of Venus are explained: the heavenly Venus, who knows about the transcendent spheres, and the earthly Venus responsible for procreation. Ficino underlines here that both are recognizable by their beauty.[57] But Ficino differs from Plato's interpretation on one precise point: that is, that the second earthly Venus is equally important, as the mother of procreation, which should not be regarded as a lower, bestial love.[58] Ficino's example here is Plotinus' interpretation of Plato's text on *Eros*.[59] The important distinction in Plotinus concerns the necessity of procreation, while the heavenly Venus stands for intelligence – that is, *Ratio*.[60] This point of moral elevation of the earthly Venus and her important role in procreation, as maintained by Plotinus and Ficino, was to be taken up by many Renaissance commentators, and also by Botticelli in his depiction of the pregnant Venuses.

Ficino adds to the two original Venuses another three *affects*, representing the *vita contemplativa*, the *vita attiva*, and the *vita voluptuosa*. These will be woven later by Landino into the story of the three Graces. Ficino like Landino combines the affects with precise interaction between the three figures, translated into a sequence of movements (*cominciano, crescono, scemano, mancano*), also combined with vision.[61] This interpolation of affects and motives in Ficino's interpretation is notably comparable to Botticelli's painting, in the hand gestures of the Graces, holding each other with gestures moving up and down, and their exchange of affects through these gestures followed by intense gazes.

Another important topic in the painting and literature concerns the garden where love is created, which is essential to both Ficino and Plato, who writes in his *Symposium*:

> Moreover, his life among the flowers argues in himself a loveliness of hue, for Love [*Eros*] will never settle upon bodies, or souls, or anything at all where there is no bud to blossom, or where the bloom is faded. But where the ground is thick with flowers and the air with scent, there he will settle, gentlemen, and there he loves to linger.[62]

Ficino mentions Zeus' spiritual garden, the *Iovis ortus*, where *Eros'* parents met among light and shadow. Zeus' garden had many fruits too, signifying the manifold ideas touched and awakened by the penetration of divine light.[63] Ficino is more detailed on the birth of *Eros*, created through the encounter of his mythic parents *Penia* and *Poros* in Zeus' garden. Precisely this garden would therefore stand for the prosperity of heavenly life, as Ficino puts it, since love was a gift of the gods. In the light and shade of this garden, human beings developed the inner wishes and their understanding.[64] Once again Ficino's primary source, Plotinus, represents Zeus' garden as a site of intelligence, where *Eros'* father *Poros* signified *Ratio*. The garden's richness was caused by the coming together of *Ratio* and *Eros*. When intelligence elevates the soul, it is nothing other than divine illumination.[65]

Many passages in Plato concerning the nature of *Eros* (expressed by his mediator Diotima), and the related interpretations of Ficino, can be transferred directly to the painting. Plato says *Eros* would appear rough, neglected, and with bare feet.[66] Ficino translates this passage into love, which always walks unshod, as lovers were more concerned with other things.[67] Ficino also adds to Plato the concept that love would walk nearly naked.[68] In the painting, everyone but Mercury, as *Ratio*, and the heavenly Venus, who wears light sandals, are barefoot. In the *Primavera*, the three Graces and the procreative Venus are virtually naked, covered with light transparent veils, whereas the two figures, Mercury and the heavenly Venus, are clad in a thick deep red garment. The prosperous female figures in the painting may also be identified following Plato and

Ficino. For Plato, all men would long to be pregnant in soul and body, but actual pregnancy would only happen with a beautiful body: this relies on the theory of procreation that implies beauty.[69] Ficino likewise points to body and soul by saying: "in all men, the body is pregnant and rich, and the soul is pregnant also."[70] Procreation has thus a corporal and an intellectual note, which in Ficino's case are coming together, as procreation would happen by man's natural instinct, given by divine inspiration. As everything given by God is beautiful, the generation of new life is inspired by beauty. Likewise, a beautiful body indicated a good and beautiful soul.[71] This is how Ficino gives procreation a more natural and thus positive imprint, where beauty plays a vital role.[72]

Similarly, the motive of wings may be deduced from Plato, which can be found in the painting in Zephyr and Mercury, for which there is a precise indication in Landino's commentary: they characterize *Eros*, the inspiration of all creatures, coming from the *Empyreum*.[73] The theme of the winged *Eros* was known to Landino obviously through Plato's other erotic text, the *Phaedrus* – and Ficino's translation and commentary on it.[74] In the painting, we see Mercury's *Ratio* pointing upwards and indicating divine help. Therefore, the soul being urged by *voluptà* and *sensualità* should be comforted by divine interaction.[75]

The interaction of *Eros* and beauty, invented by Plato and developed and interpreted by Ficino, acquires differing significance in Landino and in the *Primavera*. Landino's independence from the primary text, the *Divine Comedy*, is most visible when he inserts Plato's theory of Love into his commentary. Plato's text was obviously unknown to Dante, as these Platonic texts were discovered afterwards. For Landino, the story of Dante and Beatrice and God's inspiration provided instead a valid reason to introduce the Platonic love theory. It also offered Landino the possibility to try out his own interpretation of Plato's text on love, following the commentary by Ficino. Landino's interpretation of the three Graces and the three Venuses had a strong impact on Botticelli's painting. These features appear in neither Plato nor Ficino. The winged *Eros* comes from Plato and Landino, but wings are absent in Ficino's *Libro dell'amore*. On the other hand in Plato and Ficino, one can read about Zeus' flowering garden as the birthplace of *Eros*, the pregnant bodies, and the barefooted love.

Landino's and Marsi's Latin Commentaries on Horace and Ovid

Thus far I have considered the subject behind Botticelli's *Primavera*, relying mostly on the changing shift between *Eros* and *Ratio* and basing my ideas on the interpretation of Plato's erotic theory and on contemporary Renaissance commentaries. It is now time to consider two other Latin commentaries on classical texts: Landino's commentary on Horace's *Opera omnia*, and Paulus Marsi's commentary on Ovid's *Fasti*. Both texts were printed in 1482, the same year as Pierfrancesco's wedding, and one year after Landino's Dante commentary. Both these texts were likewise influenced by Ficino's interpretation of Plato's philosophy of love.

The original text of Horace's *Odes* provided the introduction to the general topic of spring and Venus as the mother of Cupid. In short, while Horace positively characterizes the personifications related to spring, such as the arrival of Zephyr, the dancing Graces, and the seaborn Venus, who is related to the month of April,[76] there is however a negative interpretation of the influence of "Venus, [...] the artless Nymphs, and cruel Cupid."[77] The "cruel mother of sweet Cupids," indeed, would seek little else but enchanting men above their fifty years of age.[78] Little would render in Horace's narration the idea of beauty, youth and the sweet introduction of love in an idyllic garden, which the *Primavera* is proposing.

Landino's commentary, following once again Plato and Ficino, distinguishes between the different kinds of Platonic love and introduces the topic of the three Cupids, born from Mercury and Diana, from Mercury and Venus, and the *Anteros* from Mars and Venus. He presents Venus positively as the mother of love and renders the story in a flowering garden. This, for example, happens where Horace refers to Cupid's cruel mother, capable of seduction rather than of sweetening her future lover's attendance.[79] Next, with regard to the introduction of the theme of spring in Horace, where the author describes the arrival of spring, the blowing of Zephyr towards the beach, and the dancing of Venus and the Graces, Landino instead refers to the three Graces Aglaia, Euphrosyne and Thalia, not present in Horace but introduced already by Landino himself in his Dante commentary, where he refers to their origin in Hesiod.[80] Landino's intention is obvious: Horace had rendered an ambivalent idea of Venus' intention, while Landino applied again the Neoplatonic theory of love, transforming the story into a positive narration on love.

A similar shift can be shown also in Marsi's commentary on Ovid's *Fasti*, which relates the calendrical order of the Latin year. The month of April introduces Venus, the "gracious Mother of the Twin Loves," which alludes to *Eros* and *Anteros*.[81] Venus, whom Ovid says "was called after the foam of the sea," belongs to April

> for they say that April was named from the open season, because spring then opens all things, and the sharp frost-bound cold departs, and earth unlocks her teeming soil, though kindly Venus claims the month and lays her hand on it.[82]

Ovid combines the story of Flora, Chloris and Zephyr with the month of June. Before, Ovid had mentioned Flora being celebrated in April, with festivities lasting until May. Ovid talks about Chloris – her marriage and living in a fruitful garden filled with flowers by her husband Zephyr.[83] Ovid's poetry partially explains the needed background for the *Primavera*, though some figures are still missing, and the story of Venus and Chloris remains, in the end, rather general.

However, Ovid's commentator, Paolo Marsi (accompanied by Antonio Constanzo),[84] puts part of the narrative into a context where Botticelli could benefit directly for his iconography. In his detailed narration of Chloris and Zephyr, for example, he describes Chloris as a nymph with flowering roses coming out of her mouth; the smell of the flowers would be Chloris, then called Flora, a nymph in a happy garden. She would be of admirable beauty, loved by Zephyr and given through him the primacy over flowers, that these should disseminate the earth.[85] This garden of happiness and joy ("foelicium hortorum nympha"), where happy nymphs meet with fortunate men on fertile ground in the garden of the Hesperides ("Hespidum hortos," "foecundus hortus"), is a long and detailed passage of Marsi's text.[86] Where in Ovid Venus stands beneath myrtle, the commentator (Costanzo) makes a myrtle crown out of it, or places it on Venus, which recalls Flora's flower crown in the *Primavera*.[87] The commentary also adds a detailed description of the *stolae* (vestments covering women from head to feet), which is absent in the original. These women can either be Venus herself, or "vestals virgins & pudicas matronas." Women clothed in this way would worship Venus.[88] Marsi was also familiar with the genesis of Venus and Cupid. Following the other Neoplatonic commentators like Ficino, he refers to two Venuses and three Cupids. The first Cupid was the son of Mercury and Diana; the second of Mercury and Venus; and the third would be *Anteros*. Likewise, he names Plato's two kinds of love, divine and common, both of which were absent from Ovid. Venus in Marsi is not only the seaborne, but he also calls her Aphrodite, arguing that the

month's name would have its origin here.[89] Still following other commentators, Marsi also dates the flower festivities, starting on last day of April ("Floralia sunt die ultimo aprilis") and continuing until the first day of May.[90] In book five, he refers to the wedding of Chloris and Zephyr, for which he prefers to draw on the early Christian author Lactantius rather than Ovid ("ea vero sic a Lactantio refert").[91] Combined with the nuptial topic is the flowering garden and the *floralia* ("edition ludorum quos appellant floralia"): this festivity would confer dignity on circumstances which otherwise could cause shame ("videbat ab ipso noie argumentum sumi placuit: ut pudendae rei: quaedam dignitas adderet"). Here they celebrate joyful pastimes ("celebrate ludis iocosis").[92] The subtle hint to circumstances connected to the marriage is missing in Ovid's poetry and certainly needed to be justified with the help of the early Christian author. Lactantius is introduced once again when Ovid talks about the Hore and their garments.[93] Marsi turns them into graces and sisters, with the already known names Aglata, Euphrosyne, and Thalia. They would turn the garden into fruitful flowers, then to be given to brides.[94] It is therefore not merely a coincidence that Botticelli's three figures, who shift between the appearance of ancient Hore in transparent garments and the three sisters as personification of graces, are situated in a garden full of flowers, pointing to fertility. Given the circumstances of the painting as a marriage gift, as mentioned before, this interpretation was certainly appropriate.

The Relevance of Renaissance Commentaries and Vernacular Interpretations for the Renaissance Artist

Comparing these contemporary commentaries makes clear how certain topics relevant to the *Primavera* were of higher importance to humanists than in the original texts. The commentators not only explained what happened in the ancient narrative, making the texts much more accessible, they even introduced from other ancient sources topics that had been totally absent in the original ancient version. Many stories in Plato, Ovid and Horace were of little direct use for an artist but needed explanation, which could be provided by a commentator. In this current research, these topics concern, especially, the positive interpretation of the heavenly and earthly Venuses, and the positive counterparts of *Ratio* and *Eros*, mediators of the Graces and the feast day of Venus at the end of April. Starting with Alberti – and taken up by Ficino, Landino, and Marsi – every Renaissance commentator knew the names of the Graces and had mixed their meaning following the ancient author Hesiod (Zeus' daughters), the Christian author Lactantius (Graces), and the mythology about the spring Goddesses (Horace). Now reappearing as the intermediary Graces, they make love appear as a divine gift and fructify their environment, turning the garden into blooming flowers. While re-narrating the stories in a Neoplatonic guise, the commentators emphasized relevant themes, which could have appeared as an *ekphrasis* for the painting.

Of the four commentaries relevant for the *Primavera*, it is clear that the two vernacular commentaries had a far deeper impact on Botticelli's iconography than did the Latin commentaries. Above all, Landino's discussion of Dante provides the main source for the painting, followed by Ficino's commentary on Plato's *Symposium*. Among the Latin commentaries, Paolo Marsi is of greater importance than Landino, who mainly repeats his other commentary. Ficino's commentary of 1469 on Plato's *Symposium* forms the basis of all these texts, which were all available in print by 1481 or 1482, the year of the wedding. If we presume Botticelli's knowledge of these commentaries, there was indeed no need for him to turn to the original authors, who would have added nothing significant for the

setting. Botticelli selected the relevant Renaissance commentaries dealing with a love-and-marriage topic, all interconnected and well known in the circle of the humanists. Extracting the essence of these commentaries, he composed a single narrative, where the figures appear interlinked. This required placing them in a row: the spring-born Venus, celebrating her birthday on the last day of April in the flowering garden of the Hesperides, together with her companions, who bring prosperity and fruitful love, all woven into the overarching and enduring Neoplatonic topic of the two kinds of love between *Eros* and *Ratio*. The Medici circle would immediately have perceived the pointed paraphrases in Botticelli's painting, for the relevant texts largely originated there. Moreover, Plato's *Symposium* was the text with which Lorenzo inaugurated a series of annual meetings on the anniversary of the ancient philosopher, as Ficino himself relates in the *proemio* to his commentary on the *Symposium*.[95] These *convivia*, which included Cristoforo Landino, had exactly the purpose of commenting on classical texts.[96] It is very well possible that Botticelli attended those literary discussions, too, which would also have eased his access to the discussed commentaries, especially those of Ficino and Landino. But he certainly knew Landino's commentary in any case, since he had had to provide the illustrations for it, and also used it as his main literary source for his other major mythology, the *Calumny*.[97]

It has often been proposed that Botticelli needed a humanist advisor for the composition of his mythological paintings. The majority of scholars have proposed Poliziano and some Ficino.[98] This advisor would then necessarily have helped choose appropriate ancient texts, interpret them under contemporary humanist and Christian views, and would have composed the literary snippets into a new story. For an artist, it was certainly difficult to transform an ancient text into a Neoplatonic vestment on his own; therefore, commentaries such as Landino's helped both patrons and artists immensely in finding the right up-to-date approach. However, had Botticelli needed advisory help beyond that found in commentaries, then Landino would certainly be a more plausible candidate for an advisor.[99]

It is probably more difficult to prove Botticelli's access to Marsi's text, which was printed at the end of 1482, thus perhaps slightly too late to influence the composition of the painting. However, Marsi was lecturing on this commentary in the academic year 1481–1482 at the Sapienza in Rome (and earlier in 1475–1476), when Botticelli was painting some scenes for the Old and New Testament cycle in the Sistine chapel. Marsi also lectured on Horace and Virgil, but no printed commentaries seem to have survived.[100] If we were to presume that Botticelli had attended the university classes, this would provide first-hand information for the artist. Marsi declared that his discussion took place "in publico gymnasio" and was attended by "pueris quam grandioribus."[101]

In Florence, there were certainly various possibilities for students and interested individuals to get some instruction on literary topics. Apart from university lectures and private circles, there was a category of public lectures for a general audience. Already in 1373–1374 Boccaccio was appointed to lecture *in civitate* on Dante for "all who wished to listen."[102] Then in 1428 Francesco Filelfo was hired with the task of teaching rhetoric and poetry, including Dante;[103] later the same task would be Landino's.[104] Besides Landino's Latin commentary, the young Botticelli might also have benefited from Landino's university lectures on Horace's *Odes* of 1459–60 or 1460–61.[105] A lecture on the *Fasti*, which the artist might have heard in exactly the relevant year 1481–1482 by Poliziano could also have been important.[106] However, since Poliziano's lecture notes scarcely survive, we do not know how close Poliziano's interpretation was to Marsi's.[107]

University or public lectures were highly important for the understanding of a difficult text, since the teacher would comment widely on the source, giving his own interpretation, which sometimes resulted in a printed commentary.[108] Artists could benefit from a variety of commentaries in the vernacular. There was a vernacular commentary on Ovid's *Metamorphosis* by Giovanni Bonsignori already available in the fourteenth century.[109] Also the Raphael Regius Latin edition and commentary on Ovid's *Metamorphosis* (first printed in 1493) gave access to a difficult topic.[110] In these, unclear meanings, difficult contexts or literary references have been extended and explained in order to accommodate the less knowledgeable reader. The commentator obviously wanted to introduce the reader into the matter of ancient mythology, and he even split the text into separate chapters with titles. The commentator explains why a broad access to the text and explanations are necessary: he gives the *Metamorphosis* as the relevant encyclopedia to ancient wisdom, helpful to approach all subjects, and for providing moral education in the humanist sense.

Whereas the Latin commentary would address students on all levels, as well as humanists and humanistically educated people, as Regius suggests, the vernacular commentary by Bonsignori points to a public only familiar with the Italian language and interested in the content rather than style.[111]

The Importance of Philological Commentaries for a Painter

It is now becoming clear that Botticelli was certainly not relying on ancient literature to develop topics of ancient origins. He might have been pointed to appropriate commentaries for his invention. Like humanists and philologists, Botticelli attempted his own interpretation of ancient sources, helped by the commentaries of his contemporaries. These topics and motives were woven together from different literary sources. The ambiguity of paintings following literature seems therefore intentional, as single figures and scenes may reflect several literary sources. Thus, Botticelli's paintings could well be examples of Alberti's expression of *favole*, as Dempsey is proposing.[112] In *Della Pittura*, Alberti explains how textual sources can be woven together to depict a poetic idea as *poesia*.[113] A painting with an ambivalent content, a *favola* in Alberti's terminology (or a *favola* as Landino terms the story of Love and the Graces), should be represented as a *poesia*. The nature of the *favola* is not the illustration of a single source but rather depends on the concept of *poesie* – that is, the possibility of plural sources illuminating new concepts. This is exactly what legitimizes the use of several literary sources in a painting, and especially in Botticelli's mythological scenes. The painter clearly competes here with the commentator but also benefits from him. The *Primavera* therefore gains, and perhaps exceeds, the interpretative power of a philological commentary.

Regarding the relationship of Platonic and Neoplatonic texts, we should bear in mind that most Platonic sources had been purposively modified by early Christian writers. This is why patristic writers close to Neoplatonism, like Augustine, were so important for Quattrocento humanists. Ficino and others were relying on them in interpreting classical texts in the light of Christian morality. Ficino's complex ensemble of *prisci teologi* or pre-Christian sages, from antiquity to the advent of Christianity, was intended to reintroduce the Christian spirit and thus to enable the use of antique philosophy in a Christian mantle.[114] One such philosopher was in fact Plato, and many efforts have been made to explain how close the ideas of the ancient sage were to Christianity. Also, the antique pagan mysteries could be enlivened with a Christian ethos and used for moral humanist education.[115] Ficino, Landino, Poliziano, and others examined antiquity through a Christian lens, and most of them were themselves clerics.

The same lens was used by patrons and artists. Botticelli's *Primavera* and his other mythological paintings must be seen in this light. Figures loaned from antiquity are placed in the humanist context of Renaissance Florence, with the help of select contemporary commentaries.

Botticelli was perceptive enough to select pertinent commentaries to render the idea of a love-and-marriage topic in a Neoplatonic guise. His outstanding merit is to have woven these contemporary sources and commentaries into a uniquely complex and satisfying painting on the benefits of Love and Spring.

Notes

1 A part of this paper was presented at the annual meeting of the Renaissance Society of America (March 24th–26th 2011) in Montreal under the title "Ratio and Eros in Botticelli and Landinus" and at the Warburg Institute, London (Oct 30, 2012) "The Influence of Renaissance Commentaries and Translations on Artists – the Case of Botticelli."
2 Quintus Horatius Flaccus, *Opera*, ed. and comm. by Christophorus Landinus (Florence: Antonio di Bartolommeo Miscomini, 1482); Paolo Marsi, *Paulus Marsus piscinas poeta. cl. generoso iuueni Georgio Cornelio. m. Cornelii equitis. f. salutem* (Venice: Antonius Battibovis, 1485).
3 Dante Alighieri, *Comento di Christophoro Landino fiorentino sopra La comedia di Danthe Alighieri poeta fiorentino* (Florence: Per Nicholo di Lorenzo della Magna, 1481).
4 Sandra Niccoli, "Prefazione," in Ficino (1987, v).
5 On Botticelli's preparatory drawings for the incisions and the separate set of drawings, see, for example: Schulze Altcappenberg (2000).
6 This article is able to present only some key notes on the commission, dating, and iconography of the painting relevant for the following discussion. For a comprehensive introduction to the painting, see the latest monographs: Cecchi (2005), Zöllner (2005), Körner (2006), Acidini Luchinat (2009), Dombrowski (2010).
7 The oldest and most commonly accepted interpretation of the characters provided already by Aby Warburg remains still valid. See below, n. 29.
8 The other mythology hanging next to the *Primavera* was Botticelli's *Birth of Venus*. On the wedding and the hanging of the picture, see Rohlmann (1996). This hypothesis is also sustained by Lightbown (1989, vol. 2, 51–3), Levi d'Ancona (1992, 27–8), Zöllner (1997), Zöllner (1998, 34), Burroughs (2012, 73–4). We do not know, however, whether it was commissioned by Lorenzo di Pierfrancesco – as maintained by the majority of these scholars – or by Lorenzo il Magnifico – as maintained, for example, by Zöllner (1998, 34–7), Zöllner (2009, 71), Dombrowski (2010, 60). Another hypothesis places the picture in the Villa di Castello. See, for example, Cecchi (2005, 148). Some authors tend toward a later dating, after Botticelli's stay in Rome, towards 1485–87. See Bredekamp (2002, 28: 1485–87), Acidini Luchinat (2009, 78: after 1482, before 1485), Dombrowski (2010, 54: 1482–85). See Hatfield (2009), who unconvincingly dates the *Primavera* to the seventies.
9 Gombrich (1945). An overview of Neoplatonic interpretations for the *Primavera* is also given by Stèphane Toussaint in this book.
10 Wind (1958, 100–10), Gillies (1981), Van den Doel (2008, 154–76).
11 De Girolamo Cheney (1985, 85–9).
12 Snow-Smith (1993).
13 Villa (1998).
14 La Malfa (1999, 2002). See Prestifilippo (2008), who likewise puts the most emphasis on Martianus Capella and Apuleius.
15 Marmor (2003).
16 Poncet (2008, 2012).
17 Reale (2007).
18 Dee (2013).
19 On Plato's naturalistic texts see, for example, Leinkauf and Steel (2005), see especially the introduction pp. xxi–xxiv, and pp. 363–452 – the articles by Thomas Leinkauf, James Hankins, and Mischa von Perger.

20 Bredekamp (1986/1992, 1988).
21 Acidini Luchinat (2001).
22 Dempsey (1992, 2012, 1–7, 69–114).
23 Dempsey (2009, 192).
24 Francesco Petrarca, *Canzoniere*, 3, 18, 19, 23; Petrarca (1996, 17, 76–80, 95–122).
25 Francesco Petrarca, *Canzoniere*, 9, 239, 310; Petrarca (1996, 44–6, 975–9, 1190–2).
26 Francesco Petrarca, *Canzoniere*, 12, 23, 168; Petrarca (1996, 55–7, 95–122, 760–2).
27 Dempsey (2009, 201). See also Dempsey (1992, 72–4, 77), Dempsey (2001), Dempsey (2012, 69–71, 88).
28 Alberti (2011).
29 See Bertolini (2003, 51–70). Alberti was also the author of the first Italian grammar: *Grammatichetta vaticana* (1435). See Alberti (1964).
30 Warburg (1998). *Fasti*, V, 193, 212; Ovid (1931), 275–7.
31 Horace, *Carmina*, book 1; Horace (1978). Lucretius, *De rerum natura*, 1.6–13 and 5.737–40; Lucretius (1982, vol. 3, 2–3, 434–7). There is also mention of Renaissance literature in imitation of the antique, for example: Poliziano, *Sylvae* and *Stanze cominciate per la Giostra del Magnifico Giuliano di Piero de'Medici* (dat. 1475–78); Poliziano (1993). Discussing the writings of Poliziano, Gombrich (1945, 9) rightly sees in these sources more the archetype of a medieval allegorical garden, with a comparable atmosphere, rather than an ekphrastical background for the scene.
32 Gombrich (1945, 15, 22).
33 Ficino (1556/1962, 805, 812, 834, 845, 905, 908); Ficino (1975–2012), vol. 6, 14–7 (letters 10 and 11), 54–6 (letter 42); vol. 7, 30–1 (letter 25), 74 (letter 68); vol. 8, 7 (letter 3), 9 (letter 4).
34 Gombrich (1945, 22–31). Mercury, however, does not appear in the company of Venus but in his more classical role as in the "Judgement of Paris," where he gives an orange (i.e. a golden apple) to Venus. See Gombrich (1945, 27). Unfortunately Gombrich's (1945, 25) reading of Beroaldo's commentary on Apuleius does not get much space in his interpretation. It is at least an interesting hint at a Renaissance commentary on the ancient source.
35 Bredekamp (2002, 74). Lucretius, *De Rerum Natura*, 5, 737–40; Lucretius (1982, 435–7).
36 Bredekamp (2002, 80–1). Virgil, *Aeneid*, 4, 222–3; Virgil (1998–99, vol. 1, 410–1). Two recent articles on the influence of Ovid's *Fasti* on the *Primavera*, following the traditional interpretation, do not consider Renaissance commentaries on the topic but only the original text, accessed with the help of a humanist advisor. Andrews (2011) is pointing to Poliziano's university lectures on the *Fasti* and his possible advisory on the painting. The other article by Burroughs (2012, 71–83) underlines the "nearly universal consensus," but wishes to see the ancient sources interpreted as "intertext," relying on the original multiple texts and contemporary interpretations. Although assigning the principal textual basis to Ovid, he does not know the contemporary commentary by Marsi.
37 Marmor (2003), with the preceding literature. Bredekamp (2002, 64, 84) pointed to Mercury and his *caduceus* banishing the mists on the first day in paradise, where oranges are proposed for delight.
38 *Purgatorio*, canto 31–2. Marmor (2003, 203, 207).
39 La Malfa (1999). The late antique author Martianus Capella and his work *De nuptiis Philologiae et Mercurii libri* was first introduced by Lightbown, followed also by Rehm (1999) and Reale (2001).
40 Snow-Smith (1993) proposes Marsilio Ficino as the principal ideator of Botticelli's painting. Already in 1958, Wind pointed to Ficino's version of Plato's love theory, without, however, taking advantage of Ficino's explanations and alterations; Wind (1958, 105–6). A recent study of the *Primavera* by Zorach (2007) tries instead to discontinue the iconographic line suggested by Warburg, Wind, and Gombrich by putting them in their historical perspective, and attempts to introduce a political-social context for the painting. Lately Van den Doel and Poncet are following Snow-Smith's direction, underlining the value of Ficino's *Pimander* and Landino (for the mythologies). Marieke van den Doel (2008) bases her interpretation mainly on Ficino. Poncet (2012, 10–41, 96–9, 103) bases his interpretation on Tarocchi cards, Ficino, and Landino, who provided the allegorical and mythological background. He also briefly refers to Landino's Horace commentary for the way the Graces are represented. However, the main source for Poncet is Lorenzo de' Medici's *Commento de Alcuni de miei sonetti*, from

which he takes the topic of beauty and love. See Poncet (2008, 540–42, 547) and Poncet (2012, 48–66, 76–80). New interpretations relying on the *Orphic Hymns* were proposed by Hatfield (2009), Kline (2011, 665–88).

41 Acidini Luchinat (2009, 116: catalog entry by Poletti); although Poletti does not offer an explanation for citing Landino as a source.

42 Acidini Luchinat (2009, 78–9).

43 Deimling (2009).

44 Poncet (2012, 68–70, 96–9, 103).

45 Dante Alighieri, *Comento di Christophoro Landino fiorentino sopra La comedia di Danthe Alighieri poeta fiorentino* (Florence: Nicholo di Lorenzo della Magna, 1481); Landino (2001).

46 Landino (2001, vol. 1, 349: *Inferno* 1, canto 2, vv. 43–57).

47 Augustinus, *De civitate Dei*, X, 29; Augustine (2003, 414–5). The supreme instance of grace was in God's son taking human body and soul. The son then functioned as a mediator and gave men the spirit of love, which brought him closer to God. The intellectual soul of the Platonist would actually be the human soul.

48 Landino (2001, vol. 1, 349: *Inferno* 1, canto 2, vv. 43–57): "Sono figliuole di Iove. Il che non significa altro se non che da Dio solo procede ogni gratia. [...] E nomi loro sono Aglaia, Euphrosyne, et Thalia. 'Aglaos' in greco significa 'splendido'; et certo solo da divina gratia fa l'anima nostra splendida perché la illumina. 'Euphrosyne' significa 'letitia' perché solo quella ci fa lieta. 'Thalia' significa 'fiorente', et 'verdeggiante', perché epsa fa fiorire et rinverzire in noi ogni virtù. Aggiunghono che le due seguenti raguardano la prima, perché dallo splendore di questa pende, et procede, che l'anima humana sta lieta et verdeggiante. Non dubiterà adunque l'huomo mettersi per la via della contemplatione havendo già disposto el senso a ubbidire la ragione, et havendo per guida lo intellecto non solamente illustrato di tutte l'humane doctrine, ma ancora nobilitato per le tre divine gratie."

49 Landino (2001, vol. 1, 346: *Inferno* 1, canto 2, vv. 43–57).

50 This concept is based on Ficino's model of *prisca teologia*. See, for example, Walker (1972, 1–21).

51 Landino (2001, vol. 1, 346–47: *Inferno* 1, canto 2, vv. 43–57): "Virgilio adunque, cioè la ragione superiore, confortando la inferiore, et la sensualità, dimostra potere conducere quella a salvamento se non chon le sue forze, almanco coll'aiuto della gratia divina, sanza la quale si ardua impresa sarebbe invano. Et dipoi mostra secondo la vera et christiana doctrina qual sia la via per la quale possiamo arrivare a si excelso luogo. Il che, acciò che meglio s'intenda, bisogna repetere alquanto più di lontano [...]. Affermano adunque e veri theologi che benché nell'huomo sia libero arbitrio d'operare bene et male, nientedimeno nessuno può purgarsi da'vitii et operare secondo la virtù sanza la divina gratia. [...] Né puo essere in noi virtù se non v'e ragione, perchè ogni virtù procede da recta ragione."

52 The meaning of the three Graces has been variously interpreted. Warburg explained their gestures as giving and taking familiar moral gifts, such as Pulchritudo, Castitas, and Amor. Interpretations of the Graces have so far tried to decipher the triad with virtues and vice in relation to Venus. The majority of researchers have therefore sustained the reading as a personification of beauty set as an antithesis towards Chastity-Voluptuousness-Ratio. See Wind (1958, 103: Castitas-Pulchritudo-Voluptas), Warburg (1932/1969, vol. I, 27–9, 327: *Castitas-Pulchritudo-Amor* or *Amor-Pulchritudo-Voluptas*), Bredekamp (2002, 26: Voluptuousness-Chastity-Beauty), Rohlmann (1996, 125: Ratio-Beauty), Zöllner (1998, 55: Chastity-Beauty-Love). Zöllner (1998, 55) sets the concept of beauty parallel to the female concept of virtue. Bredekamp (2002, 26) also follows the motive of 'giving' in the dance of the three Graces: giving, taking, giving back are in concordance with voluptuousness, chastity, and beauty. Dempsey (1992, 27), too, relied on the gift of the sisters, citing the example of Zeus' daughters Aglaia, Euphrosyne and Thalia in Hesiod's *Theogonia*. These women incorporated Divine Grace and could therefore be depicted with light garments and linked hands. According to Dempsey (1992, 33), the combination of Mercury with the three Graces can only be found in Horace's *Odes* and Seneca's *De beneficiis*, I.iii.2–10; Seneca (1935, 12–7). However, he notices (1992, 33–35) that contemporary sources like Alberti and Poliziano themselves refer back to these sources. However, as Gombrich (1945, 33–4) and La Malfa (1999, 260, 273) briefly noted, these three women were also mentioned in Landino's Commentary on the *Divine Comedy*.

53 Landino (2001, vol. 1, 348–49: *Inferno*, canto II, vv. 43–57). See also Landino (2001, vol. 1, 385: *Inferno*, canto III, vv. 22–33) on free will. See Lentzen (1971, 67).

54 Landino (2001, vol. 1, 348–9: *Inferno* 1, canto 2, vv 43–57): "Imperoché con la ragione discorre per la cognitione de'vitii, che è lo 'nferno; con le virtù acquistate per la ragione si purga da quegli, che è el purgatorio; et purgato può salire alla contemplatione delle chose divine, et farsi beato, che è el paradiso. Ma per rispecto che nessuna di queste tre chose può essere perfecta sanza el divino aiutorio [gratia Dei], però ci vengono da Dio tre gratie. La prima illumina la ragione, et falla habile a formare la virtù, che non è altro, che adirizare la volontà che truova in noi del libero arbitrio, a volere rectamente el bene; et questa è decta preveniente, et dal poeta è figurata per la prima donna, et disponci a volere. Et perchè la volontà innanzi che vengha in acto è nascosa nell'animo, et incognita, però la pone sanza nome. La seconda è gratia illuminante, per la quale la buona volontà la quale c'inlumina et aiutaci che sappiamo quello che dobbiamo fare; et perchè ci porge el lume del sapere, meritamente da tale luce la chiama Lucia. Per la qualchosa dice Augustino, che la prima gratia fa che noi vogliamo, la seconda fa che tale volontà non sia indarno, cioè che noi possiamo. Et queste due gratie ogni giorno chiede la chiesa nelle sue prece dicendo: 'preghianti Signore che tu prevenga le nostre operationi con tua ispiratione, et dipoi le seguiti chol tuo aiuto.' La terza è gratia perficiente, overo consumante, i. la quale adempie tutta nostra voglia, perche ci aiuta a contemplare, et conoscere el nostro sommo bene, et questa chiama Beatrice, la quale dicemo disopra figurare la theologia, la quale ci dà la cognitione delle chose divine. Et certo è Beatrice perché ci fa beati, faccendoci conoscere Idio. Imperoché conoscendo l'amiamo, et amando lo fruiamo. Né mi pare da pretermectere quello, che delle gratie scrivono e poeti, perché assai facilmente chi ha ingegno conosce ce non molto si dipartano da quello che di sopra habbiamo raccolto da'veri theologi." Landino evidently relies here on Seneca's narration of the three Graces, see Seneca's *De beneficiis*, I.iii.2–10; Seneca (1935, 12–7).

55 Landino (2001, vol. 4, 1680–1: *Paradiso*, canto 7, vv. 1–12).

56 Christophe Poncet instead refers to Ficino's twofold version of Venus in order to compare with Lorenzo's characters Simonetta and Lucrezia. He does not mention Landino's shift to three Venuses. See Poncet (2008, 542) and Poncet (2012, 45–84). For the interpretation of a marriage painting, see above, n. 7.

57 Ficino, *Libro dell'amore*, VI, 7; Ficino (1987, 129–30): "[…] la celeste abbi l'amore a cogitare la divina bellezza, la vulgare abbi l'amore a generare la bellezza medesima nella materia del mondo […]. Anzi l'una e l'altra è trasportata a generare la bellezza, ma ciascuna nel modo suo: la celeste Venere si sforza di ripingere in sé medesima, con la intelligentia sua, la espressa similitudine delle cose superiori; la volgare si sforza nella mondana materia parturire la bellezza delle cose divine, che è in lei concepita per l'abbondanza de'semi divini."

58 Ficino, *Libro dell'amore*, VI, 8; Ficino (1987, 131–3).

59 Ficino refers here to Plotinus' interpretation of the *Symposium*. See Plotinus, *Enneades*, III, 5, 1; Plotinus (1966–88, vol. 3 [1967], 167–73).

60 Plotinus, *Enneades*, III, 5, 2; Plotinus (1966–88, vol. 3 [1967], 173–7).

61 Ficino, *Libro dell'amore*, VI, 8; Ficino (1987, 133): "Adunque ogni amore comincia dal vedere, ma l'amore del contemplativo dal vedere surge nella mente, l'amore del voluptuoso dal vedere discende nel tacto, l'amore dell'activo nel vedere si rimane."

62 Plato, *Symposium*, 196; Plato (1961, 548).

63 Ficino, *Libro dell'amore*, VI, 7; Ficino (1987, 126–7). See Leitgeb (2006, 74).

64 Ficino, *Libro dell'amore*, VI, 7; Ficino (1987, 126–7).

65 Plotinus, *Enneades*, III, 5, 8–9; Plotinus (1966–88, vol. 3 [1967], 195–203).

66 Plato, *Symposium*, 203; Plato (1961, 555–6).

67 Ficino, *Libro dell'amore*, VI, 9; Ficino (1987, 138). Already Christophe Poncet (2008, 538) noted the positive shift in interpretation in Ficino.

68 Ficino, *Libro dell'amore*, VI, 9; Ficino (1987, 139).

69 Plato, *Symposium*, 206; Plato (1961, 558–9).

70 Ficino, *Libro dell'amore*, VI, 12; Ficino (1987, 154), Ficino (1944, 204).

71 Ficino, *Libro dell'amore*, VI, 11; Ficino (1987, 153). See Plotinus, *Enneades*, III, 5, 1; Plotinus (1966–88, vol. 3 [1967], 167–73).

72 For a contrary interpretation of Ficino's theory of procreation, still belonging to the lower spheres, see Van den Doel (2008, 394–5).

73 Landino (2001, vol. 1, 259–60: proemio XI).

74 Plato, *Phaedrus*, 246 a–252 b, 255 c–d; Plato (1961, 493–8, 501); Ficino (2008, 121–55, 169). See Ficino (1944, 127–32). Plato explains the nature of *Eros* in the context of the nature of soul. To explain *Eros* he therefore invents a wagon with wings, led by *Nus*. When these wings are growing and developing, the soul can ascent and find truth. Once the soul has found truth, it can decide its destination: whether to follow a friend of wisdom, a philosopher, or beauty, or a servant of the muses, or *Eros*. But God's inspiration on *Eros* should be regarded as stronger than those of the Sibyls or Muses. For *Eros*, however, looking at beauty is the initial inspiration. Therefore, he desires beauty and searches for it. Similarly, also men rage when seeing beauty and desiring the object of their love. This state of mind they call *Eros*.

75 Christophe Poncet, probably rightly, refers the depiction of Mercury to Landino's commentaries on Virgil's *Aeneid* and Horace's *Carmina*, where Mercury is described with wings on head and ankles, and entwined with serpents, scimitar, and a cap. See Poncet (2008, 545). In the comment on Dante, Landino interprets the angel as a Mercury figure, who "clears the fog." Landino (2001, vol. 2, 561: *Inferno*, canto IX, vv. 82–90). See Poncet (2008, 546).

76 Horace, *Odes*, I, iv, and IV, xi–xii; Horace (2004, 33 and 249–53).

77 Horace, *Odes*, II, viii; Horace (2004, 111–3).

78 Horace, *Odes*, IV, i; Horace (2004, 219–21).

79 Horace, *Odes*, I, xix; Horace (2004, 63); *Horatii Flacci poetae opera*, commented by Cristoforo Landino (Venice: Philippus Pincius, 1498) f. 39r. I am referring here to this later edition, for the first edition of 1482 is very rare: Quintus Horatius Flaccus, *Opera*, ed. and comm. by Christophorus Landinus (Florence: Antonio di Bartolommeo Miscomini, 1482).

80 Horace, *Odes*, I, iv; Horace (2004, 33); *Horatii Flacci poetae opera*, comm. Landino, f. 14r. See Landino (2001, vol. 1, 349: *Inferno* 1, canto 2, vv. 43–57).

81 Ovid, *Fasti* IV, 1–20; Ovid (1931, 189–91).

82 Ovid, *Fasti* IV, 49–106; Ovid (1931, 193–5).

83 Ovid, *Fasti*, V, 183–215; Ovid (1931, 275–7).

84 Two different versions of the commentary exist: one is by Paolo Marsi alone, printed first in Venice in 1482: Paolo Marsi, *Paulus Marsus piscinas poeta. cl. generoso iuueni Georgio Cornelio. m. Cornelii equitis. f. salutem* (Venice: Antonius Battibovis, 1485). The other is "cum duobus commentariis" together with the commentary by Antonio Costanzo (1436–1490), first printed in Venice in 1497. I will cite for both authors the collected edition from 1510 (which, for Marsi's parts, is close to identical to his first edition), to which I had easier access: Paolo Marsi, *P. Ouidii Nasonis Fastorum libri diligenti emendatione typis impressi aptissimisq[ue] figuris ornati co[m]mentatoribus Antonio Consta[n]tino Fanensi: Paulo Marso piscinate uiris clarissimis additis quibusdam uersibus qui deerant in aliis codicibus* (Milan: Pachel, 1510). We know from letters that Costanzo was already working on this topic in 1471 and Marsi since 1474. Both were in contact about their commentaries from at least 1482, the year Poliziano was lecturing on the same topic (see below). Paolo Marsi was a teacher of rhetoric in Rome and member of Pomponio Leto's Academy. See Della Torre (1903), Fritsen (2000). Antonio Costanzo was a former student of Guarino Veronese and then a teacher of grammar and rhetoric in Fano. See Prete (1993).

85 *Ouidii Nasonis Fastorum libri*, 1510, f. 155v (Paolo Marsi): "Ab ore rosas vernas: odorem rasarum verni tipis: Chloris erat: nunc flore chlorim se vocatam dicit."

86 *Ouidii Nasonis Fastorum libri*, 1510, f. 156r (Paolo Marsi).

87 *Ouidii Nasonis Fastorum libri*, 1510, f. 111r–112r, and f. 119r (Antonio Costanzo).

88 *Ouidii Nasonis Fastorum libri*, 1510, f. 119r (Paolo Marsi): "Quam ob causam legimus supra Silviae vestali vittam excidisse cum virginitatem amisit: & Festibus matronas tradit appellari eas fere quibus stolas habendi ius erat. Dimittebantur autem stolae ad imos pedes teste. […] Vittae & longa vestis abest […]. Quas stola contigi vittaque sumpta vetat. Sic nunc omnes mulieres colere venerem inquit praeter vestales virgines: & pudicas matronas. Sed de stola aliter sentire videtur."

89 *Ouidii Nasonis Fastorum libri*, 1510, *Ovid*, f. 111r, f. 117v (Antonio Costanzo).

90 *Ouidii Nasonis Fastorum libri*, 1510, *Ovid*, f. 148r (Paolo Marsi).

91 See in Lactantius: "Working to the same pattern, Ovid in Fasti told of a notable nymph called Chloris: she was married to Zephyrus and received as her husband's wedding gift the privilege of power over all the flowers." Lactantius, *Divinae institutiones* I, 20, 8; Lactantius (2007, 103).

92 *Ouidii Nasonis Fastorum libri*, 1510, Ovid, f. 155v (Paolo Marsi).
93 See the same passage in Lactantius, *Divinae institutiones* I, 20, 5–10; Lactantius (2007, 103–4).
94 *Ouidii Nasonis Fastorum libri*, 1510, Ovid, f. 156r (Paolo Marsi).
95 Ficino (1944, 13, 37).
96 See Della Torre (1902, 602); Ficino (1944, 13, 37).
97 See above, n. 4. On Botticelli's familiarity with Landino's commentary on Dante, see also Dressen (2017).
98 For Poliziano as an advisor see Warburg (1999, 95), Gombrich (1945, 7, 10), Bredekamp (2002, 72), Hatfield (2009, 7–35), Reale (2007, 42–3), Dempsey (2012, 1, 69–114), Andrews (2011, 73), Burroughs (2012, 72). For Ficino as an advisor see Snow-Smith (1993, 22, 70, 201).
99 On Landino's influence on artists and the use of commentaries in paintings, see my forthcoming monograph *The Intellectual Education of the Renaissance Artist 1450–1550.*
100 On Marsi's lectures, see Della Torre (1903, 266), Fritsen (2000, 358, n. 2, 368, 375).
101 Della Torre (1903, 267). The other possibility would be discussion groups at the papal court, to which both Marsi and Botticelli might have been invited. On this, we can only speculate. However, Botticelli was called to Rome as one of the leading painters of his time and then charged with the most prestigious commission. One of the leading humanists at the papal court was Bartolomeo Platina, the Vatican librarian. Before holding this position, Platina had lived some years in Florence (1457–61), where he studied with Giovanni Argiropulo and attended the literary academy. Pope Sixtus IV was much in favor of these humanist academies; he allowed Pomponeo Leto, the teacher of Marsi, to revive his banished academy. Marsi himself remained in contact with the Medici and Poliziano and wished to visit them in the summer of 1482 on his trip from Rome to Venice (the same year, he contacted Antonio Costanzo on Ovid). That this did not take place was due to rumors that he was bringing the plague from Rome. On Platina, Marsi, Leto and the academies, see Della Torre (1902, 375–9; Della Torre (1903, 107, 126, 226–7, 269–70).
102 Grendler (2002, 78).
103 Kallendorf (1989, 153); Grendler (1989, 205–29).
104 Landino began lecturing on Dante in 1458. See Kallendorf (1989, 164). Dante was until the end of the century not a regular university topic, discussed only occasionally. However there were also public lectures on Dante, which were certainly more accessible for an interested general public.
105 Grendler (2002, 237). Christoforo Landino also gave a commented lecture on Virgil at the Florentine *studio* in the year 1462–63. Notes survived in a draft of lectures compiled by a student. See Field (1978, 17–20). In the case of Horace's *Odes*, Botticelli would have been about 15 years old. In the case of Michelangelo, it has been proposed that at the age of sixteen (around 1491–92) he received literary advice from Poliziano, helping him to compose the famous relief with the centaurs. Several sources from the sixteenth century on Michelangelo confirm this contact. Lisner also points to Landino's commentary as a possible source for the relief. See Lisner (1980, 300–4, 310–1), also Hirst (1994, 14–6), Gilbert (2003, 107 and 177, n. 68). Though we are not dealing here with proper teaching and lessons, the episode of Michelangelo suggests that there were fruitful exchanges between humanists and artists, even very young ones.
106 In the same year Poliziano also lectured on Hesiod and the year before on Statius' *Silvae*. See Grendler (2002, 238). On Poliziano's lecture on Ovid's *Fasti*, see also Reale (2007, 42).
107 On Poliziano's lecture notes, see Andrews (2011, 73–84).
108 For example, Filippo Beroaldo was a well-known teacher at the University at Bologna, where he taught and wrote a commentary on Apuleius. His text was printed in 1500 with the comparatively large print run of 1,200 copies. On Beroaldo, see Glasser (2005).
109 Bonsignori (2001).
110 Regio (2008).
111 See Guthmüller (1975, 119–39). The illustrations for the commentary on Ovid follow the usual scheme of the contemporary narrative, already used in Landino's Dante commentary. See Evamarie Blattner, *Holzschnittfolgen zu den Metamorphosen des Ovid: Venedig 1497 und Mainz 1545* (Munich: Scaneg, 1998). Instead of the original text, Guthmüller could verify a variety of Ovid commentaries on the *Metamorphoses* as clear sources for Renaissance paintings. This is true, for example, for the frescoes by Giulio Romano in Mantova (Palazzo del Te) and Giovanni Bellini's *Feast of the Gods* for Alfonso d'Este. See Guthmüller (1981), also Thimann (2002).

112 Dempsey (1992, 27–8), Dempsey (2012, 1–2, 109).
113 Leon Battista Alberti, *Della Pittura*, III, 2–5; Alberti (2011, 300–5).
114 See above, n. 50.
115 To read "Pagan mysteries in the Renaissance" only under this pagan and thus one dimensional aspect, as has been done wrongly after Edgar Wind's book, means to miss its main goal. See Wind (1958), also Warburg (1999).

Bibliography

Acidini Luchinat, Cristina. 2001. *Botticelli: Allegorie mitologiche*. Milan: Electa.

Acidini Luchinat, Cristina. 2009. *Botticelli nel suo tempo*. Milano: Electa.

Alberti, Leon Battista. 1964. *La prima grammatica della lingua volgare: La grammatichetta vaticana cod. vat. reg. lat. 1370*, edited by Cecil Grayson. Bologna: Commissione per i testi di Lingua.

Alberti, Leon Battista. 2002. *Über die Malkunst*, translated by Oskar Bätschmann and Sandra Gianfreda. Darmstadt: Wissenschaftliche Buchgesellschaft.

Alberti, Leon Battista. 2011. *De Pictura: redazione volgare*, edited by Lucia Bertolini. Florence: Polistampa.

Andrews, Lew. 2011. "Botticelli's Primavera, Angelo Poliziano, and Ovid's Fasti." *Artibus et Historiae* 63, XXXII:73–84.

Augustine. 2003. *Concerning the City of God against the Pagans*, translated by Henry Bettenson. London: Penguin Books.

Bertolini, Lucia. 2003. "Agon stephanites: il progetto del certame coronario (e la sua ricezione)." In *Il volgare come lingua di cultura dal Trecento al Cinquecento*, 51–70. Florence: Olschki.

Blattner, Evamarie. 1998. *Holzschnittfolgen zu den Metamorphosen des Ovid: Venedig 1497 und Mainz 1545*. München: Scaneg.

Bonsignori, Giovanni. 2001. *Ovidio Metamorphoseos vulgare*, edited by Erminia Ardissino. Bologna: L'Indice.

Bredekamp, Horst. 1986/1992. "Götterdämmerung des Neuplatonismus." *kritische berichte* 14, 4:39–48. Repr. 1992 with minor revisions in *Die Lesbarkeit der Kunst: Zur Geistes-Gegenwart der Ikonologie*, edited by Andreas Beyer, 75–83 and 102–106. Berlin: Wagenbach.

Bredekamp, Horst. 1988. *Botticelli Primavera: Florenz als Garten der Venus*. Frankfurt am Main: Fischer.

Bredekamp, Horst. 2002. *Sandro Botticelli: Primavera*. Berlin: Wagenbach.

Brown, Alison. 2010. *The Return of Lucretius to Renaissance Florence*. Cambridge: Harvard University Press.

Burroughs, Charles. 2012. "Talking with Goddesses: Ovid's Fasti and Botticelli's Primavera." *Word & Image* 28:71–83.

Campbell, Jean. 1998. "The Lady in the Council Chamber: Diplomacy and Poetry in Simone Martini's Maestà." *Word & Image* 14, 4: 371–386.

Cardini, Roberto. 1990. "Landino e Dante." *Rinascimento* 30:175–190.

Cecchi, Alessandro. 2005. *Botticelli*. Milan: Motta.

De Girolamo Cheney, Liana. 1985. *Quattrocento Neoplatonism and Medici Humanism in Botticelli's Mythological Paintings*. Lanham: University Press of America.

Dee, John. 2013. "Eclipsed: An Overshadowed Goddess and the Discarded Image of Botticelli's Primavera." *Renaissance Studies* 27:4–33.

Deimling, Barbara. 2009. "Who Tames the Centaur? The Identification of Botticelli's Heroine." In *Sandro Botticelli and Herbert Horne*, edited by Rab Hatfield, 63–103. Florence: SUF.

Della Torre, Arnaldo. 1902. *Storia dell'Accademia Platica di Firenze*. Florence: Carnesecchi.

Della Torre, Arnaldo. 1903. *Paolo Marsi da Pescina: contributo alla storia dell'Accademia Pomponiana*. Rocca S. Casciano: Cappelli.

Dempsey, Charles. 1992. *The Portrayal of Love: Botticelli's Primavera and Humanist Culture at the Time of Lorenzo the Magnificent*. Princeton: Princeton University Press.

Dempsey, Charles. 2001. "A Hypothesis Concerning the 'Castello Nativity' and a Scruple about the Date of Botticelli's 'Primavera'." In *Opere e giorni*, edited by Klaus Bergdolt and Giorgio Bonsanti, 349–354. Venice: Marsilio.

Dempsey, Charles. 2009. "The Importance of Vernacular Style in Renaissance Art: The Invention of Simone Martini's Maestà in the Palazzo Communale (sic!) in Siena." *Studies in the History of Art* 74:189–205.

Dempsey, Charles. 2012. *The Early Renaissance and Vernacular Culture*. Cambridge: Harvard University Press.

Dombrowski, Damian. 2010. *Botticelli: Ein Florentiner Maler über Gott, die Welt und sich selbst*. Berlin: Wagenbach.

Dressen, Angela. 2017. "From Dante to Landino: Botticelli's Calumny of Apelles and its Sources." *Mitteilungen des Kunsthistorischen Institutes in Florenz* 59, 324–339.

Dressen, Angela. 2020. The Intellectual Education of the Italian Renaissance Artist. New York: Cambridge University Press.

Ficino, Marsilio. 1556/1962. *Opera omnia*. Basel: ex officina Henricpetrina. Repr. 1962, edited by Paul Oskar Kristeller. Turin: Bottega d'Erasmo.

Ficino, Marsilio. 1944. *Marsilio Ficino's Commentary on Plato's Symposium*, translated by Sears Reynolds Jayne. Columbia: University of Missouri.

Ficino, Marsilio. 1975–2012. *The Letters of Marsilio Ficino*, 8 vols., translated from the Latin by members of the Language Department of the School of Economic Science, London. London: Shepheard-Walwyn.

Ficino, Marsilio. 1987. *El libro dell'amore*, edited by Sandra Niccoli. Florence: Olschki.

Ficino, Marsilio. 2008. *Commentaries on Plato. vol. 1: Phaedrus and Ion*, edited and translated by Michael J. B. Allen. Cambridge: Harvard University Press.

Field, Arthur. 1978. "A Manuscript of Cristoforo Landino's First Lecture on Virgil, 1462–1463, Codex 13168, Biblioteca Casanatense Rome." *Renaissance Quarterly* 31:17–20.

Fritsen, Angela M. V. 2000. "Testing 'Auctoritas': The Travels of Paolo Marsi 1468–69." *International Journal of the Classical Tradition* 6, 3:356–382.

Gilbert, Creighton. 2003. *How Fra Angelico and Signorelli Saw the End of the World*, University Park, PA: Pennsylvania State University Press.

Gillies, Jean. 1981. "The Central Figure in Botticelli's 'Primavera'." *Woman's Art Journal* 2:12–16.

Glasser, Julia Haig. 2005. "Filippo Beroaldo on Apuleius: Bringing Antiquity to Life." In *On Renaissance Commentaries*, edited by Marianne Pade, 87–109. Hildesheim: Olms.

Gombrich, Ernst H. 1945. "Botticelli's Mythologies." *Journal of the Warburg and Courtauld Institutes* 8:7–60.

Grendler, Paul F. 1989. *Schooling in Renaissance Italy: Literacy and Learning, 1300–1600*. Baltimore: Johns Hopkins University Press.

Grendler, Paul F. 2002. *The Universities of the Italian Renaissance*. Baltimore: Johns Hopkins University Press.

Guthmüller, Bodo. 1975. "Lateinische und Volkssprachliche Kommentare zu Ovids 'Metamorphosen'." In *Der Kommentar in der Renaissance*, edited by August Buck and Otto Herding, 119–139. Boppard: Boldt.

Guthmüller, Bodo. 1981. *Ovidio metamorphoseos vulgare: Formen und Funktionen der volkssprachlichen Wiedergabe klassischer Dichtung in der italienischen Renaissance*. Boppard: Boldt.

Hatfield, Rab. 2009. "Some Misidentifications In and Of Works by Botticelli." In *Sandro Botticelli and Herbert Horne: New Research*, edited by Rab Hatfield, 7–61. Florence: Syracuse University in Florence.

Hirst, Michael. 1994. *The Young Michelangelo*. London: National Gallery Publications.

Horace. 1978. *The Odes and Epodes*, translated by Charles E. Bennett. Cambridge: Harvard University Press.

Horace. 2004. *Odes and Epodes*, edited and translated by Niall Rudd. Cambridge, MA: Harvard University Press.

Ilg, Ulrike. 2004. "La scoperta della natura in pittura." In *Storia delle arti in Toscana: il Trecento*, edited by Max Seidel, 171–196. Florence: Edifir.

Kallendorf, Craig. 1989. *In Praise of Aeneas*. Hanover and London: University Press of New England.

Kline, Jonathan. 2011. "Botticelli's Return of Persephone: On the Source and Subject of the Primavera." *Sixteenth Century Journal* XLII, 3:665–688.

Körner, Hans. 2006. *Botticelli*. Köln: DuMont.

La Malfa, Claudia. 1999. "Firenze e l'allegoria dell'eloquenza: una nuova interpretazione della 'Primavera' di Botticelli." *Storia dell'arte* 97:249–293.

La Malfa, Claudia. 2002. "La conoscenza delle cose divine nei commenti di Landino e Botticelli alla Divina Commedia di Dante." In *Il sacro nel Rinascimento*, edited by Luisa Rotondi Secchi Tarugi, 225–240. Florence: Cesati.

Lactantius. 2007. *Divine Institutes*, translated by Anthony Bowen and Peter Garnsey. Liverpool: Liverpool University Press.

Landino, Cristoforo. 1498. *Horatij flacci Venusini. Poete lirici Opera: cu[m] quibusdam annotat[i]o [n]ib[us]. Imaginibusq[ue] pulcherrimis. aptisq[ue] ad Odaru[m] conce[n]tus [et] sente[n]tias*. Strasbourg: Johann Grüninger.

Landino, Cristoforo. 2001. *Comento sopra la Comedia*, edited by Paolo Procaccioli, 4 vols. Rome: Salerno.

Leinkauf, Thomas, and Carlos Steel, eds. 2005. *Platons Timaios als Grundtext der Kosmologie in Spätantike, Mittelalter und Renaissance*. Leuven: Leuven University Press.

Leitgeb, Maria-Christine. 2006. *Amore e magia: La nascita di eros e il De amore di Ficino*, translated by Nicola Gragnani and Sebastiano Panteghini. Paris: Cahiers Accademia.

Lentzen, Manfred. 1971. *Studien zur Dante-Exegese Cristoforo Landinos*. Köln: Böhlau.

Levi d'Ancona, Mirella. 1992. *Due quadri del Botticelli eseguiti per nascite in casa Medici: Nuova interpretazione della Primavera e della Nascita di Venere*. Florence: Olschki.

Lightbown, Ronald. 1989. *Sandro Botticelli, Life and Work*. London: Thames and Hudson.

Lisner, Margit. 1980. "Form und Sinngehalt bei Michelangelos Kentaurenschlacht." *Mitteilungen des Kunsthistorischen Institutes in Florenz* 24:299–344.

Lucretius. 1982. *De Rerum Natura*, translated by William H. D. Rouse. Cambridge: Harvard University Press.

Marmor, Max C. 2003. "From Purgatory to the Primavera: Some Observations on Botticelli and Dante." *Artibus et Historiae* 24:199–212.

Marsi, Paolo. 1485. *Paulus Marsus piscinas poeta. cl. generoso iuueni Georgio Cornelio. m. Cornelii equitis. f. salutem*. Venice: Antonius Battibovis.

Marsi, Paolo. 1510. *P. Ouidii Nasonis Fastorum libri diligenti emendatione typis impressi aptissimisq [ue] figuris ornati co[m]mentatoribus Antonio Consta[n]tino Fanensi: Paulo Marso piscinate uiris clarissimis additis quibusdam uersibus qui deerant in aliis codicibus*. Milan: Pachel.

Ovid. 1931. *Ovid's Fasti*, translated by Sir James George Frazer. London: Heinemann [Loeb Classical Library].

Petrarca, Francesco. 1996. *Canzoniere*, edited by Marco Santagata. Milan: Mondadori.

Plato. 1961. *The Collected Dialogues of Plato, Including the Letters*, edited by Edith Hamilton and Huntington Cairns. New York: Pantheon Books. Plotinus. 1966–88. *Plotinus*, 7 vols., edited and translated by A. H. Armstrong. Cambridge, MA: Harvard University Press [Loeb Classical Library].

Plotinus. 1992. *Enneadi*, translated by Giuseppe Faggin. Milano: Rusconi.

Poliziano, Angelo. 1979. *Stanze cominciate per la giostra del Magnifico Giuliano de Medici*, translated by David Quint. Amherst: University of Massachusetts Press.

Poliziano, Angelo. 1993. *The Stanze of Angelo Poliziano*, translated by David Quint. University Park: Pennsylvania State University Press.

Poncet, Christophe. 2008. "The Judgement of Lorenzo." *Bruniana & Campanelliana* 14:535–553.

Poncet, Christophe. 2012. *La scelta di Lorenzo: La Primavera di Botticelli tra poesia e filosofia*. Pisa and Rome: Fabrizio Serra Editore.

Prestifilippo, Giada. 2008. *Oltre Marziano: Iside, Apuleio e la Primavera di Botticelli*. Catania: Università di Catania.

Prete, Sesto. 1993. "Antonio Costanzi: La sua vita, le sue opera." In *Umanesimo fanese nel '400: atti del Convegno di studi nel V centenario della morte di Antonio Costanzi, Fano, 21 giugno, 1991: XII Congresso internazionale di studi umanistici, Sassoferrato, 19–23, giugno, 1991*, 45–67. Sassoferrato: Istituto internazionale studi piceni.

Reale, Giovanni. 2001. *Botticelli: la 'Primavera' o le 'Nozze di Filologia e Mercurio'? Rilettura di carattere filosofico ed ermeneutico del capolavoro di Botticelli con la prima presentazione analitica dei personaggi e dei particolari simbolici*. Rimini: Idea Libri.

Reale, Giovanni. 2007. *Le nozze nascoste o la Primavera di Sandro Botticelli*. Milano: Bompiani.

Regio, Raffaele. 2008. *In Ovidii Metamorphosin enarrationes*, edited by Matteo Benedetti. Florence: Sismel.

Rehm, Ulrich. 1999. "'Instaurare iubet tunc hymenaea Venus.' Botticellis Primavera." In *Renaissancekultur und antike Mythologie*, edited by B. Guthmüller and W. Kühlmann, 253–281. Tübingen: Niemeyer.

Rohlmann, Michael. 1996. "Botticellis 'Primavera'. Zu Anlaß, Adressat und Funktion von mythologischen Gemälden im Florentiner Quattrocento." *Artibus et Historiae* 17, 33:97–132.

Schulze Altcappenberg, Hein-Theodor. 2000. *Sandro Botticelli: der Bilderzyklus zu Dantes Göttlicher Komödie, mit einer repräsentativen Auswahl von Zeichnungen Botticellis und illuminierten Commedia-Handschriften der Renaissance*. Ostfildern-Ruit: Hatje Cantz.

Seneca. 1935. *Moral Essays*, translated by J. W. Basore. London: Heinemann.

Shearman, John K. G. 1975. "The Collections of the Younger Branch of the Medici." *The Burlington Magazine* 117:12–27.

Snow-Smith, Joanne. 1993. *The 'Primavera' of Sandro Botticelli: A Neoplatonic Interpretation*. New York: Lang.

Thimann, Michael. 2002. *Lügenhafte Bilder: Ovids favole und das Historienbild in der italienischen Renaissance*. Göttingen: Vandenhoeck & Ruprecht.

Van den Doel, Marieke. 2008. *Ficino en het Voorstellingsvermogen: Phantasia en Imaginatio in Kunst en Theorie van de Renaissance*. Amsterdam: St. Hoofd-Hart-Handen.

Villa, Claudia. 1998. "Per una lettura della Primavera, Mercurio retrogrado e la rhetorica nella bottega di Botticelli." *Strumenti critici* 13:1–28.

Virgil. 1998–1999. *Virgil*, 2 vols., with an English translation by H. Rushton Fairclough. Cambridge: Harvard University Press [Loeb Classical Library].

Walker, Daniel P. 1972. *The Ancient Theology: Studies in Christian Platonism to the Eighteenth Century*. Ithaca: Cornell University Press.

Warburg, Aby. 1932/1969. *Gesammelte Schriften*, 2 vols. Leipzig and Berlin: Teubner. Repr. 1969. Nendeln: Kraus.

Warburg, Aby. 1998. "Sandro Botticellis 'Geburt der Venus' und 'Frühling'." In *Gesammelte Schriften: Studienausgabe*, edited by Horst Bredekamp, 26–44. Berlin: Akademie-Verlag.

Warburg, Aby. 1999. *The Renewal of Pagan Antiquity: Contributions to the Cultural History of the European Renaissance*. Los Angeles: Getty Research Inst. for the History of Art and the Humanities.

Wind, Edgar. 1958. *Pagan Mysteries in the Renaissance*. London: Faber and Faber.

Wurm, Achim. 2008. *Platonicus amor: Lesarten der Liebe bei Platon, Plotin und Ficino*. Berlin and New York: Walter De Gruyter.

Zöllner, Frank. 1997. "Zu den Quellen und zur Ikonographie von Sandro Botticellis 'Primavera'." *Wiener Jahrbuch für Kunstgeschichte* 50:131–158.

Zöllner, Frank. 1998. *Botticelli: Toskanischer Frühling*. München: Prestel.

Zöllner, Frank. 2005. *Sandro Botticelli*. München: Prestel.

Zöllner, Frank. 2009. *Botticelli*. München: Beck.

Zorach, Rebecca. 2007. "Love, Truth, Orthodoxy, Reticence, or, What Edgar Wind Didn't See in Botticelli's Primavera." *Critical Inquiry* 34:190–224.

8 "HIC EST HOMO PLATONIS"

Two Embodiments of Platonic Concepts of Man in Renaissance Art[1]

Jeanette Kohl

In a short note in the first volume of the *Journal of the Warburg Institute* (1938, no. 3), Edgar Wind drew attention to an unusual image.[2] The woodcut by Italian painter and printmaker Ugo da Carpi shows the figure of a seated man next to a pitiful plucked rooster standing upright on two legs (Figure 8.1); it is dated to 1525 circa. The print is based on a design by Parmigianino.[3] Vasari praises the woodcut as one of the most beautiful and accomplished works of Ugo da Carpi, whom he credits with the invention of the chiaroscuro woodcut proper, "di fare le stampe in legno di due sorti, e fingere il chiaroscuro."[4]

There are at least two different print versions that were made after Ugo's woodcut based on Parmigianino's design, one of them is an engraving on paper, by Giulio Bonasone for Achille Bocchi's fine book of emblems, the *Symbolicarum quaestionum de Universe Genere quas serio ludebat libri quinque*, published in Bologna in 1555 (Figure 8.2).[5] Bonasone, certainly with the book's function as a morally instructive lexicon of symbols in mind, identifies both the funny rooster and the seated man through brief captions. According to these, the rooster embodies the 'Platonic man' (HIC EST HOMO PLATONIS)[6] while the seated person in the foreground is Diogenes.[7] Wind was the first to name the text on which this juxtaposition of the cynical philosopher with a featherless chicken is based. It is a passage in the biography of Diogenes of Sinope in Diogenes Laertius' *Vitae philosophorum*.[8] Diogenes Laertius reports that after Diogenes of Sinope had heard Plato give his definition of man as an "animal bipes implume," a featherless animal on two legs – a simile for which Plato was much praised – he plucked a rooster and presented it in Plato's Academy with the words "Behold! I have brought you a man."[9]

Plato, in the *Statesman*, indeed has the Eleatic stranger in the conversation with Socrates and Theodorus say:

> I say, then, that we ought at that time to have divided walking animals immediately into biped and quadruped, then seeing that the human race falls into the same division with the feathered creatures and no others, we must again divide the biped class into featherless and feathered, and when that division is made and the art of herding human beings is made plain, we ought to take the statesmanlike and kingly man and place him as a sort of charioteer therein, handing over to him the reins of the state, because that is his own proper science.[10]

Man is defined as a biped land animal without feathers but with the capacity for rule and leadership.

Let us return to Bonasone's engraving (after Ugo da Carpi's woodcut, after Parmigianino's design) for a moment, which Edgar Wind characterized as a "sound piece of buffoonery."[11]

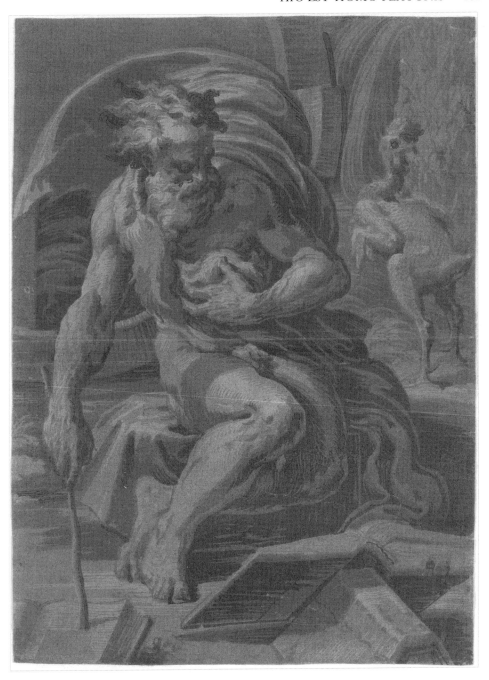

Figure 8.1 Ugo da Carpi (after Parmigianino), *Diogenes and the Platonic Man*, 1524/29. Chiaroscuro woodcut printed from four blocks in grey-green ink.
Source: New York, Metropolitan Museum of Art, Inv. 17.50.1.

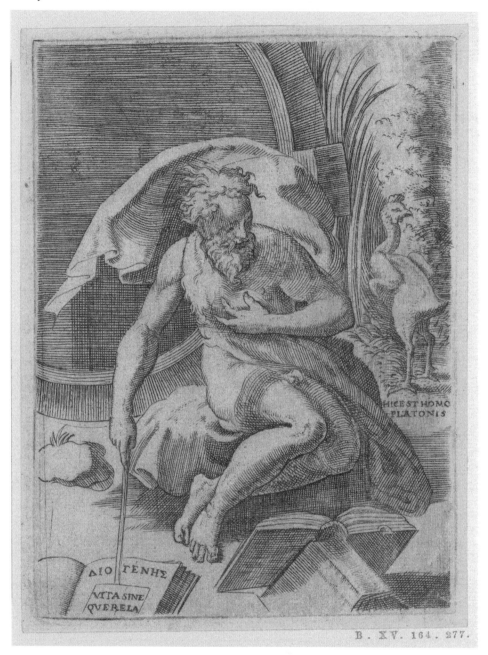

Figure 8.2 Giulio Bonasone (after Parmigianino), *Diogenes and the Platonic Man.* Engraving on paper for Achille Bocchi's Symbolicarum quaestionum de Universo genere quas serio ludebat, Bologna 1555, Plate 100.

Source: London, British Museum, Inv. H,5.62. © Trustees of the British Museum.

The center of the image is occupied by the heroic figure of the naked philosopher Diogenes, muscular and well built, with a large piece of drapery swung loosely around his loins and held up against his chest with his left hand. The massive piece of cloth fails, however, to cover his genitals; instead, it billows out dramatically behind his head and adds a dynamic backdrop to the torsion of his seated body. His left hand, which is pressed against his chest, forms the center of the composition, while his right hand holds a pointer aimed at a book on the floor, whose open pages are turned toward the beholder; its brief text, DIOGENES. VITA SINE QUERELA, praises the wise man's self-sufficient life.[12] Diogenes' eyes seem to be directed towards a second large book positioned in front of him. In the background, we see the spacious round opening of the barrel in which he was said to have lived, and to the right the plucked rooster, identified as the *homo platonis*. The animal stands on its hind legs, wings held up like two crippled arms and its head turned backwards looking out over its own rump. The naked rooster is a clear reference to Diogenes' alleged mockery of Plato. The heroic, virile cynic, who was known to have emulated the Herculean ideal of a *vita activa* and who was infamous, among other things, for his sexual 'handwork' in repeated acts of public masturbation, contrasts harshly with the poor dysfunctional poultry on two thin legs, lacking the decidedly human feature of hands. The plucked bird's deficiency (no hands *and* unable to fly) is additionally underscored by the philosopher's impressive fluttering drapery, which evokes ascending movement and action. The immediacy of cynic virility and abstract Platonic conceptualism are contrasted quite effectively in this image.

Thomas Ricklin addressed yet another aspect of the image.[13] Apart from its apparent satirical and ridiculing implications (and its moralizing function within Bocchi's book of symbols), he reads the juxtaposition of Diogenes with the *bipes implume* as a possible manifestation of a 'philosophy of hands.' While Diogenes holds, points and grasps with his hands, in tune with his reputation as a hands-on philosopher, the poor impotent rooster can at best shrug its shoulders. Diogenes' unbiased attitude towards manual labor and the practicality of thought is contrasted with less practical, 'Plato-fingered' attitudes resulting from the Platonists' disqualification of manual labor. Without assuming too much about Parmigianino's (or Ugo da Carpi's or Bonasone's) knowledge of the image's philosophical backgrounds, it is still intriguing to follow Ricklin's insightful interpretation. If the image argues in the vein of Diogenes' philosophy – and in the tradition of Socrates and Anaxagoras – for a positive attitude towards man as a creature of intellectual *and* manual labors and possibilities, of *vita contemplativa* and *vita activa*, then the image might have been produced with more than just the obvious anecdotal "buffoonery" of the Diogenes-Plato episode in mind.

If Diogenes was the exemplary philosopher who demonstrated that man was more than a 'naked biped,' it may well be assumed that Parmigianino might have seen and depicted the cynic as a prototypical artist, an ancestor of the Renaissance artist and his claim to *mano e intelletto*.[14] After all, it was Parmigianino who formulated the preeminent role of the artist's power of invention in conjunction with his manual skills in the famous *Self-Portrait in a Convex Mirror* of 1524 (Figure 8.3), where his elegantly elongated, ringed and enlarged left hand holding a pencil becomes the painting's actual protagonist.[15] It is not only the painting's obvious demonstration of artistic *bravura* that puzzles the beholder. It is also the fact that it is an early 'combine painting,' a hybrid of sculpture and painting: Parmigianino painted his own image as seen in a convex mirror onto an object in the shape of a convex mirror made of poplar wood. We thus see how he saw himself in the mirror – or so we think. On closer observation, we notice that the artist did *not* paint himself the way he must have seen in the mirror. As Rudolf Preimesberger has pointed out, the painting is not

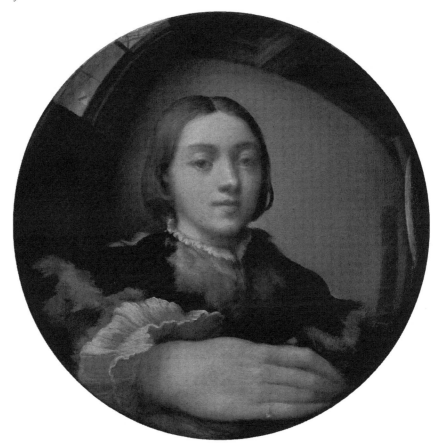

Figure 8.3 Parmigianino, Self-Portrait in a Convex Mirror, 1524. Oil on wood, ⌀ 24.4 cm. Source: Vienna, Kunsthistorisches Museum, Inv. GG_286.

what is seems to be: it is not a 'true image' in the sense of the 'true image' a mirror seem to produce – it merely feigns a real situation (and a real object), the moment when the artist sat down to check his look in the mirror before he started to draw his self-portrait.[16] It is a simulation – fiction as opposed to documentation – of the situation in which the image was about to be painted. The deceptive character of mirrors is played off against its function as a tool of self-exploration. Parmigianino's innovative painting is an image of considerable complexity, a witty meta-painting commenting on the mimetic nature of art, playing with ideas of *disegno* and self-representation, truth and deception.

Parmigianino was an artist with a considerable amount of self-esteem and audacity, as the painting makes clear. It is much less psychological than it is programmatic, and its program was to promote the elevated status of the arts and the artist in Cinquecento Rome.[17] It also visualizes the fruitful ambiguities and the intellectual potential of a 'lesser' genre of portraiture. The artist takes his own image to demonstrate his *bravura*, wit, and intellectual (and social) confidence. It is a "self-aware" image – one whose painter already knows how to play with the genre's conventions.[18] As such, it also confidently overrides any Platonic and Neoplatonic skepticism about the deficient character

and third class nature of artworks – and portraits in particular – as surrogate products twice remote from the realm of ideas.[19] Parmigianino's self-portrait creates a synthetic reality; it is pure *invenzione* in terms of the situation it feigns and plays a game with the *per se* dubious 'reality' of the mirror image it pretends to be. It is a demonstration of the idea that art creates its own reality – a credo for artifice produced by the talent of hand and intellect – and as such it is utterly anti-Platonic – as is the print of the pathetic Platonic man. Both embody a decidedly more physical and self-assured image of man as a creative, innovate and perhaps also non-conventional 'artist.'

As we have seen, Edgar Wind's note on Ugo da Carpi's woodcut of the *homo platonis* appeared in the first volume of the *Journal of the Warburg Institute* (Figure 8.4), which he co-edited with his friend and colleague Rudolf Wittkower. The journal's launch in 1937 was a milestone in the History of Art. Its intellectual concept established new standards and furthered the dissemination of iconographical and iconological interpretations in an unprecedented way. In its first four fascicles (all part of issue I), we find several articles and notes by Wind and Wittkower themselves, among them much quoted classics such as Wittkower's "Chance, Time and Virtue" and Wind's "Charity: The Case History of a Pattern." Other contributions are by William S. Heckscher, Jean Seznec, Ernst Gombrich, Gertrude Bing, Erwin Panofsky, Francis Wormald, the young Anthony Blunt, and Fritz Saxl – altogether an impressive 'Who is Who' of pioneers in Iconography and Iconology, a choice of authors and topics which corroborated the European Renaissance as the supreme discipline within Art History.

MISCELLANEOUS NOTES 261

Critics, without suspecting any such connotation have often been astonished by the extreme classicism of the style of the bust, and were inclined to explain the use of the cameo as a result of a formal interest in the antique. Actually, the antique form is dictated by an antique content. The Grecian appearance and dress of the boy correspond to the Platonic ideal which he is meant to embody and which the emblem of the cameo indicates.

A mediæval craftsman who introduced ancient jewels and stones into his own work meant to heighten the decorum of the work, but the addition did not alter the artistic structure (see Pl. 30a, b). Donatello, by inserting a cameo which expressed a Grecian idea, felt compelled to shape the work as a whole in accordance with this initial conception.

R. W.

representation of the triumphant *Amore Divino* (Bartsch XVI, No. 106). Quite logically, he adds to the horses the single horn of the unicorn and thus converts them into the symbol of Chastity (Pl. 34c). He makes Cupid shoot his arrows from the heavenly realm to the Olympic gods on earth, who give themselves up to the luxurious *Amore profano*.

HOMO PLATONIS

The ancient doxographers relate that when Plato defined man as a 'featherless biped', Diogenes ridiculed him by producing a plucked rooster and exclaiming: "This is the Platonic man !"[1]

In the Renaissance, the delight in this sound piece of buffoonery was not confined to the antiquarians. The painter Ugo da Carpi introduced into the background of his woodcut of 'Diogenes' an actual portrait of the miserable bird (Pl. 34a).[2] The woodcut was copied by Bonasone for a book of symbols devised by Achille Bocchi,[3] and in order to leave no doubt as to the meaning of the plumeless creature, the engraver added the words: "Hic est Homo Platonis". (Pl. 34b).

E. W.

[1] Diogenes Laertius, VI, 2, 40.
[2] The inscription says that the woodcut was made after a design by Parmigianino. A drawing for the woodcut, attributed to Ugo himself, is in the *Pinacoteca* at Bologna.
[3] *Symbolicarum quaestionum de Universe Genere quas serio ludebat Libri Quinque*, 1555.

Figure 8.4 Journal of the Warburg Institute, vol. 1, no. 3, January 1938, p. 261.

Aspects of Renaissance Platonism are addressed by both Wind and Wittkower in this important first volume of their ambitious journal. If we turn back the page, we notice that Wind's four-sentence comment is a postscript to Rudolf Wittkower's article "A Symbol of Platonic Love in a Portrait Bust by Donatello," a rather short piece of not even two columns.[20] Wittkower was not the first to write about this intriguing object (Figure 8.5). Prominent art historians such as Milanesi, Semper, Von Tschudi, Venturi, and Cruttwell (among others) had already drawn attention to the unusual bust as early as the 1880s.[21] Yet Wittkower, unlike his predecessors, focused less on questions of authorship and style than on the bust's iconography and symbolism. Much has been written about the *Bust of a Platonic Youth* since.

There are several reasons why this particular work of art deserves a central position in a publication discussing the role of Neoplatonic ideas for the arts of the Renaissance.[22] Not only is its subject matter – a chariot (*biga*) controlled by a winged charioteer (Figure 8.6) – an ur-Platonic metaphor, it is mentioned, *inter alia*, as a metaphor of man's vocation to rule in the passage of Plato's *Statesman* quoted above. And not only is the bust of a beautiful young boy believed to have been the *kalos*, the ideal Platonic 'lover-boy' of the Florentine circles around

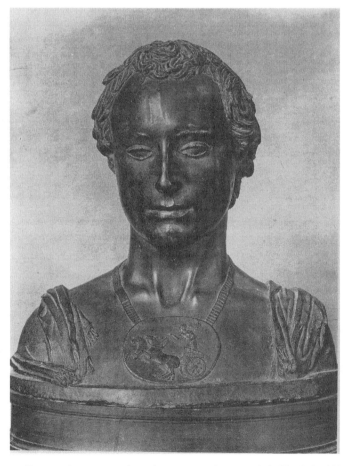

Figure 8.5 Donatello (attrib.), *Bust of a Platonic Youth*, second half of the fifteenth century. Bronze.
Source: Florence, Museo Nazionale del Bargello.

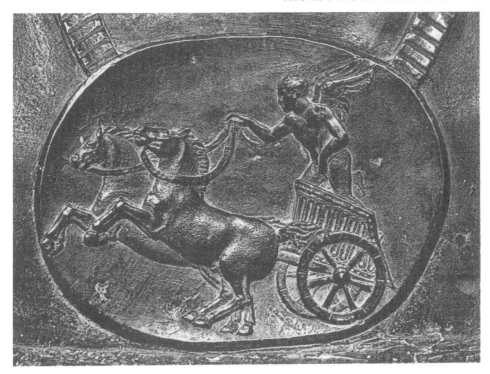

Figure 8.6 Platonic Youth, Cameo with the platonic biga, detail of Figure 8.5.

Marsilio Ficino and the Medici, an object of admiration and programmatic value;[23] the bust has also been a favorite of Renaissance scholarship from its very beginnings in the nineteenth century to the present.[24] As a demonstration object of iconological studies, it also shows, in a historical perspective, the potential and the limits of iconography and iconology. It appears that in discussing this particular 'pet object' of Renaissance art history as an embodiment of Neo-platonic thoughts, and an object that epitomizes the preeminent role of this intellectual vein in mid fifteenth-century Renaissance visual culture, one at least does not bark up the wrong tree.[25]

Wittkower, if briefly, was the first art historian to focus on the object's iconic character and its symbolism in conjunction with its rather unique image concept. In that, he made way for later interpretations going beyond questions of authorship, quality, and style. He connected the object's most striking feature, the plaque with the winged charioteer on the boy's chest, to a passage in Plato's *Phaedrus,*

> where winged genii on cars driving two horses with whips are described as symbols of the soul. The madness of love, the best of the 'Four Divine Madnesses,' is explained by Socrates in terms of this image. 'We described the passion of Love in some sort of figurative manner [...] and [...] we chanted a sportive and mythic hymn in meet and pious strain to the honour of your lord and mine, Phaedrus, Love, the guardian of beautiful boys.'[26]

He concludes that the bust presents the bearer of the Platonic symbol as one of these "beautiful boys," an embodiment of Platonic *amor celeste.* In a footnote to his short interpretation, Wittkower backs up his argument that the bust embodies a purified form

of Platonic love in discussing an emblem of the same Giulio Bonasone we already encountered as the illustrator of Bocchi's Cinquecento book of symbols with the engraving of Diogenes and the *homo platonis*. The emblem shows the triumph of divine over profane love (Figures 8.7 and 8.8),[27] and

> quite logically, he [Bonasone] adds to the horses the single horn of the unicorn and thus converts them into a symbol of chastity. He makes Cupid shoot his arrows from the heavenly realm to the Olympic gods on earth, who give themselves up to the luxurious *Amore profano*.[28]

Wittkower's observation, uttered *en passant* and largely unnoticed, emphasizes the symbol's moral tenor. In that, it takes a path slightly different from more recent interpretations, which relate the bust and its appealing and ambiguous aesthetics to Renaissance homoeroticism.[29]

Homoerotic and straightforward sexual implications are indeed part of the passages in Plato's *Phaedrus*, where the metaphor of the charioteer is discussed in greater detail.[30] Hannah Baader, for example, has addressed the bust's agency as an object of considerable appeal and relates the sculpture to codes of affectivity ("Affektübertragung") specific to the Quattrocento.[31] She stresses the bust's erotic appeal against the background of homosexuality in Renaissance Florence, and assumes that as an image of a younger, passive boy it might have been meant to address older male beholders, who, in Florentine homoerotic practices and the rather strict regimentations of role allocation, would have

Figure 8.7 Giulio Bonasone, *Triumph of Divine over Earthly Love*, 1545. Engraving.
Source: London, British Museum, Inv. 1874,0711.1545. © Trustees of the British Museum.

Figure 8.8 Giulio Bonasone, *Triumph of Divine over Earthly Love*, detail of Figure 8.7.
Source: © Trustees of the British Museum.

taken over the role of the active part, the bust of the boy thus igniting a complex game of emotional responses oscillating between sensuality and second-guessing, desire and control.[32] The bust would hence subtly undermine its obvious moral message as conveyed by the Platonic allegory on the medallion – an idea that would certainly fit well into the intricately ambivalent image concepts underlying many Renaissance paintings and sculptures of beautiful boys and adolescents.[33]

I have recently argued in a somewhat different vein,[34] and I would like to reintroduce my ideas to the discussion, not only with Wittkower's and Bonasone's moral interpretation of the Platonic *biga* in mind but also in regards to another one of Wittkower's important observation, namely that the bust portrait makes a clear reference to late medieval and Renaissance bust reliquaries:

> The way in which Donatello used an ancient cameo in his famous bust of a youth in the Bargello can best be understood by considering it in relation to medieval tradition. His prototypes are the then very numerous busts, mainly reliquaries, which were decorated with inlaid original precious stones.[35]

While it is very likely that the *Platonic Youth*'s cameo freely reproduces a similar object in Cosimo de' Medici's collection of antiques,[36] its size is unusual and does not correspond to pieces of jewelry worn around the neck in the fifteenth century.[37] Wittkower concludes:

> Yet it is characteristic of the growing Renaissance and its new conception of Antiquity that

Donatello does not incorporate an actual cameo; instead he copies one – thus pre-
serving the unity of the material (bronze). By putting the cameo on the neck of the
bust like a jewel he interprets the medieval device in a pseudo-rational way.[38]

Donatello, in not using an actual piece of jewelry, conceptualizes the motif and materially
merges the Platonic metaphor with its bearer in the cast bronze. Through both the pre-
cious metal and the formal and material reference to reliquaries, a 'heightened' spiritual
context is evoked, in accordance with the object's central motif – purified Platonic *amore
celeste* – an aspect we shall keep in mind for the following observations.

These observations stem from the question: I the 'portrait bust' of the *Platonic Youth*
a portrait at all – or rather, how is it a portrait and what does it portray? If we want to
better understand this showpiece of Neoplatonic thought and the ways in which it might
have established its particular agency, we need to take into account the visual and artistic
traditions it relates to – in addition to the textual sources and a more thorough philolo-
gical reading than I can provide here. While this particular artwork's iconography can be
determined rather conclusively (text source and the featured image on the bust can be
matched relatively well), its unprecedented formal rendering, its vagueness in terms of
portrait-character and its unusual choice of material create a set of ambiguities, which
have largely contributed to the ongoing occupation with the *Platonic Youth*. Therefore,
on a methodological level, the object epitomizes the gap between an iconographical
'reading' of a work of art and its more complex 'meaning,' created in the process of
making as well as viewing. Maybe the *Bust of a Platonic Youth* depicts one of the
'beautiful boys' protected by *amor celeste* and featuring – in a Donatellian transforma-
tion – one of Cosimo's antique gems as its central showpiece, as Wittkower suggests. Yet
perhaps it was to convey more differentiated levels of meaning and thus trigger more
complicated mechanisms of reception.

To learn more about these, let us have a closer look – behind the object's obvious
Platonic symbolism and beyond its iconography. Panofsky's attentive description char-
acterizes the boy 'portrayed' in the bust (usually dated between the 1440s and the 1470s[39])
as "androgynous," due to an "enchanting blend of thoughtfulness and sensuality."[40] It
shows a young man in his adolescence with even and pretty but not particularly distinct
facial traits. The fine bone structure and the subtlety of his face enhance the impression
of androgyny. His finely curved, full lips seem to purse slightly. His nose is straight and
slender, yet its bridge bends down gently towards the tip, which is more noticeable when
seen in profile.[41] The eyes are almond-shaped; iris and pupil however are not defined, so
that the youth makes no eye contact with the beholder. The slightly downcast eyelids
evoke an air of almost feminine demureness. Fine eyebrows as well as a high and gently
curved forehead contribute to this impression. In contrast, the curly and unruly hair lends
a somewhat leonine air to the youth, and the evident swollen vein in the middle of the
forehead expresses some sort of internal strain.[42] Both contrast with the overall smooth-
ness and motionlessness of the face.[43] On closer observation, we notice that the young
man's neck and throat appear too strong if compared to his head and shoulders. Along
with the bifurcate vein on the forehead, the bust's vertical axis is thus emphasized and its
tension uttered with intensity – a fact that again contrasts decisively with the young
man's introverted expression and contemplative air. His torso is presented almost nude
except for a fringed scarf loosely draped around his shoulders. Less a garment than an
accessory, it is too short to cover his chest, on which we see the rather large, eye-catching
cameo with the Platonic *biga* (Figure 8.6).

It has been noted that the bust is strangely deprived of distinct individuality and character, an argument that has been applied on several occasions to exclude Donatello's authorship.[44] Understood as the portrait of a real person,[45] the sculpture indeed disconcertingly deviates from what one would expect of a work of art produced by a high caliber artist such as Donatello. How is one to explain the somewhat indistinct expression and the air of introspection conveyed by the bust? Janson has rightly underscored that as it does not appear to depict a particular or identifiable individual; the bust is not a portrait proper in that, it is similar to the many reliquary bust 'portraits' that suggest individual likeness although the Saint depicted usually died centuries ago.[46]

I have argued in an essay exclusively dedicated to the *Platonic Youth* that in all likelihood it was conceived as an ideal portrait of iconic value, an emblem of Platonic love, an argument that follows the lead of Wittkower's earlier remarks.[47] Although the image potentially takes into account a homoerotically inclined audience (the boy's nudity, the playfully arranged accessory of the scarf, the coy attitude), it still and foremost aims to inspire a clear moral goal to be reached by the beholder. In order to avoid a narrowed view of the sculpture in terms of homosexual or homoerotic connotations, I refer to the concept of "homosociality" instead.[48] Since male relationships on various levels formed an integral and important part in the social, psychological and physical definition of Renaissance masculinity, we ought to be careful not to construe representations of boys or young men that appear to be androgynous, effeminate, or seductive as obvious statements of sexual preferences. Rather, it is essential to assess how artworks activate and interact with the male gaze, especially in connection with homosocial practices and well-known image traditions. In numerous studies, Marianne Koos has tackled the complex relations between norms and categories of masculinity in the Renaissance, offering a historical revaluation of gender identities and their ambivalent reflections in male "images of desire." Her interpretations form another point of departure for my understanding of the *Platonic Youth*.[49]

Let us return to the bust's medallion and its metaphorical message. The allegory of the soul as a chariot can be found in a dialogue between Socrates and the beautiful youth Phaidros in Plato's *Three Speeches on Love* within his *Phaedrus*. Socrates here meditates upon human and divine love and concludes that only the strict sublimation of desires provides access to true love: a love that in the first place is a prerequisite for the soul's immortality. To make this process more comprehensible, the philosopher introduces a figure – *eidos* – for the soul:

> We will liken the soul to the composite nature of a pair of winged horses and a charioteer. Now the horses and charioteers of the gods are all good and of good descent, but those of other races are mixed; and first the charioteer of the human soul drives a pair, and secondly one of the horses is noble and of noble breed, but the other quite the opposite in breed and character. Therefore in our case the driving is necessarily difficult and troublesome.[50]

He then describes the constitution of the two horses more specifically: one is beautiful and modest, the other ugly and in constant uproar.[51] Socrates explains the complex mechanisms of the fight between the driver and the unruly horse that sets in as soon as a lover approaches his beloved. In the process of falling in love, the bad horse sniffs a chance for body contact and satisfaction.[52] However, the rational part of the soul strives against its counterpart, so that the bad horse will be subdued, reason will prevail and lust be purified and turn into friendship. Now both lover and beloved can be friends and entirely dedicate their lives to philosophy.

Yet, we do not see such a massive struggle with the bad and ugly horse on the cameo, which leads me to think that perhaps it relates more explicitly to Marsilio Ficino's optimistic interpretation of Plato's *Phaedrus* in his commentary *De amore*:

> In the *Phaedrus* Plato calls the intellect, devoted to divine things, the charioteer in the soul of man; the unity of the soul, the head of the charioteer; reason and opinion, running through natural things, the good horse; confused fancy and the appetite of the senses, the evil horse. The nature of the whole soul is the chariot [...] He attributes to the soul wings, on which it is carried to the sublime; of these we think that one is that investigation by which the intellect assiduously strives toward truth; the other is the desire for the Good by which our will is always influenced.[53]

By successively subjugating the desires under reason and judgment, the charioteer returns to the origin of the universe, where

> the charioteer is *blessed*, and *stopping his horses*, that is, accommodating all parts of the soul subject to himself at the stable, that is, at the divine beauty, *he puts before them ambrosia and, more than that, nectar to drink*, that is, the vision of beauty, and from that vision happiness.[54]

Ficino's belief in the possibility to ultimately control the lower emotional states and the social function of such sublimation, which he discusses at length, makes use of Plato's dictum of the "winged philosopher" and the "winged soul." Socrates describes the ascent of the chariot to its celestial destination as follows:

> The natural function of the wing is to soar upwards and carry that which is heavy up to the place where dwells the race of the gods. More than any other thing that pertains to the body it partakes of the nature of the divine. But the divine is beauty, wisdom, goodness, and all such qualities.[55]

The wings of the soul are fostered by beauty, wisdom, and goodness:

> And therefore it is just that the mind of the philosopher only has wings, for he is always, so far as he is able, in communion through memory with those things the communion with which causes God to be divine.[56]

The medallion on the Platonic Youth clearly depicts a winged charioteer – but horses without wings, which differs from the translation of Plato's description above yet fully reflects Ficino's eclipsing of this particular trait.[57] It arguably indicates that the refined and therefore winged soul is on its way to its celestial origins. Michael J. B. Allen, who dedicates an entire chapter to "The Soul's Flight" in his book *The Platonism of Marsilio Ficino*, notes for Ficino:

> The formula of attributing wings 'preeminently' to the charioteer, in the next degree to the good horse, and only in the last degree to the worse horse hardly serves to clarify matters either. It suggests, indeed, and Ficino virtually says this, that one set of wings, the charioteer's, could serve to raise them all.[58]

The cameo on the Platonic Youth's chest shows exactly this: the soul, or the "celestial body," is about to be carried up on a parabolic curve by the charioteer's wings alone because the carnal, homoerotic longing has already been curbed and transformed into love of truth, and virtue has conquered the adverse desires. Both horses, whose slightly varied postures indicate their different nature, have their forelegs lifted as if to take off for their heavenly journey. A very similar motif appears on the socle of the tomb for the Cardinal of Portugal by Antonio Rosselino in San Miniato al Monte from around 1462 (Figure 8.9).[59] The relief, which shows a chariot with a winged charioteer, attests to the Cardinal's humanistic achievements – he "regained" his wings, which characterize his soul as truly philosophical – and at the same time it refers to the immortality of the soul and its journey to God.

In Platonic and Neoplatonic thought, the soul owes its wings to a form of purified love that emerges as it recognizes the idea of divine beauty through *anamnesis* while contemplating physical beauty. The lover's soul indeed is given its wings back, as "when he sees the beauty on earth, remembering the true beauty, [he] feels his wings growing and longs to stretch them for an upward flight."[60] Beholding the beloved's beauty is therefore the only way to be transfigured.[61] Ficino interprets Plato's thoughts as he proceeds to endorse the supremacy of Socratic love as follows: "True love is nothing other than a certain effort of flying up to the divine beauty, aroused by the sight of corporeal beauty. *But*

Figure 8.9 Antonio Rossellino, Monument to the Cardinal of Portugal, 1461–66. San Miniato al Monte, Florence, detail with two-horse chariot.
Source: © ArtResource.

adulterous love is a falling down from sight to touch."[62] Therefore, the contemplation of earthly beauty is the catalyst for ascending to divine beauty, a concept that – if related to the *Platonic Youth* and its medallion, which visualizes the soul's ascent through love – also connotes the bust as a *means* of Platonic "recognition" and purification.[63]

As we already noticed, the youth's coy downward glance strongly contributes to an impression of introspection. His eyes have no pupils, and he neither looks at nor can he return the beholder's gaze, which might, indeed, also refer to the well-known Pauline dictum so much valued by the Christian Platonists: "Videmus nunc per speculum in aenigmate: tunc autem facie ad faciem. Nunc cognosco ex parte: tunc autem cognoscam sicut et cognitus sum"[64] – this all the more, as Christian image concepts seem to have played another important role in the rendering of the Platonic bust.

What's more, the youth not only exercises contemplation; his inability to return the viewer's gaze also allows for projection. Similarly, by dint of a certain 'blankness' of the face and eyes, the bust of a young man, in conjunction with the medallion he wears, avoids any depiction of the soul through an expressive rendering of the face. In an act of supreme effort, signaled by the swollen vein on his forehead, he tames his carnal desires. The young man's soul, aspiring to soar heavenward, is visualized on a referential level only, through the metaphor of the soul he wears around his neck. This is underscored by the bust's 'introversion,' which seems to indicate an inner dimension. Through the depiction of the medallion, the sculptor indeed transposes the liveliness and spirituality conventionally located in the human face onto the chest, where the soul partly resides in accordance with Platonic theories.[65] One is also reminded of Socrates' statement in Plato's *Gorgias* that the body might in fact be our tomb and that the weak and persuadable part of our body where the desires hide – below our chest, in the stomach – are in fact nothing but a jar.[66]

Yet the artist also takes up the scheme and function of reliquary-bust as actual holy body-containers.[67] A bust reliquary of Saint Lawrence, dated to the late fifteenth century, shows an image concept almost identical to that of the *Platonic Youth*.[68] Albeit depicted in a portrait-like manner, Saint Lawrence's gilded bust presents a rather vague physiognomy (Figure 8.10). On his chest, a rectangular plate shows his martyrdom. In displaying the martyrdom in a signet-like relief, the image refers to the Saint's mortal remains conserved within the reliquary. Moreover, the image recalls the Saint's exemplary and virtuous death for his Christian ideals. Just as the reliquary bust confirms the Saint's self-sacrifice and self-discipline and serves as his presence, so too can the *Bust of the Platonic Youth* be understood as a presentifying image with Platonic contents, so to speak; a role model of the bodily desires' arduous yet in the end successful sublimation.

The Platonic icon of practiced self-restraint and sublimation is also an icon of beauty. Similar to the often times hermetic beauty of female Renaissance busts, the *Platonic Youth* does not disclose intimacy. In contrast, the bust's delicate, slender corporeality invites the viewer into the contemplation of a Platonic ideal, intermediary between earthly and divine beauty. Yet even if the young man's androgynous aspect plays with the homosocial gaze (and maybe even betokens attraction in a homoerotic sense), the bust first and foremost argues for the sublimation of carnality and the mastery of bodily desires, as confirmed by the representation of the winged soul on the medallion. Also, the conquest of beauty and the achievement of purity entailed in the process of self-perfection are symbolized by the charioteer's wings, which he gained as a result of the sublimation of his carnal desires. The successful refusal of a "descent from sight to touch"– that is, the fulfillment of Platonic love is both represented *in* the bust and made accessible *to* the beholder.[69] A showpiece of sublimation, it visualizes the Platonic supremacy of sight over touch by allowing the beholder to

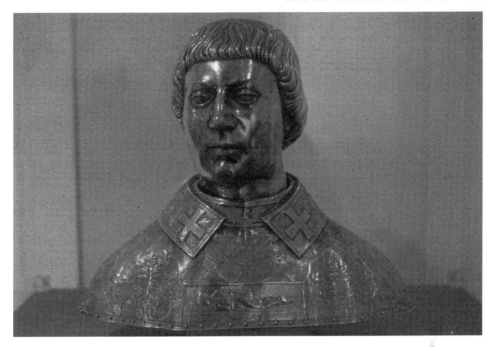

Figure 8.10 Unknown goldsmith, *Reliquary Bust of San Lorenzo*, late fifteenth century. Gilded silver.
Source: Gorizia Cathedral (Friuli).

mentally perform the act of "regaining wings" through the contemplation of beauty: a phy-
sical beauty that sparks the recollection of the "true beauty." The bust appears as yet another
manifestation of the Renaissance artistic belief in the power of beauty for moral purposes.

In taking a final glance at our poor plucked rooster, we see a distinctly different
embodiment of Platonic ideas about the nature of man in Renaissance art. In Parmigia-
nino's design of 1525 circa, the Platonic idea of man as expressed in the metaphor of the
featherless bird is discredited through the lens of Diogenes Laertius. The Platonic man
appears as the 'anti-artist' and the 'anti-philosopher,' unproductive and deprived of
ascent. In the prints of Diogenes' famous ridiculing of the plucked rooster-metaphor, the
visual argument is formulated – along the lines of Leon Battista Alberti's famous pre-
ference for a "più grassa Minerva" – in "cruder terms."[70]

The *Bust of the Platonic Youth* of some fifty years earlier on the other hand embodies
central ideas of the Neoplatonists' euphoria for Platonic love. A showpiece of exquisite
beauty, intellectuality and accomplishment, it is a learned piece, an *exemplum* of moral
refinement and purification, and an embodiment of the human (and perhaps artistic)
potential of winged flight towards heavenly love. The work's intrinsic connection with
questions of Renaissance philosophy, moral standards and the transformative power of
beauty on the one hand and its indebtedness to Christian ideas and the image concept of
the reliquary-bust on the other turn it into a unique icon of Neoplatonism and its mani-
fold attempts to reconcile classical antique with Christian beliefs.

One of its most irritating aspects is the lack of 'vision' and, equally, the lack of an
often times blunt call for interaction with the viewer. The youth's undeniable beauty is
not deflected by his posture or by any other apparent traits of character. He is given to

inner contemplation, and perhaps even the contemplation of someone else's beauty – someone who might long to be a mirror of his own beauty.[71] Like no other sculpture of the fifteenth century, the *Platonic Youth* features a work of art as an embodied agent of philosophical cognition, religious and inner contemplation, as well as strategies of self-fashioning. It clearly lends a different, utterly optimistic meaning to the cynic's mocking "Hic est homo platonis!"

Notes

1 I am thankfully indebted to Thomas Leinkauf (Münster/Berlin), Heiko Damm (Mainz), Marianne Koos (Fribourg), Ulrich Pfisterer (Munich), and Sergius Kodera (Vienna) for generously sharing their ideas and texts with me. Parts of this text are based on a slightly modified and shortened version of my interpretation of the *Bust of a Platonic Youth*; Kohl (2010)
2 Wind (1938, 261).
3 For Parmigianino, see ibid, n. 2. Wind locates a drawing for the woodcut, "attributed to Ugo himself," in the *Pinacoteca* at Bologna. The inscription reads "FRANCISCUS/PARMEN./PER UGO CARP." See Gnann (2007, no. 40–2).
4 Vasari (1906, vol. 5, 226, 231).
5 Plate 100 from a series of 150 engravings in the British Museum, see: London, British Museum, Prints & Drawings, Inv. H,5.62, and Von Bartsch (1803–21, XV.164.227).The plate is dated to 1525 circa. Another version by Giovanni Jacopo Caraglio shows a lantern and a mouse in addition to the rooster; New York, Metropolitan Museum of Art, Prints, Inv. 17.3.3416.
6 For the rooster, see also Brandt (2010, 179–82).
7 Kossoff (1979).
8 Wind (1938, 261, n. 1). Diogenes Laertius, *Vitae philosophorum*, VI, 2, 40.
9 After this incident, Laertius continues, the specification "with broad flat nails" was added to Plato's definition of man. For a close reading of the text passage and the implications of the term "with broad flat nails," see Ricklin (2010, 27–8).
10 Plato, *Politikos*, 266e; Plato (2014b, 41).
11 Wind (1938, 261), and in that sense also Kossoff (1979).
12 Bocchi's book of emblems was very popular in the sixteenth century. The image of Diogenes with the 'homo platonis' visualized the lemma of "Vita sine querela optima." Its illustrations show careful craftsmanship and underscore the book's main function as a compendium of knowledge and moral formation. See also Manning (2002, 114).
13 Ricklin (2010, part. 26–8, 35–40).
14 For an early mentioning of the double concept of "fantasia e operazione di mano" see Cennino Cennini, *Il libro dell'Arte*, I, 61 (Cennini, 2003), and in particular Leon Battista Alberti, *Della Pittura*, I, 24: "[...] e quella mano seguita velocissimo, quale sia certa ragione d'ingegno ben guidata [...]" See also III, 59. Alberti (2002, 101–2, 162–3). For an English translation see Alberti (1972, 93).
15 For a lucid and concise interpretation, see Preimesberger (2005, 50–1).
16 Preimesberger (2005, 50).
17 The image was presented to Pope Clement VII in 1524, probably by Parmigianino himself and in order to recommend him for future commissions. See also Ferrino-Pagden (2003, 42–5).
18 Stoichita (1997).
19 Neoplatonist Plotinus was profoundly skeptical of the nature of art, and of portraiture in particular. In a well-known episode told by his biographer Porphyrius Malchus, one of Plotinus' pupils once asked him for a portrait. "He showed, too, an unconquerable reluctance to sit to a painter or sculptor, and when Amelius persisted in urging him to allow of a portrait being made he asked him: 'Is is not enough to carry about this image in which nature has enclosed us? Do you really think I must also consent to leave, as a desirable spectacle to posterity, an image of an image?'" Porphyrius Malchus, *On the Life of Plotinus and the Arrangement of his Work*, paragraph 1, quoted after Plotinus (1962, 1). On Plotinus and the status of images in Neoplatonic thought, see Leinkauf (2016, 23–36). For a contextualization of the episode in Plato and Cicero, see Baader (1995, 91–5).

20 Wittkower (1938, 260–1). The images for both articles, which were published in the rubric *Miscellaneous Notes*, are arranged together on Plate 34.

21 Milanesi (1887, 26), Semper (1887, 84), Von Tschudi (1887, 24), Venturi (1908, 296), Cruttwell (1911, 121).

22 Michael J. B. Allen uses it as a frontispiece for his seminal publication *The Platonism of Marsilio Ficino: A Study of His Phaedrus Commentary, Its Sources and Genesis*; Allen (1984).

23 Janson brought up the idea that the bust might represent the ideal Platonic beloved of the Florentine Platonists "assimilated to the role of Phaedros," see Janson, "Bust of a Youth, Museo Nazionale, Florence," in: Janson (1957, vol. 2, 142).

24 As a matter of fact, one could discuss both the emergence and developments of iconology and, more generally, the changing approaches in Renaissance art history through a separate discussion of the literature on the *Platonic Youth* alone – a task I will have to leave up to others. The most important contributions (after Wittkower's short interpretation) are: Lányi (1939), Chastel (1950, 73–4), Janson (1957, vol. 2, 142), Chastel (1959, 39–44), Panofsky (1960/1972, 189), Barocchi (1980, 312–24), Parronchi (1984), Collareta (1985); Zervas and Hirst (1987), Freedman (1989), Freedman (1993), Rosenauer (1993, 315–6, no. 87), Lewis (2001, 33–54), Ames-Lewis (2002), Baader (2002), Zöllner (2005), Pfisterer (2009, 350–64, with additional literature and a late date for the bust in the 1470s or 1480s), Kohl (2010).

25 See Horst Bredekamp's much quoted article "Götterdämmerung des Neuplatonismus" (Bredekamp 1986/1992), which in its critical (and political) questioning of the role of Neoplatonism in Renaissance culture and twentieth-century iconology made quite a splash in German art history when it appeared some 30 years ago.

26 Wittkower (1938, 260). Plato, *Phaedrus*, 265 b–c; Plato (2017, 533).

27 The Illustrated Bartsch (1985, no. 106).

28 Wittkower (1938, 260–1).

29 For the social background of homoeroticism and homosexuality, see Rocke (1996).

30 For the adaptations of *Phaedrus* in the Renaissance, see, in particular, Allen (1980, 131–53); see also Hankins (1990, vol. 1, 67–8, and vol. 2, 396 *et passim*). Plato's *Phaedrus*, in which the soul is described as a chariot with two horses that need to be tamed, was first translated into Latin by Leonardo Bruni in 1424. For a detailed discussion of the different commentaries and translations of the *Phaedrus* and their possible relevance for the bust, see Pfisterer (2009, 350–64).

31 Baader (2002), Pfisterer (2009, 353–55) follows her argument to a certain extent.

32 Baader (2002, 233–4). For the larger context, see again Rocke (1996).

33 See in particular Koos (2006a) and Koos (2006b).

34 Kohl (2010).

35 Wittkower (1938, 260 and n. 5), see also Pfisterer (2009, 357–9). Sometimes these busts were adorned with mirrors instead of stones. Wittkower's observation might in turn have inspired Irving Lavin to draw parallels between the boom of bust portraiture not only in terms of a reception of antiquity but also as a continuation of medieval bust reliquaries and their *pars-pro-toto* concepts. See Irving Lavin's seminal article (which also mentions the *Bust of the Platonic Youth*); Lavin (1970).

36 Wittkower (1938, 260, n. 6), with references to an inventory of the collection of Lorenzo de' Medici, and De Ricci (1931, 30, no. 27); see also the antique examples in Lewis (2001, 36–7), which are similar but not identical to the *Platonic Youth*'s cameo.

37 See Lewis (2001, 37), Wittkower (1938, 260).

38 Wittkower (1938, 260).

39 Chastel (1950), Panofsky (1972) and Zöllner (2005) date the bust around 1470; Freedman (1989) and Baader (2002) suggest a date around 1460; Lewis (2001), with interesting arguments, suggests a date in 1453; Wittkower (1938), Janson (1957) and others have argued for a date around 1440. Pfisterer (2009) is the first to propose a much later date, in the late 1470s, or around 1480.

40 Panofsky (1960/1972, 189).

41 Lányi (1939) first noted the slightly irregular traits of the face which show clearly when seen in profile, a fact that led him to doubt Donatello's authorship.

42 Lewis (2001, 41) has pointed to the fact that the youth's conspicuous vein on the forehead appears in a similar form on Donatello's first work in Padua, the *Crucified Christ* dating to 1444.

43 Freedman (1989) has related the rendering of the bust's clearly structured facial proportions to Marsilio Ficino's canon of proportion in *De amore* (1469), V, 6. Ficino, following Vitruvius, points out that regular features will be perceived as beautiful, in particular if the face can be

divided vertically into three even parts based on the length of the nose. See Ficino (1985, 93): "[...] Nor does this equality of distances pertaining to Arrangement suffice unless there is added a Proportion of the parts, which gives to every part a moderate size, preserving the proper proportion of the whole body, so that three noses placed end to end will fill the length of one face, the semi-circles of both ears joined together will make the circle of the open mouth, and the joining of the eyebrows will also amount to the same; the length of the nose will match the length of the lip, and likewise of the ear. [...]."

44 Lányi (1939) argues that while the bust of San Rossore and the head of the Gattamelata are not life-like portraits (they are posthumous, fictitious or idealized representations), they give evidence of Donatello's outstanding artistic talent – the more so in that he bestows individuality and character upon his sculptures. His and also Chastel's (1950) argument is that if Donatello was able to endow "ideal" or "invented" portraits without actual sitters with such a tremendous amount of individual singularity and living presence, how can he not have been able to do the same in a "real" portrait? Thus, the bust can only be by the hands of an artist inferior to Donatello. Janson (1957, 141), relying on stylistic comparisons, rebuts this argument and rejects the assumption that the portrait lacks life and spirit because of a presumed lesser talent of the artist.

45 Early scholars, probably following a suggestion by Wilhelm von Bode, considered the bust to be a portrait of Giovanni Antonio da Narni, son of the famous Condottiere Gattamelata; see Von Tschudi (1887, 23) Müntz (1885, 71), Semper (1887, 84–5). Parronchi (1984, 301–7) argues for a portrait of Lionello d'Este. None of these identifications are consistent, or convincing.

46 Janson (1957, 142): "Inherently, it seems to me, our Youth is no more portrait-like than Michelangelo's Brutus," and therefore "must not be judged by ordinary standards of portraiture." Recently, Lewis (2001, 36) has argued in the same direction.

47 Kohl (2010).

48 Sedgwick (1985), Simon (1997), Randolph (2004).

49 Koos (2006a) and Koos (2006b).

50 Plato, *Phaedrus*, 246a–b; Plato (2017, 471–3).

51 Plato, *Phaedrus*, 253 d–e; Plato (2017, 495).

52 "Now as they lie together, the unruly horse of the lover has something to say to the charioteer, and demands a little enjoyment in return for his many troubles; and the unruly horse of the beloved says nothing, but teeming with passion and confused emotions he embraces and kisses his lover, caressing him as his best friend; and when they lie together, he would not refuse his lover any favor, if he asked it;" Plato, *Phaedrus*, 255e–256a; Plato (2017, 501).

53 *De amore*, VII, 14; Ficino (1985, 171); for the Latin original see Ficino (1956, 256). See Allen (1981, 222–4).

54 *De amore*, VII, 14; Ficino (1985, 171); for the Latin original see Ficino (1956, 256).

55 Plato, *Phaedrus*, 246d–e; Plato (2017), 473.

56 Plato, *Phaedrus*, 249c; Plato (2017), 481. The Platonic feather-metaphor was known in Florentine erudite circles already before Ficino's *De amore*. It appears in several earlier Renaissance sources, among those a letter by Ficino to bishop Antonio degli Agli, in which he states: "[Plato] says in his Phaedrus that only the philosopher's soul regains wings." Ficino (1975–81, vol. I, 43). See also Freedman (1989, 121).

57 See the detailed account by Allen (1981, esp. 146–8); see also Allen (1984, 91, n. 10) for the problems of translating the passage in Plato's *Phaedrus*.

58 Allen (1984, 92).

59 The similarity has been stressed by Chastel (1959, 42). The relief has been interpreted in different ways. Hansmann (1993) adopts an identification as chariot of Helios. See also Freedman (1989, 121–2).

60 Plato, *Phaedrus*, 249d; Plato (2017, 483).

61 "But he who is newly initiated, who beheld many of those realities, when he sees a godlike face or form which is a good image of beauty, shudders at first, and something of the old awe comes over him, then, as he gazes, he reveres the beautiful one as a god, and if he did not fear to be thought stark mad, he would offer sacrifice to his beloved as to an idol or a god." Plato, *Phaedrus*, 251a; Plato (2017, 487).

62 *De amore*, VII, 15; Ficino (1985, 172); Ficino (1956, 260).

63 Pico della Mirandola, *Oration on the Dignity of Man*, § 113, with reference to Plato's *Phaedrus*, relates the winged ascent of the philosopher's soul to looking at beauty in the person of Phoebus: "For, raised to her [Theology's] most eminent heights, and thence comparing to indivisible eternity

all things that are and shall be and have been, we shall be the Phoebean seers of those things; and, admiring that primeval beauty, we shall become its winged lovers." Pico della Mirandola (2012, 169). Phoebus as well as Phaedrus both mean "the shining one." It should be noted here that a Medici inventory of 1560 describes the medallion of the *Platonic Youth* as "medaglia entrovi Febo sul carro," see Janson (1957, 2, 142). If in the sixteenth century the charioteer on the bust was interpreted as Phoebus or Phaedrus, then Janson's conjecture that the boy might depict Phaedrus as the *kalós* of Florentine Platonic humanists needs to be reconsidered.

64 1 Corinthian 13:12. I am thankfully indebted to Sergius Kodera for this reference.

65 Kohl (2010, 58–62).

66 *Gorgias*, 492e–493a: "In fact I once heard sages say that we are now dead, and the body is our tomb, and the part of the soul in which we have desires is liable to be over-persuaded and to vacillate to and fro, and so some smart fellow, a Sicilian, I daresay, or Italian, made a fable in which – by a play of words – he named this part, as being so impressionable and persuadable, a jar, and the thoughtless he called uninitiated." Plato (2014a, 415). I am again thankful to Sergius Kodera for sharing his knowledge.

67 See, among the many recent publications on body part reliquaries, the contributions in *Gesta* 36, 1997, and the publications by Bruno Reudenbach; also Hahn (2010).

68 For further information on the bust, see Angeli (1995/1996). I am grateful to Heiko Damm (Mainz) for making me aware of the bust and for providing the image.

69 A more general context of concepts of love in the Renaissance is provided by Nelson (1958).

70 Leon Battista Alberti, in his first sentences of *Della Pittura*, I, 1; Alberti (2002, 66): "Noi, perché vogliamo le cose essere poste da vedere, per questo useremo quanto dicono più grassa Minerva […]." Alberti (1972, 37): "We, on the other hand, who wish to talk of things that are visible, will express ourselves in cruder terms […]."

71 See Ficino, *De amore*, II, 8; Ficino (1985, 54–7); Ficino (1978, 155–8).

Bibliography

Alberti, Leon Battista. 1972. *On Painting*, translated by Cecil Grayson, introduction and notes by Martin Kemp. London: Phaidon.

Alberti, Leon Battista. 2002. *Leon Battista Alberti: Della Pittura – Über die Malkunst*, edited by Oskar Bätschmann and Sandra Gianfreda. Darmstadt: Wissenschaftliche Buchgesellschaft.

Allen, Michael J. B. 1980. "Cosmogony and Love: The Role of Phaedrus in Ficino's Symposium Commentary." *Journal of Medieval and Renaissance Studies* 10:131–153.

Allen, Michael J. B. 1981. *Marsilio Ficino and the Phaedran Charioteer: Introduction, Texts, and Translations*. Berkeley: University of California Press.

Allen, Michael J. B. 1984. *The Platonism of Marsilio B. Ficino: A Study of his Phaedrus Commentary, its Sources, and Genesis*. Berkeley: University of California Press.

Ames-Lewis, Francis. 2002. "Neoplatonism and the Visual Arts at the Time of Marsilio Ficino." In *Marsilio Ficino: His Theology, His Philosophy, His Legacy*, edited by Michael J. B. Allen and Valery Rees, 327–338. Leiden, Boston and Cologne: Brill.

Angeli, M. 1995/1996. *Il busto reliquiario di San Lorenzo nel Tesoro della cattedrale metropolitana di Gorizia*. Tesi di laurea, Università degli Studi di Udine, Facoltà di Lettere e Filosofia, anno academico.

Baader, Hannah. 1995. "Marcus Tullius Cicero: Der Körper als Gefäß der Seele: Transformationen einer Metapher." In *Porträt*, edited by Rudolf Preimesberger, Hannah Baader and Nicola Suthor, 91–95. Berlin: Reimer.

Baader, Hannah. 2002. "Das Gesicht als Ort der Gefühle. Zur Büste eines jungen Mannes aus dem Florentiner Bargello von ca. 1460." *Querelles* 7:222–240.

Barocchi, Paola. 1980. *Palazzo Vecchio: Committenza e collezionismo medicei, 1537–1610*. Florence: Electa.

Brandt, Reinhard. 2010. *Philosophie in Bildern: Von Giorgione bis Magritte*. Cologne: DuMont.

Bredekamp, Horst. 1986. "Götterdämmerung des Neuplatonismus." *kritische berichte* 14, 4:39–48. Repr. with minor revisions 1992 in *Die Lesbarkeit der Kunst: Zur Geistes-Gegenwart der Ikonologie*, edited by Andreas Beyer, 75–83 and 102–106. Berlin: Wagenbach.

Cennini, Cennino. 2003. *Il libro dell'Arte*, edited by Fabio Frezzato. Vicenza: Neri Pozza.

Chastel, André. 1950. "Le jeune homme au cammée platonicien du Bargello." *Proporzioni* 3:73–74.

Chastel, André. 1959. *Art et humanisme a Florence au temps de Laurent le Magnifique.* Paris: Presses Universitaires de France.

Collareta, Marco. 1985. "Busto di Giovane." In *Omaggio a Donatello 1386–1986*, exh. cat. Museo Nazionale del Bargello, edited by Paola Barocchi, 336–342. Florence: S.P.E.S.

Cruttwell, Maud. 1911. *Donatello*. London: Methuen.

De Ricci, Seymour. 1931. *The Gustave Dreyfus Collection: Reliefs and Plaquettes*. Oxford: Oxford University Press.

Ferrino-Pagden, Sylvia. 2003. "Parmigianinos Selbstporträt: Materie und Reflexion." In *Parmigianino und der europäische Manierismus*, edited by Sylvia Ferrino-Pagden *et al.*, exh. cat. Vienna, 42–45. Cinisello Balsamo: Silvana.

Ficino, Marsilio. 1956. *Commentaire sur le Banquet de Platon*, edited and translated by Raymond Marcel. Paris: Les Belles Lettres.

Ficino, Marsilio. 1975–81. *The Letters of Marsilio Ficino*, introduction P. O. Kristeller, translated by the Members of the Language Department of the School of Economic Science. London: Shepheard-Walwyn.

Ficino, Marsilio. 1985. *Commentary on Plato's Symposium*, translated by Jayne Sears, 2nd revised edition. Dallas: Spring Publications.

Ficino, Marsilio. 2001–6. *Theologia Platonica: Platonic Theology*, edited by James Hankins and William Bowen, translated by Michael J. B. Allen and John Warden, 6 vols. Cambridge, MA: Cambridge University Press.

Freedman, Luba. 1989. "Donatello's Bust of a Youth and the Ficino Canon of Proportions." In *Il ritratto e la memoria: materiali*, 3 vols., edited by Augusto Gentilini, vol. 1:113–132. Rome: Bulzoni.

Freedman, Luba. 1993. "The Counter-Portrait: The Quest for the Ideal in Italian Renaissance Portraiture." In *Il ritratto e la memoria: materiali*, 3 vols., edited by Augusto Gentili, vol. 3:62–81. Roma: Bulzoni.

Gnann, Achim. 2007. *Parmigianino und sein Kreis: Druckgraphik aus der Sammlung Baselitz*, edited by Staatliche Graphische Sammlung München. Ostfildern: Hatje-Cantz.

Hahn, Cynthia. 2010. "The Spectacle of the Charismatic Body: Patrons, Artists, and Body-Part Reliquaries." In *Treasures of Heaven*, exh. cat. Cleveland Museum of Art, ed. Martina Bagnoli *et al.*, 163–172. New Haven: Yale University Press.

Hankins, James. 1990. *Plato in the Renaissance*. Leiden: Brill.

Hansmann, Martina. 1993. "Die Kapelle des Kardinals von Portugal in S. Miniato al Monte." In *Piero de' Medici, il Gottoso: Art in the Service of the Medici*, edited by Andreas Beyer and Bruce Boucher, 291–316. Berlin: Akademie-Verlag.

Janson, Horst W. 1957. *The Sculpture of Donatello*, 2 vols. Princeton: Princeton University Press.

Kodera, Sergius. 2009. "Ingenium: Marsilio Ficino über die menschliche Kreativität." In *Platon, Plotin und Marsilio Ficino: Studien zu Vorläufern und zur Rezeption des Florentiner Neuplatonismus*, edited by Maria-Christina Leitgeb, Stéphane Toussaint, and Herbert Bannert, 155–172. Wien: Österreichische Akademie der Wissenschaften.

Kohl, Jeanette. 2010. "Body, Mind, and Soul: On the So-Called 'Platonic Youth' in the Bargello, Florence." In *Subject as Aporia in Early Modern Art*, edited by Alexander Nagel and Lorenzo Pericolo, 43–69. Aldershot: Ashgate.

Koos, Marianne. 2006a. "Amore dolce-amaro: Giorgione und das ideale Knabenbildnis der venezianischen Renaissancemalerei." *Marburger Jahrbuch für Kunstwissenschaft* 33:113–174.

Koos, Marianne. 2006b. *Bildnisse des Begehrens: Das lyrische Männerporträt in der venezianischen Malerei des frühen 16. Jahrhunderts – Giorgione, Tizian und ihr Umkreis*. Berlin and Emsdetten: Edition Imorde.

Kossoff, Florence S. 1979. "Parmigianino and Diogenes." *The Sixteenth Century Journal* 10, 3:85–96.

Lányi, Jenö. 1939. "Problemi della critica donatelliana." *Critica d'Arte* 4, 19:9–22.

Lavin, Irving. 1970. "On the Sources and Meaning of the Renaissance Portrait Bust." *Art Quarterly* 33:207–226.

Leinkauf, Thomas. 2016. "Überlegungen zum Status des Bildes und der Kunst bei Plotin." In *Zur-Erscheinung-Kommen. Bildlichkeit als theoretischer Prozeß. Festschrift für Wilhelm Schmidt-Bigge-mann*, edited by Anne Eusterschulte, 23–36. Berlin: Meiner.

Lewis, Douglas. 2001. "Rehabilitating a Fallen Athlete: Evidence for a Date of 1453/1454 in the Veneto for the Bust of a Platonic Youth by Donatello." In *Small Bronzes in the Renaissance*, edited by Debra Pincus, 33–54. Washington: National Gallery of Art.

Manning, John. 2002. *The Emblem*. London: Reaktion Books.

Milanesi, Gaetano. 1887. *Catalogo delle opere di Donatello*. Florence: Tipi dell'Arte di Stampa.

Müntz, Eugène. 1885. *Donatello*. Paris: Rouam.

Nelson, John Charles. 1958. *Renaissance Theory of Love: The Context of Giordano Bruno's Eroici Furori*. New York: Columbia University Press.

Panofsky, Erwin. 1960/1972. *Renaissance and Renascences in Western Art*. Stockholm: Almqvist & Wiksell. Repr. 1972. New York: Harper and Row.

Parronchi, Alessandro. 1984. "Il busto bronzeo di 'Giovane' del Bargello." In *Scritti di Storia dell'Arte in onore di Roberto Salvini*, 301–337. Florence: Sansoni.

Pfisterer, Ulrich. 2009. *Lysippus und seine Freunde. Liebesgaben und Gedächtnis im Rom der Renaissance oder: Das erste Jahrhundert der Medaille*. Berlin: Akademie-Verlag.

Pico della Mirandola, Giovanni. 2012. *Oration on the Dignity of Man: A New Translation and Commentary*, edited by Francesco Borghesi, Michael Papio, and Massimo Riva. New York: Cambridge University Press.

Plato. 2014a. "Gorgias." In *Plato, vol. 3: Lysis – Symposium – Gorgias* [Loeb Classical Library 166], translated by W. R. M. Lamb, 247–533. Cambridge, MA: Harvard University Press.

Plato. 2014b. "Politikos." In *Plato, vol. 8: The Statesman – Philebus – Ion* [Loeb Classical Library 164], translated by Harold N. Fowler and W. R. M. Lamb, 1–195. Cambridge, MA: Harvard University Press.

Plato. 2017. "Phaedrus." In *Plato, vol. 1: Euthyphro – Apology – Crito – Phaedo – Phaedrus* [Loeb Classical Library 36], translated by Harold N. Fowler, 412–579. Cambridge, MA: Harvard University Press.

Preimesberger, Rudolf. 2005. "Parmigianino: Selbstbildnis im Konvexspiegel." In *Der Künstler als Kunstwerk: Selbstporträts vom Mittelalter bis zur Gegenwart*, edited by Valeska von Rosen and Ulrich Pfisterer, 50–51. Stuttgart: Reclam.

Randolph, Adrian W. B. 2004. "Donatellos David: Politik und der homosoziale Blick." In *Männlichkeit im Blick: Visuelle Inszenierungen seit der Frühen Neuzeit*, edited Mechthild Fend and Marianne Koos, 35–51. Cologne: Böhlau.

Reudenbach, Bruno. 1996. "Individuum ohne Bildnis? Zum Problem künstlerischer Ausdrucksfor-men von Individualität im Mittelalter." In *Individuum und Individualität im Mittelalter*, edited by Jan Aertsen and Andreas Speer, 807–818. Berlin: De Gruyter.

Reudenbach, Bruno. 2000. *Reliquiare als Heiligkeitsbeweis und Echtheitszeugnis: Grundzüge einer problematischen Gattung*. Berlin: Akademie-Verlag.

Ricklin, Thomas. 2010. "Die Hände des Diogenes von Sinope und der Hahn des Parmigianino." In *Die Hand – Elemente einer Medizin- und Kulturgeschichte*, edited by Mariacarla Gadebusch Bondio, 23–42. Berlin: LIT Verlag.

Rocke, Michael. 1996. *Forbidden Friendships: Homosexuality and Male Culture in Renaissance Florence*. New York: Oxford University Press.

Rosenauer, Artur. 1993. *Donatello*. Milan: Electa.

Sedgwick, Eve Kosofsky. 1985. *Between Men: English Literature and Male Homosocial Desire*. New York: Columbia University Press.

Semper, Hans. 1887. *Donatellos Leben und Werke*. Innsbruck: Wagner.

Simon, Patricia. 1997. "Homosociality and Erotics in Italian Renaissance Portraiture." In *Portraiture: Facing the Subject*, edited by Joanna Woodall, 29–51. New York: Manchester University Press.

Stoichita, Victor I. 1997. *The Self-Aware Image: An Insight into Early Modern Meta-Painting*. Cambridge: Cambridge University Press.

The Illustrated Bartsch. 1985. *Vol. 28: Italian Masters of the Sixteenth Century*, edited by Suzanne Boorsch and John T. Spike. New York: Abaris Books.

Vasari, Giorgio. 1906. *Vite de' più eccellenti pittori, scultori ed architetti, con nuove annotazioni e commenti di Gaetano Milanesi*. Florence: Sansoni.

Venturi, Adolfo. 1908. *Storia dell'arte italiana, VI: La scultura del Quattrocento*. Milan: Hoepli.

Von Bartsch, Adam. 1803–21. *Le Peintre graveur*, 21 vols. Vienna: J. V. Degen.

Von Tschudi, Hugo. 1887. "Donatello e la critica moderna." *Rivista storica italiana* IV, 2:1–36.

Wind, Edgar. 1938. "Homo Platonis." *Journal of the Warburg Institute* 1, 3:261.

Wittkower, Rudolf. 1938. "A Symbol of Platonic Love in a Portrait Bust by Donatello." *Journal of the Warburg Institute* 1, 3:260–261.

Zervas, Diane, and Michael Hirst. 1987. "The Donatello Year." *Burlington Magazine* 129:207–210.

Zöllner, Frank. 2005. "The Motions of the Mind in Renaissance Portraiture: The Spiritual Dimension of Portraiture." *Zeitschrift für Kunstgeschichte* 68:23–40.

9 Iconology as a Spiritual Exercise

The *compositio loci* in Ignatius of Loyola[1]

Paul Richard Blum

When in 2004 Mel Gibson's film *The Passion of the Christ* was hyped, I organized a reading group among my colleagues at our Jesuit university to read Ignatius' *Spiritual Exercises* and specifically to interpret the *compositio loci* as a means to the same effect without creating mass hysteria but also without cashing in millions of dollars. Probably, the esthetics of movies has been studied more than the esthetics of the *Spiritual Exercises*. My thought experiment in this paper is to read the sensuality of images as a kind of exercise of the soul, or – conversely – to understand the directions of Ignatius' *Exercises* as an invitation to compose iconological programs that may reach beyond the pious purpose of the author.

The Activity of the Soul

Let me first describe the procedure and directions as they are in the text. We should notice that the work, *Spiritual Exercises*,[2] is quite an unusual genre of text. It opens with twenty preliminary remarks that would well suit a handbook for guided or self-guided meditation. After that ensue more definitions and suggestions concerning meditation (21–44), before the exercises themselves are described (45–237). The book concludes with classifications of prayer (238–60), a recapitulation of the major events of the life of Christ (261–312), and a long list of rules regarding the self-perception of the pious person, actions, and – most famously – regarding the obedience to the Church.

The *Exercises* offer theologico-psychological insight combined with technicalities and procedures that induced Roland Barthes to compare the book with the obsessively systematic permutation of sexual pleasure in Marquis de Sade. Barthes diagnosed "an incessant, painstaking, and almost obsessive separation" of acts, times, mysteries, etc., which for some inscrutable reasons made him compare Ignatius' text with the scholastic technique of argumentative distinctions.[3] However, what is distinguished in the *Exercises* are not concepts, notions, or definitions but, rather, images. "The image is very precisely a unit of imitation. The imitable material (principally the life of Christ) is divided into fragments so that it can be contained within a framework and fill it completely."[4] Barthes also does not fail to relate this method of distributing images and parts of images to the rhetorical and mnemotechnic tradition.[5] It is at this point where we need to part company with Barthes's brilliant analysis because I believe that Ignatius' way of operating with images warrants an epistemological and metaphysical interpretation. The first parallel that comes to mind is the rigorous curriculum of early Jesuit education; the *Ratio studiorum* (definitive version of 1599) was quite a similar combination of abstract ideas and day-to-day technicalities.[6] More closely related to our topic, readers of Renaissance mnemotechnics and topics will recognize that the medium is the message: the exercises proposed by Ignatius are not preparations for something

other than the exercises, they are not practice for the final tournament; rather, they are what piety is all about – namely, the exercise of the soul, or the soul in action.

This can be seen in the very first opening annotation, which offers the definition of 'exercises':

> The term 'spiritual exercises' denotes every way of examining one's conscience, of meditating, contemplating, praying vocally and mentally, and other spiritual activities (*spirituales operationes*) […]. For just as strolling, walking and running are exercises of the body (*corporales*), so 'spiritual exercises' is the name given to every way of preparing and disposing one's soul to rid herself of all disordered attachments, so that once rid of them one might seek and find the divine will in regard to the disposition on one's life for the good of the soul.
>
> (1)[7]

The definition is clearly circular in that it defines exercise by exercise; therefore, it must be intended to be descriptive rather than classificatory. Indeed, it invites praxis which is not conceptual. The aim of "preparing" the soul is for the soul to function in an uninhibited way – that is, to 'operate' properly. In a Christian context, we may grant that "the good of the soul" is nothing but finding the divine will. However, Ignatius refers to the Aristotelian point of view that has the 'exercise' of the body by walking or running as the nature of the body's operation, so that the *telos* of the operation is the operation itself.[8]

Already the second introductory remark, directed at the supervisor or personal guide of an exercise, comes to the main feature of the whole enterprise. It may be termed experiential, as it assumes that meditation and contemplation can only be taught by example and by narrating the personal experience and thus inviting the other to relive the same experience.

> The person who gives to another the way and order to meditate or contemplate should tell faithfully the *history* of this meditation or contemplation […]. For if a person begins contemplating with a true foundation of the *history* and thinks it through and reasons about it *with his own effort*, he may find something that makes the *story* more clear or allows him to *savor* it […] then it is of more spiritual *taste and fruit*. […] For it is not so much knowing that fills and *satisfies* the soul but *sensing and tasting the things themselves* internally.[9]

The key concepts in this advice are: *historia, gustare*, and *gustus et fructus historiae*.[10] This is the constellation: the spiritual director narrates the history, or rather story, of the contemplation (and we need to come back to that), adding some hints but no full interpretation or theory; the exercitant – as the other person is commonly called – is thus enabled to think for himself rationally with the purpose of savoring the story and hence to draw a taste and spiritual fruit of the experience. Ignatius adds that it is indifferent at this point whether the insight comes from one's own intellectual capability or by divine inspiration. His point is that the fruit is no mediated and distanced understanding of something but the thing itself. Access to it can only be described in sensual terms as tasting and internally relishing. At the point of this writing, Ignatius was not anymore an illiterate gung-ho, a self-taught preacher, but someone who had gone through the Paris schools.[11] So, if he retained from his early career as a heretic in Spain some of the techniques and psycho-therapeutical expertise present in mystical and spiritual movements of the time, he nevertheless knew the terminology and rules of Aristotelian epistemology.

This is patent in the third preliminary remark, which refers to the well-known tandem of *discursus* and *voluntas*; interestingly, in this case he adds that *voluntas* requires more *reverentia* than acts of the intellect. We are immediately reminded of the anthropological fact, elaborated by Marsilio Ficino, that human relation to God is in its essence a form of reverence that is manifest, present and prefigured in the self-reference of the human being.[12] Given this framework, as to the language of taste and sensuality, we may assume Ignatius meant what he said when he taught the act of relinquishing rational discourse after having made use of it. We will see soon that Ignatius is deliberately making use of sensuality in order to reach a level of savor that outsmarts rationality, including that of present-day pragmatism.

We cannot pass over the very "principle and foundation" of all spiritual exercises (in the defined meaning): what begins as a pious commonplace "The human person is created to praise, reverence and serve God [...]" morphs immediately into intellectual stoicism:

> It follows from this that one must use other created things in so far as they help towards one's end. To do this we need to make ourselves indifferent to all created things [...]. Thus as far as we are concerned, we should not want health more than illness [...], but we should desire and choose only what helps us more towards the end for which we are created.
>
> (23)

Indifference, taken seriously, is to not be ashamed of having good things. The stoic indifference is that of the superior operation of the mind, to which all is good that makes good. The spiritual position of indifference will turn out to be the condition for the possibility to contemplate the absolute by balancing the physical sensual with the spiritual imaginative. Since the aim and proper operation of the soul transcends rational discourse, the sensual has to be transformed into the visionary.

This, by the way, is not an unusual form of thought: in metaphysics, the notion of God has to be thought of as indifferent to the entanglement with matter, otherwise the philosophical theology would deviate into mere dualism rather than the foundation of reality, material or not.

Hans Urs von Balthasar, temporarily a Jesuit, elaborated on the mystical and metaphysical importance of Ignatius' call for indifference. He related the indifference to *apatheia* (passionlessness) in the Church Fathers, equanimity (*Gelassenheit*) in the Rhenisch mystics, and "abandon" in seventeenth-century French mysticism. To him, *indifferentia* is the universal principle and fosters the leap beyond all creation into the immediacy with God (*Unmittelbarkeit zu Gott*). Hence, he infers that the meditating person is stripped of all personal values (*jedes eigenen Guten entkleidet*).[13] This may be correct and integrates Ignatius into standard notions of spiritual elevation that relinquish the earthly and egotistic perspective.[14] However, that should not distract from Ignatius' emphasis on the ancillary importance of the material and sensual once it is liberated of any peculiar value that could be mistaken for absolute and resilient to spiritual power.

The exercises proper contain the famous "compositio loci." Much has been written and speculated about it, for the most part from the perspective of the further development of Jesuit spirituality and, in general, of asceticism and psychology.[15] However, I hope I can shed some light on it by reading the text as it stands. The composition of the place is but one preparatory to the exercise itself. Therefore, it helps in understanding the 'composition' to know that the preparation to the exercise consists in activating the three faculties of the soul – namely, memory, intellect, and will:

> Bring the memory to bear on the first sin [that had been exposed before] [...], then apply the intellect to the same event, in order to reason over it (*el entendimiento discurriendo*), and then the will, so that by seeking to recall and to comprehend all this, I may feel all the more shame and confusion [...].
>
> (50)

The standard triad of psychic faculties — memory, intellect, and will — is portrayed as interacting towards the perfection of the soul. The composition of the place unmistakably prepares the ground by providing the object of contemplation, the stuff to think and act upon. There is nothing mystical about it and no reason to divert the operation towards something psychological that may sound more familiar.[16] It is understandable that for a modern audience one is tempted to jump to the ascetic aim of the whole exercise, so that we seem to know already that the exercitant is expected to "let himself be led by Jesus,"[17] but in order to do justice to the author, we have to acknowledge that Ignatius is clearly referring to the three powers of the soul. And those faculties have first and foremost cognitive power.

The intellectual preamble to contemplation is "composición viendo el lugar." It should be noted, Ignatius adds, that

> for contemplation or meditation of visible things, e.g. a contemplation about Christ Our Lord who is visible, the 'composition' consists in seeing through the gaze (*vista, oculo*) of the imagination the material place where the object I want to contemplate is situated. [...] e.g. a temple or a mountain where Jesus Christ or Our Lady is to be found, according to what I want to contemplate.
>
> (47)

So far we are hearing a quite commonsensical advice – namely, to visualize the object of meditation or contemplation. The soul is active in focusing the attention on an object of noteworthy importance. This advice would be well applicable to a student of geometry who tries to grasp Pythagoras' theorem, to visualize the triangles and squares and their relations. The student might even pray, if it is a question on an exam. What is remarkable is the fact that Ignatius instructs the exercitant to put the image together or compose it deliberately and consciously. Therefore, Hans Urs von Balthasar paraphrases it with *Zurichtung*, preparing, finishing, conditioning.[18] This meditation is a planned program for a psychological workshop.

The deliberateness and purposefulness of the meditative act becomes even more patent if the intended object of contemplation is not a corporeal visible given as in the example above, but invisible, such as a sin. In this case, "the composition will be to see with the gaze of the imagination and to consider that my soul is imprisoned in this [perishable] body, and my whole composite self as if exiled in this valley among brute beasts" (47). The view of the imagination when it chooses for its object a psychic reality requires the corporeal human condition as an integral part of that whole person that is ready to meditate. Ignatius' advice is to work with the body as with the condition *sine qua non* to become liberated from it. There is, of course, some pious padding, like the reference to 'exile' and 'valley of tears,' but they only reinforce the call for integrating and employing sensible reality. The presence of the body is accepted in the spirit of indifference.[19] Since the triad of memory, intellect, and will are taking command and exercising their power, the senses are put to work. And tears will flow.

The second preliminary to contemplation is the begging for emotions: for instance, "in contemplating the Resurrection one asks for joy with Christ joyful, but in contemplating the Passion one asks for grief, tears and suffering with the suffering Christ." And in the case of the invisible sin "I will ask for personal shame and confusion as I see how many have been damned on account of a single mortal sin [...]" (48). He is talking about emotions that by definition overcome a person from external events and are consequently unasked for and unexpected. The exercitant is encouraged and even required to produce the state of mind that is agitated by visual experience and emotional response to it. Ignatius was a glutton for punishment.

The composition of places, we can conclude, is part of a process that involves the whole of the human mind on its way to shape the conscience consciously. Ignatius is interested in the actions of the soul and their union and synergy. That makes it possible to bestow on will and intellect the control of sensual and emotional experience.

But we are not done, yet, with the first exercise, the first directed operation of the soul in contemplating. A final component of the process of meditation is the imaginary dialogue: "Imagining Christ Our Lord [...] on the cross make a colloquy asking how it came about that the Creator made himself man [...] Then, turning to myself I shall ask, what have I done for my sins [...]." The colloquy is defined as

> speaking as one friend speaks with another, or a servant with a master, at times asking for some favour, at other times accusing oneself of something badly done, or telling the other about one's concerns and asking for advice about them.
>
> (53)

The colloquy completes the activity of the soul in meditation by lifting the sensual imagination up to an imaginary discourse: seeing Christ "hanging on the cross, talk over whatever comes to mind" (53). To be sure, not only seeing but equally hearing, tasting, and tactile feeling will be employed (66–69).

One of the recurrent terms in the context of the composition of place is the 'application of the senses.' The term *applicatio sensuum* (and variants of it)[20] was a coinage of the humanist translator of the *Exercises*, Andreas Frusius, S.J.; his version became the 'vulgate' of the text.[21] The term conveniently connotes the voluntary and deliberate employment of the sensory faculties towards the object of contemplation. Ignatius' Spanish text has the verb *traer*, which perhaps even more suggestively associates the act of controlling and puts the senses in a position dependent on reason.[22] For instance, in section 121, where the Latin versions use the term *applicare/applicatio*, the Spanish has: "traer los cinco sentidos sobre la primera y secuna contemplación." Those "contemplations" had pondered the incarnation and the nativity; now the exercitant is invited to "ver las personas con la vista ymaginativa, [...] oýr con el oýdo lo que hablan o pueden hablar," etc. (122–123; see also 66–67, 169). Notice that the imaginative senses 'imagine' possible dialogues. Furthermore, by 'application' one should not be induced to think of the senses as some object that could be attached to some other object like a hand to a handle. In the composition of the place, the object of contemplation is not 'objective' in the modern sense of the word; it is a product of the creative imagination.

The reference to the relation master-servant makes us aware that this colloquy does not create some kind of partnership; it does not at all level out the hierarchy – rather, it reaffirms the difference in making it consciously operable. Remember that at the very beginning *reverentia* is said to be a main feature of the will.[23] We should also emphasize that the same

twofold movement is happening as in the local imagination: from the external visual image to the imagined self; here, from the partner in dialogue to the self-dialogue. Therefore, we may say that the spiritual exercise in the psychological workshop consists in asserting the metaphysical distinctiveness and hierarchy in which a human being is located; it asserts the position on the spiritual level so that the sensual, the emotional, the cognitive, and the voluntary powers each contribute with their peculiar competences.

Aristotelian and Neoplatonic Epistemology

It is suitable to raise the question: what kind of epistemology is implied in this exercise of the powers of the soul? We may take for granted that in medieval and Renaissance epistemology and physiology the cognitive act of sensation consists in sense perception, which is first processed in the mind with the help of imagination and phantasy, then qualified by the cogitative power and stored in the memory. A discussion arose reading Aristotle's *De anima*, book 2, namely to what extent the sensing is an active process or, rather, a merely passive perception. To illustrate the issue, I chose the commentary of the Jesuits of Coimbra on this issue. Although this work appeared only in 1598, it is representative of the Jesuits' reading of Aristotle, who was at that time about to be established as the standard teaching for Jesuit philosophy courses.[24] After referring to the medieval and late medieval discussion, the Conimbricenses establish that

> sensation (*potentia sensitiva*) has three aspects: it receives the *species* of the object [that is: the image of the object insofar as mentally representing it]; once informed it brings about the act of sensing (*actum sentiendi*); and it receives this kind of act in itself.

The authors then state the obvious – namely, that the middle aspect refers to "an active power, because it does not undergo anything but, rather, is operating (*operatur*)." The conclusion is that both image and operation are not actually "immediately received" in the mind but only thanks to the intervention of the power.[25] This implies that already on the level of sensation human understanding is actively producing images. The Jesuits of Coimbra invoke Aquinas and some of his commentators for approval of this theory. However, the cited passage[26] happens to say the opposite: in the context of the question of whether we need to assume an agent intellect, Aquinas draws the comparison with sense experience and declares without further argument that it is not necessary to assume there is an "agent sense" (*sensus agens* – i.e., an operative power in the senses), because all potentials of the senses are passive. (Not that there is anything noble about being active: the digestive powers of the soul are, obviously, active.) But the Conimbricenses invoke as their main authority the Church Father Nemesius of Emesa, who in his *De natura hominis* treated the 'phantastic' power of the soul as something operative through the senses.[27] Nemesius further elaborates on the mechanism of perception, which is quite interesting because he also refers to the "animal spirit," which Descartes would still employ to explain the operation of sense perception on the body.[28] The Jesuits must have been aware that the *Exercises* worked at the core of current epistemology and physiology.

The Conimbricenses confirm their interpretation in their commentary on *De anima*, book III. But they also insert some remarks about truth and falsehood. It is obvious that in 'phantastic' imaginations there can be deception. On the other hand, we might think that truth and falsehood are beyond sensual experience, since it is only judgment and predication that can be misled. But if sensation is an operation, or a movement of the

soul, it may be wrong. Aristotle said, indeed, that imagination combines the souls and the senses; and it is only true if this operation works together with the senses.[29] The Jesuits elaborate on that by warning: imagination is a sort of cognition that is generated by the representation of the image that is produced by it; consequently, imaginations may be false; and such truth and falsehood may depend on the presence or absence in space and time of the things imagined.[30]

For our purpose, the literary references offered by the Jesuit commentators on Aristotle's understanding of the senses are helpful because they lead us back to the potential sources Ignatius might have known. Whereas Aquinas represents the officially approved stream of Aristotelian philosophy, Nemesius leads us to Platonism. While we saw that the Jesuits misappropriate the Aristotelian account, it is obviously the Platonic tradition that yields a theory of perception, in which the senses are active, or rather, in which operational activity is the fundamental principle of the mind that naturally branches out into perception.

The easiest accessible Neoplatonic source, at least to us, but perhaps also to Ignatius and his teachers, is Marsilio Ficino.[31] In his *Platonic Theology*, intended as a defense of the immortality of the soul against certain Aristotelians, he unmistakably emphasizes the activity of the soul in the process of sense cognition:

> Sensation is concerned with bodies, imagination with the images of bodies perceived. [...] The phantasy has at least an inkling of substance [...]. [The] particular concepts of the phantasy are [...] bodiless intentions of bodies.[32]

Ficino also takes into account the volitional component of cognition:

> [...] Nothing appears to me to demonstrate more that the nature of the human mind is midway than its natural inclination towards both [goals]. If this inclination is via the intellect then either begins from bodies and thence straightway transfers itself into things incorporeal, or it arises now and then from things incorporeal and descends in turn to bodies' images. If it is via the will, then either it chooses things eternal [...] or [...] it desires things temporal, and in turn is often kept back from them by its reverence for things eternal.[33]

Neoplatonism held that sense perception and imagination are areas of intellectual competence that are not passively dependent on external input (as empiricists would have it); rather, they are creative modes of being of the soul. From there it is only a small step towards producing images deliberately and freely. In his dialogues on Plato's *Symposium*, Ficino explains summarily: between the soul and the body mediates a spirit; and the soul adopts from the spirit the bodily images thus cognizing the corporeal world. However, in observing those images it conceives (*concipit*) of itself and in itself much purer images – this he calls imagination or phantasy.[34] Ficino's classification of senses seems at odds with Ignatius's appreciation of sensual perception because the Platonist occasionally advocates a dualism between the bodily senses touch, taste, and smell and the intellectual senses reason, sight, and hearing.[35] On the other hand, he does agree with the *Exercises* in presupposing that the soul is active in finding its orientation in the hierarchy of beings while, as he quotes from Plato, "she is eager (*affectat*) to intuit the divine seeing in it what is cognate to her."[36] Since this dialogue is about love, we hardly will find descriptions of compassion and suffering; and yet, emotions are at the core of the activity of the human soul: pleasure is the key term when

Ficino describes the incorporeality of beauty.[37] Even God's face, the source of beauty, is termed *gratia* in the sense of 'pleasantness' insofar as it shines through the corporeal eyes, making them capable of affections.[38]

One main feature of the Platonic tradition, relevant for our interpretation of the *Exercises*, is the fact that human beings gauge themselves in relation to the world and God. Ficino and other Platonists speak about the divinization through contemplation, meaning the passage from the earth towards salvation. Ficino even concludes his interpretation of Diotima's speech by stating: "first we appear to revere God in things, while revering the things in God, and we appear to revere things in God in order to embrace ourselves in Him; eventually, in loving God we must have loved ourselves."[39] Therefore, for historians of Platonism welcome evidence for the Platonic mentality of the *Exercises* is the objective number 3 of the Second Exercise; here the person is confronted with the hypostases of the world:

> I look at who I am, diminishing myself by means of comparisons: (i) What am I compared to all human beings? (ii) What are all human beings compared to all the angels and saints in Paradise? (iii) What can I alone be, as I look at what the whole of creation amounts to in comparison with God? (iv) I look upon all the corruption and foulness of my body. (v) I look at myself as though I were an ulcer or an abscess, the source of many sins and evils, and of great infection.
>
> (58)

Raimundus Sabundus would have nodded first and then cringed towards the end because he, too, had made self-positioning in the hierarchy of beings the key to piety without making self-effacement a requirement.[40] Nicolaus Cusanus, Marsilio Ficino, Giovanni Pico, and Giordano Bruno would have all applauded to this renewed appeal for the dignity of man searching the human position among the hypostases, although regretting that Ignatius had joined the ranks of the pessimist strain of the Protestants. Bruno's *Eroici furori* (1584) might even be read as a response to the *Exercises*.[41]

The Emplotment of Images

The procedure will be repeated with every further exercise: prayer, composition of place, begging for emotions, and concluding colloquy. But to round out our irreverent look at Ignatius' masterpiece, we need to discover one more feature that will definitely lead us into the history of iconology. In the Second Week, the object of visual and speculative contemplation, the secular king, should lead to the Eternal King, and to that effect the visual images are to be "synagogues, towns and villages where Christ Our Lord went preaching" (91). From there, it is a small step to animate the stationary imagery with dynamic action. We observed already that the guide of the exercises will tell the exercitant the history/story to be made the object of contemplation. There, in the Second Annotation, it was "the *history* of this meditation or contemplation" that was made self-referential for the purpose of savoring its lasting meaning. Now, from the second week on "proponere historiam" means expanding the imaginary field and therefore it precedes the *compositio loci*. The first instance that occurs in the book suggests that in order to contemplate the Trinity one should imagine the perspective of God on the history of salvation (102). For the composition of the place, this is the 'historic' background, which consists in imagining first the vast world and then St. Mary's cubicle (103). In the next

instance, the history/story is Mary's and Joseph's travel from Nazareth to Bethlehem, followed by the imagery of the same event (111–2). In another case, *historia* is Christ's calling to gather under his flag (*vexillum*) against Lucifer and his army, with the images of the battle fields of Jerusalem and Babylon (137–8). It is not anymore surprising that detailed scenes of the life of Christ become material for further contemplations (161; 191 ff., 261 ff.). The familiar scenes of the life of Christ and of salvation become part of a narrative plot. Ignatius recommends the technique of emplotment.[42]

An advice for the Seventh Day of the Third Week sheds more light on the epistemological meaning of the composition of stories and images: Ignatius suggests that "anyone who wants to spend more time on the Passion should take fewer mysteries in each contemplation, e.g. in the first, only the Last Supper, in the second, the washing of the feet," and so on (209). The exercitant shall have full control of the spiritual experience and free disposition over the material that is to be transformed into a spiritual activity.

It is commonplace that imagery was one of the foremost homiletic, literary, and artistic productions of the Jesuits.[43] Theater performances, both for didactic purposes and for public display, were also meant to impress the lower faculties of the mind for higher goals.[44]

Antonio Possevino, the encyclopedist of the early Jesuits, defended the use of images, especially sacred images and those of God, with the argument that visual representations have a status of education and elevation: they do not prove that God exists but in which form he suggests himself to vision. Images do not express the essence of the thing but make the thing visual. Images present the invisible by means of the visible.[45] In his chapter on poetry and pictorial art, he stresses the meaning of imitation by identifying the emotional meaning of a story and a representation with 'the thing itself.'[46] In this vein, Possevino gives advice on how to create an image of Christ that evokes passion: the artist has to pray and to conceive not just the "idea of the future artwork" but a sense of the pain (*sensum dolorum*). The painter has to live the magnitude of the emotion internally, and it is from there that suffering in the viewer can erupt: "If you want me to weep, you, artist, have to weep first."[47] The thing itself, as noted in section 2 of the *Exercises*, is its sentimental meaning.

Most conspicuous among the many artistic achievement of the Jesuits are the programmatic architectural paintings, like the vault of Sant Ignazio in Rome;[48] the *Vita Beati Ignatii Loiolae* (1609), illustrated by Peter Paul Rubens (1577–1640) and others with the purpose of empathizing with the struggles and torments of the author of the *Exercises*;[49] the *Pia desideria* of Herman Hugo; and the spiritual chants by Friedrich von Spee, which are exuberant in imagery.[50] Yet here I should make some observations on the illustrations of the New Testament by Hieronymus Nadal (1507–1580).

Nadal planned and wrote the book of *Annotations and Meditations on the Gospel* with illustrations by various artists.[51] The work was commissioned by Ignatius himself and eventually appeared in 1593.[52] The luxurious layout and the artistry of the illustrations culminate in the illustration no. 131, which shows Christ's descent into the Limbo and which is at the same time an illustration of Dante's *Inferno* (Figure 9.1).[53] However, the majority of the illustrations are more modest, and they perfectly fulfill the requirements of the *compositio loci* because they focus on a major event (e.g., the Annunciation, Figure 9.2) and offer the emplotment through organically added side scenes in the background. Nadal's work has every image adorned with notes that explain the factual details on the plate. After that ensues the relevant reading from the Bible, more extensive explanations of the details, and a meditative prayer.[54] Nothing is left unorganized. In other words, this book is the execution of the transition from the purposefully guided imagination to visible images.

Figure 9.1 Hieronymus Natalis, *Adnotationes et meditationes in Evangelia* … (Antverpiae: Martinus Nutius, 1595). Folio following p. 394, Christ's descent into the Limbo.
Source: Biblioteca del Monasterio de Yuso de San Millán de la Cogolla. La Rioja. España.

Figure 9.2 Hieronymus Natalis, *Adnotationes et meditationes in Evangelia* … (Antverpiae: Martinus
 Nutius, 1595). Folio following p. 404, Annunciation.
Source: Biblioteca del Monasterio de Yuso de San Millán de la Cogolla. La Rioja. España.

Ignatius is reported to have collected himself images that would enhance his personal meditations.[55] In commissioning the commented illustrations to the Bible, he initiated the decisive transition from the imaginarily construed *locus* to the artfully designed visual help for the composition of the object of meditation and its emplotment. Therefore, it has been said that Nadal's spiritual reading of the Bible differs from antecedents "thanks to the system of annotations [...], which serves the purpose of embedding the historical truth of the Scripture. Nadal's meditation thus avoids the danger of dissolving the reality of the Gospel into mystical meanings [...]"[56] This form of combined image and text, art work and inspirational reading became very popular among the Jesuits when their spirituality merged with, or adopted, the Renaissance emblem book tradition.[57] Herman Hugo's *Pia desideria* is an example of the emblematic tradition turned into mediation.[58] As the *Exercises* recommend, it is the pictorial narrative of the soul in search of God, told in images that are suggestive through their plainness.

To sum up: iconology, understood as the artful, educated, and purposeful construction of pictorial images, not only relies on canons of representation and their ingenious application and transformation; Ignatius' *Spiritual Exercises* suggest that it also requires a peculiar epistemology that aims at gathering and coordinating a host of psychic faculties and processes: memory, imagination or vision, rational discourse, projection, empathy, abstraction, and conceptualizing. Furthermore, at least in the ascetic context, the ultimate aim is not the external object of a painting or a narrative but the formation and self-regulation of the psychic faculties. Hence, I dare to conclude my contribution by speculating that Baroque spiritual art was at the origin of the modern understanding of art as arousing rationalized emotions. "Aesthetischer Genuss ist objektivierter Selbstgenuss," as Wilhelm Worringer phrased it.[59] Against such secularized piety, he reclaimed art as primarily decorative and diagrammatic (*graphisch*). When Mel Gibson reenacted the Passion of Christ in graphic[60] movie pictures, he relied on the self-indulging function of images and invited the audience to suffer with Christ and to feel guilty with his murderers. The success according to the program of the *Spiritual Exercises* or the degree of secularization should be measured by the number of viewers who experienced a conversion.

Notes

1 Research for this contribution was funded by the Czech Science Foundation as the project GA CR 14–37038G "Between Renaissance and Baroque: Philosophy and Knowledge in the Czech Lands within the Wider European Context." Some of the topics and sources treated in the present text were also discussed in my "Heroic Exercises: Giordano Bruno's *De Gli Eroici Furori* as a Response to Ignatius of Loyola's *Exercitia spiritualia*." *Bruniana & Campanelliana* 18 (2012): 359–73, as well as in my "Psychology and Culture of the Intellect: Ignatius of Loyola and Antonio Possevino." In *Cognitive Psychology in Early Jesuit Scholasticism*, edited by Daniel Heider, 12–37. Neunkirchen-Seelscheid: Editiones Scholasticae, 2016.

2 Ignatius de Loyola, *Exercitia spiritualia*, ed. Iosephus Calveras and Candidus de Dalmases (Romae: Institutum historicum Societatis Iesu, 1969) (Monumenta Historica Societatis Iesu, vol. 100); plain numbers will refer to the sections of this edition; modern editions offer the same numbering system. Quotations and my translations are from the original Spanish and the literal Latin versions in this edition.

3 Barthes (1989, 52).

4 Barthes (1989, 54).

5 Barthes (1989, 55).

6 Blum (1998, ch. 4: Schulphilosophie).

7 Ignatius (1996). This translation is based on the Spanish so-called Autograph. Quotations without further additions refer to this translation. In this case, I corrected "for the body" to "of the body."

8 For instance, Aristotle's *Nicomachean Ethics*, book II, which elaborates on the exercise as performative virtue with examples from athletics. Bacht (1977, 214) underscores the "ascetic-active component."

9 Nr. 2; my translation, my emphases.

10 The translation by Munitz and Endean (Ignatius 1996) took refuge to pale fashions of speech, like: "throw light" and "bring home."

11 On the history and development of the book, see Candidus de Dalmases, "Introductio" in Ignatius (1969, 27–33).

12 Marsilio Ficino, *Theologia Platonica*, book 14, esp. chapter 8; Ficino (2002–6, vol. 4, 279–89). See Blum (2010, 124).

13 Von Balthasar (1961–67, vol. 3/1 [1965], 456).

14 An exhaustive assessment of the *Exercises* in the mystical tradition in Bacht (1977). On the influence of the abbot of Montserrat García Jiménez de Cisneros and *devotio moderna*, see Demoustier (1996).

15 Sudbrack (1990), with discussion of various interpretations.

16 Translators suggest that "composition" has to do with modern American 'composure' or composing oneself. Unfortunately, the text does not allow for that at all. See Ignatius (1996, xv–xvi): "composition (*composición*): A preliminary to prayer, as one 'composes' oneself by 'composing' (= recalling to mind) the locale of the scene being contemplated or by imagining a suitable setting for a topic, e.g. a happy, or a shameful, or an awesome situation." Similarly Ignatius (1991, 397).

17 Classen (1977, 241). A comparison with Saint Bonaventure is suggested by Cousins (1984); common ground could be devotion to the humanity of Christ (51) and the method of re-presenting the life of Christ (58–61).

18 Von Balthasar (1961–67, vol. 1 [1961], 361). On early Jesuit interpretations and sources in Bonaventure and Augustine, see p. 361 ff.

19 See De Boer (2011, 240), with further literature.

20 See sections 121, 129, 134, 159, 204, 208 a and f.

21 Candidus de Dalmases, "Introductio," in Ignatius (1969, 118–9; the first edition was printed in Rome 1548).

22 Candidus de Dalmases, "Introductio," in Ignatius (1969, 110): "Textus hispanus seape utitur verbo *traer* ad indicandum usum potentiarum vel sensuum."

23 Reverence is not exactly the purpose of the colloquy as Munitz and Endean (Ignatius 1996, xv) suggest, but it is not excluded.

24 A brief overview on Jesuit teachings on the soul: Simmons (1999). It may be helpful to recapitulate standard school teaching on the parts of the soul: the five senses; the *sensus communis* (to which the information from the external senses are transmitted), which is the first cognitive faculty of the soul; phantasy, which transforms the images into immaterial concepts; the lower and the higher judgment (*aestimatio, cogitatio*); reason (*ratio*), which ponders the information; intellect, which understands. This is paraphrased from a Jesuit encyclopedia of learning: Antonius Possevinus, *Bibliotheca selecta de ratione studiorum*, 2nd edition (Venetiis: Salicatius, 1603), lib. 12, cap. 43, vol. 2, 13. I did not have access to Milner (2011).

25 *Commentarii Collegii Conimbricensis Societatis Iesu In tres libros Aristotelis De anima* [Coimbra 1598] (Coloniae: Zetzner, 1617), II, cap. 6, q. 1, art. 2, col. 186.

26 Thomas Aquinas, *Summa theologica*, I. 79. art. 3: "Ad primum ergo dicendum quod sensibilia inveniuntur actu extra animam, et ideo non oportuit ponere sensum agentem. Et sic patet quod in parte nutritiva omnes potentiae sunt activae; in parte autem sensitiva, omnes passivae; in parte vero intellectiva est aliquid activum, et aliquid passivum."

27 *Nemesii Episcopi Premnon physicon* (Burkhard 1917), chapter 6, p. 72: "Phantastica igitur est virtus irrationalis animae per sensus operativa; phantaston autem, hoc est imaginabile, est quod phantasiae subiacet, ut sensus et sensibile; phantasia vero, id est imaginatio, est passio irrationalis animae ab aliquo imaginabili facta." According to *Tusculum-Lexicon griechischer und lateinischer Autoren* (Buchwald, Hohlweg and Prinz 1982, 549), this work was popular in the Middle Ages.

28 *Nemesii Episcopi Premnon physicon* (Burkhard 1917), chapter 6, p. 73: "Instrumenta vero eius sunt anteriores cerebri ventres et animalis spiritus, qui in ipsis est, et nervi, qui sunt ex ipsis rorantes animalem spiritum et compositio sensuum."

29 Conimbricenses text, 160–1.

30 This is probably a precaution on behalf of the "discernment of the spirits" (313–36), the concern to distinguish God's inspiration from evil insinuations, a topic that exceeds the scope of this paper.

31 See Voss (1996). This paper casts a net far too wide to be useful in our context; the author enrolls Ignatius in the magic tradition and focuses on Ficino's cosmology in *De vita*.

32 Ficino, *Theologia Platonica*, book 8, 1.2–3; Ficino (2002–6, vol. 2, 263/265).

33 Ficino, *Theologia Platonica*, book 15, 10.2; Ficino (2002–6, vol. 5, 111).

34 Marsilio Ficino, *De amore*, VI, 6; edition used: Ficino (1956, 207). Translations from this work are mine.

35 *De amore*, V, 2; Ficino (1956, 180).

36 *De amore*, IV, 5; Ficino (1956, 173). See Plato's *Second Letter*, 313a.

37 See the anaphoric "Placet …" in *De amore* V, 3; Ficino (1956, 183).

38 *De amore*, V, 5; Ficino (1956, 18): "admiratione commoti diligimus." At this point it should be noted that Ficino develops the affective quality of contemplation into his theory of divine furor (VII, 13–15). Although he declares that love is another word for sincerity, piety, and worship (VII, 15; Ficino, 1956, 260), I do not see a viable connection with Ignatius' spirituality.

39 *De amore*, VI, 19; Ficino (1956, 239).

40 Raimundus Sabundus, *Theologia naturalis seu liber creaturarum*, titulus 63; Sabundus (1966, 81). See Blum (2010, 16).

41 Voss (1996, n. 52) mentions in passing that "Bruno had produced the same techniques found in *The Spiritual Exercises*." See meanwhile Blum (2012). Regarding Bruno without reference to Ignatius, see Otto (1999).

42 A term from the philosophy of history of Paul Ricoeur: data are gathered and made understandable in a narrative plot.

43 Just some examples out of the plethora of literature: Bailey (2003) with indications regarding the impact of the composition of place on art (7–13), with bibliography; O'Malley (2006), part 2: The visual arts and the arts of persuasion. An extensive overview on Jesuit spirituality in printed and decorative arts offers Polleross (2001). I had no access to Fabre (1992). The *Exercises* are not mentioned in Bocken and Borsche (2010).

44 For an example, see McCreight and Blum (2009), with an introductory section on theater as a spiritual exercise and bibliography.

45 Possevinus, *Bibliotheca selecta* (1603), lib. 8, cap. 16–17, vol. 1, p. 413–8. He names as his source the fellow Jesuit Petrus Thyraeus.

46 Possevinus, *Bibliotheca selecta* (1603), lib. 17, cap. 35, vol. 2, p. 454: "At ego summam esse artem constantissime assero, quae rem ipsam imitetur, martyria in martyribus, fletum in flentibus, dolorem in patientibus, gloriam, et laetitiam in resurgentibus exprimat, et in animis figat."

47 Possevinus, *Bibliotheca selecta* (1603), cap. 36, p. 546: "Ut igitur funestissimus Christi [...] interitus admirationem, et acerbum dolorem in aliis pariat, necesse est ut in Pictoris animo insit, unde existat admirationis magnitudo, et impetus doloris erumpat. Si vis enim me flere, prius flendum est tibi, inquit Poeta." See Horace, *Ars poetica*, 102–103. On the decoration of churches with scenes of martyrdom "that spared the viewer none of the brutality," see Levy (1990, 49).

48 Levy (1990), Bailey (2003) on several Roman churches.

49 Navas Gutiérrez (1992). See O'Malley (2008).

50 See Sievernich (1991, 620–23).

51 Hieronymus Natalis, *Evangelicae historiae imagines, ex ordine Evangeliorum, quae toto anno in missae sacrificio recitantur …* (Antverpiae: N.N., 1593); *Idem*, Adnotationes et meditationes in Evangelia … (Antverpiae: Martinus Nutius, 1595). Nadal (2003–7). On the history of the book, see Wadell (1985).

52 Buser (1976, 424–6). On Nadal's acquaintance with Ignatius' spirit, see Rahner (1953, 88–108).

53 Obviously due to a typographical error, this illustration is missing in the reprint, where it should have been on p. 271 of vol. 2, but it is available on the CD that accompanies the print.

54 A thorough study of Nadal's theory and practice of imagination and prayer is the "Introductory Study: The Art of Vision' in Jerome Nadal's *Annotationes et meditationes in Evangelia*" by Walter S. Melion in Nadal (2003–7, vol. 1, 1–96). See Melion (2012) and Melion (1998).

55 Buser (1976, 425). An alleged commission by Ignatius to illustrate the *Exercises* is discussed in Fabre (1996).

56 Dekoninck (2004, 61).

57 From the host of literature, here are some examples: Campa and Daly (2010), Enenkel and Visser (2003), Daly (2000). Possevino does not mention Nadal's work when he treats emblematic art (*Bibliotheca selecta*, lib. 17, cap. 38–39), and he only cites it in his *Apparatus Sacer* (Coloniae: Gymnich, 1608, 522 and 743).

58 Herman Hugo, *Pia desideria emblematis, elegiis & affectibus SS. patrum illustrata* (Antwerp: Aertssen, 1624). See Rödter (1992).

59 Worringer (1906–7/1921). His paradigmatic opponent was Theodor Lipps, whose classification of empathy and emotion in art, as quoted by Worringer (7, but see the entire introduction) sounds like a secularized summary of Ignatian sensuality: "Indem [das sinnlich gegebene Objekt] für mich existiert […], ist es von meiner Tätigkeit, von meinem inneren Leben durchdrungen."

60 The modern understanding of 'graphic' as (sexually, violently) explicit (first occurrence 1856, *Oxford English Dictionary*, Draft Additions December 2002, http://www.oed.com.ezp.lndlibrary.org/view/Entry/80829) appears to be yet another derivative of the *compositio loci*.

Bibliography

Bacht, Heinrich. 1977. "Early Monastic Elements in Ignatian Spirituality." In *Ignatius of Loyola. His Personality and Spiritual Heritage, 1556–1956: Studies on the 400th Anniversary of His Death*, edited by Friedrich Wulf, 200–236. St. Louis: Institute of Jesuit Sources.

Bailey, Gauvin A. 2003. *Between Renaissance and Baroque: Jesuit Art in Rome, 1565–1610*. Toronto: University of Toronto Press.

Barthes, Roland. 1989. *Sade, Fourier, Loyola*, translated by Richard Miller. Berkeley: University of California Press.

Blum, Paul Richard. 1998. *Philosophenphilosophie und Schulphilosophie: Typen des Philosophierens in der Neuzeit*. Stuttgart: Steiner.

Blum, Paul Richard. 2010. *Philosophy of Religion in the Renaissance*. Farnham: Ashgate.

Blum, Paul Richard. 2012. "Heroic Exercises: Giordano Bruno's *De gli eroici furori* as a Response to Ignatius of Loyola's *Exercitia spiritualia*." *Bruniana & Campanelliana* 18:359–373.

Blum, Paul Richard. 2016. "Psychology and Culture of the Intellect: Ignatius of Loyola and Antonio Possevino." In *Cognitive Psychology in Early Jesuit Scholasticism*, edited by Daniel Heider, 12–37. Neunkirchen-Seelscheid: Editiones Scholasticae.

Bocken, Iñigo, and Tilman Borsche, eds. 2010. *Kann das Denken malen? Philosophie und Malerei in der Renaissance*. Munich: Fink.

Buchwald, Wolfgang, Armin Hohlweg, and Otto Prinz. 1982. *Tusculum-Lexicon griechischer und lateinischer Autoren*. Munich and Zurich: Artemis.

Burkhard, Carolus, ed. 1917. *Nemesii Episcopi Premnon physicon*. Leipzig: Teubner.

Buser, Thomas. 1976. "Jerome Nadal and Early Jesuit Art in Rome." *The Art Bulletin* 58:424–433.

Campa, Pedro F., and Peter M. Daly, eds. 2010. *Emblematic Images and Religious Texts: Studies in Honor of G. Richard Dimler, S.J.* Philadelphia: St. John's University Press.

Classen, Lambert. 1977. "The 'Exercise with the Three Powers of the Soul' in the Exercises as a Whole." In *Ignatius of Loyola, His Personality and Spiritual Heritage, 1556–1956: Studies on the 400th Anniversary of His Death*, edited by Friedrich Wulf, 237–271. St. Louis: Institute of Jesuit Sources.

Cousins, Ewert H. 1984. "Franciscan Roots of Ignatian Meditation." In *Ignatian Spirituality in a Secular Age*, edited by George P. Schner, 51–64. Waterloo, Ontario: Wilfrid Laurier University Press.

Daly, Peter M., *et al.*, eds. 2000. *Emblematik und Kunst der Jesuiten in Bayern: Einfluß und Wirkung*. Turnhout: Brepols.

De Boer, Wietse. 2011. *Invisible Contemplation: A Paradox in the Meditatio – Refashioning the Self: Theory and Practice in Late Medieval and Early Modern Intellectual Culture*, edited by Walter Melion and Karl Enenkel, 235–256. Leiden: Brill.

Dekoninck, Ralph. 2004. "The International Genesis and Fate of two Biblical Picture Books (Hiël and Nadal) Conceived in Antwerp at the End of the Sixteenth Century." In *The Low Countries*

as a Crossroads of Religious Beliefs, edited by Arie-Jan Gelderblom, Jan L. de Jong, and Marc van Vaeck, 49–63. Leiden: Brill.

Demoustier, Adrien. 1996. "L'originalité des 'Exercices spirituels." In *Les Jésuites à l'âge baroque (1540–1640)*, edited by Luce Giard and Louis de Vaucelles, 23–35. Grenoble: Millon.

Enenkel, K. A. E., and A. S. Q. Visser, eds. 2003. *Mundus Emblematicus: Studies in Neo-Latin Emblem Books*. Turnhout: Brepols.

Fabre, Pierre-Antoine. 1992. *Ignace de Loyola le lieu de l'image: le problème de la composition de lieu dans les pratiques spirituelles et artistiques jésuites de la secone moitié du XVIe siècle*. Paris: EHESS.

Fabre, Pierre-Antoine. 1996. "Les 'Exercices spirituels' sont-ils illustrables?" In *Les Jésuites à l'âge baroque (1540–1640)*, edited by Luce Giard and Louis de Vaucelles, 197–209. Grenoble: Millon.

Ficino, Marsilo. 1956. *Commentaire sur le Banquet de Platon*, edited and translated by Raymond Marcel. Paris: Les Belles Lettres.

Ficino, Marsilio. 2002–6. *Theologia Platonica/Platonic Theology*, 6 vols., edited by James Hankins and Michael J. B. Allen. Cambridge, MA: Harvard University Press.

Ignatius de Loyola. 1969. *Exercitia spiritualia*, edited by Iosephus Calveras and Candidus de Dalmases [Monumenta Historica Societatis Iesu, vol. 100]. Rome: Institutum historicum Societatis Iesu.

Ignatius de Loyola. 1991. *The Spiritual Exercises and Selected Works*, edited by George E. Ganss. New York: Paulist Press.

Ignatius de Loyola. 1996. "The Spiritual Exercises." In Ignatius of Loyola, *Personal Writings*, edited by Joseph A. Munitz and Philip Endean, 281–328. Harmondsworth: Penguin.

Levy, Evonne. 1990. "'A Noble Medley and Concert of Materials and Artifice': Jesuit Church Interiors in Rome, 1567–1700." In *Saint, Site, and Sacred Strategy: Ignatius, Rome, and Jesuit Urbanism – Catalogue of the Exhibition Biblioteca Apostolica Vaticana*, edited by Thomas M. Lucas, 47–61. Città del Vaticano: Biblioteca Apostolica Vaticana.

McCreight, Thomas D., and Paul Richard Blum. 2009. *Jacobus Pontanus, S.J., Soldier or Scholar: Stratocles or War*. Baltimore: Apprentice House.

Melion, Walter S. 1998. "Aritifice, Memory, and *Reformatio* in Hiernoymus Natalis's *Adnotationes et meditationes in Evangelia*." *Renaissance and Reformation* 22:5–33.

Melion, Walter S. 2012. "Parabolic Analogy and Spiritual Discernment in Jéronimo Nadal's Adnotationes et Meditationes in Evangelia of 1595." In *The Turn of the Soul: Representations of Religious Conversion in Early Modern Art and Literature*, edited by Lieke Stelling, Harald Hendrix, and Todd M. Richardson, 299–338. Leiden: Brill.

Milner, Matthew. 2011. "The Senses and the English Reformation. Farnham: Ashgate." Review by Stuart Clark, *Journal of the Northern Renaissance*. http://www.northernrenaissance.org/reviews/ (viewed March 1, 2012).

Nadal, Gerónimo. 2003–7. *Annotations and Meditations on the Gospels*, 3 vols., edited by Frederick A. Homann and Walter S. Melion. Philadelphia: Saint Joseph's University Press.

Navas Gutiérrez, Antonio M., ed. 1992. *Jean Baptiste Barbé and Peter Paul Rubens, Artists, Vida de San Ignacio de Loyola en imágenes*. Granada: Universidad de Granada.

O'Malley, John W., ed. 2008. *Constructing a Saint through Images: The 1609 Illustrated Biography of Ignatius of Loyola*. Philadelphia: Saint Joseph's University Press.

O'Malley, John W., et al., eds. 2006. *The Jesuits II: Cultures, Sciences, and the Arts, 1540–1773*. Toronto: University of Toronto Press.

Otto, Stephan. 1999. "Die Augen und das Herz. Der philosophische Gedanke und seine sprachliche Darstellung in Giordano Brunos Heroischen Leidenschaften." *Scientia Poetica* 3:1–29.

Polleross, Friedrich. 2001. "Nuestro Modo de Proceder: Betrachtungen aus Anlaß der Tagung 'Die Jesuiten in Wien' vom 19. Bis 21 Oktober 2000." *Frühneuzeit-Info* 12, 7:93–128.

Rahner, Hugo. 1953. *The Spirituality of St. Ignatius Loyola*. Westminster, MD: Newman.

Rödter, Gabriele Dorothea. 1992. *Via piae animae: Grundlagenuntersuchung zur emblematischen Verknüpfung von Bild und Wort in den "Pia desideria" (1624) des Herman Hugo S.J. (1588–1629)*. Frankfurt am Main: Lang.

Sabundus, Raimundus. 1966. *Theologia naturalis seu liber creaturarum*, edited by Friedrich Steg-müller. Stuttgart, Bad Cannstatt: Frommann.

Sievernich, Michael S. J. 1991. "*En todo amar y server*: Die ignatianische Spiritualität als Formprinzip des Lebens und des Werkes von Friedrich von Spee." In *Ignacio de Loyola, Magister Artium en Paris 1528–1535*, edited by Julio Caro Baroja *et al.*, 615–634. Donostia, San Sebastián: Kutxa.

Simmons, Alison. 1999. "Jesuit Aristotelian Education: The *De anima* Commentaries." In *The Jesuits: Cultures, Sciences, and the Arts, 1540–1773*, edited by John W. O'Malley *et al.*, 522–537. Toronto: University of Toronto Press.

Sudbrack, Josef S. J. 1990. "Die 'Anwendung der Sinne' als Angelpunkt der Exerzitien." In *Ignatianisch: Eigenart und Methode der Gesellschaft Jesu*, edited by Michael Sievernich and Günter Switek, 96–119. Freiburg: Herder.

Von Balthasar, Hans Urs. 1961–67. *Herrlichkeit: Eine theologische Ästhetik*, 3 vols. Einsiedeln: Johannes Verlag.

Voss, Karen-Claire. 1996. "Imagination in Mysticism and Esotericism: Marsilio Ficino, Ignatius de Loyola, and Alchemy." *Studies in Spirituality* 6:106–130.

Wadell, Maj-Brit. 1985. *Evangelicae historiae imagines: Entstehungsgeschichte und Vorlagen*. Göteborg: Acta Universitatis Gothobugensis.

Worringer, Wilhelm. 1906–7/1921. *Abstraktion und Einfühlung: Ein Beitrag zur Stilpsychologie*, PhD diss. Bern; 11th edition, Munich: Piper, 1921.

10 Neither Drunk nor Sober

Dionysiac Inspiration and Renaissance Artistic Practices

François Quiviger

The following pages examine the Neoplatonic theory of Dionysiac inspiration presented in the works of Marsilio Ficino in the context of Renaissance artistic practices. The return of Bacchus in Renaissance philosophy is one of the many cultural repercussions of the expansion of wine and wine making which took place all over Europe from the end of the fourteenth century onwards. As means of production, conservation and transport improved in the late Middle-Age, wine became more affordable and more accessible. Consumption increased. It seems to have trebled. The research of economic historians has established that from the early thirteenth century onwards we move from annual figures of c. 100 liters per capita to well over 300 liters from the fifteenth century onwards.[1] Since these figures are usually calculated from tax records, they are considered underestimates of the real alcohol consumption of the early modern era; they seem modest in comparison to the five daily liters of wine consumed by the workforce of the Venetian Arsenal.[2] Such figures stand in sharp contrast with present day statistics for France and Italy, assessed at respectively 63.4 and 60.4 liters per person per year.[3] Indeed, the sixteenth century, a time when it was much safer to drink wine rather than water, has been declared a 'drunken century.'[4] Thus the Renaissance and Baroque periods were Dionysian eras; the return of classical literature and philosophy occurred in a continent irrigated by wine in the South and beer in the North. The revival of Platonic theories of inspirations is one aspect of this phenomenon. Others, as we shall see, are the emergence of a new iconography representing Bacchus as a god of inspiration and a proliferation of images of Bacchanals, a genre absent from the Middle Ages and which stands out in the Renaissance as a representation of the dangers of excessive drinking.[5]

This paper endeavors to explore aspects of this phenomenon in so far as it pertains to Neoplatonism, inspiration, and the visual arts. The first part discusses the place assigned to Bacchus and to wine in Marsilio Ficino's theory of inspiration and health. The second part examines some iconographic repercussions of Renaissance attitudes to wine and the third part explores instances of the use of wine by artists.

Neoplatonic Wine

Plato never approved of states of frenzy. He promoted the expulsion of poets from his ideal state, and the dialogue he devoted to poetic inspiration, the *Ion*, has been analyzed as a particularly ironic characterization of poets.[6] Ficino is the main artisan of the transformation of Plato's unflattering observations into a Neoplatonic theory of inspiration. His commentaries on the *Phaedrus*, the *Ion* and the *Symposium* broadcast the concept of frenzies as states of enthusiasm, experienced by poets, Maenads (the followers of

Bacchus), prophets, and lovers.[7] As is well known, this aspect of Ficino's thought passed to mainstream vernacular literature thanks to influential works such as Baldassare Castiglione's *Cortegiano* and Pietro Bembo's *Asolani*.[8] But Bembo did far more: the Italian vernacular tradition which he initiated took Petrarch's *Canzoniere* as its poetic model and Ficino's *De amore* as its philosophy. It is principally through this channel that Neoplatonic ideas permeated vernacular poetry and love literature and became accessible to artists.

This mundane philosophy can be characterized as an aspiration towards the divine initially triggered by either auditory or visual perception. Indeed, Neoplatonism sets a sensory hierarchy privileging sight and hearing over the other senses.[9] Sight and hearing are considered spiritual senses in so far as they convey an immaterial beauty unattainable by the lower senses of contact with matter – taste, touch, and smell. These incorporeal attributes of beauty perceived by sight and evoked with words such as *grazia, vaghezza, maestà* etc. were deemed the first ascending steps towards the divine.[10] This is indeed a matter of male gaze triggered by the sight of beautiful bodies as much as the impact of Ficino's commentary on the *Symposium* and its belief that the perception of beauty can initiate a mystical ascension.

Ficino's sources are neither mundane nor vernacular; they point to his links with the Christian Platonism of the Camaldolese order.[11] He probably borrowed the Christian mystical image of the itinerary of the soul to God and adapted it to four steps corresponding to each of the four frenzies listed by Plato: Poetic, Bacchic, Prophetic or Divinatory, and Amorous, from which derive four human activities, as he wrote in his *De amore*: "Poetry is from the Muses, mystery from Dionysus, prophecy from Apollo; love from Venus."[12]

To summarize, he explained how these four states are ascending steps leading from worldly multiplicity to divine unity:

> [...] the first madness tempers the scattered and dissonant things. The second makes the tempered things into a single whole from parts. The third makes it a single whole above the parts. The fourth leads it to the One which is above being.[13]

I would like to focus on the second *furore*: the mysteries, or more precisely the Bacchic mysteries. It seems very difficult, however, to take Ficino literally. Can drinking bouts bring together scattered parts on the way to Apollonian unity? Could the consumption of wine replace the perception of beauty as a means of ascending towards the divine? To understand this better, we must turn to Ficino's medical writings. Indeed, wine is not only part of the new Platonic philosophy; it is also part of the diet of Renaissance intellectuals. The first book of *De vita libri tres*, which Ficino wrote to help scholars preserving their health, recommends drinking wine at least twice a day, a diet which Ficino admitted practicing assiduously himself.[14] The book is in fact dedicated to Bacchus and begins with an interpretation of the Bacchic mysteries:

> But our task is not at present to speak of sacred mysteries, when we are presently about to bring help to the sick by natural means. Nor ought we proceed in a style that expresses gravity – after beginning somehow or other with Father Liber – but rather in a style that is free [pun on 'Liber'] and jocose [...]. For he [Bacchus/Liber] perhaps heals more salubriously with his nourishing wine and his carefree jollity than Phoebus with his herbs and songs.[15]

Thus Bacchus stands for a rhetorical mode, lighthearted and joyful, like the comforting sensations brought about by moderate wine consumption.

> For assuredly Phoebus and Bacchus are brothers and inseparable companions. Phoebus brings us principally two things, namely light and the lyre; just so, Bacchus brings us principally two things in particular, wine and the odor of wine to renew the spirit, by the daily use of which the spirit finally becomes Phoeban and liberated [pun on Bacchus as Liber].[16]

Ficino then goes on with the Apollonian benefits of music and concludes with remarks hinting to a very intensely sensorial relationship to wine:

> You ought to take a similar attitude toward wine, the gift of Bacchus, begotten by the kindness of Apollo [...]. Take wine in the same proportion as light – abundantly, so long as neither sweat nor dehydration, as I said, nor drunkenness occurs. But besides the substance of wine taken twice daily, absorb more frequently the odor, partly indeed by rinsing your mouth with wine, whenever you need to recreate your spirit, partly by washing your hands in it, partly by applying it to your nostrils and temples.[17]

Thus, like most moralists of his time, Ficino condemns drunkenness but recommends consuming wine in the same proportion as sunlight. For Ficino, and the tradition he inherits – from Aristotle, to Galen, Avicenna, Pietro d'Abano and Arnaldo da Villanova – wine has the nature of fire and carries the properties of spices and medicinal herbs to the brain.[18] The warm vapor of wine sustains and feeds the spiritus essential to the good functioning of the body and mind.[19] Today, sensible alcohol intake is quantified in terms of daily units: no more than 4 for men and 3 for women.[20] This approach is entirely irrelevant to Ficino and the tradition in which he was working. For Ficino, you can drink as much as you need to keep your spirit warm – as long as you do not get drunk. Excessive consumption is damaging, but prolonged moderate absorption is beneficial.[21] Thus we have in Ficino a medical and philosophical justification for what we might today identify as a form of alcoholism: it amounts to cultivating an in-between state neither drunk nor sober, just warmed up – lighthearted and playful like the rhetorical tone which Ficino himself associated to Bacchus.

The alcoholic Renaissance clearly distinguished between the effect of temperate drinking and the consequence of excess. According to the early sixteenth-century writer Mario Equicola abusive drinking eventually makes the body tremble, gives a fetid breath and kills memory.[22] Not only the medical tradition observed the negative effect of excessive alcohol on the body but also the condemnation of drunkenness and its association with the mortal sin of gluttony is a theme harking back to the early Church Fathers.[23] The allegorical language of the Renaissance broadcast the same ideas. Anton Francesco Doni, for instance, in his *Pitture* of 1564, depicts wine in the bad company of the enemies of Vigilance: Sleep and Drunkenness.[24] In a similar vein, Giacomo Zucchi, in his *Discorso sopra li Dei de' Gentili e loro imprese* of 1602, echoes a common characterization of the destructive consequences of drunkenness:

> Drunkenness takes memory away, ruins the senses, confuses the intellect, incites sexual appetite, thickens the tongue, corrupts blood, debilitates the body, shortens life and in the end takes away all health.[25]

Such views also feature in emblematic literature, with an emphasis on the positive aspects of wine. Giovanni Ferro's monumental compilation *Teatro d'imprese* of 1623 discusses wine in two chapters respectively dedicated to the symbolism of barrels and that of grapes. The chapters on barrels (*Botte, Vaso di Legno, Cerchio*) opens with a lyrical praise of wine:

The liquor of Bacchus is the consolatory of souls, vivifying the spirit and is pleasant and sweet to everyone [...].[26]

The chapter on grapes, in Italian *Vite*, brings many punning opportunities on life, *Vita*, as well as a summary of the benefits and dangers of wine:

[...] which in large quantity causes harm to the entire body and principally to the brain; but taken moderately [wine] clears up the mind, illuminates the intellect, sharpens the wit, corroborates strength, gives souls courage, increases audacity, vivifies spirits, makes hearts rejoice, and chasing away melancholy, maintains men in life for long.[27]

Renaissance elites fondly adopted temperate drinking while cultivating vernacular eloquence in particular through the art of conversation, an interactive activity particularly congenial to the Ficinian approach to drinking. Stefano Guazzo's *Civile conversatione* of 1588 confirms this impression. Book 4 of this important text, the late sixteenth-century equivalent of Castiglione's *Cortegiano*, describes a banquet in which wine features as a subject of conversation. There we encounter advices and practices very similar to those advocated by Ficino and, indeed, some emphasis on the odor/vapor of wine, which comforts and rejoices melancholic spirits.[28]

[...] for good health we should drink a little and often [...]. Because if we drink too abundantly such a heaviness of body and soul follows, that we can hardly breath, and even less think. But if [wine is] taken often but in small glasses, in this way not only will we not suffer drunkenness, but we will also feel invigorated and brought to a major joy by some kind of pleasing eloquence.[29]

The tempered use of wine advocated by Guazzo – *bevere spesso ma poco* (to drink often, but a little at a time) – means not getting drunk but simply, in early modern medical terms, keeping one's inner fire temperate. The stylistic and social outcome of this medical approach is a joyful and pleasing eloquence in full convergence with the Renaissance ideal of social grace, voiced in milestone texts of European diffusion such as Castiglione's *Cortegiano* (1528), Erasmus's *On the Education of Children* (1529) and Della Casa's *Galateo* (1558). Here being civilized is not about sobriety but about self-control.

Images

This Dionysian rebirth in the heart of Renaissance culture had several iconographic repercussions. These include the image of the winged Bacchus and the rise of the Renaissance Bacchanal, which, as we shall see, brought in its trail a wealth of pictorial representations of the effect of wine on the human body and on visual perception.

In an article of 1980, Michael Screech identified the source of the winged Bacchus in the works of Rabelais, who in turn borrowed it from Erasmus, Pausanias, and Athenaeus. From there, the winged Bacchus spread to emblem books and even drinking bowls (Figure 10.1).[30] Rabelais's introduction to his *Gargantua* provides hints of this Renaissance wine, as the text begins with praise of Silenus, followed by praise of drinking. The aspect of wine to which Rabelais alludes is neither exclusively spiritual nor metaphorical. Rabelais explains that he wrote while boozing and that the reader should also drink in order to access the precious wisdom he concealed under the mask of playful light drunkenness.[31] The winged Bacchus

Figure 10.1 The Winged Bacchus from Hadrianus Junius, *Emblemata*, Antwerp, 1565, p. 260. Source: The Warburg Institute.

remains, however, a fairly rare theme, with only four occurrences in the 2,695 images of the god held in the Warburg iconographic database at the time of writing.

Early modern ideas on good manners and wine consumption expand in parallel with the Renaissance Bacchanal, inaugurating a plethoric imagery of inebriation. The ARTstor database provides a visualization of this phenomenon. The illustrated timeline, based on a sample of 629 images, records almost no image of Bacchus between late Antiquity and the late Middle Ages and a proliferation from the fifteenth century onwards (Figure 10.2). The Warburg Institute iconographic index, which currently holds over 2,695 images of Bacchus, records a similar pattern.[32]

Ancient images of Bacchanals survived mostly through sarcophagi but do not display the excesses characteristic of their Renaissance re-invention featuring the effects of wine from the most pleasant to the least desirable.[33] Not by coincidence are these the very same intense sensory experiences enacted in images of peasant feasts, a genre born in the sixteenth century and displaying the same progression from drinking, to talking, dancing,

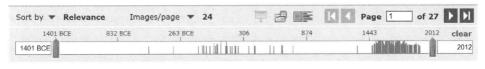

Figure 10.2 Timeline from ARTstor (http://www.artstor.org/).

sexual molestation, staggering, vomiting and collapse. Rubens' *Peasant Kermis*, kept at the Louvre, is an eloquent example of adaptation of classical art and Renaissance Bacchanals to represent rustic behaviors.[34] For a high society upholding elegance and self-control, peasant feasts and Bacchanals provided a model of unrestrained release as well as an entertaining catalog of bad manners.

Indeed, Bacchanals are not subtle in showing abusive drinking, often enacted by children, *putti*, because their restless and irrational behavior was considered similar to the effect of alcoholic abuse.[35] A Bacchanal of *putti* with a wine press attributed to a follower of Raphael, and inspired by a passage of the *Hypnerotomachia Poliphili*, offers a suitable starting point, frequently repeated throughout the European tradition.[36] The *putto* sleeping by a pot of wine dripping over towards the viewer is a very common sight of most Bacchanals, as are his companions bathing in a barrel, pressing grapes, and drinking wine. A Florentine print of the late fifteenth century rehearses these themes with a variation of wine-drinking with a straw – a well-known means of accelerating inebriation (Figure 10.3). Unrestrained drinking seems the keyword of Lorenzo Loli's children's Bacchanal – another illustration of alcohol and its infantilizing effects as well as an example of the use of *putti* as bearers of meaning (Figure 10.4).

The genre of the Bacchanal challenged artists to express a wide range of sensations: dance movements and postural disorders as well as the experience of taste, touch, sound, and altered vision. Titian's *Bacchanal of the Andrians* of 1518 provides an early synthesis, with its figures engaged in singing, dancing, drinking, urinating, and sleeping, and with a song that says: 'who does not drink and drinks again does not know what drinking is' (Figure 10.5).[37]

Representing and viewing wine is at the center of Titian's *Bacchanal*. It illustrates a simple phenomenon: that liquid remains horizontal, even if its container is inclined. This device, preceding the invention of the spirit level by more than a century, invites the viewer to lose or perhaps keep balance with the whirling universe surrounding it. This appealing contrast between the horizontal and stable aspect of wine in a whirling world may have been inspired by a detail from Giovanni Bellini's *Drunkenness of Noah*, where the opposition between the horizontal remaining wine and the inclined cup, at the front of the picture, also suggests a loss of balance.[38] Later, in the seventeenth century, we encounter a very similar theme in genre scenes of merry companies with figures holding an inclined glass by artists such as Judith Leyster and Gerrit van Honthorst.[39]

In the *Bacchanal of the Andrians*, Titian has also set a contrast between the figure on the left hand side absorbing wine from an amphora he holds above his head and the female figure in the middle group receiving wine in a flat cup. In opposition to the rustic vase of peasants and shepherds, the flat cup or *tazza*, one of Bacchus standard attributes, is the vessel of temperate drinking par excellence, as its flat surface and low borders force slow absorption. This flatness also inspired sophisticated goldsmith work, which on the banqueting table became animated and colored by wine, engaging the drinker's visual field especially while drinking. In his *Dames Galantes*, Brantôme mentions an instance of such combined use of

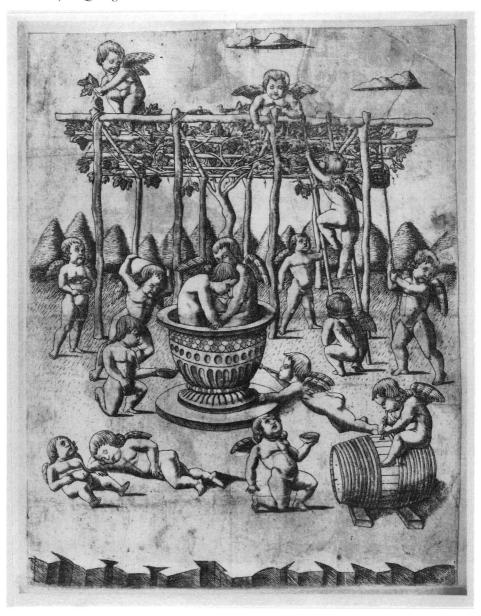

Figure 10.3 Bacchanal of Children, Anonymous print, Ferrara 1470–80. Dry point.
Source: The Warburg Institute.

wine and images. A prince bought from a goldsmith a cup with embossed figures inspired from *I Modi*, an early sixteenth-century kama sutra, and took considerable entertainment from observing the reactions of the ladies whom he invited to drink from it.[40]

Using drinking to bring the sight of drunkenness to the viewer seems one purpose of a cup designed by Annibale Carracci to represent the drunken Silenus and destined to grace the banqueting table of his patron, Cardinal Odoardo Farnese (Figure 10.6).[41] The

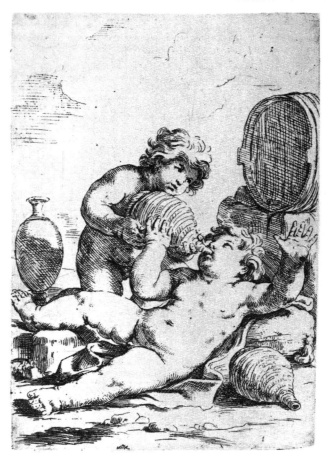

Figure 10.4 Lorenzo Loli, *Bacchanal of Children*, c. 1640. Etching, 17.9 x 12.9 cm.
Source: *The Illustrated Bartsch* (1981, 147)

position of the two *putti* on either side blurs expectations of space: they should both be in the foreground, but the way they hold the grapes around and behind the central group confuses the brain as to their 'real' position in space. Such images were probably composed with some awareness of their final metallic destination. When embossed, gilded, animated, blurred and reddened by wine, Annibale's cup would reproduce the visual effect of drinking as much as Silenus and warn the drinker to sip just a little at a time.

Renaissance patrons might have looked at images through wine; they also very much liked to look at wine itself. After all, wine is assessed and appreciated for its taste as much as its color, and not surprisingly one of the most recurring visual themes is the contemplation and monstrance of a glass of wine. It is central to Titian's *Bacchanal of the Andrians* as much as to Michelangelo's staggering Bacchus and frequently features in scenes of banquets such as Veronese's *Marriage at Cana* (Paris, Louvre), as well as in genre and still life painting. There, variations on red and white wine serve as painterly pretexts to represent color and transparency and the optical distortions perceived when looking through a glass.

Figure 10.5 Titian, *The Andrians*, 1518. Oil on canvas, 175 x 193 cm.
Source: Madrid, Museo del Prado.

Another well-known effect of alcohol is the loss of balance. This aspect is best seen through the representation of the drunken Silenus and Bacchus, described by Marcel Détienne as a staggering god, a theme central to Michelangelo's youthful Bacchus.[42] In so many instances, the drunken gods are represented with attendants preventing them from falling down. Depicting the drunken Silenus requested artists to suggest bodily weight, a demand previously only met through themes such as the descent from the cross or the entombment, as in the Mantegna set of Bacchanal prints (Figure 10.7). Collapsing rather than staggering remains the most common postural effect of wine. Sleep brought on by excessive intoxication may or may not differ from natural sleep; its representation, nevertheless, inspired many variations on the motif of the reclining river god.

Artists and Wine Consumption

Did Renaissance artists drink for creative purposes? Many ancient and modern writers praised the benefits of wine for literary creation, but there is no such parallel in the visual arts; Renaissance artists tended to imitate the behavior and manners of their aristocratic patrons

Figure 10.6 Annibale Carracci, *The Drunken Silenus*, n.d. Engraving, plate mark diameter: 3.23 cm.
Source: *The Illustrated Bartsch* (1980a, 147)

and this included their approach to wine.[43] There are other straightforward reasons for this. Inebriation may inspire flows of words easy to transcribe in writing, but it is less compatible with the concentration required by painting and sculpture. Using a hammer and chisel on an expensive piece of marble when drunk verges on foolishness. But this also applies to the practice of the less physical arts of painting and drawing. The case is best summed up in an anecdote from the life of the painter Hendrik Goltzius (1558–1617). A group of gentlemen once invited Goltzius in the hope that he would draw their portrait. In order to woo him, they had much wine brought to the table. Understanding that his hosts wanted a drawing from him, the painter refused to drink the wine that was insistently offered to him adding: "[...] and what could I ever do for you with my art with all that wine in my head?"[44]

An artist could conceivably sketch in a drunken state. Medical wisdom has it that wine has the nature of fire – surely an element suited to fuel inspiration. To my knowledge, the only extant example of such positive use of wine comes from Vasari's life of Battista Franco, which attributes the achievement of a certain Martino Tedesco – who might be Maarten van Heemskerck – and his team to the fiery property of "good Greek wine":

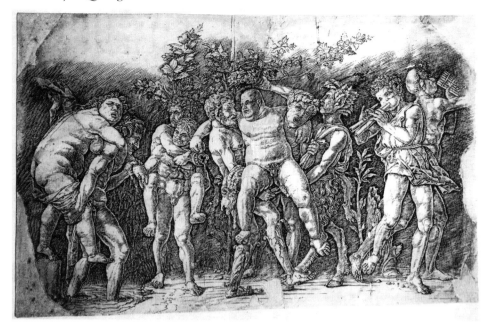

Figure 10.7 Andrea Mantegna, *Bacchanal with Silenus*, c. 1470. Engraving, 33.5 x 45.4 cm.
Source: *The Illustrated Bartsch* (1980b, 57)

> And what was the most extraordinary is that the aforesaid Martin and his assistants
> made these canvases with so much attention and promptness [*solecitudine e pre-
> stezza*], that these works were completed on time not only as they were working on
> them very steadily but also because they were continuously supplied with some good
> Greek wine to drink, and because they worked continuously and were always drunk
> and warmed up [*ubriachi e riscaldati*] by the *furore* of the wine and by means of
> their craftsmanship they did exceptional things.[45]

Vasari's concept of *furore* refers to promptness of execution rather than to divine illu-
mination, but his remarks are rather unusual.[46] Of course, Renaissance and Baroque
artists may well have drunk three daily liters like everyone else, but drunkenness was
generally frowned upon.

Wine, in particular, and drinking habits, in general, are hardly mentioned by the
biographers of sixteenth-century artists unless they became problematic, as in Vasari's
negative assessment of Ercole de' Roberti's untimely death resulting from his frequent
drinking.[47] It is only later in the seventeenth century, with the emergence of artists
specializing in genre and tavern scenes, that wine took some prominence through the
association between style of life and style of painting. Nevertheless, alcoholic artists
tend to take back the brush only once they have run dry. The Flemish painter Joachim
Patinier is credited for working in order to finance his drinking habit, while Frans
Floris met an early death – poor, sick, and in debt – as a result of his numerous
drinking bouts.[48]

Drinking involves frequenting taverns, an activity associated with the Roman misdeeds
of the Northern Caravaggists. The fiery power of wine seems to have caused the death of

the French painter Valentin de Boulogne, who after smoking much tobacco and abundantly drinking found himself prey to such fire and threw himself into a fountain of cold water only to catch a worse fever, which eventually killed him.[49]

Thus, remaining evidence suggests that wine is very rarely considered an aid to inspiration in the visual arts. Early modern artists and writers on art may have had the Neoplatonic theory of the four frenzies at hand, but they had little or no concept of cultivating creative altered states other than health – an aspect which does not seems to enter Western culture before Romanticism. Nevertheless, artists drank regularly, like everyone else, and their work was appreciated for the same qualities of wit, ingenuity and playfulness associated with the psychological effect of temperate drinking – for Renaissance artists 'temperate drinking' is merely a way of maintaining an ideal state of mental and physical health.

Conclusion

Ficino's Neoplatonism brought philosophical and medical support to the traditional idea of wine as a means of inspiration and converges with the emergence of the Renaissance Bacchic iconography. Mythology is a flexible language, particularly responsive to the tensions and ideas of the time. In this respect, Ficino's approach to Apollo and Bacchus as brothers and complementary energies stands in sharp contrast with Nietzsche's canonical polarity laid out in *The Birth of Tragedy*, opposing the unrestrained Dionysian release of all vital forces to Apollonian solar rationality.

This pre-modern union of Apollo and Bacchus converges with the philosophical, medical and social foundations of temperate drinking – i.e., drinking without getting drunk – and constitutes the background of the largest corpus of images celebrating wine, its gods, and its effects. Yet Renaissance Bacchanals are not particularly moralistic; they are advisory and merely show the effect of excessive drinking. Their main implicit social comments can be deducted from the tendency of painters to use Bacchanals as a model to depict peasant's feasts, thus transcribing the deplorable effects of binge drinking from mythology to the lowest level of society – for the entertainment of the educated, wealthy and self-controlled patrons of the arts.

By the eighteenth century, the commercial introduction of distilled beverages with much higher alcohol contents than wine and beer was already causing considerable social damage and inspired prints such as Hogarth's *Beer Street and Gin Lane* (1751), contrasting the prosperous and peaceful world of 'temperate' beer drinkers to the physical and social hell of gin addicts. It is indeed distilled alcohols which generated the nineteenth-century temperance movement, leading to the disastrous years of prohibition in America. Renaissance drinkers only knew the lesser damages of wine and beer; they saw Apollo and Bacchus as brothers – rather than polar opposites – and symbolic of ascending steps in an ideal process of psychological and civic transformation.

Thus by linking body and mind through mythology, philosophy, and medicine, Ficino, in his influential *De Vita Libri Tres*, brought forward a concept of temperance which is not about not drinking but about not getting 'drunk.' Such an ideal state is achieved by keeping the constancy of the element of fire powering thinking in words and images. In this way, the Renaissance Neoplatonism of Marsilio Ficino would allude to an ideal state of creativity and receptivity. Here, the Neoplatonic approach to wine invites us to look for traces of its inner fire in the lighthearted and witty painterly and literary style generated by this balanced ideal of warm and fluid mental activities.

212 *François Quiviger*

Notes

1 Martin (2001, 29).
2 Davis (1997).
3 Martin (2001, 30).
4 Austin (1985, 138).
5 Emmerling-Skala (1994). On Bacchus as a god of inspiration, see Moffitt (2005).
6 Tigerstedt (1969, 5–77).
7 Brann (2002).
8 Baldassare Castiglione, *Il Cortegiano*, IV, 67; Pietro Bembo, *Gli Asolani*, III, vi.
9 Marsilio Ficino, *De amore*, V, 2, 6; Ficino (1987, 77–80). See also Quiviger (2010, 99–102).
10 See, e.g., Agnolo Firenzuola, *Delle bellezze delle donne*, Florence 1548; Firenzuola (1992, 33–43).
11 See Lackner (2001).
12 Ficino, *De amore*, VII, 14; translated by Sears (Ficino 1985, 170); Ficino (1987, 213): "La poesia dalle Muse, el misterio da Bacco, la divinatione da Apolline, l'amore da Venere dipende."
13 Ficino, *De amore*, VII, 14; translated by Sears (Ficino 1985, 171); Ficino (1987, 214): "El primo furore adunque tempera le cose disadacte e dissonanti, el secondo fa che le cose temperate di più parti uno tutto diventano, el terzo fa uno tutto sopra le parti, el quarto riduce a quell'uno el quale è sopra l'essentia e sopr'al tutto." On Ficino and Dionysian frenzy, see Bárberi Squarotti (2000).
14 Marsilio Ficino, *De Vita Libri Tres*, Florence 1489, II, xiv; Ficino (1989, 205).
15 Marsilio Ficino, *De Vita Libri Tres*, Florence 1489, Proemium; Ficino (1989, 102): "Sed de sacris impraesentia mysteriis non est loquendum, ubi mox physica potius ope languentibus opitulaturi sumus. Nec agendum stilo gravitatis servo, sed libero potius et iocoso, postquam a Libero patre nescio quomodo statim exorsi sumus [...] Hic enim almo quodam vino securitateque laetissima salubrius forte medetur, quam herbis ille suis carminibusque Phoebus."
16 Marsilio Ficino, *De Vita Libri Tres*, Florence 1489, III, xxiv; Ficino (1989, 378): "Fratres certe sunt individuique comites Phoebus atque Bacchus. Ille quidem duo potissimum vobis affert: lumen videlicet atque lyram; hic item praecipue duo: vinum odoremque vini ad spiritum recreandum, quorum usu quotidian spiritus ipse tandem Phoebeus evadit et liber."
17 Marsilio Ficino, *De Vita Libri Tres*, Florence 1489, II, xxiv; Ficino (1989, 378–80): "Similiter habere vos oportet ad merum, Bacchi donum, Apollinis beneficio procreatum. Eadem igitur proportione qua lumen accipite vinum; abunde quidem quatenus nec destillatio, nec exsiccatio, qualem dixi, ebrietas ne contingat. Atque praeter substantiam vini quotidie bis acceptam odorem eius frequentius haurite, partim quidem os, ubi spiritus fuerit recreandus, colluentes mero, partim lavantes eodem manus, partim naribus et temporibus admoventes."
18 On the igneous nature of wine, see Athenaeus, *Deipnosophist*, 429 c-d; Macrobius, *Saturnalia*, VII, 6, 18; Arnaldus de Villanova, *De vinis*: Arnaud de Villeneuve (2011, 44–6).
19 Ficino, *De Vita Libri Tres*, II, xviii; Ficino (1989, 221).
20 http://www.patient.co.uk/health/Alcohol-and-Sensible-Drinking.htm [9 April 2013].
21 This question is treated by Tlusty (2001, 56–60).
22 Equicola (1996, 546): "pallore, tremore de membra, fettido anhelito, lacrimosi occhi et de la memoria morta."
23 See Gately (2008, 56–61).
24 Anton Francesco Doni, *Le pitture del Doni Academico Pellegrino ...*, Padova: Gratioso Perchacino, 1564, 7; Doni (2004, 148).
25 Zucchi (1602, 64): "La Ebrietà toglie la memoria, rovina i sensi, confonde l'intelletto, incita la libidine, ingrossa la lingua, corrompe il sangue, debilita le membra, diminuisce la vita; et in ultimo ci toglie ogni salute."
26 Ferro (1623, 140): "E il liquor di Bacco consolatore de gli animi, vivificatore de gli spiriti, & a chiascheduno grato e soave [...]"
27 Ferro (1623, 716): "[...] la quantita di quello nuoce ad ogni nostra parte & principalmente al cervello; così preso moderamente rischiara la mente, dilucida l'intelletto, acuisce l'ingegno, corrobora le forze, rincora gli animi, accresce l'ardire, vivifica gli spiriti, rallegra i cuori, e scacciando da' tristi petti la malinconia, gli mantiene lungamente in vita."
28 Guazzo (1588, 277r).
29 Guazzo (1588, 273r): "[...] per sanita si vuol bere poco e spesso [...] Cosi a noi se troppo copiosamente beviamo, segue tal gravezza di corpo, e d'animo, che appena possiamo respirare, non che

ragionare. Ma ce si sarà ministrato spesse volte ne piccioli vasi, noi con questi modi non solamente non patiremo ubbriachezza, ma da una certa grata persuasion si sentiremo rinvigorire e tirare a maggiore allegrezza.

30 Screech (1980, 259–61). On drinking vessels, see Konečný (2003).
31 François Rabelais, *Les oeuvres de M. François Rabelais ...*, Lyon: P. Estiard, 1574, 7–8.
32 http://warburg.sas.ac.uk/photographic-collection/iconographic-database [9 April 2013]. For a general overview, see now Morel (2015).
33 On the sensory aspects of the Renaissance Bacchanal, see Quiviger (2014, 196–9).
34 On the peasant feast and its iconography, see in particular Alpers (1972–73) and Alpers (1995).
35 Garrard (2014, 28)
36 Follower of Raphael, *Putti with a Wine Press*, c. 1500, oil on panel, diameter 33.3 cm, Washington D.C., The National Gallery of Art, Samuel H. Kress Collection, Inv. 1952.5.72.
37 "Qui boit et ne reboit, il ne sait que boire soit." See Smith (1953). The literature on this picture is vast, although no author, to my knowledge, addresses the central motif of the inclined drinking vessel. See Cavalli-Björkman (1987).
38 Giovanni Bellini, *The Drunkenness of Noah*, c. 1500, oil on canvas, 103 x 157 cm, Besançon, Musée des Beaux Arts, No. 869.1.13.
39 Gerrit van Honthorst, *Merry Company*, c. 1617, oil on canvas 138 x 203 cm, Florence, Uffizi, 1890, No. 735; Judith Leyster, *Merry Company*, 1630, oil on canvas, 68 x 57 cm, Paris, Louvre R.F. 2131.
40 Brantôme (2012, 815): "[...] et celles qui ne l'avoient jamais veue, ou en beuvant ou après, les unes demeuroient estonnées et ne sçavoient que dire là-dessus: aucunes demeuroient honteuses, et la couleur leur sautoit au visage [...]"
41 See Benati and Riccomini (2006, 344).
42 Détienne (1986). On Michelangelo's *Bacchus*, see Lieberman (2001).
43 See Commager (1957); McKinlay (1953, 101–36). On artists and wine, see also Land (2013) and Morel (2015, 297–306).
44 Baldinucci (1974–75, vol. 3 [1974], 191).
45 Vasari (1966–87, vol. 5 [1984], 460): "E quello che fu cosa maravigliosa, fece il detto Martino e' suoi uomini quelle tele con tanta sollecitudine e prestezza, perché l'opera fusse finita a tempo, che non si partivano mai dal lavoro; e perché era portato loro continuamente da bere, e di buon greco, fra lo stare sempre ubriachi e riscaldati dal furor del vino e la pratica del fare, feciono cose stupende." My translation.
46 See in particular Vasari's correspondence with Annibale Caro, in Caro (1909, 123–4: letter of 10 May 1548).
47 Vasari (1966–87, vol. 2 [1967], 423): "Piaceva a Ercole il vino straordinariamente; per che spesso inebriandosi, fu cagione di accortarsi la vita, la quale avendo condotta senza alcun male insino agl'anni quaranta, gli cadde un giorno la gocciola di maniera che in poco tempo gli tolse la vita."
48 Baldinucci (1974–75, vol. 2 [1974], 109: Patinier, and 316–7: Floris).
49 Baglione (1976, vol. 1, 338).

Bibliography

Alpers, Svetlana. 1972–73. "Bruegel's Festive Peasants." *Simiolus* 6:163–176.
Alpers, Svetlana. 1995. *The Making of Rubens*. New Haven: Yale University Press.
Arnaud de Villeneuve. 2011. *Le livre des vins*, edited by Patrick Gifreu. Perpignan: Éditions de la Merci.
Austin, Gregory A. 1985. *Alcohol in Western Society from Antiquity to 1800: A Chronological History*. Santa Barbara, CA: ABC-Clio. Baglione, Giovanni. 1976. *Le vite de' pittori, scultori et architetti dal pontificato di Gregorio XIII del 1572 in fino a' tempi di Papa Urbano VIII nel 1642*, edited by Costanza Gradara Pesci. Sala Bolognese: Arnaldo Forni.
Baldinucci, Filippo. 1974–75. *Notizie dei professori del disegno da Cimabue in qua ...*, 7 vols. Firenze: Studio per Edizioni Scelte.
Bárberi Squarotti, Giovanni. 2000. "Da Bacco a Orfeo: Vino, uva ed ebbrezza nella letteratura dell'età Laurenziana." In Giovanni Bárberi Squarotti, *Favole Antiche: Modelli, Imitazione, Riscrittura*, 9–52. Alessandria: Edizioni dell'Ors.

Benati, Daniele, and Eugenio Riccomini, eds. 2006. *Annibale Carracci*, exh. cat., Bologna, Museo Civico Archeologico. Milan: Electa.

Brann, Noel L. 2002. *The Debate over the Origin of Genius during the Italian Renaissance: The Theories of Supernatural Frenzy and Natural Melancholy in Accord and in Conflict on the Threshold of the Scientific Revolution.* Leiden: Brill.

Brantôme, Pierre de Bourdeille. 2012. *Vie des dames galantes*. Paris: Les ecrivains de Fondcombe.

Caro, Annibale. 1909. *Prose Scelte*, edited by Mario Sterzi. Livorno: Giusti.

Cavalli-Björkman, Görel. 1987. *Bacchanals by Titian and Rubens: Papers Given at a Symposium in Nationalmuseum, Stockholm, March 18–19, 1987.* Stockholm: Nationalmuseum.

Commager, Steele. 1957. "The Function of Wine in Horace's Odes." *Transactions and Proceedings of the American Philological Association* 88:68–80.

Davis, Robert C. 1997. "Venetian Shipbuilders and the Fountain of Wine." *Past & Present* 156:55–86. Détienne, Marcel. 1986. *Dionysos à ciel ouvert*. Paris: Hachette.

Doni, Anton Francesco. 2004. *Le pitture del Doni Academico Pellegrino …* [Padova: Gratioso Perchacino, 1564], edited by Sonia Maffei. Naples: La Stanza delle scritture.

Emmerling-Skala, Andrea. 1994. *Bacchus in der Renaissance*. Hildesheim: Georg Olms.

Equicola, Mario. 1996. *La redazione manoscritta del Libro de Natura d'Amore*, edited by Laura Ricci. Roma: Bulzoni.

Ferro, Giovanni. 1623. *Teatro d'imprese*. Venetia: Appresso Giacomo Sarzina.

Ficino, Marsilio. 1985. *Commentary on Plato's Symposium on Love in English*, translation by Jayne Sears. Dallas, TX: Spring Publications.

Ficino, Marsilio. 1987. *El libro dell'amore*, edited by Sandra Niccoli. Florence: Olschki.

Ficino, Marsilio. 1989. *Three Books on Life*, edited by Carol V. Caske. Binghampton, NY: Center for Medieval and Early Renaissance Studies.

Firenzuola, Agnolo. 1992. *Discorsi delle bellezze delle donne – On the Beauty of Women*, translated and edited by Konrad Eisenbichler and Jacqueline Murray. Philadelphia: University of Philadelphia Press. Garrard, Mary. 2014. "Michelangelo in Love: Decoding the *Children's Bacchanal*." *The Art Bulletin* 96, 1:24–49.

Gately, Iain. 2008. *Drink: A Cultural History of Alcohol*. New York: Gotham Books.

Guazzo, Stefano. 1588. *La civile conversatione*. Vinegia: presso Altobello Salicato, alla Libraria della Fortezza.

Konečný, Lubomír. 2003. "Augustine Käsenbrot of Olomouc, his Golden Bowl in Dresden, and the Renaissance Revival of 'Poetic' Bacchus." *Artibus et Historiae* 24, 48:185–197.

Lackner, Dennis F. 2001. "The Camaldolese Academy: Ambrogio Traversari, Marsilio Ficino and the Christian Platonic Tradition." In *Marsilio Ficino: His Theology, His Philosophy, His Legacy*, edited by Michael J. B. Allen, Valery Rees and Martin Davies, 15–44. Leiden: Brill.

Land, Norman E. 2013. "Wine and the Renaissance Artist." *Source: Notes in the History of Art* 32, 3:17–20.

Lieberman, Ralph. 2001. "Regarding Michelangelo's Bacchus." *Artibus et Historiae* 22, 43:65–74.

Martin, Lynn A. 2001. *Alcohol, Sex, and Gender in Late Medieval and Early Modern Europe*. Basingstoke: Palgrave.

McKinlay, Arthur P. 1953. "Bacchus as Inspirer of Literary Art." *The Classical Journal* 49, 3:101–136.

Moffitt, John. 2005. *Inspiration: Bacchus and the Cultural History of a Creation Myth*. Leiden: Brill.

Morel, Philippe. 2015. *Renaissance dionysiaque: inspiration bachique, imaginaire du vin et de la vigne dans l'art européen (1430–1630)*. Paris: Le Félin.

Quiviger, François. 2010. *The Sensory World of Italian Renaissance Art*. London: Reaktion Books.

Quiviger, François. 2014. "Art and the Senses: Representation and Reception of Renaissance Sensations." In *A Cultural History of the Senses, vol. 3: In the Renaissance*, edited by Herman Roodenburg, 169–202. London: Bloomsbury. Screech, Michael. 1980. "The Winged Bacchus, Pausanias, Rabelais and later Emblematists." *Journal of the Warburg and Courtauld Institutes* 43:259–261.

Smith, Gertrude P. 1953. "The Canon in Titian's *Bacchanal*." *Renaissance News* 6, 3/4:52–56.

Tigerstedt, Eugene Napoleon. 1969. *Plato's Idea of Poetical Inspiration*. Helsinki: Societas Scientiarum Fennica.

Tlusty, B. Ann. 2001. *Bacchus and Civic Order: The Culture of Drink in Early Modern Germany*. Charlottesville: University Press of Virginia.

Vasari, Giorgio. 1966–87. *Le vite de' più eccellenti pittori, scultori e architettori nelle redazioni del 1530 e 1568*, 6 vols., edited by Rosanna Bettarini and Paola Barocchi. Firenze: Sansoni.

Zucchi, Giacomo. 1602. *Discorso sopra li Dei de' Gentili e loro imprese*. Roma: Nella Stamperia di Domenico Gigliotti.

Appendix

Twilight of the Gods for Neoplatonism (1986/1992)*

Horst Bredekamp

> S'ella poesia s'estende in filosofia morale, e questa
> (pittura) in filosofia naturale.
>
> <div align="right">Leonardo da Vinci</div>

Iconology

In a recently published novel, the literature of antiquity was portrayed as the product of a vast forgery perpetrated by scholars during the Renaissance – as an intellectual fairy tale that never actually existed in reality.[1] The author was probably aware that his imaginary story about the fictitious nature of an entire cultural epoch is not so far from the truth, for the historical processes involved can no longer be authentically relived, and anything that appears to be a historical fact is at first nothing more than a projection backwards from the reality of one's own age: this is why history will continue to be radically revised for as long as the present continues to change.

A transformation of this type is evidently taking place at present in relation to the Renaissance. What had long been regarded as symptomatic of the period now seems oddly unfamiliar: although its presence can still be felt, Neoplatonism appears to have lost its leading role in the interpretation of Renaissance art.

This raises the question of whether Neoplatonism was ever actually located anywhere except in the mind of posterity. Even in the late 1960s, a general account of the *Neoplatonism of the Italian Renaissance* was able to claim that "The diffusion of Neoplatonism in the sixteenth century was so enormous that it is not possible to estimate its direct influence on the artists of the age with anything approaching certainty."[2] From today's point of view, the uncertainty expressed in this statement appears to be due more to the fact that the Neoplatonism that was evident in philosophy and poetry, and sometimes also in the theory of art, exercised only a rather minor effect on the visual arts.

It may be suggested as a hypothesis that the validity of Neoplatonism is less of a problem for the reality of art history than it is for the type of scholarly history that was associated mainly with the Warburg Library, in Hamburg and later in London. With slight exaggeration, it might be said that Neoplatonism in Renaissance art had its origins in the impression that was made on Erwin Panofsky by a lecture given by Ernst Cassirer at the Warburg Institute in Hamburg in 1924, on "The Problem of the Beautiful and of Art in Plato's Dialogues." Panofsky's book *Idea*, which provided the program establishing a Platonic pattern of interpretation, is certainly indebted to the lecture.[3] Panofsky considers that there is a specifically Neoplatonic significance in the emancipation from the world of experience and in the equation of artistic creation with divine creation that originates in the realm of Ideas – i.

e., in the transition between Ficino's commentary on the *Symposium*[4] and Giovanni Paolo Lomazzo's *Idea del Tempio della Pittura*.[5]

The hypothesis that a back-projection of Neoplatonism based on Ficino is involved affects not only Panofsky but also two other major representatives of iconology – probably the twentieth century's most productive school of art history: Ernst H. Gombrich and Edgar Wind. Even among its opponents, there is no doubt regarding the objective importance of this method of illuminating the work of art on the basis of its literary, philosophical and cultural setting and in this way interpreting the special qualities of its form historically. English-language art history in particular would scarcely be conceivable without the art historians who were associated with the Warburg Library in Hamburg, or who joined it in London after 1933. Beyond any matters of their individual preferences, there appears to have been a recognizable effort among all of those originally involved to consolidate an intellectual world based on conceptual argumentation and enlightening intentions, in contrast to German National traditions and the way in which they were being increasingly radicalized. The story of the Department of Art History in Hamburg shows that Nazi attacks were aimed not only at individual members of the teaching staff and their students but also and above all against the iconological method itself.[6]

In an article first published in 1940 on "The History of Art as a Humanistic Discipline," Panofsky confirmed in reaction to this that from his point of view it was precisely the study of Plato that would help erect barriers against ideologies such as Nazism. In a footnote, he mentions a letter published in the *New Statesman and Nation* in 1937 from a reader who wanted to ban the distribution of works by "Plato and other philosophers" because these were making it more difficult for intellectuals to come into contact with Marxist approaches. In criticizing this clearly Stalinist position, Panofsky emphasizes the necessity of studying Plato, since "Needless to say, the works of 'Plato and other philosophers' also play an anti-Fascist role."[7] In accordance with this view, Panofsky also emphasized even after the war that an iconological study of the traditions of antiquity was also to be regarded as a barrier against contemporary nationalism.[8]

The same also applies to Wind[9] and Gombrich. In 1945 – i.e., in the same period in which Karl R. Popper in his *Open Society and Its Enemies* was settling scores with Plato as the guiding intellectual force behind all forms of totalitarianism – Gombrich, the later admirer of Popper, was resolutely committed to the humane side that he saw as having been preserved in Florentine Neoplatonism.[10] From this starting point in Florence, Western thought appeared to sustain itself, despite all the ruptures and obstructions it endured, as a consistent construct in which even the boundaries of different epochs could now be read as the marginalia to a larger, harmonious structure that appeared to uphold the bright side of Western culture and that is worthy of preservation.

Against this background in contemporary history, it is painful to note that in their flight into Neoplatonism, the iconologists had sought out the wrong sanctuary. A critique of the mania for Neoplatonism appears indispensable, particularly in response to two more recent developments. The first of these affects the field of the humanities and is a new version of the anti-Enlightenment pictorial hermeneutics which Walter Benjamin as long ago as 1932 diagnosed as not carrying out research but rather merely "experiencing."[11] This approach, in which every form of iconological thinking is regarded as intellectual iconoclasm,[12] also represented a resurrection of that "aestheticizing art history" towards which Warburg expressed "an honest disgust."[13] This was due in no small part to the fact that in the process of establishing its methodology, iconology had become attached in terms of its content to Neoplatonism. A critique of this conceptual approach

thus does not imply condemning iconology as such but can be regarded rather as a means of defending and reviving it.

This is all the more so in that the triumphant progress of Neoplatonism[14] in the field of pictorial theory, which coincided with the advent of modern reproduction media, can now be seen emerging from every computer screen with the force of a natural phenomenon, without anyone being aware of the traditions and content – or even the risks – of this philosopheme.[15] In the face of the "new hermeneutics," an open iconology attending more to forms than to formed ideas might be able to serve as an antidote, and the application of an undogmatic iconology to the field of digital image production might be able to drive away the sense that we are trapped in a new Cave now equipped with monitor screens.[16]

Specifications

Criticism of the restrictive focus on Neoplatonism also appears necessary because, in its innermost nature, it actually runs counter to iconology. Among the undisputed merits of iconology is its openness towards formed objects – from the sculptures of classical Greek antiquity to the radiator emblem on the Rolls-Royce.[17] Warburg's concept of an "atlas of images" covered the entire field of pictorial production, and Panofsky and Gombrich in particular repeatedly developed the unhierarchical approach used in "their" method out of the material itself. It seems all the more surprising that it was above all major works of the High Renaissance such as Titian's *Sacred and Profane Love*[18] and Dürer's *Melencolia I*[19] that acquired the status of providing prime evidence for the superior capabilities of iconology. The 'original sin' of Neoplatonism is evident in an exemplary fashion in these, as they owe their outstanding position not only to their enigmatic, confusing pictorial language but above all to the fact that it was possible for their complexity to be transcended in the culture of Neoplatonism – or at least for it to be linked to the philosophy in an illuminating way.

The history of research into Botticelli's *Primavera*, as the third outstanding example of this fixation, is already of special importance because the iconological method was tested on it for the first time in Warburg's dissertation on the painting.[20] Far from suggesting that the literary and mythological topoi that he traced in the painting had a definable overall philosophical character that could be assigned to Neoplatonism, Warburg recognized the principal iconological message of the painting as lying in the subsidiary motif of the fluttering robes and hair, which embody Alberti's conception of *libertà*: that "liberty" of the artist which, as a metaphor for the new era and the shattering of medieval collective constraints, could also be seen as symbolizing the isolation of the modern individual in early capitalist Florence.[21]

In the face of this approach insisting on progress and rationality,[22] the representatives of a "romanticism in reserve"[23] that brusquely made iconology its target during the 1920s regarded Botticelli no longer as being the hero of a renaissance of antiquity but rather as an authority illustrating the continuation of the Middle Ages.[24] Decidedly opposed to this rigorously ahistorical, subjectively intuitive view, Gombrich attempted in 1945, as mentioned earlier, to specify and define the philosophical context of the *Primavera* in closer proximity to Neoplatonism.[25]

To the extent to which any attempt to offset the Middle Ages against the Renaissance must appear as a kind of shadowboxing,[26] in the light of a Neoplatonic philosophy shaped by Marsilio Ficino, Gombrich's defense of iconology based on the *Primavera* was consistent

with a much earlier trend towards conceiving the whole of post-antiquity culture from the viewpoint of Neoplatonism. This was the standpoint that Panofsky had been able to use when examining both the "Neoplatonic Movement in Florence and North Italy" (1939)[27] and also the theology of Abbot Suger of St. Denis (1946),[28] using this link to conceive of the Gothic age and the Renaissance as kindred epochs, despite the differences between the two periods in relation to the ways in which they viewed antiquity.[29]

Neoplatonism became a magic formula for educated art historians. The highest goal, the paradise of interpretation, appeared to have been attained when one had succeeded in making the work of art gleam with the aura of Neoplatonism, under whose Christianized dome it was possible to gather together even Rubens's mythological paintings.[30] Extensive projections of the philosophy onto art-theoretical texts and their illustrations, as well as onto works of art in every genre, occurred. Most recently, even the ithyphallic square man in Cesare Cesariano's 1521 edition of Vitruvius has been claimed for Neoplatonism.[31] A similar case is seen in Francesco Colonna's *Hypnerotomachia Poliphili*,[32] which underwent just as much Neoplatonic distortion as Giulio Romano's painting of the Sala di Psiche in the Palazzo del Te in Mantua, which was based on the same romance.[33] Other examples that could serve as leitmotifs for their genres include Giorgio Ghisi's engraving *Raphael's Dream*,[34] the Carracci frescoes in the Palazzo Farnese in Rome,[35] Donatello's sculptures – particularly the bronze *David*[36] – and the Mannerist garden in Bomarzo.[37]

The work of Michelangelo above all has also been so comprehensively overwhelmed by "Neoplatonic interpretation speculators"[38] that only a few examples from the various genres can be offered here – the tomb of Julius II, the sculptures in the Medici Chapel,[39] the frescoes in the Sistine Chapel, whose colors appeared to correspond to the Neoplatonic doctrine of ascent from the lower realm of material shadows to the illuminated zone of the divine spirit;[40] a painting such as the *Doni Tondo*, in which a homoerotic love scene was identified in order to raise the painting, in accordance with Ficino and Plato, "to its philosophical aspect as representing an ascension of the soul";[41] drawings such as the Ganymede sheet, the Neoplatonic interpretation of which was safely assured by the philosophy of Ficino;[42] and finally also Michelangelo's poems, providing support for the theory.[43]

Openings

On closer examination, however, hardly any of the Neoplatonic analyses have stood the test of time. Two recent attempts to release Federigo Zuccari's theory of art, dating from 1607, from its Platonic framework of interpretation were particularly revealing.[44] The demystification of the Renaissance versions of the Vitruvian Man enclosed in a circle and square[45] also signified the overthrow of one of the monuments of art theory; and even before that, Abbot Suger's theology – the chief witness in favor of the Neoplatonic Middle Ages – had already found its way back into Christian orthodoxy.[46]

The same also applies to the Neoplatonic interpretation of some of the fundamental works of the Renaissance. Dürer's *Melencolia* engraving has been explained using motifs from the Bible with contemporary updating,[47] and its Neoplatonic significance has been explicitly rejected[48] or at least placed in a wider context,[49] while Botticelli's *Primavera* – as the restoration of the painting that was completed a few years ago has confirmed – does not represent a Neoplatonic devotional image for a young member of the Medici family, for example, but rather an element of that cult of Venus that categorically denies the division of the goddess of love between the heavens and the earth.[50] Titian's *Sacred and Profane Love* also evidently does not represent a Neoplatonic devotional image – so far as any philosophemes at all can be

isolated from it – but rather an Epicurean application of motifs from the *Hypnerotomachia Poliphili*.[51] The book itself – "'Poliphilus' strife of love in a dream"[52] – only toys with such motifs, in contrast to the way in which they are exploited in the service of Neoplatonism in order to reduce them all the more conclusively to absurdity; and the same also applies to the paintings in the Sala di Psiche in Mantua,[53] which can be traced back to it; Ghisi's dream image;[54] the frescoes in the Palazzo Farnese;[55] Donatello's bronze David,[56] and the garden of Bomarzo.[57]

The image of Michelangelo as a Neoplatonist has also acquired a few cracks.[58] The sculptures in the Medici chapel have turned out not to be conveying upward-soaring souls or to be embodiments of the Platonic concept of the *vita activa* and *vita contemplativa* but rather to epitomize Michelangelo's conception of wise sovereignty refracted by inward melancholy,[59] incorporated into a thoroughly Christian liturgy.[60] And the tomb of Julius II was not destined to be a failure, because it attempted to express in stone a form of Platonizing thought that was capable of soaring above all difficulties; for example, but rather because, at every stage of the narrative it presents, it was expressing the tension between individual emotion and the demands of office and family.[61] With the cleaning of the Sistine frescoes, exposing the originally clear colors, the Neoplatonism that argued along with Pico della Mirandola that divine truth must be "concealed under enigmatic veils"[62] was practically washed away as well. Whether it is pure, Platonic male love that is depicted in the background of the *Doni Tondo* is already questionable because the central two figures, which do not overlap, have androgynous traits and thus recall rather the ideal hermaphroditism of Michelangelo's Bacchus. By contrast, Michelangelo's *Ganymede* sheet can scarcely have been an expression of affection that was intended purely platonically.[63] In the sonnets, particularly those on the topic of night, "the balance sheet for Neoplatonism," finally, is "particularly unfavourable."[64]

Critical views – usually developed on the basis of reinterpretations of these major works of iconology – were expressed occasionally from the 1960s onwards and then more and more strongly, and have become increasingly persuasive. As early as the beginning of the 1970s, it was noted that Neoplatonism was being used as a lever to prise art works out of their historical and social foundations and take them "into quieter waters."[65] By the end of the decade, it was being asked more generally whether Gombrich, Panofsky and Wind might not have represented merely a "fashion" that was influential in the mid-twentieth century as they "plowed the furrow of Neoplatonism."[66]

Alternatives

The contradictory characteristics of the Renaissance – hermetic and occult, Christian or atheistic, marked by escapism as much as by a cult of sensuality – were of course never completely ignored. But the Neoplatonic burdens weighing on the works of art could have been shrugged off more quickly and comprehensively and with greater conceptual clarity if the full implications of the alternatives developed by historians of culture and philosophy had been more openly accepted.

This applies, above all, to the Epicureanism that was *per se* attractive for artists. The horizons of Epicureanism are easier to reconcile with the art works mentioned – from the *Hypnerotomachia Poliphili* to the garden of Bomarzo – without those works having to be turned in the process into illustrations for a philosophy that has merely been arbitrarily applied. Without the influence of the Epicurean theory of nature, the festive culture of Florence would hardly have been able to reach the high standards that it did; Ficino himself

had studied Epicurus during his youth, and Lorenzo di Pierfrancesco de' Medici – who was the owner of the *Primavera* and probably the person who commissioned it – kept Michele Marullo, an important follower of Lucretius and Epicurus, as his household philosopher.[67] At this personal level, the impression already suggested by Warburg that the intellectual background for the painting must be sought in the area of this philosophy is thus confirmed. It may be mentioned in passing here that the Neoplatonism radiating from the screens of today's computer terminals (as mentioned at the outset) might also be counterbalanced by an atomistic theory of the image based on Epicurus that would conceive of the phenomenon in a much more appropriate way.[68]

As was already suggested during the 1950s, there was also Aristotelian thinking present at the heart of such an apparently firm Neoplatonic stronghold and such a "Florentine" text as Alberti's *Della Statua*.[69] All of this intellectual variety also exercised an influence across boundaries: even if one were to concede that Florence had a predominance of Neoplatonism that would be relativized in the context of Renaissance culture as a whole by regional schools that had different philosophical orientations. In contrast to Neoplatonism, the new Aristotelianism[70] sought to work with and through nature to attain greater knowledge; in this way, it made possible in the region of Padua a Bacchic–Arcadian world of voluptuous satyrs and nature gods who appear to mock Neoplatonism.[71] The basis for the Neoplatonic interpretation of the Renaissance was also supported by the exploration of occult strata of thought. Evidence that Florentine Neoplatonism was viewed in its time only as a transitional stage leading to the higher wisdom of the Egyptian revelation of Hermes Trismegistos was able to take the sting out of any fixation on the philosophy.[72] Florentine Neoplatonism was thus characterized as a sophisticated but nevertheless secondary philosophy that remained constantly aware that its cognitive powers were doubly borrowed: while it was itself derived from Plato, behind and above Plato hovered the mysterious Hermes Trismegistos. Just as Ficino now appeared as an occultist who believed in magic, the *Primavera* also received an almost magical and talismanic significance.[73] In contrast with these variants of an epistemological faith based on earthly life and magic, Neoplatonism embodied a rather over-meticulous conceptual world; the quality of representing a political compromise[74] it conveys is that of a Humanist culture that was already an expression of the "crisis" of the city-state of Florence.[75]

But what held an unequalled attraction for twentieth-century interpreters was precisely the way in which Neoplatonism mediated between Christianity, the traditions of antiquity, and the "religion of art" – as well as its Humanist ideals, which appeared to represent a summation of older European thought and were perceived by the founders of this interpretative method as raising a protective shield against totalitarianism. Under the flag of Neoplatonism, however, not only Renaissance culture but also the iconological method as well were gradually standardized and moderated and deprived of their original vitality. Taken to the extreme, this led back to the cult of the ageless nature of the work of art, which the method had originally been developed to oppose.[76] In their quality of compulsive Neoplatonism, the great moments of iconology had involuntarily become signposts leading to a dead end.

It should be emphasized all the more strongly that iconology and the Neoplatonic interpretation of art do not necessarily belong together. A rejection of the iconological method, of the sort formulated in a review of Wind's *Eloquence of Symbols*, is thus misguided because it confuses the form with the content that guided the interpretative study of the work of art more or less unconsciously for decades.[77]

An effort to combine everyday experience and artistic style represents a possible path towards revitalization.[78] Alongside this type of restoration of Neoplatonic philosophy to its foundations in real life, an appreciation of alternative schools of thought inside and

outside Florence, and in particular a thorough review of Neoplatonic topoi of interpretation, might offer prospects for a renovation of the pre-Platonic vigor of iconology. The forms of art works always contain meaning, but they never reflect philosophemes without refraction. A systematic farewell to the obsession with Neoplatonic Florence might therefore be helpful above all in regaining for the work of art the function that uniquely belongs to it – not materializing philosophy but rather through its formal shape creating a distinct conceptual power that goes beyond word-related model systems and intervenes in cultural incrustations and schematic forms of thought in a liberating way. It was not without inner reason that Jakob Burckhardt warned as early as 1886 against the Neoplatonic approach to interpretation,[79] arguing in his *Reflections on History* that it is in the nature of art and of culture to have an "incessantly modifying and subversive" effect.[80] A correspondingly critical form of iconology, one that attempted to counter expectations and accustomed patterns of thought, as well as its own philosophical obsessions, would have in its favor not only a more complex interpretation of meaning but also a more sensitive eye and more precise formal analysis.

Notes

* First published 1986 as "Götterdämmerung des Neuplatonismus." *kritische berichte* 14, no. 4:39–48. Reprinted 1992 with minor revisions in *Die Lesbarkeit der Kunst: Zur Geistes-Gegenwart der Ikonologie*, edited by Andreas Beyer, 75–83 and 102–6, Berlin: Wagenbach. Translation by Michael Robertson. The editors wish to thank professor Bredekamp for kindly granting his permission to translate and reproduce this text.

1 Bramly (1982).

2 Robb (1935/1968, 212).

3 Panofsky (1924/1960), preface [English translation: Panofsky 1968]. In contrast to his later work, Panofsky still draws a clear distinction here between the general concept of the "Idea," Neoplatonism, and art theory.

4 Ficino (1985).

5 Panofsky (1960/1970, 28–9, 53–5) [see Lomazzo (2013)].

6 Dilly and Wendland (1991).

7 Panofsky (1938/1955, 25, n. 18). [The date of the first publication is 1938, not "1940" as stated in *Meaning in the Visual Arts*.]

8 Panofsky (1960/1970, 6), a lecture given in Uppsala in 1952.

9 Wind (1934, xvii).

10 Gombrich 1945/1972. Ten years later, Gombrich had also come to regard Neoplatonism as a form of "self-deception" that attaches "a rather questionable philosophical aura" to the work of art; 1956 lectures, Gombrich (1960, 155–6). However, this did not prevent him from holding to the hypothesis in the new edition in 1972 (31–5, "A Postscript as a Preface"), despite critical objections and his own doubts about the Neoplatonic character of Botticelli's mythological paintings.

11 Benjamin (1932/1972, 365, 371).

12 Hoffmann (1986).

13 Quoted in Gombrich (1970, 88).

14 Busch (1989b, 13–4).

15 Bolz (1991) attempts to provide an overview based on the tradition of the "ancient struggle between appearance and being."

16 See Bredekamp (1991, 288) – intended as a warning against premature abandonment of the traditional tools of analysis in the face of digital images.

17 See Eberlein (1986, 174–5).

18 *Sacred and Profane Love* can be regarded as a textbook example for the justification, deepening and extension of the Neoplatonic interpretation on the part of Panofsky, who studied the painting throughout his life. Once he had defined the two female figures as sister embodiments of the two opposing principles of Love in Plato (Panofsky 1930, 173–4), he attached this concept to the two Venus sisters of the Neoplatonist Ficino (Panofsky 1939/1962, 151–2) in order – in a

new interpretation of Titian's (controversial) painting *Wisdom* – to subordinate practically all of the artist's allegorical works to the Neoplatonic pattern of *Sacred and Profane Love* (Panofsky 1926/1955, 168; German translation 1975, 168), ultimately comparing the painting with Botticelli's *Birth of Venus* and *Primavera* in the same sense (Panofsky 1969, 110–1).

19 On the exemplary character of the Neoplatonic appropriation of *Melencolia I* and *Earthly and Heavenly Love*, see Liebmann (1966/1984, 310–13, 321). For Eberlein as well, Dürer's engraving of melancholy is the outstanding example; Eberlein (1986, 178–81).

20 Although they were not fully coordinated with each other, all of the elements of iconology are gathered together in the study, including above all the attempt to bring image and "life" into harmony. Warburg (1893/1932, 37–8 [see Warburg 1999]).

21 Although it is present throughout, this social-psychology approach is not explicitly formulated in Warburg's dissertation; Gombrich's monograph (1970, 69) has shown that Warburg was well aware of his own premises.

22 On the definition of iconology as a "struggle for enlightenment", see Warnke (1980, 60).

23 Panofsky (1960/1970, 6).

24 Schaeffer (1921); Schmarsow (1923); Yashiro (1925).

25 Gombrich (1945/1972, 38–9).

26 Gombrich (1945/1972, 42–3, 62–3).

27 Panofsky (1939/1962).

28 Panofsky (1946).

29 Panofsky (1960/1970, 187–8).

30 Svetlana L. Alpers (1967, 287) would scarcely wish to maintain her view that the *Rape of the Daughters of Leucippus*, like other mythological paintings, represents the theme of the Neoplatonic "salvation of the soul." Her most recent approach (Alpers 1983) may perhaps be regarded as a self-critical exoneration of Dutch painting from the usual moralizing interpretations.

31 Lücke (1991, 75–6).

32 See, for example, Jacobsen (1972, 424).

33 Hartt (1950).

34 See the list of Neoplatonic interpretations of the page by Albricci (1983).

35 Marzik (1986); Reckermann (1991).

36 Schneider (1973); Ames-Lewis (1970, 144–6).

37 Most recently and most decisively, Darnall and Weil (1984, 72).

38 Perrig (1981, 275).

39 The associated interpretations are apparently boundless, but the most impressive in their concision are still Panofsky's views on the "Neoplatonic Movement and Michelangelo"; Panofsky (1962). He claims that the objects mentioned provide the strongest possible evidence for Neoplatonism (p. 183).

40 See, for example, De Tolnay (1949, 40–1).

41 Levi d'Ancona (1968, 49).

42 Panofsky's interpretation (1962, 212–3) was also particularly successful in this case; see, for example, Frommel (1979, 32, 35–6).

43 In relation to Ludwig von Scheffler, Karl Borinski, and Henry Thode, Panofsky judges "that the worldview expressed in Michelangelo's poems is essentially determined by Neoplatonic metaphysics"; Panofsky (1924/1960, 64).

44 Summers (1987, 283–310); Kieft (1989).

45 Zöllner (1987). If Lücke had done more than merely dismiss this study with a glib remark, he would have been spared a plethora of errors; Lücke (1991, 80, n. 1).

46 See Büchsel (1983, 73–4); and Kidson (1987).

47 Hoffmann (1978).

48 Böhme (1989, 60–9).

49 Schuster (1991) takes up Neoplatonic motifs once again in order to shift them into a much more complex perspective, the "optimistic" content of which recalls Warburg's interpretation.

50 Bredekamp (1988/1990).

51 This counter-hypothesis by Friedländer (1938), the conception of which is still convincing, was never seriously discussed by Panofsky. On this controversy and other interpretive approaches, see Pächt (1977, 266–7) and Radnóti (1983, 146–51). To this one could add Liebmann's critique of Panofsky's Neoplatonic reading of the painting; Liebmann (1966/1984, 312–13). Gentili

(1980, 58–64, 172–3) proves to be a late but critical adherent of Panofsky's view of the two contradictory Venus sisters.

52 See Bredekamp (1985) and more generally Lefaivre (1991).

53 Verheyen (1972).

54 Bredekamp (1987).

55 A Neoplatonic program such as that developed by Marzik (1986) needs to make the core of the fresco cycle, the triumph of Bacchus and Ariadne, into an educational image illustrating the Platonic doctrine of Eros. This is a metamorphosis with which one can scarcely concur (and certainly not with a reference to Tasso's *Aminta*; p. 254). It is also difficult to derive it from the confused philosophical milieu that preceded the turn of the century. The author's authority, Francesco Patrizi (pp. 255–6), as a conservative and Catholic, strictly Counter-Reformation Platonist, would make an improbable inspiration for the upper scenes in the *sala*; in addition, his Platonism was so heavily overladen with a hermetic sense of mission that it brought him into conflict with the Inquisition; see Firpo (1950/1951). It also ignores the character of the individuals who are honoured in the frescoes, such as Cardinal Alessandro Farnese (see Riebesell 1989) and above all that of the patron, Odoardo (Zapperi 1988). In addition, the Carraccis' conception of life is also not shaped by Platonism (Zapperi 1990, 93–122).

56 More convincing than the Neoplatonic interpretations is Volker Herzner's attempt to see the sculpture as a depiction of the Medicis' usurpation of Florence, which pretends to be conciliatory by "relaxing" the motif of David and thereby giving the artist a unique degree of freedom; Herzner (1981, part. 102, 106–7).

57 Bredekamp (1985/1989).

58 See the careful argumentation provided in Summers (1981, 11–17).

59 Panofsky (1962, 207–12); see by contrast Perrig (1981, 275) and Bredekamp (1989, 174–5).

60 Panofsky's Neoplatonic interpretation of the Medici tombs (1962, 199–213) plays no further role in Ettlinger's meticulous analysis of the chapel's liturgical function; Ettlinger (1978).

61 Panofsky loses sight of the monument's purposes in relation to family and political office, and the way in which these are refracted by personal desires for immortalization on the part of both the patron and the artist. More historically appropriate than this type of effort to demonstrate that Neoplatonism is being given physical shape, it seems better – while not excluding the importance of that philosophy – at least to subordinate it to the tension between the claims of office and those of the individual. In particular, the tomb's eventful story unquestionably resulted from more important causes than a conflict of ideas between Christian orthodoxy and Humanist Platonism; Panofsky (1962, 194–9). In his analysis of Michelangelo's David, Verspohl (1981) has shown the way in which a historically more striking conceptualization than the distinction between matter and idea can lead to a new and more authentic view of the work of art itself. Applied to Julius's tomb, this would mean that what is expressed in the gaze of Moses is not, for example, "nothing but what the Neoplatonists called the 'splendour of the light divine'" (Panofsky 1962, 193) but instead represents the tragic moment in which a figure who is the founder of a religion, founder of a state, and a military leader initially seeming to be an embodiment of Machiavelli's Prince is confronted with his own death; Verspohl (1991). For a critique of the Neoplatonic interpretation of the so-called "Slaves" in the Louvre, see Weinberger (1967, vol. 1, 145).

62 Cited after Wind (1958/1968, 123).

63 For a summary account of the various criticisms of this Neoplatonic interpretation, see Kruszynski (1985, 25, 32–3).

64 This is the conclusion reached by Hans Sckommodau in a balanced analysis intended to have an exemplary effect; Sckommodau (1962, 47; see also 30 and 37–8). See the similarly sceptical balanced position in Moses (1981). An early critique of a Neoplatonic reading of the sonnet by Michelangelo that is central to this issue is provided by Bosco (1965).

65 Forster (1972, 467).

66 Pope-Hennessy (1980, xiii).

67 On Marullus, see Munro (1886, 6–14), Perosa (1951), and Kidwell (1989, 158–9). [See also Marullus 2012.] On Epicureanism in the Renaissance, see Allen (1944) and Jones (1989), although in the section on Italy it barely goes beyond Allen.

68 Models that might serve here include Busch (1989a).

69 Parronchi (1959).

70 See, for example, Schmitt (1984). Essays dating from 1981, 1983 and 1985 were also published in the journal *History of Universities*, which Schmitt founded.

71 Beck and Bol (1985), esp. the articles by Dieter Blume, "Beseelte Natur und ländliche Idylle" (173–7), and Norberto Gramaccini, "Das genaue Abbild der Natur – Riccios Tiere und die Theorie des Naturabgusses seit Cennino Cennini" (198–225).

72 Frances Yates's work on Hermetic traditions up to Giordano Bruno (Yates 1964) was able to build on D. P. Walker's study on Ficino (Walker 1958). Walker (1972) also presented a more recent panorama of Hermetic Platonism.

73 Yates (1964, 77).

74 A return of Ficino's "pagan" Platonism into "the arms of Catholic orthodoxy" – already initiated by Cassirer (1927, 65–6, 81–2 [see Cassirer 1963]) – is undertaken by Allen (1984, part. 581–2).

75 Baron (1955).

76 Gombrich (1985).

77 Hope (1984). Hope's aversion is expressed cryptically, in that he plays off Kenneth Clark's *The Art of Humanism* (Clark 1983) as a genuinely "Warburgian" achievement against Edgar Wind's *Eloquence of Symbols* (Wind 1983): truly devastating praise. Although Wind can certainly be accused of a number of suggestively guided findings, it must nevertheless be recognized in principle that he was a researcher who was thoroughly form-sensitive and always took the sensory world into account, and who was constantly able to think his conception of Neoplatonic Renaissance art systematically beyond its own boundaries. His interpretation of the *Primavera*, a shining example of the way in which formal analysis was capable of inspiring conceptual analysis, towers above every other interpretive effort made by the new Neoplatonists either before or after him. See Wind (1958/1968, 113–27). See Bernhard Buschendorf's epilogue to *Pagan Mysteries* in the German translation (Wind 1981, 396–414, 401), and Buschendorf (1985, 166 and 189).

78 The interest in Pythagorean–Platonic theories of harmony, the influence of which is overestimated and the content of which is idealized in Wittkower (1949/1971, 124–6), appears in Baxandall (1972, 103–4) as an abstraction of the everyday obligation of purchasers and sellers to find equivalent values visually. Zöllner (1987) offers a critical assessment of Wittkower.

79 Burckhardt (1980, 23): "I do not dispute that Michelangelo was aware of philosophical ideas and specifically those of Platonism, but I see the origination and completion of a work of art in the mind and through the hand of the master as being something that is certainly touched by his other knowledge and thoughts, but is not essentially conditioned by them and instead arises from a different source."

80 Burckhardt (1905/1969, 61 [see Burckhardt 1943]).

Bibliography

Albricci, Gioconda. 1983. "'Il Sogno di Raffaello' di Giorgio Ghisi." *Arte Cristiana* 71:215–222.

Allen, Don Cameron. 1944. "The Rehabilitation of Epicurus and his Theory of Pleasure in the Early Renaissance." *Studies in Philology* 41:1–15.

Allen, Michael J. B. 1984. "Marsilio Ficino on Plato, the Neoplatonists and the Christian Doctrine of the Trinity." *Renaissance Quarterly* 37:555–584.

Alpers, Svetlana L. 1967. "Manner and Meaning in Some Rubens Mythologies." *Journal of the Warburg and Courtauld Institutes* 30:272–295.

Alpers, Svetlana L. 1983. *The Art of Describing: Dutch Art in the Seventeenth Century*. Chicago: Chicago University Press.

Ames-Lewis, Francis. 1970. "Art History or *Stilkritik*? Donatello's Bronze David Reconsidered." *Art History* 2:139–155.

Baron, Hans. 1955. *The Crisis of the Early Italian Renaissance: Civic Humanism and Republican Liberty in an Age of Classicism and Tyranny*. Princeton: Princeton University Press.

Baxandall, Michael. 1972. *Painting and Experience in Fifteenth Century Italy: A Primer in the Social History of Pictorial Style*. Oxford: Clarendon Press.

Beck, Herbert, and Peter C. Bol, eds. 1985. *Natur und Antike in der Renaissance*, exhib. cat. Frankfurt am Main: Liebieghaus.

Benjamin, Walter. 1932/1972. "'Strenge Kunstwissenschaft'. Zum ersten Band der 'Kunstwissenschaftlichen Forschungen'. Erste und zweite Fassung (1932)." In Walter Benjamin. 1972. *Gesammelte Schriften, vol 3: Kritiken und Rezensionen*, edited by Rolf Tiedemann and Hermann Schweppenhäuser, 363–374. Frankfurt am Main: Suhrkamp.

Böhme, Hartmut. 1989. *Albrecht Dürer: Melencolia I*. Frankfurt am Main: Fischer.

Bolz, Norbert. 1991. *Eine kurze Geschichte des Scheins*. Munich: Fink.

Bosco, Umberto. 1965. "Non ha l'ottimo artista …" *Rivista di Cultura Classica e Medioevale* 7, 1–3:181–186.

Bramly, Serge. 1982. *La Danse du loup*. Paris: Belfond.

Bredekamp, Horst. 1985. "Der 'Traum vom Liebeskampfe' als Tor zur Antike." In *Natur und Antike in der Renaissance*, exhib. cat., edited by Herbert Beck and Peter C. Bol, 139–153. Frankfurt am Main: Liebieghaus.

Bredekamp, Horst. 1985/1989. *Vicino Orsini und der Heilige Wald von Bomarzo: Ein Fürst als Künstler und Anarchist*, 2 vols. Worms: Werner. 2nd rev. ed. 1989 in one vol. Worms: Werner.

Bredekamp, Horst. 1987. "Traumbilder von Marcantonio Raimondi bis Giorgio Ghisi." In *Zauber der Medusa: Europäische Manierismen*, exhib. cat., edited by Werner Hofmann, 62–71. Vienna: Löcker.

Bredekamp, Horst. 1988/1990. *Botticelli, Primavera: Florenz als Garten der Venus*. Frankfurt am Main: Fischer. 2nd ed. 1990 as *Sandro Botticelli: La Primavera*. Frankfurt am Main: Fischer.

Bredekamp, Horst. 1989. "Grillenfänge von Michelangelo bis Goethe." *Marburger Jahrbuch für Kunstwissenschaft* 22:169–180.

Bredekamp, Horst. 1991. "Mimesis, grundlos." *Kunstforum international* 114:278–288.

Büchsel, Martin. 1983. "Ecclesiae symbolorum cursus completus." *Städel-Jahrbuch*, n.s. 9:69–88.

Burckhardt, Jakob. 1905/1969. *Weltgeschichtliche Betrachtungen*, edited by Jakob Oeri. Berlin: Spemann. Commented ed. 1969 by Rudolf Marx. Stuttgart: Kröner.

Burckhardt, Jakob. 1943. *Force and Freedom: Reflections on History*, edited by James Hastings Nichols. New York: Pantheon Books.

Burckhardt, Jakob. 1980. *Briefe, vol. 9: Der Rücktritt vom historischen Amt und sein Nachspiel*. Basel: Schwabe.

Busch, Bernd. 1989a. "Holmes, Epikur und die Welt der fotografischen Bilder." In *Denkzettel Antike: Texte zum kulturellen Vergessen*, edited by Gerburg Treusch-Dieter, Wolfgang Pirscher, and Herbert Hrachovec, 201–228. Berlin: Reimer.

Busch, Bernd. 1989b. *Belichtete Welt: Eine Wahrnehmungsgeschichte der Fotografie*. Munich: Hanser.

Buschendorf, Bernhard. 1985. "'War ein sehr tüchtiges gegenseitiges Fördern': Edgar Wind und Aby Warburg." *Idea* 4:165–209.

Cassirer, Ernst. 1927. *Individuum und Kosmos in der Philosophie der Renaissance*. Leipzig: Teubner.

Cassirer, Ernst. 1963. *The Individual and the Cosmos in Renaissance Philosophy*, translated by Mario Domandi. Oxford: Basil Blackwell.

Clark, Kenneth. 1983. *The Art of Humanism*. London: John Murray.

Darnall, Margaretta J., and Mark S. Weil. 1984. "Il Sacro Bosco di Bomarzo: Its 16th-Century Literary and Antiquarian Context." *Journal of Garden History* 4, 1:1–94.

De Tolnay, Charles. 1949. *Michelangelo, vol. 2: The Sistine Ceiling*. Princeton: Princeton University Press.

Dilly, Heinrich, and Ulrike Wendland. 1991. "'Hitler ist mein bester Freund …' Das kunsthistorische Seminar der Hamburger Universität." In *Hochschulalltag im Dritten Reich: Die Hamburger Universität 1933–1945*, edited by Eckart Krause, Ludwig Huber, and Holger Fischer, 607–624. Berlin: Reimer.

Eberlein, Johann Konrad. 1986. "Inhalt und Gehalt: Die ikonologische Methode." In *Kunstgeschichte: Eine Einführung*, edited by Hans Belting, Heinrich Dilly, Wolfgang Kemp, Willibald Sauerländer, and Martin Warnke, 164–185. Berlin: Reimer.

Ettlinger, Leopold David. 1978. "The Liturgical Function of Michelangelo's Medici Chapel." *Mitteilungen des kunsthistorischen Institutes in Florenz* 22:287–304.

Ficino, Marsilio. 1985. *Commentary on Plato's Symposium on Love*, translated by Sears R. Jayne. 2nd rev. ed. Dallas: Spring Publications.

Firpo, Luigi. 1950/1951. "Filosofia italiana e controriforma." *Rivista di Filosofia* 41:150–173, and 42:30–47.

Forster, Kurt W. 1972. "Critical History of Art, or Transfiguration of Values?" *New Literary History* 3:459–470.

Friedländer, Walter. 1938. "*La tintura delle rose* (the Sacred and Profane Love) by Titian." *Art Bulletin* 20:320–324.

Frommel, Christoph Luitpold. 1979. *Michelangelo und Tommaso dei Cavalieri*. Amsterdam: Castrum Peregrini.

Gentili, Augusto. 1980. *Da Tiziano a Tiziano: mito e allegoria nella cultura veneziana del Cinquecento*. Milan: Feltrinelli.

Gombrich, Ernst H. 1945/1972. "Botticelli's Mythologies: A Study in the Neoplatonic Symbolism of his Circle." *Journal of the Warburg and Courtauld Institutes* 8:7–60. Repr. 1972 in Ernst H. Gombrich, *Studies in the Art of the Renaissance, vol. 2: Symbolic Images*, 31–81. London: Phaidon.

Gombrich, Ernst H. 1960. *Art and Illusion: A Study in the Psychology of Pictorial Representation*. London: Phaidon.

Gombrich, Ernst H. 1970. *Aby Warburg: An Intellectual Biography, with a Memoir on the History of the Library by F. Saxl*. London: Warburg Institute.

Gombrich, Ernst H. 1985. "Topos und aktuelle Anspielung in der Kunst der Renaissance." *Freibeuter* 23:15–40.

Hartt, Frederick. 1950. "Gonzaga Symbols in the Palazzo del Te." *Journal of the Warburg and Courtauld Institutes* 13:151–188.

Herzner, Volker. 1981. "David Florentinus II: Der Bronze-David Donatellos im Bargello." *Jahrbuch der Berliner Museen* 23:63–142.

Hoffmann, Konrad. 1978. "Dürers 'Melencolia'." In *Kunst als Bedeutungsträger: Gedenkschrift für Günter Bandmann*, edited by Werner Busch, Reiner Haussherr, and Eduard Trier, 251–277. Berlin: Mann.

Hoffmann, Konrad. 1986. "Die Hermeneutik des Bildes." *kritische berichte* 14, 4:34–38.

Hope, Charles. 1984. "Naming the Graces." *London Review of Books*, 15 March–4 April 1984, 13–14.

Jacobsen, Michael A. 1972. "Vulcan Forging Cupid's Wing." *Art Bulletin* 54:418–429.

Jones, Howard. 1989. *The Epicurean Tradition*. London: Routledge.

Kidson, Peter. 1987. "Panofsky, Suger, and Saint Denis." *Journal of the Warburg and Courtauld Institutes* 50:1–17.

Kidwell, Carol. 1989. *Marullus: Soldier Poet of the Renaissance*. London: Duckworth.

Kieft, Ghislain. 1989. "Zuccari, Scaligero e Panofsky." *Mitteilungen des kunsthistorischen Institutes in Florenz* 33:355–368.

Kruszynski, Anette. 1985. *Der Ganymed-Mythos in Emblematik und mythographischer Literatur des 16. Jahrhunderts*. Worms: Werner.

Lefaivre, Liane. 1991. "Eine erotische Einmischung: Die verkannte Hypnerotomachia Poliphili." *Daidalos* 15:92–100.

Levi d'Ancona, Mirella. 1968. "The Doni Madonna by Michelangelo: An Iconographic Study." *Art Bulletin* 50, 2:43–50.

Liebmann, Michael. 1966/1984. "Ikonologie." *Kunst und Literatur* 14:1228–1243. Repr. 1984 in *Ikonographie und Ikonologie: Theorien – Entwicklung – Probleme*, edited by Ekkehard Kaemmerling, 301–328. Cologne: DuMont.

Lomazzo, Giovanni Paolo. 2013. *Idea of the Temple of Painting*, edited and translated by Jean Julia Chai. University Park, PA: Pennsylvania State University Press.

Lücke, Hans-Karl. 1991. "Mercurius quadratus: Anmerkungen zur Anthropometrie bei Cesariano." *Mitteilungen des kunsthistorischen Institutes in Florenz* 35:61–84.

Marullus, Michael. 2012. *Poems*, translated by Charles Fantazzi. Cambridge, MA: Harvard University Press.

Marzik, Iris. 1986. *Das Bildprogramm der Galleria Farnese in Rom*. Berlin: Mann.

Moses, Gavriel. 1981. "Philosophy and Mimesis in Michelangelo's Poems." *Italianistica: Rivista di Letteratura Italiana* 10, 2:162–177.

Munro, H. A. J., ed. 1886. *T. Lucreti Cari De Rerum Natura Libri Sex, vol. 1: Text*. 4th rev. ed. London: Bell.

Pächt, Otto. 1977. *Methodisches zur kunsthistorischen Praxis*. Munich: Prestel.

Panofsky, Erwin. 1924/1960. *Idea: Ein Beitrag zur Begriffsgeschichte der älteren Kunsttheorie*. Leipzig and Berlin: Teubner. 2nd rev. ed. 1960. Berlin: Hessling.

Panofsky, Erwin. 1926/1955. "Sacred and Profane Love." *Burlington Magazine* 49:177–181. Revised Repr. 1955 in Erwin Panofsky. *Meaning in the Visual Arts: Papers in and on Art*, 301–328. Garden City, NY: Doubleday. Translated into German 1975 as "Himmlische und irdische Liebe." In Erwin Panofsky, *Sinn und Deutung in der bildenden Kunst*, 167–191. Cologne: DuMont.

Panofsky, Erwin. 1930. *Hercules am Scheidewege und andere antike Bildstoffe in der neueren Kunst*. Leipzig: Teubner.

Panofsky, Erwin. 1938/1955. "The History of Art as a Humanistic Discipline." In *The Meaning of the Humanities*, edited by Theodore M. Greene, 89–118. Princeton: Princeton University Press. Repr. 1955 in Erwin Panofsky, *Meaning in the Visual Arts*, 1–25. Garden City, NY: Doubleday.

Panofsky, Erwin. 1939/1962. "The Neoplatonic Movement in Florence and North Italy (Bandinelli and Titian)." Repr. 1962 in Erwin Panofsky. *Studies in Iconology: Humanistic Themes in the Art of the Renaissance*, 129–170. New York: Harper & Row.

Panofsky, Erwin. 1946. "Introduction." In Erwin Panofsky, *Abbot Suger on the Abbey Church of St.-Denis and its Art Treasures*, 1–37. Princeton: Princeton University Press.

Panofsky, Erwin. 1960/1970. *Renaissance and Renascences in Western Art*. Stockholm: Almqvist & Wiksell. Repr. 1970. London: Paladin.

Panofsky, Erwin. 1962. "The Neoplatonic Movement and Michelangelo." In Erwin Panofsky, *Studies in Iconology: Humanistic Themes in the Art of the Renaissance*, 171–230. New York: Harper & Row.

Panofsky, Erwin. 1968. *Idea: A Concept in Art Theory*, translated by Joseph J. S. Peake. Columbia: University of South Carolina Press.

Panofsky, Erwin. 1969. *Problems in Titian, Mostly Iconographic*. New York: New York University Press.

Parronchi, Alessandro. 1959. "Sul 'Della Statua' Albertiano." *Paragone* 9, 117:3–29.

Perosa, Alessandro, ed. 1951. *Michaelis Marulli Carmina*. Zurich: Artemis.

Perrig, Alexander. 1981. "Die Konzeption der Wandgräber der Medici-Kapelle." *Städel Jahrbuch*, n. s. 8:247–287.

Pope-Hennessy, John. 1980. "Introduction (1979)." In Herbert P. Horne, *Botticelli: Painter of Florence*, ix–xiii. Princeton: Princeton University Press.

Radnóti, Sándor. 1983. "Die wilde Rezeption: Eine kritische Würdigung Erwin Panofskys von einem kunstphilosophischen Gesichtspunkt aus." *Acta Historiae Artium Hungariae* 29:117–153.

Reckermann, Alfons. 1991. *Amor mutuus: Annibale Caraccis Galleria-Farnese-Fresken und das Bild-Denken der Renaissance*. Cologne: Böhlau.

Riebesell, Christina. 1989. *Die Sammlung des Kardinal Alessandro Farnese: Ein 'Studio' für Künstler und Gelehrte*. Weinheim: VCH.

Robb, Nesca A. 1935/1968. *Neoplatonism of the Italian Renaissance*. London: Allen & Unwin, 1935. Repr. New York: Octagon Books.

Schaeffer, Emil. 1921. *Sandro Botticelli*. Berlin: Bard.

Schmarsow, August. 1923. *Sandro del Botticello*. Dresden: Reissner.

Schmitt, Charles B. 1984. *The Aristotelian Tradition and Renaissance Universities*. London: Variorum Reprints.

Schneider, Laurie. 1973. "Donatello's Bronze David." *Art Bulletin* 55:213–216.

Schuster, Peter-Klaus. 1991. *Melencolia I: Dürers Denkbild*, 2 vols. Berlin: Mann.

Sckommodau, Hans. 1962. "Michelangelo und der Neuplatonismus." *Jahrbuch für Ästhetik und allgemeine Kunstwissenschaft* 7:28–47.

Summers, David. 1981. *Michelangelo and the Language of Art*. Princeton: Princeton University Press.

Summers, David. 1987. *The Judgement of Sense: Renaissance Naturalism and the Rise of Aesthetics*. Cambridge: Cambridge University Press.

Verheyen, Egon. 1972. "Die Malereien in der Sala di Psiche des Palazzo del Te." *Jahrbuch der Berliner Museen* 14:33–68.

Verspohl, Franz-Joachim. 1981. "Michelangelo und Machiavelli." *Städel-Jahrbuch* 8:204–246.

Verspohl, Franz-Joachim. 1991. "Der Moses des Michelangelo." *Städel-Jahrbuch* 13:155–176.

Walker, D. P. 1958. *Spiritual and Demonic Magic: From Ficino to Campanella*. London: The Warburg Institute.

Walker, D. P. 1972. *The Ancient Theology: Studies in Christian Platonism from the Fifteenth to the Eighteenth Century*. London: Duckworth.

Warburg, Aby. 1892. *Sandro Botticellis 'Geburt der Venus' und 'Frühling': Eine Untersuchung über die Vorstellungen von der Antike in der italienischen Frührenaissance*, PhD diss. Frankfurt am Main: Osterrieth. Repr. 1932 in Aby Warburg, *Gesammelte Schriften*, vol. 1, 1–58. Leipzig: Teubner.

Warburg, Aby. 1893/1932. *Sandro Botticellis 'Geburt der Venus' und 'Frühling': Eine Untersuchung über die Vorstellungen von der Antike in der italienischen Frührenaissance*, PhD diss. Hamburg and Leipzig: Leopold Voss. Repr. 1932 in Aby Warburg, *Die Erneuerung der heidnischen Antike: Kulturwissenschaftliche Beiträge zur Geschichte der europäischen Renaissance*, vol. 1, 1–58. Leipzig: Teubner.

Warburg, Aby. 1999. "Sandro Botticelli's 'Birth of Venus' and 'Spring': An Examination of Concepts of Antiquity in the Italian Early Renaissance." In *The Renewal of Pagan Antiquity: Contributions to the Cultural History of the European Renaissance*, translated by David Britt, 223–262. Los Angeles: Getty Research Inst. for the History of Art and the Humanities.

Warnke, Martin. 1980. "Ikonologie." In *Die Menschenrechte des Auges: Über Aby Warburg*, edited by Werner Hofmann, Georg Syamken, and Martin Warnke, 55–61. Frankfurt am Main: Europäische Verlagsanstalt.

Weinberger, Martin. 1967. *Michelangelo the Sculptor*, 2 vols. London: Routledge & Kegan Paul.

Wind, Edgar. 1934. "Einleitung." In Bibliothek Warburg, ed., *Kulturwissenschaftliche Bibliographie zum Nachleben der Antike*, vol. I, i–xvii. Leipzig: Teubner.

Wind, Edgar. 1958/1968. *Pagan Mysteries in the Renaissance*. London: Faber & Faber. Rev. ed. 1968.

Wind, Edgar. 1981. *Heidnische Mysterien in der Renaissance*, translated by Christa Münstermann. Frankfurt am Main: Suhrkamp.

Wind, Edgar. 1983. *The Eloquence of Symbols: Studies in Humanist Art*. Oxford: Clarendon Press.

Wittkower, Rudolf. 1949/1971. *Architectural Principles in the Age of Humanism*. London: Warburg Institute. Rev. ed. 1971. New York: Norton.

Yashiro, Yukio. 1925. *Sandro Botticelli*. London: Medici Society.

Yates, Frances. 1964. *Giordano Bruno and the Hermetic Tradition*. London: Routledge & Kegan Paul.

Zapperi, Roberto. 1988. "Odoardo Farnese: Principe e Cardinale." In *Les Carrache et les décors profanes: actes du colloque organisé par l'Ecole française de Rome, Rome, 2–4 octobre 1986*, 335–358. Rome: Ecole française de Rome.

Zapperi, Roberto. 1990. *Annibale Carracci: Bildnis eines jungen Künstlers*, translated by Ingeborg Walter. Berlin: Wagenbach. [1989. *Annibale Carracci: ritratto di artista da giovane*. Turin: Einaudi.]

Zöllner, Frank. 1987. *Vitruvs Proportionsfigur: Quellenkritische Studien zur Kunstliteratur und Vitruvrezeption im 15. und 16. Jahrhundert*. Worms: Werner.

Index

Note: page numbers in italics refer to illustrations